WONDER GIRLS

PAOLA GIANTURCO & ALEX SANGSTER
FOREWORD BY MUSIMBI KANYORO

WONDER GIRLS

CHANGING OUR WORLD

powerHouse Books
Brooklyn, NY

WONDER GIRLS: CHANGING OUR WORLD

Photographs and text © 2017 Paola Gianturco & Alex Sangster

Foreword © 2017 Musimbi Kanyoro

Published in the United States by powerHouse Books,
a division of powerHouse Cultural Entertainment, Inc.
32 Adams Street, Brooklyn, NY 11201-1021
telephone 212.604.9074, fax 212.366.5247
e-mail: info@powerHouseBooks.com
website: www.powerHouseBooks.com

First edition, 2017

Library of Congress Control Number: 2017938957

Hardcover ISBN 978-1-57687-822-4

Printing and binding by Pimlico Book International

10 9 8 7 6 5 4 3 2 1

Printed and bound in China

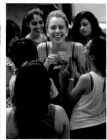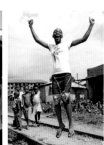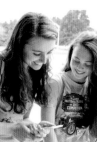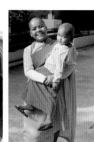

TABLE OF CONTENTS

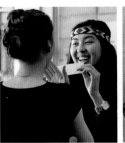

INTRODUCTION

Wonder Woman, superhero, fights for peace, equality, and justice using magic bracelets, a tiara, and a lasso of truth.

Wonder girls, real-life heroes, transform our world using energy and intelligence, creativity and confidence, determination and dreams.

This book may overturn assumptions about girls age 10 to 18. Some people perceive them as "the future." But *right now,* they are enhancing education, health, equality, and the environment—and stopping child marriage, domestic violence, trafficking, and war.

Between 2013 and 2016, I spent one week each with 15 girl-led nonprofit groups in 13 countries. My 11-year-old co-author, Alex Sangster, interviewed them via FaceTime with increasing excitement. "Girls should share their own voices. This is one way!" she urged. You are about to read 90 activist girls' stories, all told in their own words.

This book is third in a triptych. *Women who Light the Dark* told about women activists; *Grandmother Power: A Global Phenomenon* described grandmother activists; *Wonder Girls: Changing Our World* features girl activists.

My path to this book began long ago. I grew up at a time when women and girls were discounted in many parts of the world. I became a feminist, passionate about the idea that men and women are equal and deserve equal opportunities. I was a principal in the first women-owned advertising agency, committed to representing women and girls with respect and dignity. In 1995, I began creating books about women around the world whose stories had been considered unimportant.

This is my sixth book. I have learned that when women and girls are heard, they recognize their own strength. And when they understand each other more completely, they collaborate to catalyze positive change that will affect them, their families, communities, countries, and our world.

Many influences ignited the idea for this book, but early on, I was inspired by Jameela Nishrat from Hyderabad, India, who presented a speech titled,

"The revolution will be led by a 12-year-old girl." Her thesis was that adolescent girls' rebellion against what they perceive to be unjust and wrong can reshape the world. Her organization, Shaheen, which is featured in a chapter of this book, proves her point.

I searched for more examples. Many nonprofits help girls, but I was looking for nonprofits where girls do the helping. I discovered such organizations in Asia and Central Asia, North and Latin America, the Middle East, Africa, and Oceania.

Ultimately, I watched girls lobby U.S. senators to increase funding for universal girls' education. I saw girls in Mexico inventing mobile phone apps to solve social problems such as health and hunger. I met girls in rural Malawi who caused Parliament to outlaw child marriage. I witnessed girls in Uganda arguing for girls' rights at a U.N. Women meeting. Others wrote blogs and poetry, created radio shows and videos, invented dances, songs, and art to promote their causes. I was dazzled. I suspect you will be, too.

Throughout my research, I felt as if I were watching Trojan horses. Most people don't expect young girls to speak truth to power or to be strategic and effective. Their age works to their advantage; their creative approaches, stamina, and resilience catch people off guard and win them. Wonder girls are unlikely to outgrow their passion for the issues; one girl in Maryland told me, "I will be wedded to this cause for the rest of my life."

Unlike the women's groups I documented for other books, several *Wonder Girls* groups included boys who were welcomed as peers and collaborators. All 15 groups included adult women mentors who offered expertise, contacts, or transportation, but who were wise enough to let the girls run the show.

Today's girls are citizens of the world. They Skype, Snapchat, FaceTime, Instagram, and email across borders. Even in poor, rural areas where Wi-Fi is iffy and phone service is unaffordable, they text. They surf the Internet for information. Their world is small: I was not surprised to see girls in Kyrgyzstan posting graffiti pictures of the Mexican artist Frida

Kahlo. Girls who speak different languages use the words "like," "cool," and "awesome" as if they were sprinkling sugar on their conversations.

The girls in this book welcomed me as an honored guest and some adopted me as their grandmother. They called me Jajja in Uganda and Bibi in Kenya. Ten-year-olds took me by the hand. Older girls confided in me and friended me on Facebook.

Creating *Wonder Girls* with my granddaughter Alex Sangster as co-author was a joy. Since the book focuses on ages 10 to 18, I knew the project would benefit from the perspective of someone closer to that age group. When we started, Alex was 10.

Alex is something of a wonder girl herself. She and her sister Avery launched a children's program at an international poverty conference. They hoped youngsters from around the world would become friends, and, perhaps, someday, tackle the problems that face people everywhere.

My friends imagined that Alex would learn from talking to girls around the world, from researching and writing, and from working with me. But nobody anticipated how much I would learn from Alex.

The first time she called me to talk about *Wonder Girls,* I tucked the phone between my chin and shoulder. Suddenly, I heard her voice, "Excuse me please, Grandmother, I think I am looking into your ear." Yep; I had never FaceTimed. Later, Alex grabbed Google Maps when I got us lost in Los Angeles, and downloaded Google Translate to render menus in Guadalajara into English.

Since her fourth and fifth grade studies took priority over traveling, Alex conducted most of her interviews electronically, working across time zones. Sometimes I sat in distant countries and marveled as she solved connectivity issues that flummoxed me.

I also learned new ways to think about photography from Alex, who took most of the pictures in the chapters titled "Developing Solutions" and "Igniting Issues." When she was two, I gave her a point-and-shoot camera. Then she was so short that her pictures featured only her parents' feet and her dog's

tail. Long since, she graduated to a digital single-lens reflex camera. She shoots from above, below, diagonally, and sometimes goes outside to shoot in through windows. Alex's creativity inspired, pushed, and liberated me.

Alex's essential responsibility was to research and write the sections titled "How YOU Can Change OUR World." Those sections invite readers (and the girls in their lives) to support the girls' group featured in each chapter.

These sections are, in my view, the reason for this book: to engage readers in collaborations with girls everywhere. Alex and I both hope you will contribute some time, energy, and money to empower girls locally and globally, and that you will encourage your friends, networks, and communities to follow your example. As Alex says, "These girls are changing the world. You can pitch in—and spread the word!"

By purchasing this book, you have already begun to support girls around the world. One hundred percent of the author royalties from *Wonder Girls* go to the Global Fund for Women, which supports girls' groups in many countries.

The President and CEO of the Global Fund for Women, Musimbi Kanyoro, wrote the foreword that you are about to read. All her working life, she has fostered social justice internationally, and supported girls globally. For 10 years, she was General Secretary of the World YWCA in Geneva, which she transformed into an organization run by young women. You and I are privileged that she is sharing her perspective here.

I hope *Wonder Girls* will motivate you to reconsider your preconceptions about adolescent girls, to be inspired by the girls in this book, and to join them. Only by working together can we create hope and possibility for our complicated, troubled world. Alex and I invite you to become an ally of these groundbreaking young activists.

We dedicate this book to wonder girls everywhere.

THE WONDER OF IT ALL

by Musimbi Kanyoro

My work at the Global Fund for Women has made me acutely aware of a phenomenon you may not have noticed: young girls can be powerful forces for positive change. *Wonder Girls: Changing Our World* documents this dramatically and convincingly.

Its inspiring message: empowering such imaginative and courageous girls—and supporting their initiatives—promises a healthier, more sustainable world for all of us.

I was humbled when Paola Gianturco invited me to write this foreword back when this book was a gleam in her eye. She recognized that my own involvements with GFW, YWCA, and United Nations would give me a distinctive perspective. Now that her gleam is a reality I can attest to its power based on personal experience.

This kind of storytelling speaks deeply to my soul, and I hope it will do the same for everyone who comes in contact with this book.

I believe that supporting the efforts of girls is the most effective investment to spur economic development and end global poverty.

We know that the poorest countries face the most rapid population growth, and girls and young women are the most disadvantaged. It is through major and sustained improvements in their conditions that we can anticipate a brighter future for all of us.

What does investing in girls actually look like on the ground? What have we learned about the kinds of investments that have the greatest return? And whom to invest in?

The challenges are systemic; educating one girl here and another there is not enough. We must support changing education systems to enroll, offer quality, and keep girls in school. We must invest in movements and people working to change cultures and norms.

We must be willing to get money to places where girls and women can't own property or open a bank account. And we must be patient, or we will never reap the rewards.

Success stories like those you will read about in this compelling book create a fertile ground for change to take root. We must multiply them many-fold to achieve sustainable development.

It is a proven concept that investing in girls made vulnerable by poverty is a priority. Investing in education enables girls to defer child bearing, which saves their lives and slows population growth.

Too many programs that claim to "empower" or "uplift" are long on rhetoric and short on giving girls real power and space. Not so with the initiatives in this book. It features girls who are creative, gutsy, and determined to be responsible citizens.

We must enable all girls everywhere to have such voice, confidence, and agency.

WONDER GIRLS

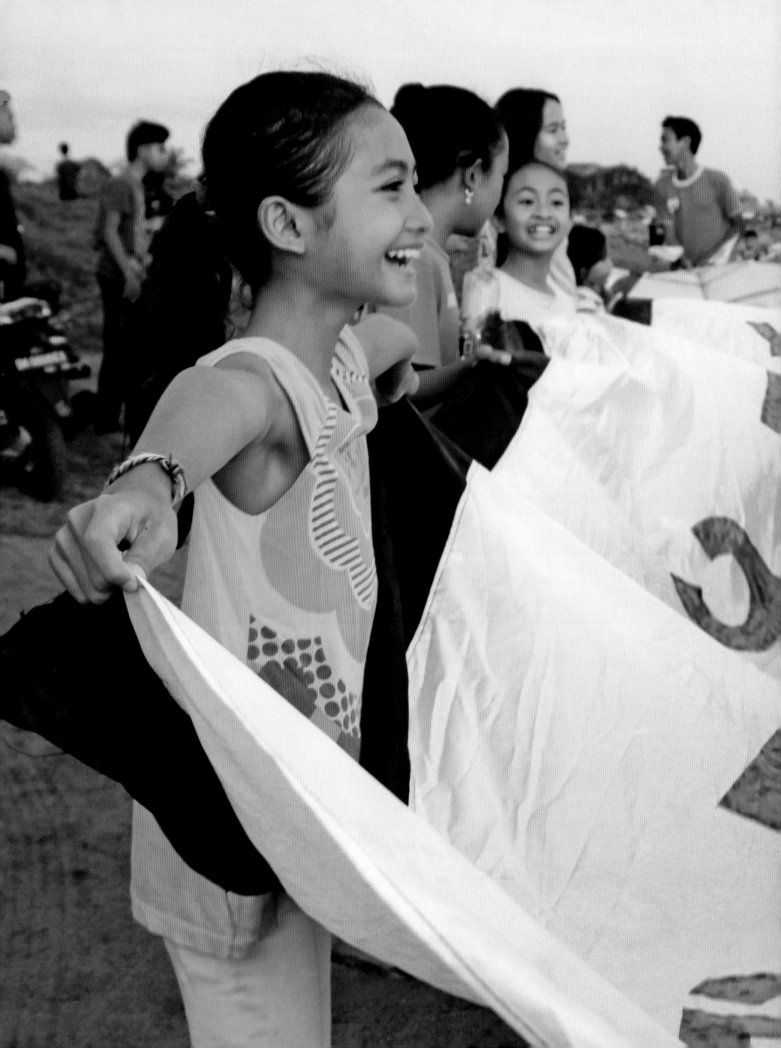

PROTECTING THE PLANET

Indonesia

I WAS DAZZLED by Bali 20 years ago: rice fields whose waters mirrored palm trees...floating shrines...swaths of white sand...tangles of tropical plants and orchids...temples decorated with bright banners, parasols and offerings of flowers, fruit, and incense...festivals upon festivals. An island paradise.

The Bali I encounter today is shockingly different; not just because of tourism, traffic, and development. Today it's encrusted with the detritus of modern life: plastic.

BELOW AND OPPOSITE: **Balinese children are convincing tourists and locals to stop using plastic bags, which are destroying their idyllic island environment.**

Plastic trash clogs roadsides and chokes beaches. You might think there'd be a law against littering, but Bali's constitution mandates that nothing can be banned, so every day, Bali's residents and visitors dump 5,000 tons of solid garbage.

Plastic bags blow past me in the wind. They never disintegrate. Birds, land, and sea animals eat them and die. Well-meaning locals burn bags, releasing polyvinyl carbonate and dioxins into the air for everyone to breathe.

Two sisters, Melati and Isabel Wijsen, decided to do something about it. I've been invited to their home for dinner.

Their Dutch mother and Javanese father designed their house, which is adjacent to a Hindu shrine. Villagers pass their open-air livingroom bearing offerings to the temple. Geckos bark. The girls' mother, Elvira, cooks while we talk.

"Two days, 16 presentations, over 1,000 children!"

MELATI RIYANTO WIJSEN, 14

"ISABEL AND I WERE TAKING A CLASS about significant people, learning about Nelson Mandela and Martin Luther King. I said to Isabel, 'Don't we want to be like them? Don't we want to do something to make the world better?' We were like, 'Yeah! Let's do it.'

"We sat here on this bench and made a list of problems in Bali: pollution, traffic, too many hotels. For us, garbage was the biggest thing. Isabel said, 'But garbage is a big problem; maybe we should leave that to the big people.'

"'Plastic bags are a problem, right Bel?' 'Yeah! Write that down.' 'Everybody uses plastic bags. People toss them from cars, put them in bins, and where do they go? Into rice fields, rivers, the ocean.' It was like, 'Yes! We're doing it!'

"The name was a joint effort. We had Plastic Bags-Bali and Keep Bali Beautiful, plus some weird, out-there, random ideas. Then we just looked at each other and said, 'We're getting plastic bags, so let's call our project Bye Bye Plastic Bags!' It seemed cool because we were going to involve kids like us and we thought the name fit our purpose.

"We decided to create an online petition. I was 12. I had never done this before. I chose Avaaz.org because it started with A so it was at the top of the list. On the petition, we said, 'We want to collect a million signatures urging the government to make a law banning plastic bags.'

"Within 24 hours, we had 6,000 signatures. The next day, 10,000. It became a game. We'd get up, go online, and see how many signatures. Strangers from all over the world! It was crazy! We were getting this ridiculous momentum.

"Next thing we knew, we were invited to speak to the Global Initiative Network. We were really nervous. Amazing people spoke before us. A U.N. delegate. Someone from Greenpeace. We thought, 'That's weird; this is a youth networking conference but we are the only kids!'

"We looked like goofballs up there reading from scripts with shaky voices. A 10 and 12-year-old! But it was cool. We introduced, 'A social initiative driven by children to make the people of Bali say no to plastic bags.' We did a call-to-action to join our team.

"Bye Bye Plastic Bags started in October 2013—and 2014 began with a fresh group of people, which was crazy: kids I had never met who heard us speak at the GIN conference. We are still meeting new kids who are like-minded, which makes for good friendships and teamwork.

"Not long afterwards, we made a presentation to Rotary. Our mother is a member so the Rotarians knew us. Bye Bye Plastic Bags became part of the Interact Club, the younger version of Rotary International. We want to email Indonesia's 340,000 Interactor clubs inviting them to sign our petition. That is a big amount! It will be great if we can do that.

"When the United Nations Secretary General Ban Ki Moon came to our school to sign a Memorandum of Understanding with UN-REDD Indonesia (which works against deforestation), the school made it possible for us to have 10 minutes with him.

"Isabel and I were to escort him. He had bodyguards, so that was a strange experience. We had to be pre-analyzed. There were people testing his coconut before he drank from it, and deciding where was he going to walk, around this or that side of a tree.

"He came out of his limo with his wife. We introduced ourselves and told him about Bye Bye Plastic Bags.

"We asked him to sign our petition! And he said, 'I wish I could, but I can't because of protocol.' So we contacted his protocol lady. She was amazing. Now she supports us, and Bye Bye Plastic Bags proudly carries the United Nations logo.

"This year, Tanya, who is my age, invited us to speak at her school in Singapore. Isabel and I wanted to do a road trip to as many schools as we could. We took Billy and Lotte, who are on our board, and it was so much fun! We arrived at 1:00 AM and they wanted our first presentation at 7:00 AM. We were sleeping in the taxi on the way to the school.

"The thing that surprised all of us (jaw dropping shocked us!) was that when we spoke at schools, the audiences were as large as our entire school. We had 400 kids in one auditorium, and that was just one grade!

"Two days, 16 presentations, over 1,000 children. Unforgettable! Every time we finished a presentation, we'd check the petition online and it would be Singapore, Singapore, Singapore, Singapore. We have a lot of kids spreading the word now. It's really cool."

OPPOSITE AND OVERLEAF: Girls and boys from the project's pilot village, Pererenan, help fly a giant kite carrying the Bye Bye Plastic Bags logo, to increase awareness.

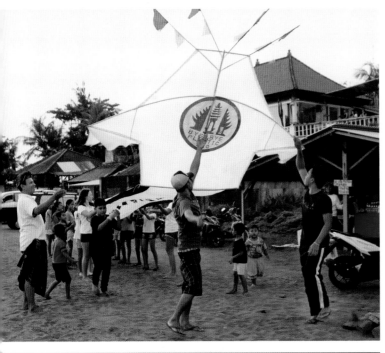
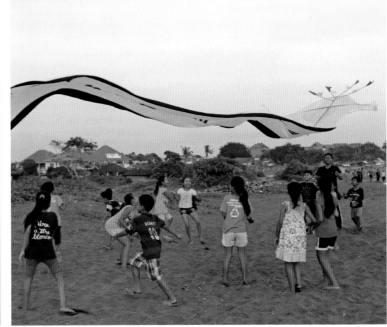
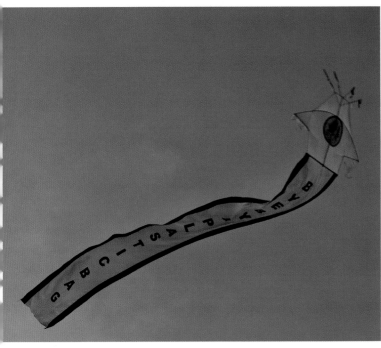

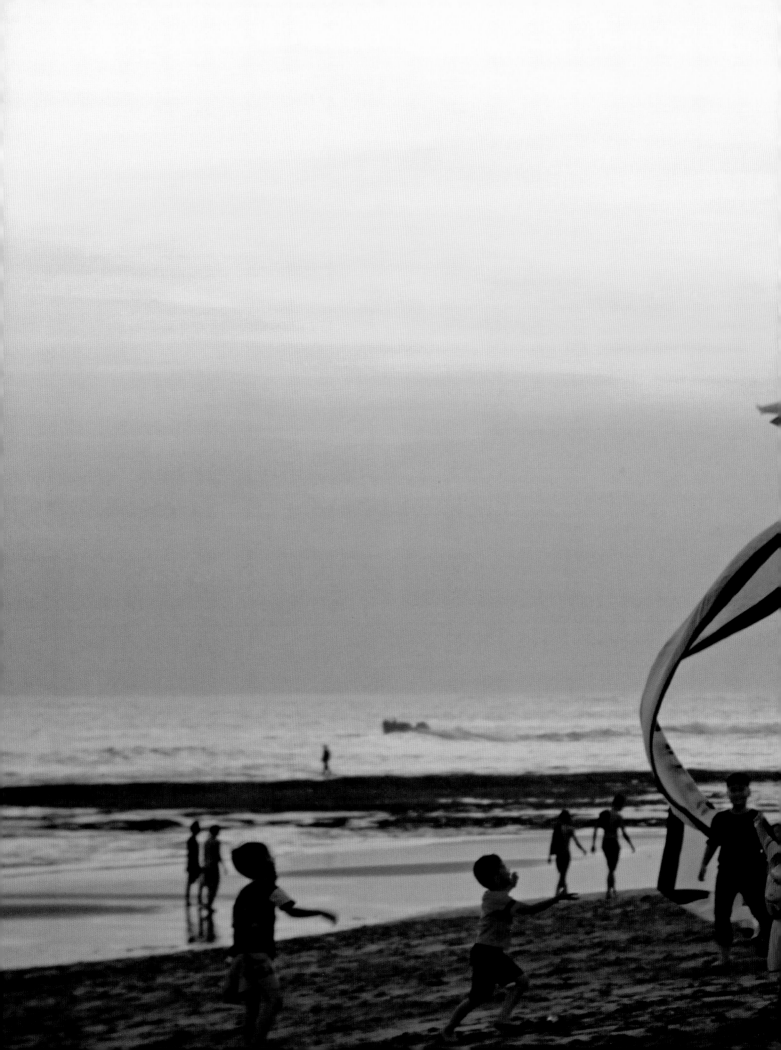

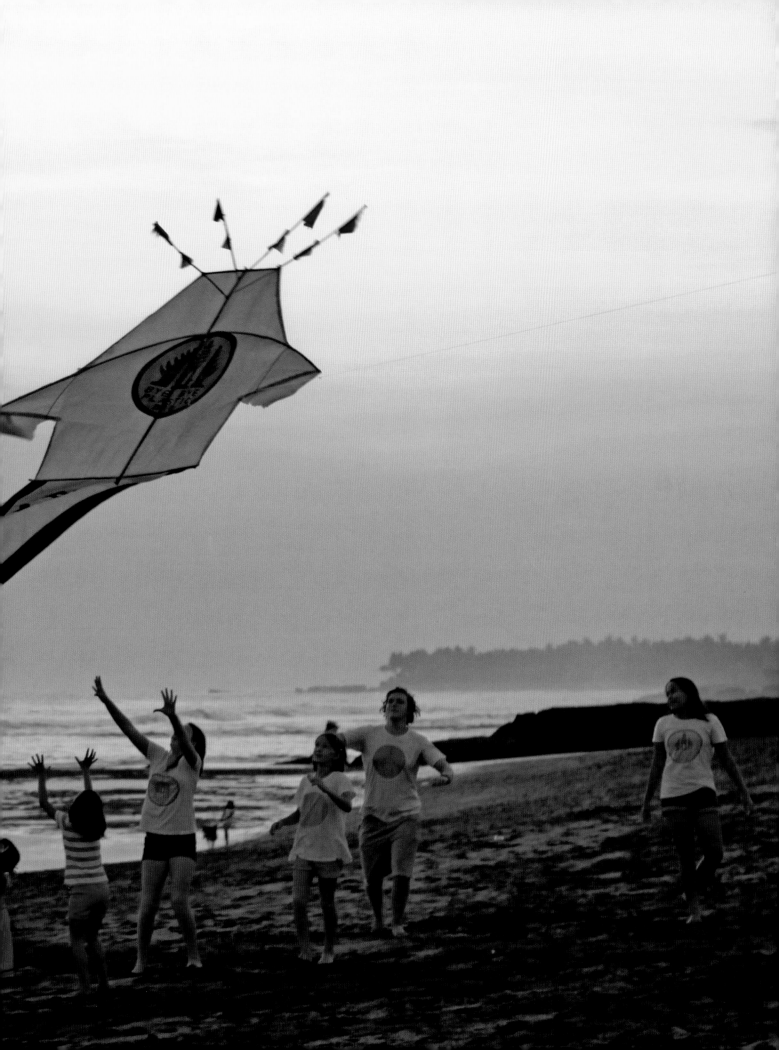

"We sent a letter to the governor saying we were going on a hunger strike."

ISABEL SARI RIYANTO WIJSEN, 12

I START INTERVIEWS by inviting girls to tell me about themselves. Isabel confides, "Maybe I would like to be an elephant mahout when I grow up because elephants are brilliant, magestical creatures. I also want to do performing arts, which is one of the best ways to spread a message."

I have never met a girl who wants to be a mahout. Isabel leads the pack in the dream department.

One of the youngest leaders I've met, Isabel makes leadership sound easy. "We learned to lead by doing something. For example, if we were going to a market to have a booth, we'd say, 'Who wants to organize this?' Someone would say, 'Me!' Then they'd ask, 'Who wants to join me?' and they'd organize a team, and its leader would lead naturally."

While the girls were in school today, I explored Pura Tanah Lot, a Hindu temple near Canggu. Now I ask Isabel, "How did Bye Bye Plastic Bags stickers get on Tanah Lot's recycling bins?"

"We decided to do a flash mob in front of the temple. We went to Tanah Lot and had a meeting with the King of Tanah Lot, who was supportive. He said, 'I will stop using plastic bags.' And he allowed us to ask people there to sign our petition.

"We did a freeze flash mob. The temple gong would ring and we would freeze. People would look at us—and another gong would ring and we'd freeze in a different position. We had plastic bags in our pockets and we waved them and shouted, 'Bye Bye Plastic Bags!' That was the first flash mob ever on Bali and it was cool! Afterwards, we asked everyone to sign our petition."

Isabel reports, "Last year, we heard that there are 16 million people going in and out of the Bali airport every year. So we were like, 'Jackpot! That's where we're going!' We knocked on doors, and finally the Commercial Manager of Bali Airports granted us permission to ask people to sign our petition.

"Sometimes, we'd go with five kids for three hours and get 800 signatures. That was our high score. We always have competitions: who can collect the most? We're like, 'Hi, we're from an initiative, Bye By Plastic

Bags, to stop the use of plastic bags on Bali.' They're already like, 'Yes! I will sign!' Usually, if they're not worried about missing their flight, people sign."

I ask how Isabel and Melati got support from the Governor of Bali, Made Mangku Pastika.

Isabel remembers, "It was two years, and we still hadn't gotten to meet the governor. We thought. 'This is it.' So we sent a letter saying that we were going on a hunger strike. We did radio and television interviews, which is the best way to send messages fast. And it blew up on the Internet.

"We tried not to be active when fasting; no PE. We drank juices that contained Vitamin C. Before sunrise, we ate a lot, then back to bed. We'd drink coconut water all day. Sundown, we'd eat, then rest.

"The second day, the phone rang and the governor's assistant said, 'The governor is in Jakarta but he will see you tomorrow.' So it was scheduled!

"The next day, we were at school and our parents came to pick us up. We rushed to Denpasar. We were so excited! 'This is really happening!'

"He was super supportive. He even put on a Bye Bye Plastic Bags hat. He signed our MOU that states he has to help get the people of Bali to say no to plastic bags by 2018. Civil servants signed too since he may retire when his term ends. Today, we work with the government to make sure that they are keeping their promise."

"What's next?" I ask. "A campaign called One Island, One Voice. We have divided Bali into six sections. We are contacting 50 shops from every section and asking them if they want to become plastic-bag-free.

"The alternatives are cotton or recycled newspaper bags. Or banana leaves, which they used to wrap things in the past: completely organic. (There's now a formula for bags made from banana or potato peels that feels like plastic. It's waterproof. It's organic. You can throw it away and it melts into the ocean or earth and it's good for the soil. A girl in Turkey who's 14, found that formula. Cool!)

"When the shops are plastic-bag-free, they can put a sticker on their reception desk or in their window so customers know they are part of the One Island, One Voice Campaign. We will publish their names on social media (we have more than 10,000 Facebook followers). And BaliNOW Magazine will feature these shops every month."

As a recovering marketing executive, I appreciate the value of test markets, and marvel that Bye Bye Plastic Bags is applying them to their initiative—and to their pilot village, Pererenan.

Isabel remembers, "We thought, 'Why don't we start somewhere small where we can find out where our plan needs improvement, implement that, touch it up, and then take it to the whole island of Bali?'

"We contacted Kepala Desa, head of the village, and he was like, 'I'm good with it, but you have to talk to my people.' So we spent six nights explaining.

"We asked, 'Are plastic bags good or bad?' People were like, 'Good! Why would they be bad? I go to the shop, buy my groceries, put them in a bag, go home, burn the plastic bag and it's gone.'

"They didn't know burning plastic isn't good. We started educating them, because education is how change happens. That was definitely a humongous step. We gave out a packet of reusable bags to each of the 800 families.

"Then we started supplying shops with bags, and their customers would come back the next day and say, 'I brought my bag back!' And they were all proud and happy. One of our favorite moments is seeing someone with a BBPB bag slung over their shoulder.

"There are two schools in the village, about 300 kids total. We decided to do a Sports Event day with all of them. We had a volleyball area, a sponge area (throw a soapy sponge at Lotte), a bowling place, and a water jug area. We did a presentation about Bye Bye Plastic Bags and all the kids were like, 'I love it!'

"Now these kids all come to our events. They go home and tell their moms, 'We can't use plastic bags; they're bad.' We began to see the mindset changing, slowly but surely. You can do nothing without local support."

The BBPB core-team of 25 includes children from many schools in addition to the one Melati and Isabel attend, Green School, whose mission is to make the world sustainable by educating and empowering young environmental leaders.

Isabel reports, "Green School is helping us. There is a 4-hour period in the morning once a week when students work on community outreach programs. Bye Bye Plastic Bags is one of them. There is a list of things to do. Help organize events. Answer emails. (We get a lot.) Go on our Facebook page. Do a pilot village round. Collect signatures. Go to local schools and do presentations."

The Bye Bye Plastic Bags team includes boys, as do several other groups profiled in this book. I ask, "Do boys bring something different?" Isabel responds, "Guys are just as good as us. They are really good when you have to carry big things. And they're competitive, so that helps collecting more signatures at the airport."

"The most fun of all was our Plastik Tidak Fantastik Festival—Plastic Is Not Fantastic—on June 14, 2014. An amazing day. Jane Goodall visited Green School, and arrived one day early especially for us. She signed our petition. We became officially part of her Roots and Shoots program; we are thankful for that. It was great!

"At the festival, Bye Bye Plastic Bags had many activities. We had a Fun Run; kids ran and every lap, money came in. The team ran the booth and workshops. We did a flash mob.

"We ended with a plastic fashion show. We all put on clothes made from plastic. I wore a humongous chicken basket filled with squashed soda cans, chip packets, soap and candy wrappers. It had a newspaper corset with Hawaiian flowers. We looked so cool, so awesome, standing in a line to show our clothes off—like a group of garbage people!"

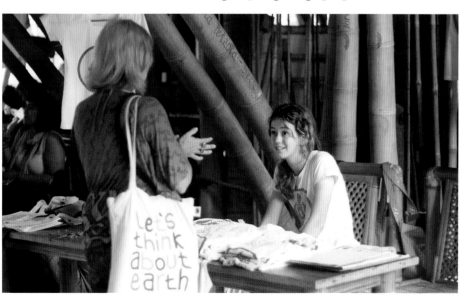

RIGHT: **Bye Bye Plastic Bags participants sell bracelets, t-shirts, and stickers to promote their cause at a Sustainability Fair at Green School.**

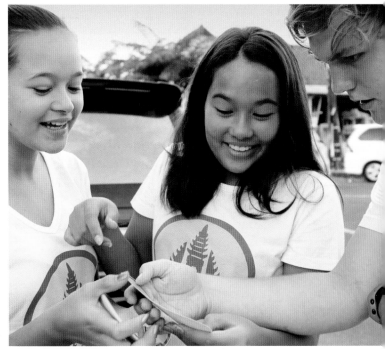
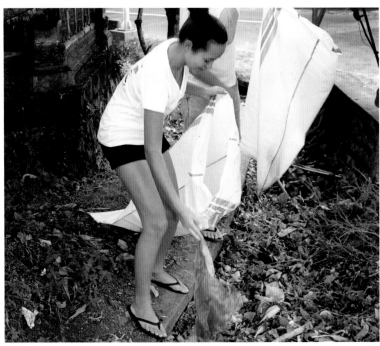
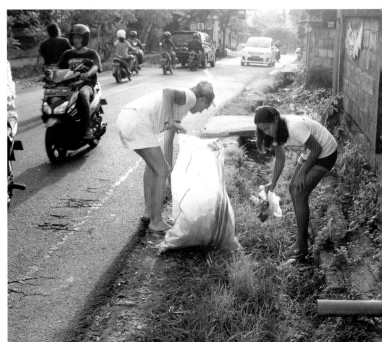

"Our pilot village is already 60% plastic bag free!"

LOTTE CREZEE, 12

"I'M FROM HOLLAND. We moved here for one year to take a break. We are staying at least one more. For me, Bali is paradise: everything you dream of when you think of the perfect place to live. The garbage is terrible. But besides that, it's gorgeous.

"When I arrived, I didn't speak one word of English. But Isabel is half-Dutch, and she helped me so much that I wanted to help her. Also, I didn't have many friends, and I thought it would be a great step to be on a team. So I became one of the first members of Bye Bye Plastic Bags.

"At first, it was a bit unstable. There were five or ten of us, all making plans, trying things out. Nobody knew how it would go. I saw the problems with garbage. I thought the situation could become better. I could see more people becoming involved. My main role has always been to go to every single event.

"At our first event, the Bali Spirit Festival, we had a booth in a corner, and we sold 30 or 40 t-shirts. I loved it. If you were walking past, I'd say, 'Do you want to solve Bali's garbage problem?' And you'd look at the products. And I'd say, 'I have a great deal. You can buy a t-shirt and get a sticker free.' I'd ask if you wanted one of our reusable bags. And I'd explain that some of the money goes to our campaign, and the rest to the women who make the bags.

"Our pilot village is already 60% plastic bag free! Every week we look at their bag stock and count what they have left. We look around outside, and if we see people with plastic bags, we'd know it's not going well. But it is going well.

"When I was invited onto the board, I thought, 'This is awesome!' It's different from volunteering. A lot more serious. We talk about what we need to improve on. You're actually taking the lead, which I love. It's a cool feeling of being important."

Lotte's English is perfect by now, and she's proud of it. "When I was 11, I went to Jakarta and gave a Bye Bye Plastic Bag presentation on my own. I'd been speaking English for about a year, and I really wanted to go. My parents, sisters, and the team all supported me. I was like, 'Finally it is my chance to shine!' I was talking to important people and I had a 14-year-old boy translating into Indonesian! It was cool." Lotte is not the only crusader in her family. Her two-year-old sister also sports a Bye Bye Plastic Bags t-shirt.

RIGHT AND OPPOSITE: Team members clean up roadsides, beaches, and tourist sites, supply recyclable bags to local retailers who go "plastic bag free," and post stickers on their store windows to reward their support.

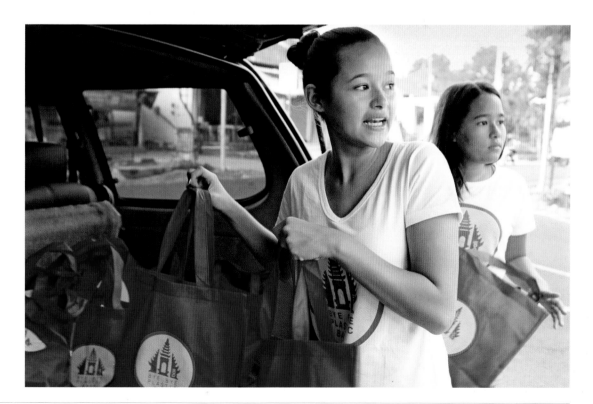

"Global warming is the world's biggest environmental problem."

INCA SONAS HOYFUNG HEARN, 10

INCA ARRIVES FOR HER INTERVIEW with her rabbit, Alaska, on her shoulder. "I have a nice family. Dogs named Flash and Harry. Cats named Madu ('honey' in Indonesian) and Lolly, who sleeps with me."

Inca is the second of four sisters whose names start with "I." "I was born at sunrise; and Incas believed they came from the sun; so my parents said, 'Let's call her Inca.' Indigo was named for my dad's favorite color. Imari means truth. I don't know about Ishvara.

"I am half Irish, a quarter English and a quarter Chinese. Born in England. When I was four, we came to Bali on holiday. I hated it. It was hot. There were mosquitoes. I wanted to go back to the cold and my friends. Then I found out we were moving here. I was so unhappy. Now, I love Bali as much as England.

"I go to the Montessori School. Melati's and Isabel's mother told my mom about Bye Bye Plastic Bags. My sister Indigo and I wanted to help. We went to a meeting, which was boring. I almost fell asleep. After that, things started happening. I've had so much fun with Bye Bye Plastic Bags, flying kites, going to festivals, cleaning up the pilot village, going to the airport."

No other Bye Bye Plastic Bags member talks about the global consequences of plastic bags, but Inca predicts Armageddon. "Indonesians burn them, which leads to global warming."

She believes global warming is the world's biggest environmental problem, and her passion for the environment prompted her to recruit Montessori students for Bye Bye Plastic Bags.

I ask whether Inca is the youngest member of the Bye Bye Plastic Bags team. "There are others my age but I am the youngest who does the most," she says.

RIGHT AND OPPOSITE: Tourism is Bali's main economic sector; plastic bags are used to package everything from banners to cotton candy to souvenirs.

"No adults. We are a child-run initiative."

INDIGO HEARN, 12

"MELATI USED TO DO GYMNASTICS WITH ME. One day, we bumped into their family at a mall. They said, 'Can you come to our meeting on Monday? We've always wanted you to be on our team.' I was like, 'Yeah, sure.'

"But when I got there, I was like 'Whoa! This is big!' And when I heard the name, I was like, 'I'm in!' I got involved, and love it.

"I became a board member. Melati and Isabel are Presidents; there are no other officers. The eight kids on the board are the most committed. No adults. We are a child-run initiative.

"Everybody is involved in everything. Anyone can show up at meetings. If you have a choreography idea for a flash mob, we say, 'Show it to us,' and then, 'We can use that!' Bye Bye Plastic Bags is get-to-it organized. At our meetings, the whiteboard calendar is packed. Every other day something is going on.

"Plastic bags are destroying the earth. If an animal finds food in a bag, it will eat it and choke to death. In Bali, you see smoke when you drive around, and you smell plastic and garbage. It's not only bad for you when you breathe it, it's bad for rice fields, plants, animals, everybody."

"If we get Bali done, we can do anything."

MIMI STEWART, 12

MIMI, LIKE MOST BYE BYE PLASTIC BAGS MEMBERS, SURFS. "When you're surfing, you think, 'The ocean is getting polluted by this trash.' It breaks your heart.

"I was surfing one day and two friends were bringing in a sea turtle and its baby who'd died. We asked, 'What could have happened?' They didn't know, 'It could have been a disease.' 'Mama could have died of old age.' 'But since both died, it's probably something happening to all the turtles. Probably plastic.' That really opened my eyes.

"I did this big beach clean up with Isabel and Melati. It was hours of hard work. We went into the water afterward, stepping on plastic. Just floating, trying not to touch bottom. As we looked back, the tide was coming in, bringing rubbish. After all our work!

"Every river and subak (water channel for rice) has trash in the bottom. It goes from pure water in the mountains, down into the ocean. It's a cycle that will never stop until we get it done."

Mimi joined the group about three months after Bye Bye Plastic Bags launched. "What really convinced me was when I found out this is a kids' initiative, so you never have anyone telling you what to do. Kids are just as smart as adults. Adults might have more experience, but a different generation can think of different things. The potential for a kids' group and an adult group, is the same. We have creative ideas (perhaps some over-the-top) but they are just as good."

Mimi was one of the first board members. "Isabel and Melati do so much, and we wanted to take the pressure off them. So we started the board to organize events and organize other team members."

As a board member, Mimi particularly enjoys making presentations at schools. "When we first walk in, they think we are trying to do the impossible. They get a lot more interested when we start to talk—and after about half an hour, they're putting up hands with amazing ideas. We'll use those ideas."

Even celebrities find the group's passion irresistible. "India Arie was singing in Ubud. Everyone was like, 'Let's get tickets!' I talked to her. She made an announcement about Bye Bye Plastic Bags and how great we were. From the stage! At another concert Michael Franti invited Isabel to the stage to sing 'Say Hey!' And the professional surfer, Sunny Perrussel, who is a friend of my brother's, comes to our meetings sometimes, gives out t-shirts at competitions, and talks about Bye Bye Plastic Bags in surfing magazines."

Mimi's family has lived in Bali for two years and will return home to Australia this summer. "I want to bring Bye Bye Plastic Bags to Australia. One friend thought it was such a good idea! She had never heard of something like it (except Clean Up Australia Day) and had never heard of something kids do. Many members are international and I think getting more international is a good idea. If we get Bali done, we can do anything."

As of this writing, Bye Bye Plastic Bags has chapters in Australia, Nepal, New York City, Myanmar, and Mexico.

FOR A WEEK, I DOCUMENT the Bye Bye Plastic Bags team's activities. We get up early to be in Denpasar at 7:00 AM for the governor's town meeting, where they are the only youngsters to take the microphone. They and the pilot village kids pull on latex gloves and climb into the ditches to pick up roadside trash. They deliver armloads of reusable shopping bags to retailers. They organize local children to fly a huge kite on the beach to raise awareness; it has their logo on it, and the name stretches all the way down the kite's 38-foot tail. The team ends the week at the Sustainability Fair at Green School, where their booth does a thriving business in what Lotte calls "awesome products."

I wrap up my visit to Bali with the founding sisters. Melati tells me, "2014 was an amazing year. We were invited to talk at the INK, sort of a TED Talk in India. We trained for three months. Day after day, working up to something really big. Every day we rehearsed our script at least three times. Isabel and I would lie in bed and say our lines in funny voices because, after three months, that's how we managed to get through it. We've learned that when something's challenging, make it 'funner,' if that's a word.

"While we were waiting to speak at INK, we watched the speakers. Sometimes when I think about that conference, I get goosebumps. I couldn't believe that Isabel and I were chosen among all the famous, accomplished people. The audience was huge: 1,000 people in the live audience, 4,000 watching on Google, and two Indian schools and two American schools watching Livestream.

"We were scared the speech would fly out of our heads. But we got onstage and squeezed each other's hands, and stayed looking at each other for a good 10 seconds, which was enough to get the audience thinking, 'They forgot their lines!' But we didn't. We wanted them on their edge of their seats.

"We started, 'Bali, Island of Gods, a green paradise…' We can still do it. You never forget! Like riding a bike! When we finished, I remember the feeling of everybody standing up…it was unbelievable… the two of us standing there and everybody standing up for our initiative. We just hugged and squealed.

"After India, we were bombarded. We were nominated for the Yak Awards. It's like the Oscars of Bali. So we were pretty psyched to be nominated by the people of Bali in the Outstanding Achievement category.

"Again, there were only adults at the award night. Isabel and I were wearing our Bye Bye Plastic Bag t-shirts. They were announcing the winners, and people came to say, 'Sorry girls, maybe next year,' because we were up against really great people. Bel and

I wondered, 'What's going on? Did they announce our category and we didn't hear?' Then the lady said, 'Winners of 2014 Outstanding Achievement Award are Melati and Isabel from Bye Bye Plastic Bags!' And we were like, 'What?' And everybody was like, 'What?' There's a cute picture of Bel and me onstage. We did a dance and came off with the trophy.

"The next weekend, the R.O.L.E. Foundation nominated us as high school role models. And we weren't even in high school. This time, it was more formal. Not something Isabel and I had ever experienced. A gala dinner. Food served on platters. It was cool. We wore formal dresses. The night went on. They called out, 'The winners of the high school role model award are…Melati and Isabel from Bye Bye Plastic Bags!' Two weekends and two unbelievable awards."

Melati acknowledges, "Our focus has changed. It's not just about getting a million signatures—because we got one signature; the governor signed our MOU, which requires him to support Bye Bye Plastic Bags and get Bali's people to say no to plastic bags by 2018.

"But one million signatures represents political support…and symbolizes that kids are bigger than the world thinks! 'Hey, kids got a million signatures!'"

I ask Melati, "What advice do you have for other girls who'd like to work on issues they are passionate about?" "Isabel and I may be featured in magazines, on TV, on the radio…but the truth is that nothing happens if there isn't a team. You can't do everything on your own.

"At most events, Isabel and I are the only kids. There's no correlation between your age and what you can do. If you're passionate about something, you can do as much as anyone. You just have to start now."

From Isabel to this book's readers: "Say NO to plastic bags. Show people solutions: cotton, newspapers, recycled bags. Show how you can make bags out of t-shirts. Bring your own bags with you. Put one in your pocket or purse. It's simple and it will have a big effect on the world!

"Kids are 25% of the world's population…and 100% of its future."

OPPOSITE: **Bye Bye Plastic Bags board members meet the island's governor who signed a Memorandum of Understanding to support their work and get Bali's population to "say no to plastic bags" by 2018.**
OVERLEAF: **Bye Bye Plastic Bag members of all ages present their case at environmental conferences, in classrooms in Indonesia and abroad, online, even at the airport in Denpasar.**

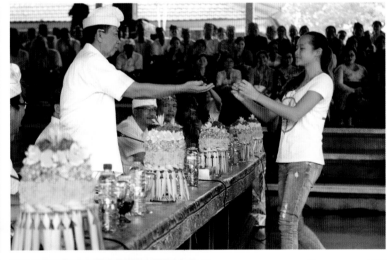

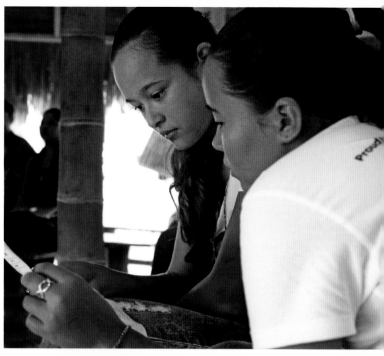
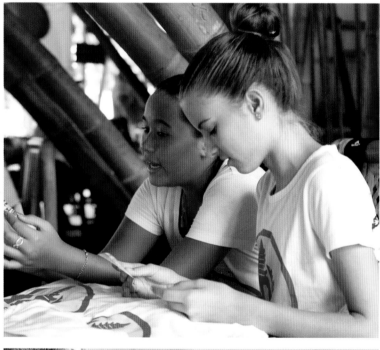
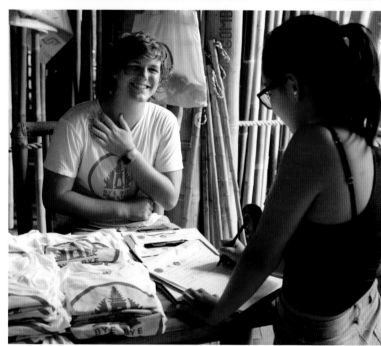

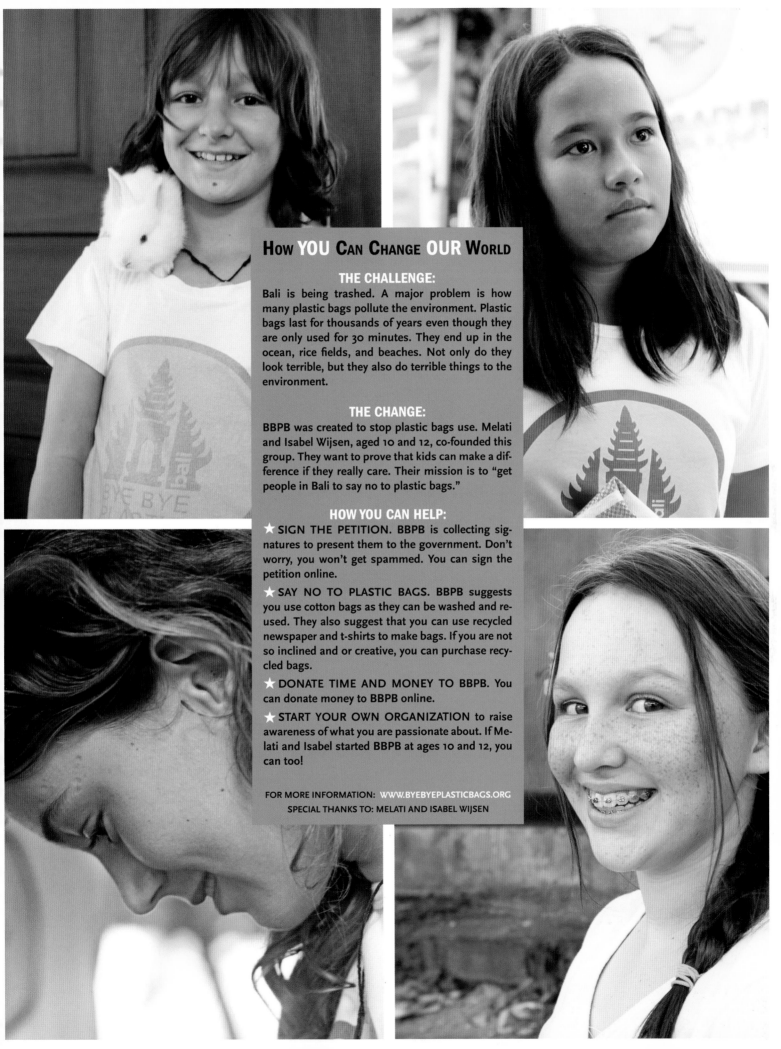

How YOU Can Change OUR World

THE CHALLENGE:

Bali is being trashed. A major problem is how many plastic bags pollute the environment. Plastic bags last for thousands of years even though they are only used for 30 minutes. They end up in the ocean, rice fields, and beaches. Not only do they look terrible, but they also do terrible things to the environment.

THE CHANGE:

BBPB was created to stop plastic bags use. Melati and Isabel Wijsen, aged 10 and 12, co-founded this group. They want to prove that kids can make a difference if they really care. Their mission is to "get people in Bali to say no to plastic bags."

HOW YOU CAN HELP:

★ SIGN THE PETITION. BBPB is collecting signatures to present them to the government. Don't worry, you won't get spammed. You can sign the petition online.

★ SAY NO TO PLASTIC BAGS. BBPB suggests you use cotton bags as they can be washed and re-used. They also suggest that you can use recycled newspaper and t-shirts to make bags. If you are not so inclined and or creative, you can purchase recycled bags.

★ DONATE TIME AND MONEY TO BBPB. You can donate money to BBPB online.

★ START YOUR OWN ORGANIZATION to raise awareness of what you are passionate about. If Melati and Isabel started BBPB at ages 10 and 12, you can too!

FOR MORE INFORMATION: WWW.BYEBYEPLASTICBAGS.ORG
SPECIAL THANKS TO: MELATI AND ISABEL WIJSEN

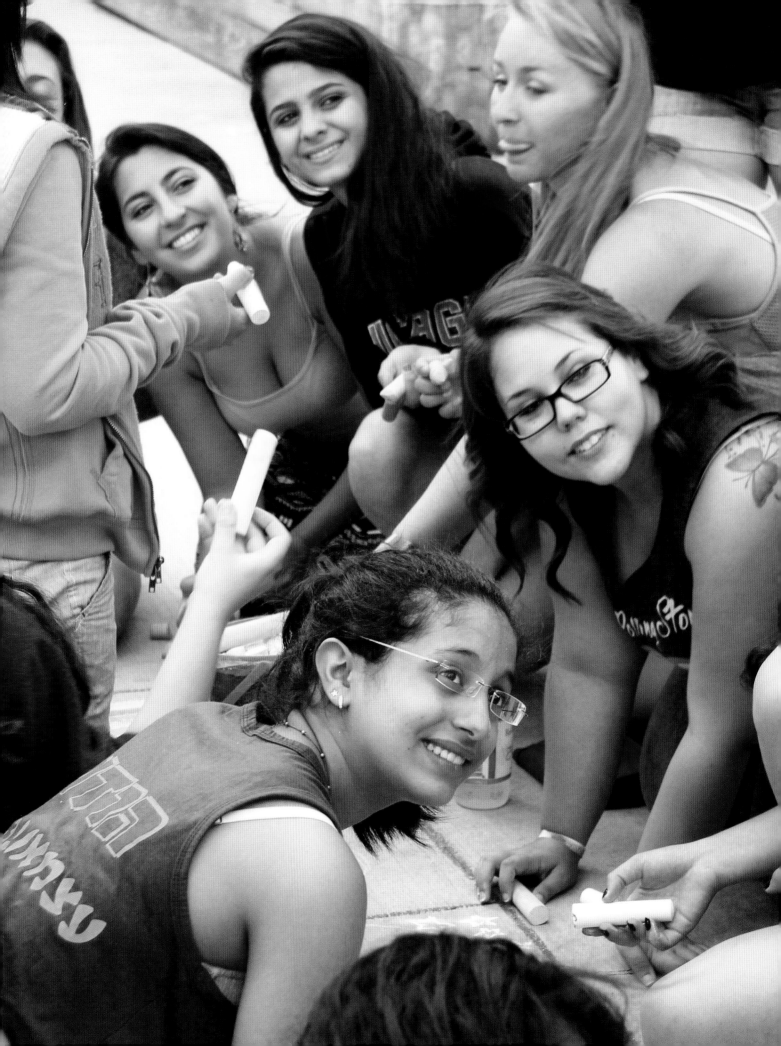

CREATING PEACE

Israel and Palestine

LIZA MASRI and I meet at the Café de la Paix in Ramallah. The restaurant's name is apt; I am about to interview one of the girls Creativity for Peace has trained to work for peace in Israel and Palestine. This could be Paris. Edith Piaf sings, "Non, je ne regrette rien."

Liza asks me to watch a video. As she fiddles with her smartphone, I wonder if she will show the al-Nakba parade that took place two days ago. Many marched from Yasser Arafat's tomb to commemorate "the catastrophe" in 1948 when Israel evicted 800,000 Palestinians from their homes and appropriated their property.

Instead, she shows a video recorded by home security cameras on the roof of a house in Beitunya. I see protestors throwing stones, and Israeli Defense Forces using tear gas and firing rubber bullets.

Suddenly, the bullets become real. Two teen-aged Palestinian boys are hit as they walk along the sidewalk. "Both died," Liza tells me. "And another boy was also shot, a friend of my brother."

This incident triggered reciprocal killings in Israel and Palestine, and raised fears of a third *intifada* (an Arabic word usually translated as "uprising" but originally meaning "shaking" the system).

The violence did not dissuade Liza and her fellow graduates of the Creativity for Peace leadership program. They understand that fear and hatred can be transformed into a recognition of common humanity if people listen to each other's experiences. They embrace Quaker peace activist Gene Knudsen Hoffman's observation that "an enemy is one whose story we have not heard."

I MET THE GIRLS I am now interviewing in Israel and Palestine at a three-week summer camp in Santa Fe, New Mexico. They'd just embarked on the first phase of Creativity for Peace's multi-year peace leadership program. All were 15, 16, or 17 years old; half were Israeli, half Palestinian.

They arrived bristling with fear and rage. Many were still grieving for family or friends who had been killed in the conflict. Israeli and Palestinian girls were assigned as roommates. One stayed awake that first night, trying to figure out how to murder the "enemy" with whom she had to share a room. There were two housemothers, one Israeli and one Palestinian. For three weeks, Israelis and Palestinians were paired for every activity.

Every morning the girls spent three hours in Dialogue sessions where they shared their experiences and feelings, guided by therapist facilitators—one Israeli, one Palestinian.

In the afternoons, they participated in art therapy, making books, jewelry, paintings, and more. Most had never met anyone from the other side. They had no idea what each others' lives were like.

Israeli girls believed that if Israel didn't exist, no country would welcome them. As prospective soldiers (two years of military service are mandatory for girls), they viewed the Israel Defense Forces (IDF) as crucial to Israel's security, and dreaded being attacked. Those who lived near Gaza often had to dodge rockets—as many as 195 per day, according to one IDF count.

Palestinian girls had memories of the Israeli army occupying their villages, raiding their houses, and stealing from their families. They had lived under curfew for months at a time. They had experienced humiliation and punishment at the checkpoints. They believed that all Israelis are soldiers and are cruel. They grew up with their grandparents' stories of eviction. The West Bank barrier stranded some from farms, family, and friends, making freedom of movement impossible.

OPPOSITE: **Girls from Israel and Palestine create chalk art together on the streets of Santa Fe, New Mexico during Creativity for Peace's summer camp.**

"Tell your own truth."

DOTTIE INDYKE, Executive Director

"**BOTH SIDES ARE SHOCKED** by what they learn of the others' lives," Dottie observes. "They realize that what they have been taught by family and media is not the truth. That these young women are willing to face these dichotomies head on is, to me, a mark of great strength and courage.

"Our Dialogue methodology borrows from nonviolent communications and compassionate listening, compassion being a foundational aspect of a peacemaker. We teach the girls how to listen without bringing all their triggers and preconceptions to the table—to listen and be openhearted.

"Pain gives way to confusion. The barriers start to drop. Compassion is an important part of the healing as girls cry together. Peace is a culture in which all people's humanity is equally respected.

"The girls go home with the molecules in their body moved around," Dottie reflects, having witnessed 350 girls' transformations, first as President of the Board, then as Executive Director, of Creativity for Peace.

"At home, they talk to their families and friends and have influence. Their job is not to recruit others to their way of thinking. We just say, 'Tell your own truth and you will be planting seeds.'

"After the girls return home, Creativity for Peace trains them as leaders and peacemakers. Some have spoken at universities, conferences, and global summits. Some Israeli girls who became army officers later have talked to soldiers under their command or volunteered to staff checkpoints, hoping to make it easier for Palestinians. (Most of our Israeli girls do not request combat positions.)

"We work hard to instill a belief that will not change. I hope that the girls use the tools we give them, and that they don't give up. I hope they will choose careers in which they can be influential— such as law, conflict resolution, diplomacy, or social work. But whether they are artists, engineers, teachers, therapists, or mothers, they can still be peacemakers.

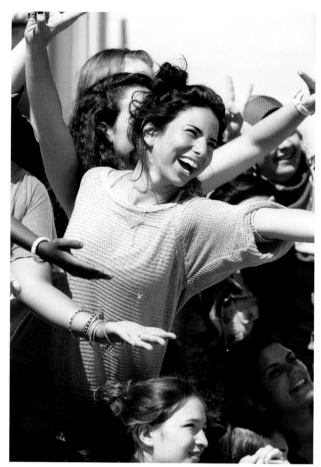

"Creativity for Peace operates in the reality of Israel's occupation of Palestine, in which the balance of power is not equal, and basic human rights are violated.

"Governments are in the business of maintaining the status quo, which is why peace is so difficult to achieve. It is shared hopes for the future, not Abbas or Netanyahu, that will solve this conflict. I believe people are always ahead of governments. As one of our girls said, 'What's the use of peace treaties if the people still hate one another?'

"An Israeli girl recently wrote me, 'The people I miss most in these times are my Palestinian friends. They are my only proof that we can learn to love each other—and that peace is possible.'

"Creativity for Peace works exclusively with girls, and supports U.N. Resolution 1325, which affirms women's role in the resolution of conflicts. Women have played defining roles ending violence in Liberia, Northern Ireland, Kenya, and South Africa. We believe they can do the same in Israel and Palestine."

ABOVE: Young women who attended the Creativity for Peace camp when they were younger often return as counselors, acting as role models, coaches and cheerleaders.
OPPOSITE: Campers learn acrobatics from a women's circus troupe. Nothing encourages collaboration and communication like relying on "the enemy" to hold you up.

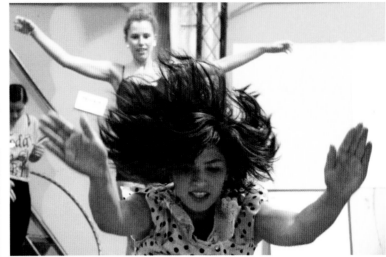
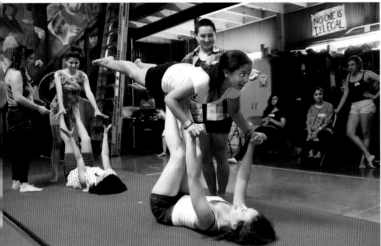
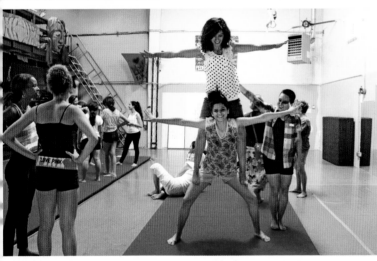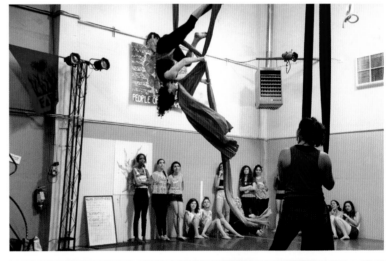
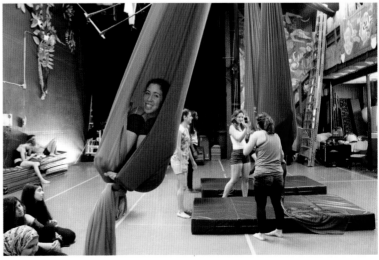

"Knowing how to listen gives me power."

ELEANOR COHEN, 17, Israeli

THE FENCE AROUND ELEANOR'S HOUSE in Kadima, north of Tel Aviv, is buried in fuchsia bougainvillea. We walk through the leafy residential neighborhood to a park where jacaranda trees spill lavender blossoms onto the grass.

Eleanor feels at home here now, but her family moved several times between Israel and Greenville, South Carolina, while she was growing up. And she acknowledges that she found it "hard to fit in."

Eleanor plays classical piano, acts, bikes, Zumba dances, and tutors elementary school students in Math and English.

We talk about language. During the open house finale to the summer camp in New Mexico, the girls sang Linda Allen's song, "I Believe that Peace Will Come." They sang in English, Hebrew, and Arabic. The conflict in their homeland was intractable—yet their conviction and collaboration were so moving that my eyes swam with tears.

"We just taught each other the words," Eleanor tells me. "My mom's parents came to Israel from Iraq, and my grandpa teaches me a word of Arabic every time I come over. I studied Arabic in eighth and ninth grades. Arab children who live in Israel learn Hebrew in school, but most Jewish people don't know Arabic. After camp, I thought, 'If only Israeli Jews learned Arabic the way Israeli Arabs learn Hebrew, there would be peace.'"

I ask how Eleanor became involved with Creativity for Peace. "A girl who went told me about it. I was excited and felt it was something for me. So I did everything I could to learn more. I did research on the Internet, participated in a program about conflict resolution, and joined a Model U.N. program that included Israeli Arabs."

I ask how she would describe the Dialogue sessions at camp. "It was therapy. We started every day by lighting a candle in the center of the circle so everyone would feel included. Every day, another girl would say an intention; for example, 'Understanding the other side.' Or 'Listening from the heart.' We would have that in the back of our minds.

"It was so hard for me! There were these things a girl said about the army, for example. I said, 'My sister is in the army and I will be too. I can't believe the things you're saying! This can't be true!' It's not that I didn't believe. I did, but it was so hard to believe.

"In the beginning, I was always justifying: 'No! There have to be checkpoints or people will come and do bombs in the buses again.'

"But we couldn't be enemies. When we had the festival, we dressed together. We helped each other. We were sisters. We told each other, 'It doesn't matter that we're supposed to be enemies, or what the world says. We know in our hearts that we are sisters.'"

I ask how her friends reacted to her experience when she got home. "They were shocked. 'You slept in the same room with a Palestinian? What are you talking about?' My mom came closest but no one really understood."

"Do you feel responsible for spreading the word?" I wonder. Eleanor smiles and recalls a conversation she had on a train with a Haredim (Orthodox Jewish man) in his early 20s. "I understood that his opinions were really different from mine. But I was calm, and just showed him my view. He was like, 'No! It's our country. They should all go away.' I said, 'What if it were you? What would you say then? It doesn't matter who was here first, the point is that they are also here. I think we should all learn to live together.'

"I think the reason he listened to me was that I listened to him first. In camp, I learned how to listen—or found out I was good at listening. Knowing how to listen gives me power. I don't know if I changed his view, but I made him listen. That's something I'm happy about. The future is a mystery. He might go into politics in ten years."

Eleanor has attended several Young Leader training sessions since she got home. "This program is called A.C.T. (Action for Conflict Resolution). It makes us think about acting, not just feeling and understanding."

I ask Eleanor's thoughts about military service. "I am excited about it. It's part of the culture. Every Israeli has been, or will be, in the military. My parents met in the military. My sister is a lieutenant; I am proud of her. The army keeps us safe. I will be proud to be a part of it. People will listen to me. It's a big organization but inside, everyone is just a person with different opinions."

"At camp they told us, 'Imagine change.' And I am."

"Fighting for your rights is not in conflict with being a peacemaker."

RAND MASSALAH, 16, Palestinian living in Israel

RAND COMMUTED WITH HER FATHER to meet me at my hotel in East Jerusalem. We sit on a terrace in the sun near a fountain covered with mosaic designs.

"When I was younger, it surprised me that some Arabs are afraid of Jews and the opposite is also true. Historical events don't change the fact that we are human. We need to treat each other as equals and respect each other."

"To be connected to people, you must listen to your heart and feelings."

Rand's experience during Dialogue sessions in Santa Fe underscored this conviction. "We'd argue, fight, cry, scream, shout. To be connected to people, you must listen to your heart and feelings. The emotional part is very important. When we got back to our house, we were friends. This was wonderful."

How is it to be a Palestinian living in Israel?

"I am in the middle, a bridge. I have Israeli citizenship. I can connect with both sides because I know both sides. I can say, 'I am part of this and I want change. If anyone wants to be involved in this change, I am ready to help them become more connected to each other.'

"Governments make things more complicated. The change needs to stem from the people. We need to take responsibility and do something that will help change happen."

Rand wrote about demonstrating against Israel's Prawer Plan, which would destroy Arab villages and displace some 70,000 Bedouins. "Arabs of all ages from all over the country were there, all wearing the Palestinian scarf. I called for my own dignity. I called for equality. I screamed as loud as I could, 'No future for Prawer!'

"Israeli policemen stepped toward us with their hit sticks and tear gas bombs, then attacked us with water hoses. They took 33 young and adult males and females prisoners. They pushed them to the ground and hit them. The policemen yelled, 'Who are you? Identify yourself!' The only answer I could give was, 'I'm just a human.'

"All around seems to be black. But my heart is still white and pumps out peace. In order to live, I need to fight. Yes, I'm a Palestinian freedom fighter."

I ask Rand where she draws the line: Would she throw rocks? Kill people? "No! I will be violent in my voice, but not in my actions."

We continue talking as we stroll to the Damascus Gate, which leads to the Muslim section of Jerusalem's Old City. Rand is wearing a diaphanous green dress decorated with traditional Palestinian embroidery. A person could get married in such a dress! Women selling vegetables admire her finery with enthusiastic flurries of Arabic.

Rand buys salad greens to take home to her mother. As we walk back, she reflects about her village and the project she plans to conduct there to create awareness of a developing problem.

"The Israeli army is surrounding our village. We will be stuck in the middle. The soldiers are going to train on land they took from us. I have researched the street being widened. There is no need for such a huge street. It takes the land Arabs are living on. The entrance to the village will be closed. You will be able to go only one way. This is a terrible thing to do.

"We will protest to the government and to the people who are in favor of doing this. I am not against widening the street, but taking Arab land. If you want to make it, do it not just for the Jews, but equally for the Arabs. If we let our voices be heard, I think we can affect the government."

Rand anticipates earning support from villagers. "I will lead. The change starts with me, but to be effective, it must get bigger. Family, neighbors, then it moves out. It is urgent to move quickly. Letters to the government. We can go to radio and media. Let our voice be heard. So people are talking about it."

Some people expect peacemaking to be, well, peaceful. But Rand knows that, to live with integrity, her actions must express her belief in equality. "I am a human rights fighter," she says. "And I am a peacemaker. Fighting for your rights is not in conflict with being a peacemaker."

OVERLEAF: Every afternoon at camp, Israeli and Palestinian girls pair up to create books, jewelry, collages, drawings, and paintings. Here, they trace, then design body-shaped patterns of solidarity.

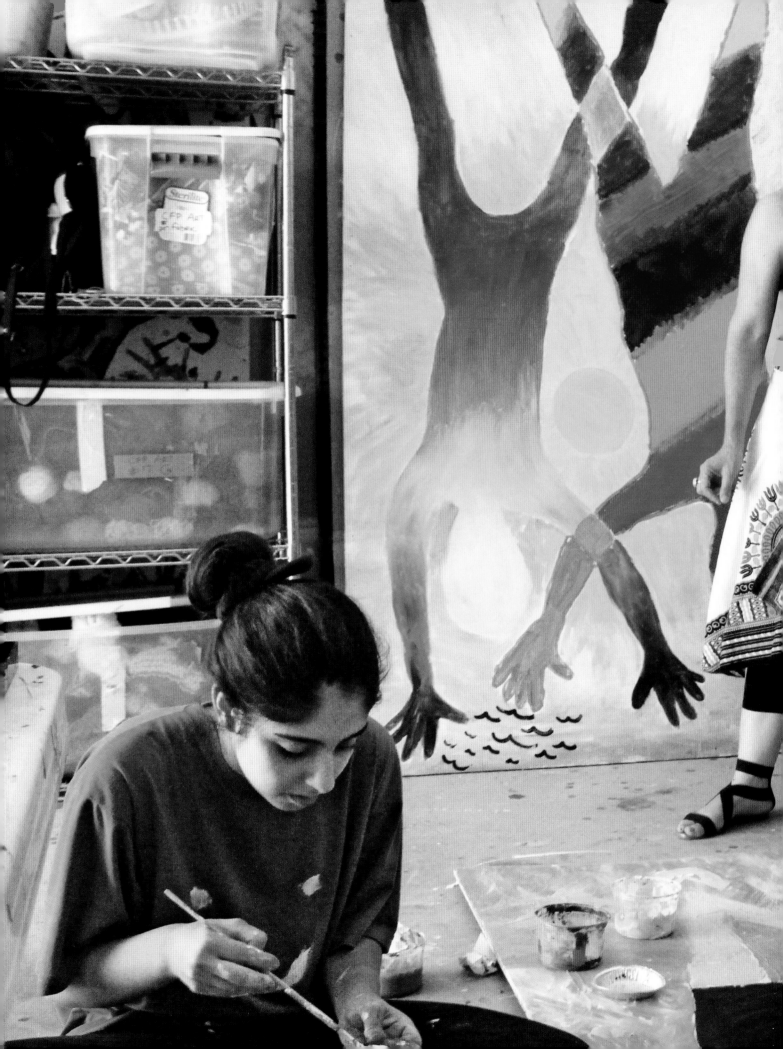

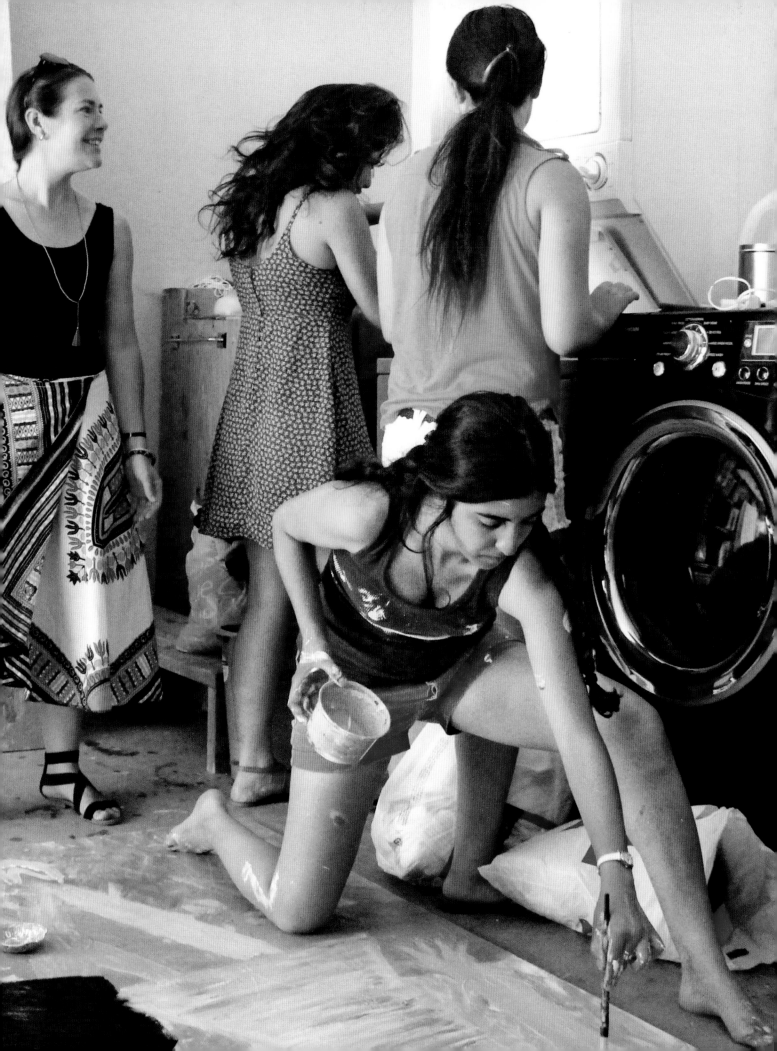

"I'm strongly for equality; accepting everybody."

SHOSHANA BEN-DAVID, 17, Israeli

ONE AFTERNOON during Creativity for Peace's summer camp, the girls learned gymnastics from a woman's circus troupe in Santa Fe. Nothing could make you trust others faster than relying on them to catch you before you plank face down. Or support you while you stand on their shoulders.

A superstar in the acrobatic activity was Shoshana, an agile, athletic girl who studied gymnastics for five years when she was younger. She could flip faster and cartwheel more perfectly than anyone else.

"Moving is really my fun," she tells me when we talk in her hometown, Jerusalem. "I love to work out. I belong to a gym. Running. Biking. Dance."

Shoshana, whose mother is Dutch and whose father is American, went to kindergarten in the United States and visits her grandmother every year in New York or Florida. It was her grandmother who suggested that Shoshana participate in Creativity for Peace.

I ask Shoshana to describe her time in New Mexico. "I found it a special and confusing experience. I liked the camp and I'm happy I went. There is nothing like making personal connections. We had Dialogues, which were hard, but then we did fun stuff. They made sure we had a great time. I do want to work for peace.

"But I regretted that I didn't come more prepared. I was upset that Creativity for Peace didn't tell us more about what we were going to do; I think knowledge is power. On the other hand, maybe one of the goals is that you come open-minded.

"I was expecting different views, and that's what I got. But Israeli girls who are willing to go to this camp have almost the same political view. The Palestinian Arabs were more diverse.

"I don't dodge speaking politically. I don't think it's right to do that. Politics are something people are scared to talk about and you shouldn't be."

I ask how Shoshana sees politics at the moment. "Nobody's willing to give up enough. They're not willing to be courageous.

"Bibi Netanyahu, the Prime Minister, is bound to the right wing, which is not pro-peace. If he makes a move that doesn't look good to the right wing, he might lose his position. That's what he's scared of. Same thing with Abbas. We need someone who can take a step; if there's consequences, there's consequences.

"What I learned from going to this camp is that peace is about changing people's mindsets, which is the hardest thing to do, maybe almost impossible. It starts with education for all age groups.

"When people are educated, they know more, have stronger opinions, and feel more confident in their views. They realize that violence leads to more violence.

"Israeli schools could meet with Arab Palestinian schools. Sit and talk. Get out of your shoes and try to see where the other is coming from. Outside of meetings, you should process what you've gone through and learn from it.

"If Netanyahu said, 'We're moving out of the Territories; we'll give you some settlements and your own country,' I think it would give the Palestinians a feeling of independence, which they are fighting for (as are we Jews). But there is also the risk that they will try to get revenge. That's why I think there should be an education process first, so nobody will seek revenge, because we're starting a new page."

Shoshana is so animated discussing the politics of the conflict that I ask what career she might be pursuing if I met her in ten years. "I do see myself in politics. I'd love to follow what I believe in. God willing, I'd like to have my own party with my own views. I am strongly for equality; accepting everybody. Maybe one day! Who knows? Seems like a big shot from here, but I tell myself, 'Why not?!'"

Shoshona hopes to spend the next nine years earning two degrees while in the army. "I'm excited to serve. I believe that we're the most humane army on earth. No army is perfect. I understand that Palestinians don't get the nicest view of it. I wouldn't like a Palestinian army to be where I live either.

"I think the army is a good opportunity for me. There may be some stuff I won't agree with. But I strongly believe in Israel and the need to keep it safe.

"The Israeli army is needed. I just spent a week in the army to see what it's about. We were learning how to shoot guns. But before we learned this, we had two whole days about when to use them, and when not to.

"The army is called the Israel Defense Forces, and it really is for defense. We have a lot of people

who don't agree with the state of Israel, and I think it's time they do."

In 2016, The Huffington Post published a column by Shoshana: "I felt like I had to take action following the violence, hatred and racism," she wrote. So she founded a girls' group called Runners Without Borders, which includes Jewish, Muslim, and Christian girls aged 15 to 19. They have run marathons in Jerusalem and Milan. Shoshana hopes to open chapters in other mixed cities such as Jaffa and Haifa.

The girl for whom "moving is my fun" is following her path.

"It's my dream to see Palestinians happy."

LIZA MORSHED AL-MASRI, 18, Palestinian

LIZA RETURNED FROM NEW MEXICO to study at Al-Quds University, whose mission reads in part: "It is freedom that allows humans to become what we were truly born to be, to create new possibilities, to grow and flourish. We encourage our students to express their views and to create debate on issues that are important to them."

The university pays a price for this commitment. Israeli soldiers have attacked the East Jerusalem campus 31 times in the past three years. Twelve thousand students had to evacuate it three times during Liza's first year. Six hundred forty lectures had to be canceled, and the Red Crescent treated 830 students for tear gas injuries.

Liza's reaction? "These actions confuse me. One side of my mind thinks someday Shoshana or another Israeli girl in Creativity for Peace may shoot my mother, my brother, my sister. The other side says maybe things have changed and we will have something good. It's important to be optimistic, but difficult.

"I applied to Creativity for Peace because I wanted to know what Israeli opinions of us were. When I told my family that I wanted to go, it was hard for them to understand that I wanted to meet Israeli girls. But I said, 'I will make a difference there.'

"The experience has opened my mind to a lot of things. First, how to negotiate with the other side and not see them as enemies. We would fight and then we would go out and have fun, then the next day, we would go back into a Dialogue session. It was amazing.

"I was so excited and wanted to tell everyone about what we did in the USA. They thought that the Dialogue was worthless. 'Governments cannot make a difference so how can girls?' 'How did that benefit us?'

"The Israeli girls had very intense ideas that they 'will not—never, never—change,' about their government, about their soldiers. It made me feel very good to just tell them what their soldiers are doing with us. Even if the change I made there was small, in their minds it was big.

"It's my dream to see Palestinians happy, to make them smile, not to lose anyone from their family. To have a normal life. Occupation is the most difficult thing anyone can suffer; it controls you and prevents you from doing things you believe you can do."

Liza is learning to be a Creativity for Peace Young Leader, which requires all participants to create a project. "I had many project ideas. One was to help Palestinians who had to leave the country, return. Another was to help orphans attend university—everyone should have that opportunity, especially those who have no fathers and mothers. I was strong enough to handle the loss of my father, but I know what it feels like. I want to help them feel they can be very big in the future."

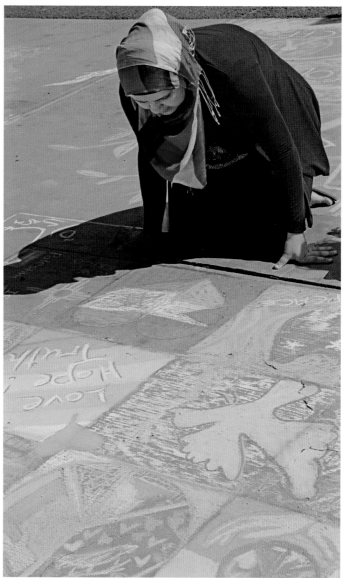

Israeli and Palestinian girls create chalk drawings on the sidewalks of Santa Fe, expressing pain, hope, and dreams, collaborating with "the other."

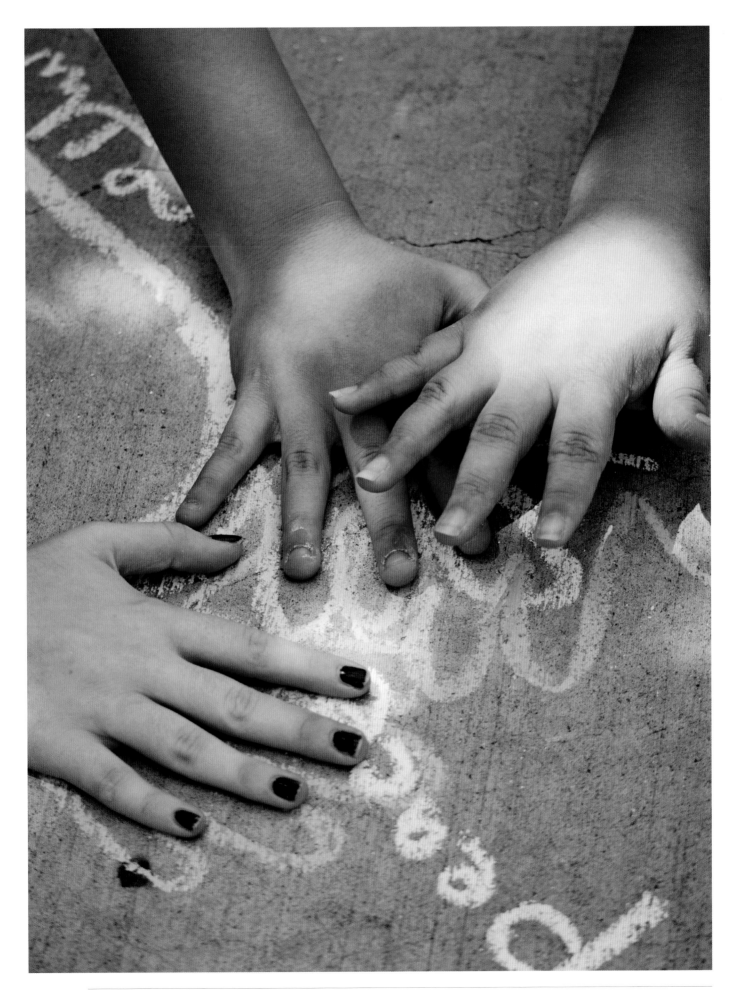

Although this book is about girls age 10 to 18, I decide to interview three women who attended the Creativity of Peace camp in Santa Fe as teenagers, to see where that experience has taken them.

"I will do this work until peace is realized."

AMEERA SAED, 27, Palestinian

AMEERA WAS BORN during the first intifada. She has never known peace. Her father died trying to get through a checkpoint to an Israeli hospital.

Ameera attended the Creativity for Peace summer camp in 2005. "It changed my opinion about the other side. We share a lot."

Ameera became Creativity for Peace Senior Leader, and is now the NGO's Palestinian Coordinator.

"I want a normal life for me, for my family, for my child Roza," her captivating toddler who gurgles, smiles, and makes herself known throughout our interview.

Ameera tells me that many people on both sides view working for peace as a betrayal of their cause. But this doesn't deter her. "I will do this work until peace is realized. Or until the day that I die."

I take a taxi to Nazareth to interview Siwar Hamati. The driver is a Palestinian man who lives in East Jerusalem. He has an Israeli ID and license plate so (unlike most Palestinians) he can drive anywhere.

We head toward the Dead Sea, then north, paralleling the Jordan border through the West Bank. Signs warn, "Entrance for Israeli citizens is forbidden, dangerous to your lives, against Israeli law." We pass plantations of palm trees, sheep, corn fields.

At the Beit She'an checkpoint, an Israeli soldier instructs me to remove my suitcase from the trunk. "But I'm an American!" Doesn't matter. I am nervous about this: I am not traveling as a member of the press and a tourist wouldn't carry two professional cameras, three lenses, a flash unit, digital recorder, and computer.

As directed, I heave my bags onto the conveyor belt and watch them disappear into the x-ray machine. A soldier copies my passport. Another tells me to unpack everything, leafs through my belongings, dwells thoughtfully on my books, then offers to help repack my suitcase. Outside, a soldier peers under our hood. Finally, we are cleared, and cut toward the west.

Between Afula and Nazareth, there are acres of sunflowers, green, irrigated fields, olive orchards, vineyards. It could be Tuscany.

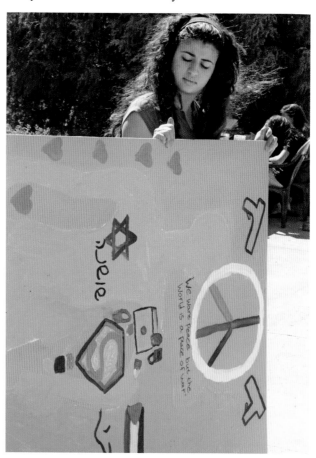

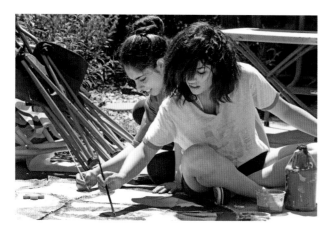

ABOVE, RIGHT, AND OPOSITE, TOP: Art complements Dialogue sessions in which girl campers learn to speak authentically and listen compassionately, guided by two therapists, one Israeli and one Palestinian.

ABOVE: Having discovered "an enemy is someone whose story you don't know," the girls close the session singing in each other's languages, Hebrew and Arabic.

"To work for peace, I had to be at peace with myself."

SIWAR HAMATI, 23, Palestinian living in Israel

I MET SIWAR IN SANTA FE IN 2013 when she was a Young Leader and camp counselor. She was born in Nazareth where she now attends university, but she grew up in Acre, whose diverse population includes Christians, Muslims, Jews, and Bahais.

She acknowledges, "I didn't feel the hatred people talk about in the media because a lot of my Jewish neighbors are of Tunisian origin and speak Arabic; some are Moroccan; some are Druze. I felt connected with them.

"After I went to summer camp in 2007, I felt disconnected. I felt I didn't know how to present myself to the world. Am I Palestinian? I am not Arab, but my mother tongue is Arabic.

"In 2009, I entered the Young Leaders program. It made me realize that to work for peace, I first had to be at peace with myself. Now, I don't have a problem saying, 'I'm a Palestinian.' But if I have to say, 'I want to get all the Jews out of here'…no! I don't have to say that to be a Palestinian.

"I recently discovered that I want to go further than where I am. And I should not be afraid to wish or imagine. The people who made the reality you are living are not smarter than you. They are not more influential than you. Maybe only a few people want this reality."

Siwar has just conducted reconciliation workshops for 15 and 16-year-old Palestinian and Israeli girls in Acre, using the Dialogue method and leadership tools that she learned from Creativity for Peace.

"Nothing helps if we don't talk. It's the only solution."

YAARA TAL, 23, Israeli

YAARA WAS A CAMPER IN 2008. I met her as a Young Leader and camp counselor during the 2013 session.

Her mother was born in South Korea, but converted to Judaism when she married Yaara's Israeli father. The family lives on a kibbutz about six miles from the Gaza Strip. This summer, the Israel Defense Forces identified 33 underground tunnels dug by the Palestinians between Gaza and Israel; they suspect there are more.

Yaara served in the Israeli army for two years as an observer on a military base about 1,000 yards from Gaza. "Our job was scanning to be sure no one was coming over the border. Only women do this job. We were the only unit that stayed on the base the whole time. People in the units who rotated in would all say, 'Did you hear something under the ground?' Then, this summer, there was the whole tunnel issue. We felt much more secure before the tunnels. A new game. Something else."

Yaara spent her summer vacation working in a factory near her home, part of an IDF veterans' program. "I really was happy to be home instead of far away worrying and asking questions like, 'The rockets fell there? Someone died?'

"Rockets have gone on for more than ten years. They are part of our reality, all the time, everywhere, surrounding you; we kind of get used to it. But this was the first time they came while I was driving. It's a different story when you're driving."

"People listen to happy music on the radio, then they hear an alarm. Right now, what you need to do is stop the car, turn the engine off, take the key out, run a couple of meters from your car, lie on the ground and cover your head with your hands. I was like, 'OK, I have to do this, people really die.' Then we are back to music.

"The Israeli government calls it 'occupation' but everyone else calls it 'war.' We keep hurting them, they keep hurting us. It's stupid. If we kill more and they kill more, people go away thinking about revenge.

"Communication is our best tool. Nothing really helps if we don't talk. It's the only solution."

Yaara received an academic scholarship from Creativity for Peace and is enrolled in Peace Studies at Lane Community College in Eugene, Oregon.

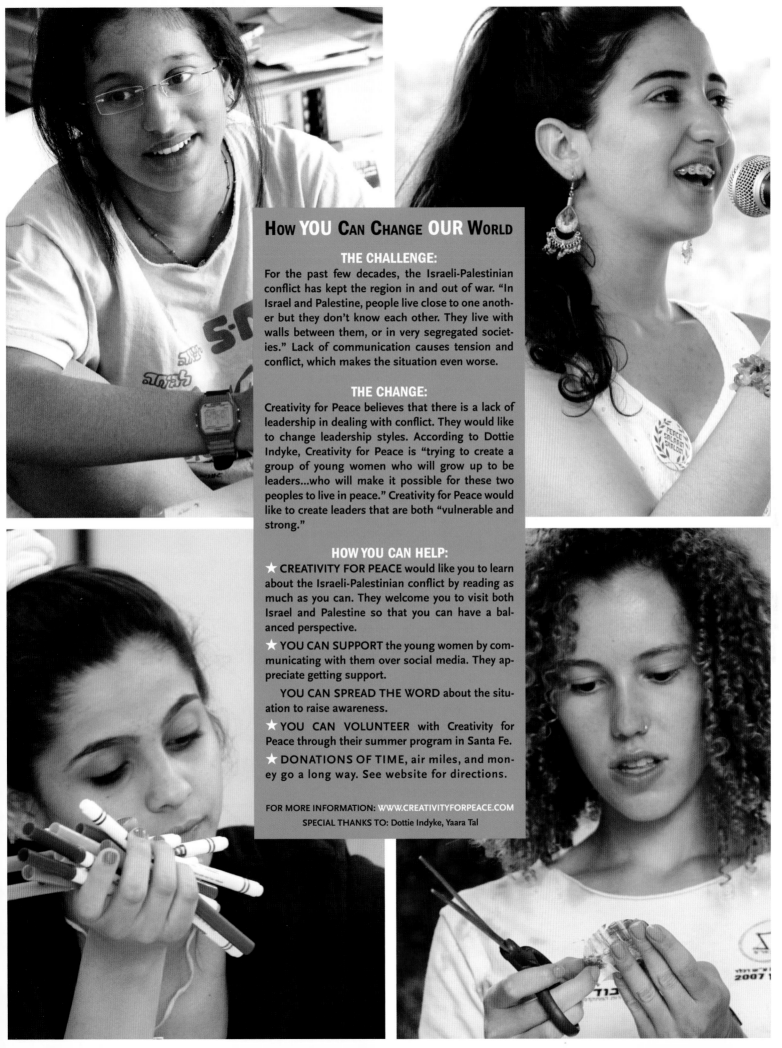

HOW YOU CAN CHANGE OUR WORLD

THE CHALLENGE:

For the past few decades, the Israeli-Palestinian conflict has kept the region in and out of war. "In Israel and Palestine, people live close to one another but they don't know each other. They live with walls between them, or in very segregated societies." Lack of communication causes tension and conflict, which makes the situation even worse.

THE CHANGE:

Creativity for Peace believes that there is a lack of leadership in dealing with conflict. They would like to change leadership styles. According to Dottie Indyke, Creativity for Peace is "trying to create a group of young women who will grow up to be leaders...who will make it possible for these two peoples to live in peace." Creativity for Peace would like to create leaders that are both "vulnerable and strong."

HOW YOU CAN HELP:

★ CREATIVITY FOR PEACE would like you to learn about the Israeli-Palestinian conflict by reading as much as you can. They welcome you to visit both Israel and Palestine so that you can have a balanced perspective.

★ YOU CAN SUPPORT the young women by communicating with them over social media. They appreciate getting support.

YOU CAN SPREAD THE WORD about the situation to raise awareness.

★ YOU CAN VOLUNTEER with Creativity for Peace through their summer program in Santa Fe.

★ DONATIONS OF TIME, air miles, and money go a long way. See website for directions.

FOR MORE INFORMATION: WWW.CREATIVITYFORPEACE.COM
SPECIAL THANKS TO: Dottie Indyke, Yaara Tal

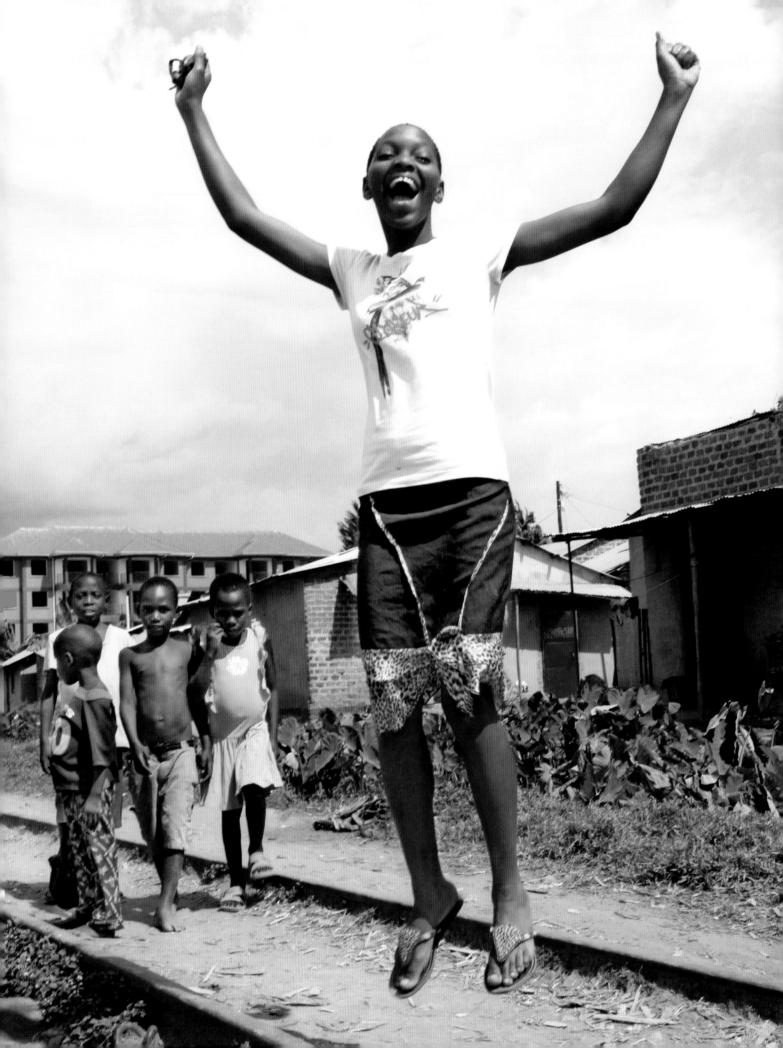

DEMANDING RIGHTS

Uganda

THE GIRLS OF RHYTHMIC VOICES grew up in the slums around Kampala's red light district. Their friends are often sex workers' daughters, who are all too likely to become sex workers themselves because they have few options. Rhythmic Voices members aim to break this cycle. They campaign passionately for girls' rights and universal education.

"This is not right. It must be changed."

HARRIET KAMASHANYU TUMUSIIME,
Founding Director
RHYTHMIC VOICES IS AN INITIATIVE OF RHYTHM OF LIFE, an NGO whose founding director, Harriet Kamashanyu Tumusiime, grew up in these slums. She is one of 10 children in a family of nomadic Rwandan cattle herders who migrated to Uganda before the genocide.

Harriet attended school, including university, on scholarships. She learned international development in India and Sweden. She's energetic, positive ("Kamashanyu means happy") and so articulate and quick that interviewing her is like talking with a rapper.

OPPOSITE: **Sharon, who lives near Kabalagala, where sex workers ply their trade, jumps for joy knowing she is disrupting the pattern of girls following their mothers into prostitution.**

Harriet understands life in Kabalagala, the red light district, which is filled with pubs, bars, night-clubs, restaurants, entertainments (think pole dancing), and tourists. "Around 4:00 PM, sex workers start walking the streets. Women who find clients at the Sheraton Hotel earn enough to drive cars—but in Kabalagala, they get $1.00 U.S. per trick, which pays for a bed in a lodge and a pimp. They net about 20 cents."

Harriet founded Rhythm of Life in 2013 to provide sex workers an essential service they were previously denied: medical attention. Rhythm of Life provides health care, HIV and STD testing and treatment, medicine, and counseling. Her office is stacked with cartons of female condoms—in shocking pink; her NGO gives them away. Rhythm of Life also trains sex workers do other jobs. They visit her office, know her staff, and carry her mobile phone number in case they need help.

Rhythm of Life's involvement with sex workers has enabled it to forge relationships with their daughters, some of whom don't know that their mothers are, or were, prostitutes. The NGO has launched an initiative run by and for those girls and their supporters, called Rhythmic Voices.

A digression to illustrate
organizational relationships:

RISE UP - An NGO that helps girls around the world in a variety of ways.

LET GIRLS LEAD - A Rise Up initiative that trains girls to advocate for policy change.

RHYTHM OF LIFE - A Let Girls Lead grantee.

RHYTHMIC VOICES - A Rhythm of Life initiative.

NOW BACK TO OUR STORY... Rhythm of Life selects girls for Rhythmic Voices based on their academic performance; gives them scholarships through high school; and provides them with Let Girls Lead's public advocacy training.

The girls learn to open their presentations with personal anecdotes, define the issues with facts and statistics, charge the audience with responsibility, and demand a response. Their presentations run five or 10 minutes and jolt audiences to attention and action.

Harriet brags that "each of them represents millions of girls in Uganda who cannot stand up and speak out freely. They need our girls to say, 'This is happening; it's not right; it must be changed!'"

"I believe I can change the world and the future, so I'm starting now."

AISHA, 10

RHYTHM OF LIFE TRAINED AISHA'S MOTHER to be a hair stylist, and she currently runs her own salon. I am to meet Aisha at her mother's shop, which she named "The Rhythm of Life Beauty Salon" to honor her benefactor.

The Elegance Unisex Spa next door advertises "earpieacing, jewelly, necklences." There's a sink-hole in the street; misstep and you fall into a sewer. A shepherd drives a flock of goats down the road.

In the salon, an employee braids in hair extensions for a customer. Aisha, who's been home doing chores, joins us.

The eldest of three sisters and a brother, Aisha is slight, shy, and speaks so softly that I lean close to hear her. She speaks English well, and tells me proudly that she got a 92 in the subject.

Aisha's dreams are as big as she is small. When she grows up, she says, "I want to be a nurse. I want to help people who are sick, lame, and pregnant." She repeats this, to make sure I quote her correctly.

I ask, "What do you want to change to make life better for the girls you are helping?" Her answer is unequivocal: "I can help girls who are being beaten. I can talk to their teachers and parents and urge them to stop. For example, I pleaded for one girl: 'This girl is innocent. You have no reason to beat her.' They stopped."

"I believe I can change the world and the future, so I'm starting now."

I ask, "What gave you the idea that a 10-year-old girl could change the way grown-ups behave?" Aisha looks me in the eye: "I believe I can change the world and the future, so I'm starting now."

When we walk down the street to take photographs, I realize that I've misjudged Aisha by assuming she is shy. She takes my hand and leads me around her neighborhood. At the end of the week, she tells me, "Goodbye. I love you."

FOUR RHYTHMIC VOICES GIRLS, plus Harriet and I, enter the security gate at U.N. headquarters in Kampala. The guard doesn't have enough name badges, so I suggest that only I need one because the others are my "granddaughters." (They've been calling me *Jajja,* Grandmother, all morning.) Since I'm the only white person in our group, the guard laughs out loud...and lets us pass.

As we make our way to a conference room, I marvel that four girls from the slums are about to address representatives of the United Nations. Sarah Parle, Program Analyst for U.N. Women's Violence Against Women, and Heleen Annemans, Program Analyst for Political Participation, Women and Leadership, welcome us.

Latifah speaks first: "Girls are considered items to play with. Imagine, your own daughter—! Fistula is killing girls in our country. It's you, our leaders, who must stop rape. Enforce laws against men! Rapists should be castrated or imprisoned!"

Who is this passionate, articulate girl who speaks truth to power?

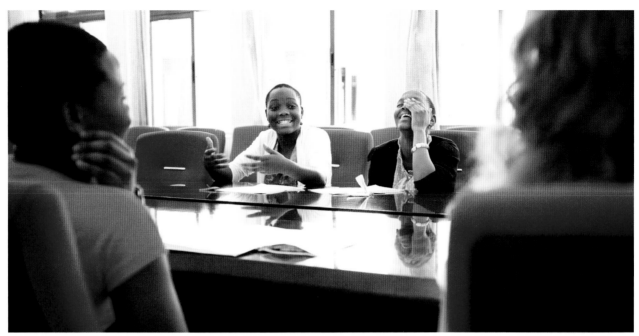

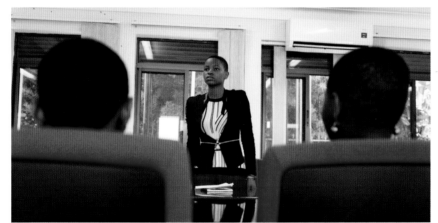

ABOVE: Members of Rhythmic Voices present to U.N. Women. Latifah challenges the executives: "It is you who must stop rape. Rapists should be castrated or imprisoned!"

"We are using our power as educated girls who know our rights."

LATIFAH, 14

I VISIT LATIFAH AND HER MOTHER AT HOME, a few hundred yards down a dirt road from the local well. They run a grocery store in their house.

Latifah reflects, "I'm the youngest, with four brothers. There was a time when we had nothing. Totally nothing. Nowhere to stay. Nothing to eat. Nothing to wear. We covered ourselves with polyurethane bags and slept on newspapers.

"Now we live in a home with two rooms. We do not rent. We built our house," Latifah tells me proudly. Her mother remembers, "When I got some money, we put up some plaster. Little by little. Cement. Iron sheeting for the roof."

Latifah explains, "Our father does not send us money. It's only our mother who looks after us. She is our light. She is the one we lean on. Being youngest is usually like being the baby. But here Mother and I are our family's heads. She gets up early, goes to market and buys things to sell. We sell tomatoes, onions, banana leaves, and cooking oil so we earn school fees and have enough to eat.

"We struggle. If customers don't come, we pray we will have enough to eat for the day." While we are talking, several customers hand Latifah coins to pay for vegetables. The store nets $1.50 U.S. on an average day.

Yet Latifah feels fortunate. "God helped me. The Christian Women's Concern, a partner of Rhythm of Life, was passing by. They gave scholarships to two of us, so mother could use the money she earned to take care of the rest. I passed my English interview, and got a five-year scholarship that covers half the cost. Mother pays the other half plus uniforms, shoes, mattress, bed sheets, books, jerry can, everything.

"I study hard, so I can be someone important, help my family, pay back what my mother has done for me, and make her proud of me.

"My dream is to become a lawyer. Children are being tortured. They are denied their rights, like the right to education. The right to have love. The right to eat. Even where to stay. And the right not to marry at an early stage. Girls are discriminated against, segregated, and not liked in the family. That can be stopped by my effort. That gives me the determination to be a lawyer, to defend young people and see that wrongdoers go to prison."

Until Latifah earns her law degree, she helps girls other ways. "We counsel girls up to age 18. I am proud that sometimes I advise girls older than I am. We help them if they are having problems. We guide them on what to do.

"Rhythmic Voices makes our voices heard in every sector. Everyone can listen to me and pick something that is inspiring. Life is hard; we need to struggle and change it so everyone gets a chance for everything she is owed, and equality can be promoted."

Latifah has been part of Rhythmic Voices since it began. I ask what she found most difficult. "If I try to help someone and I see that I'm failing, that hurts me the most," she replies. "But at least I do everything in my power and put a smile on that person's face."

I ask, "What have you done that you are most proud of?" "Helping a girl who was forced into early marriage. Now she is free. She is learning to do handwork. If she can go back to school, she can be economically free. She can earn a living and even save for her future."

I ask which issues are most important to Latifah. She names three.

"The problem of being discriminated against. That one I can help so girls have equal rights and opportunity.

"The problem of rape. I tell local leaders they have the ability and the right to stand up for younger ones who are tortured.

"The right to education. Once, local leaders and other big people thought girls were not supposed to go to school. They thought women should cook and serve their husbands. They didn't know that girls can also become MPs and presidents. We are using our power as educated girls who know our rights, to stop this, so girls become a priority and segregation ends. I mostly talk to the parents about this. As children we need their support most of all. If there is a chance, I talk to local leaders so it becomes easier for the girls in the community. I would even talk to MPs and the President, who could pass a law against discrimination."

I ask if Latifah has ever pitched an MP. "Yes. At the Let Girls Lead training, we talked to a Member of Parliament. She promised change. We are waiting."

ALLAN BUSBY, MY INTERPRETER, is one of two men on the Rhythm of Life staff. He drives Harriet and me along the railroad tracks. Most families do not have cars in this neighborhood, so it doesn't matter to residents that roads are unpaved and uneven. Clothes flap on laundry lines. People buy from scattered stalls that display merchandise on either side of the tracks. A vendor sells us ice cream cones through the car window.

Ahead is the house where Sharon lives with her parents and six brothers and sisters ages 21, 18, 14, 12, 8, and 5. Their small yard is dusty and rocky, but they've cleared a space for beans to dry in the sun. Sharon and her mother welcome us, and seat us in a room that is just the right size for a couch, two chairs, a coffee table, and a TV.

"If girls are denied education... They will be misfits, isolated, unqualified for jobs."

SHARON, 16

"SOMETIMES, LIFE IS NOT EASY. We always encourage each other. We fight to see that poverty does not follow us. We are not rich. We fight hard to survive. Mom has a store that sells fruit and vegetables like *matooke* (green bananas), Irish potatoes, and tomatoes. I help her. Dad is a carpenter. He may look for a job and find nothing, so he comes home without money. But we tell him, 'Try, look, you may find work.'"

Sharon is the only girl I interviewed for this book who has a micro-credit account. "I make a deposit whenever I get money. I take it and save it. In the future, my parents may die and at least I will have money. Maybe I can start a business." But business wouldn't be her first choice.

"I want to be an optician. I've seen many people suffering from eye problems. Shortsighted students looking at the blackboard…it's hard for them to understand what is being taught so they can't perform well. Others, like grandmothers, love reading the Bible but have problems with small type. I want to help them."

Being an optician is a logical step for Sharon, who was elected Health Prefect at her school. "I have always encouraged girls to be clean, tidy, improve on their health. Encouraged little children not to drink unboiled water. A sick person has to get medicine from the school clinic. The school compound must be clean, to prevent flu. I talked counselors into providing sanitary towels. Without them, girls miss a

week of school every month."

Sharon is as committed to girls' education as she is to their health. At the United Nations, she argued, "If girls are denied education, they will not be respected. They will be misfits, isolated, unqualified for jobs, and will have no alternatives except early marriage. Imagine a Uganda with educated mothers! I call for U.N. Women to enforce the laws against female genital mutilation, teen pregnancy, and early marriage."

Sharon describes four barriers to girls' education:

"If someone gets pregnant at an early age, it's a bad case. So we have to fight hard and not go for teen pregnancies and early marriages because they will affect us—alone. The biggest barrier to attending school is teen pregnancy." (U.N. Women's research says 24% of all girls in Uganda are teenage mothers.)

"Some girls have no one to provide for them. So if a man says, I am going to give you this and that, they think, 'I will marry him to get what I want.'

"If girls don't have parents—maybe because they are dead—they lack school fees. When they don't have them, they may become prostitutes to earn a living.

"Some girls belong to groups that force them into drug abuse instead of school."

Given these four problems, I wonder what arguments Sharon uses to convince girls to continue their education. She gives an example, "Perhaps a girl goes to the school administrator and says, 'At least, give me time so I can work to earn my fees on Friday and Saturday instead of attending school.' Of course, they will let her."

I ask, "How can you convince a pregnant girl to continue going to school?"

"She can go to another school after she has delivered the baby."

Sharon remembers Let Girls Lead's workshop. "They told us we must bring out our rights to show

that we are also human beings. That we should fight hard so every girl in the country can achieve education. I look forward to the time when the whole country will hear me."

Just as Sharon's family members encourage one another, Sharon encourages struggling girls. "I tell them, 'Don't give up. This is our moment to see that girls are no longer seen as inferior. Always work hard, which helps you achieve what you want in the future.'"

Sharon wrote a poem of praise for girls, which I've excerpted here:

Girls hold the nation,
Incomparable and hardworking...
Girls are the mothers of tomorrow
The creators of future generations...
Girls are like bright stars in the sky...
Their beauty lights the world.

Rhythmic Voices girls live and work with their mothers. LEFT: Sharon, with her mom and Harriet Kamashanyu.
RIGHT: Latifah with her mom in the grocery store they run from their living room.

LATIFAH AND SHARON plan to discuss girls' rights with the slum community leaders. They accompany Harriet, Allan, and me to a meeting that's scheduled for noon. Harriet has warned, "If we are not there on time, these guys will split." We walk along an open sewer; graffiti warns there's a 50,000 shilling fine for throwing trash into the ditch. The warning has not stopped anyone.

We're 15 minutes early. There are no community leaders anywhere, but we assume they will materialize. They don't. Harriet knocks on the doors of four nearby shacks and finally finds a man who waves to his left, "They had an emergency meeting down there."

Rhythmic Voices will return. These girls don't accept absence for an answer.

Rhythmic Voices has appointments to talk about girls' rights with the leaders of the school that provides office space for Rhythm of Life, Muyenga High School. Its Head Mistress, Deputy Head Mistress and Deputy Head of the Primary Section welcome us.

I expect that this will be a simple sell since the administration resonates with Rhythm of Life's mission, and 60% of the school's students are girls. Instead, the meeting reveals just what the Rhythmic Voices girls are up against.

Sumaeya reiterates the importance of girls' education and identifies some of the reasons it often doesn't happen: parents' discrimination against girls; unaffordable school fees; unavailable sanitary pads; early marriage; teen pregnancy.

"What," she challenges, "is Muyenga High School doing about these problems?"

The administrators waffle, "We have neither the training nor time to teach sex education. We are attached to Christian values of abstinence. We see three or four pregnant girls each year, mostly senior girls who get pregnant because of curiosity, peer pressure, or poverty. We counsel families, 'It was a mistake; she deserves another chance,' but really, the only options are to marry, abort, or transfer to a different school after the baby is born. Parents believe educating the girl child is a waste of time, and are not surprised when girls mess up. They say, 'Of course. We never thought a girl could make it.'"

"Frankly," the Head Mistress says, "we rely on Rhythmic Voices. They are articulate, and a good distribution system for information. Girls listen to girls. We let the girls educate and sensitize each other."

I am disheartened by this meeting.
Sumaeya is undaunted.

"If you change someone's life, that person will change another person's life. It's a good cycle."

SUMAEYA, 17

WHEN SHE WAS NINE, Sumaeya's grandmother taught her to be tenacious and resilient. She grew up with her "father" in Nakaseke District. One day her grandmother told her the truth: her father died in a motorcycle accident when she was a year old; no one knew her mother's whereabouts; the man who claimed to be her father was really her brother. Sumaeya was devastated.

"When I realized I didn't have a dad, I was very discouraged. My granny took care of me for three years. She is an icon in my life. She encouraged me not to give up: 'Be strong, be persistent, smile, fight for who you are in the world.' She helped me believe in myself."

Sumaeya is now a high school senior and has a scholarship from Rhythm of Life. She tells me she got the scholarship "because my grades were not bad," but I encourage her to brag a little. She smiles, "I was performing really well."

"I became a hard-working girl to achieve my dream of becoming an accountant." "Why accounting?" I probe. "I want lots of cash! If I become an accountant, I can fund organizations that help women and girls in my community and country. I'd fund Rhythm of Life, which has helped me and other girls, as well as other organizations."

Sumaeya is the first girl I've interviewed who intends to become a philanthropist.

At the moment, she uses her time and talents to support girls via Rhythmic Voices. Sometimes she channels her grandmother at school assemblies: "Some girls think themselves inferior, but I tell them, 'You are smart, you can do everything a boy or man does. You should not be down. Be yourself. Be strong!'

"At Rhythm of Life," Sumaeya says, "we carry out different outreaches. In the health sector, we distribute sanitary pads and teach girls how to use them. Many girls cannot afford sanitary towels. They use leaves or newspapers. Without protection, they are ashamed to attend school.

"We need to develop these girls. We can teach skills to those who can't afford school. I have some computer skills. If I teach them, they will be able to get good jobs and earn a living—or to learn something and pass it on."

I've now heard Sumaeya address public meetings about issues as diverse as teen pregnancy, child marriage, domestic violence, women's health, and universal education. She is such an impressive advocate that I wonder if her ability is innate. She admits, "At first, I was scared. But now, I am OK. I'm proud of the changes I'm bringing about in my country. If you change someone's life, that person will change another person's life. It's a good cycle."

VALERIAN NURSERY AND PRIMARY SCHOOL IS NEXT. Three Rhythmic Voices girls meet with the Head Teacher and Deputy Head Teacher.

Twelve-year-old Sheilah moderates. She distinguished herself in the sixth grade, ranking sixth in her class of 51. The administrators regard her highly as "humble and hardworking."

Sharon and Latifah hold forth about girls' rights. The Head Teacher takes notes. When they challenge him to describe what his school is doing to solve the problems, he responds to every charge. Valerian Nursery and Primary School seems to be the polar opposite of Muyenga.

Valerian has counseling sessions for girls to deal with pregnancy and menstruation; parent programs about early marriage and teen pregnancy; parent roundtables to discourage drops-outs and sensitize parents about girls' physical and psychological needs. ("Give them cosmetics and clothes so sugar daddies won't," the Head Teacher advises.)

I especially like Valerian's response to the President's Initiative on AIDS Communication. The school's exterior walls are festooned with messages that debunk popular myths. "Sex does not cure menstruation," addresses a myth I've never heard, but girls beginning puberty might have. Valerian's girls won't be fooled.

The Head Teacher's response takes 45 minutes. At one point, I wink at Sheilah, who is politely attentive during his lengthy lecture. She smiles.

OVERLEAF: **Sheilah, proud of being at the top of her class, reigns over her classroom at Valerian Nursery and Primary School.**

"I want to reduce the number of girls who are getting AIDS."

SHEILAH, 12

I FIRST MEET SHEILAH AND HER MOTHER at the Rhythm of Life office. Of all the girls, only Sheilah has written a page to introduce herself. In English. I am so impressed that I ask her if she would like to read it aloud.

"My mom told me the story about her path and my path.

"She told her stepmother when she was pregnant with me. Then she told the grandparents, and they told her, 'Remain here.' After some time, her grandmother's sons said my mother could cause problems to them.

"She stayed with her other grandmother and got a job in a hotel for 500 shillings only (15 cents, U.S.). She went in the morning to earn her money and came back at night. At the time of producing me, her grandmom died.

"When they told her that, she wanted to stay at my father's home. She didn't know where my father lived.

"Her cousin took her to Kampala where she started selling bananas. Her cousin told her that since she had a baby, she should work hard and get her own house. She worked hard and got her own house for 30,000 Shillings ($9 U.S.).

"She would lay clothes on the ground and we would sleep. I remember becoming sick. She took me for a check up. I was shaking like a mad person. She told my dad I was HIV positive. My dad told my mom, 'I couldn't produce an HIV positive girl, so that is not my child.' She returned to Kampala and continued selling bananas.

"Then she got a friend and he told her, 'I am going to help you.' She produced another two children. Her friend left her. She started selling bananas again.

"Another friend asked, 'How could I help you?' She said, 'My children are not in school.' Her friend told her, 'You come. I will take you to a Universal Primary Education school. He got another friend to write Rhythm of Life. Now, I have got many things from that organization."

After the meeting at Valerian Nursery and Primary School, I ask Sheilah when she first learned her family history and what surprised her. "My mom told me the day before I met you. I found out that my father neglected me. And I was HIV positive. I did not know that. It was not good news. It was really sad. But my mom encouraged me."

Sheilah understands what it means to have AIDS. ("They taught us.") Neither her brother nor sister is HIV positive, and she knows no other children who are. But she realizes the infection is widespread. She knows that nutrition can help. ("A balanced diet. Proteins, carbohydrates, vitamins. I may have forgotten some.") ARVs are free in Uganda, but Sheilah believes, "The government should have more hospitals so everyone can access medicines." She reflects on the situation. "I want to reduce the number of girls who are getting AIDS."

Despite her condition, Sheilah is an active, busy girl. "I run. I race. I read. I draw."

Sheilah is a new member of Rhythmic Voices. "When Rhythm of Life came to my school and I was introduced, I was very active giving answers, and that made me proud." Now she attends school on a full scholarship from Rhythm of Life, "including books, pens, rulers, and erasers."

Sheilah tells me she "was elected Academic Prefect at school, responsible for debate competition between the classes. Recently, we debated 'Polygamy Is Better than Monogamy.' I argued for polygamy. If you have only one wife, there's a lot of work for her to do. If you have many, everything is done in just a minute."

I ask whether Sheilah knows a family where the husband has more than one wife. "My dad had more than one. Like five," she says. I ask, "Were they nice to you?" "No. They didn't like my mom so they transferred that to me. Together, we were ten children. I liked them."

Recalling Sheilah's written introduction, I ask whether she would like to be a writer. "No, I want to be a lawyer. I heard my father was a lawyer and I want to follow in his footsteps. What interests me is bringing justice."

OPPOSITE TOP: Rhythmic Voices girls sport new t-shirts at a celebration breakfast.

MIDDLE: Sharon argues for girls' rights at the YWCA in Kampala.

BOTTOM: The Muyenga High School principal listens attentively to the girls' demands.

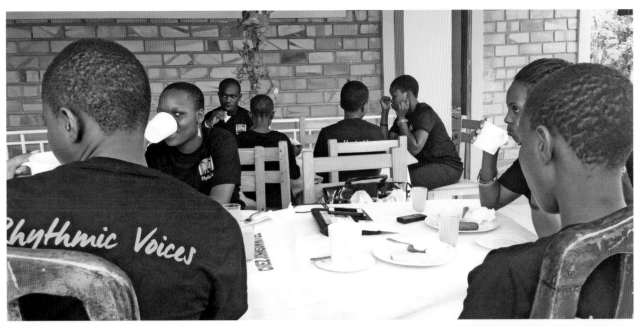

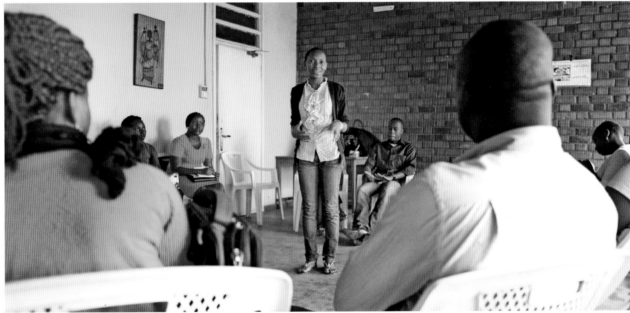

I'M SITTING ON THE PORCH of the house where Aishah lives with her mom, two sisters, and a brother. A cloth curtain covers the doorway. Hens peck the dust. A naked toddler inspects us. Aishah is making a collage with yarn, seeds, beads, and shells.

As we talk, her art becomes bright and beautiful. She confides that she dreams of opening a gallery to show and sell her work. But that is not her first dream.

"All children are equal. Send your daughters to school."

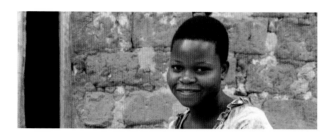

AISHAH, 18

"OUR MOTHER IS A SINGLE MOTHER. It was difficult for her to raise us. She has a roadside business. She woke up early in the morning and got *gonja* (sweet plantains) and maize in the market in Kabalagala to sell.

"I was also working, smoking plantains to get school fees. We worked hard. I knew that through working, you can achieve anything. Since I was working with my mom, she and God gave me courage.

"My dream was to be a doctor. In 2008, I started secondary school. I studied and studied. I took my Uganda certification exam. Unfortunately, I got unexpected results. I was not able to read well since I had spent so much time working.

"I had to sit out for a year. Many said I should not sit home. I should go for a course—or start a job. Mama also doubted me.

"I said, 'No. Education is success. If you are out of school, your success can die. I have to continue. I can wait one year.'

"Rhythm of Life has been helping me. They are still hoping. They have given me a scholarship and taught me to be economically independent."

I ask whether Aishah considers herself an activist. "Yes. Yes. I help distribute condoms to men so women and girls are protected from HIV. I tell parents, 'All children are equal, created in God's image. Treat them equally. Send your daughters to school.'"

I'm not surprised to discover how determined Aishah is to finish her education. She was just as resolute when she talked to the U.N. Women, "Fifteen million Ugandan girls marry before they are 18, sometimes to old men. I call on the United Nations and the government of Uganda to prioritize girls and change the legal age of marriage to 18."

If Aishah had less spine, she might have given up along the way, yet she has stayed the course. "I am about to complete senior six (the last year of high school). I am proud of that."

I ask her what advice she has for girls around the world. "I advise people not to lose hope. In life when you face challenges, you can overcome them by working hard.

"The place where we stay," she gestures to the neighborhood around us, "is full of sex workers. I say, 'I am not going to do that.' Without education, I cannot live."

BELOW: Sheilah asked to be photographed with her best friends in their classroom

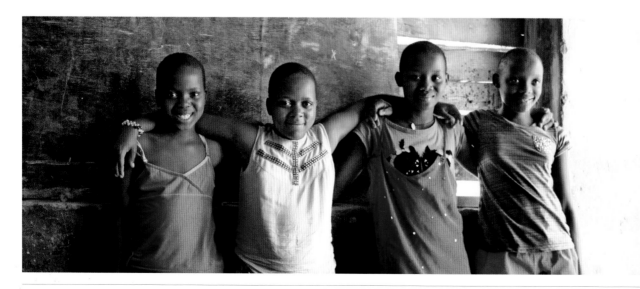

Note: Rise Up and Rhythm of Life have policies that allow only first names to be used for girls 18 and younger.

HOW YOU CAN CHANGE OUR WORLD

THE CHALLENGE:

In Uganda, many girls aren't given access to school. This is a problem because without an education, it is more difficult to get a decent job and earn enough money to avoid homelessness. This cycle of poverty can be ended through education for all, especially girls. In the words of one activist, "Denial of education is a stain on our nation."

THE CHANGE:

Rhythm of Life is working to "create a community" where girls are educated and aware of their rights. According to Sumaeya Nassuna, if girls go to school, "they can stop being dependent on men." Girls' education is important in order for them "to be empowered economically, so in the future they can be employed and survive." Rhythm of Life (through its Her Tomorrow initiative) helps girls access schooling from primary level through university.

Rhythmic Voices helps create other girl leaders by sharing and teaching skills. Their hope is that by teaching, they will become more confident in themselves and their abilities, and most importantly, less dependent on men.

HOW YOU CAN HELP:

★ DONATE FUNDS so Rhythm of Life can hire teachers, buy laptops and books, and send girls to school. Donations of books and technology are greatly appreciated because they directly affect the way girls live and teach daily. Email the Executive Director for instructions about wiring funds: harriet@rhythmoflifeuganda.org

MORE INFORMATION: WWW.RHYTHMOFLIFEUGANDA.ORG
SPECIAL THANKS TO: Sumaeya Nassuna, Latifah Nansubuga

FLYING FREE

India

IN 2012, JAMEELA NISHAT, founder of the Shaheen Women's Resource Center, gave a speech titled "The Revolution Will Be Led by a 12-year-old Girl." As soon as I read about it, I realized that I had to meet this kindred spirit.

"What did you mean?" I ask her when we meet in Hyderabad, India. She explains, "Rebelling in society comes only when you are teenaged and realize what your talent is, what you can do, and how you can change your world. If you are 40, your mindset will not change. Change can only happen when these girls question and rebel. They will say, 'No!' and ask for equality."

Jameela tells me that, although as a child she was good at dancing, singing, and painting, those were considered inappropriate for Muslim girls. She turned to poetry. Her six published volumes have established hers as a strong, compassionate feminist voice. Her activism has established her as a champion of social justice, peace, and freedom.

Shaheen focuses on Hyderabad's 20 slum districts where women suffer from profound institutional, community, and family discrimination. The NGO works with 700 girls younger than 18 who are Muslim, Dalit (née "Untouchable"), or Other Backward Castes. Three-quarters of these slum families live on less than $1.15 U.S. a day.

Shaheen's research in 2013-14 found that the majority of women and girls in these areas are not allowed to leave their houses unaccompanied. They are forced to cover their heads; those who don't are cursed and rebuked. Men and in-laws govern the girls' lives.

LEFT: Shaheen girls in Old City, Hyderabad dare to sing, even though it's considered culturally unacceptable. Soon, they will record a CD, a paean to freedom that defies institutional, family, and community discrimination.

"Life in Old City is very complex," Jameela tells me. "Freedom is not about one girl in one house. The whole area will stop her. If one girl goes out, her neighbors start questioning. We may talk to 10 or 20 families so they agree she can be free.

"Money lenders bleed these poor people; they charge a lot of interest and families cannot repay. So under that pressure, girls are forced into marriage.

"In the beginning, I told the girls, 'Paint whatever you like.' One painted a bird without wings. I asked her, 'Don't you think anything is missing?' She rushed back and drew a cage.

"I talked to the girls about what freedom means and what the painting communicated. Then they came out with the word *shaheen*, a bird that flies high in the sky. It is especially important in a very famous Urdu poem.

"And that's how our NGO got its name. We aim to free these girls from their caged lives. Those who don't have wings—who should have wings—they should fly!"

When she was a child, Jameela's grandfather insisted that their family move to Hyderabad's more affluent "New City" so she and her sisters could attend good schools. When she launched Shaheen, Jameela moved back to the poorer, predominately Muslim "Old City," and that, plus her NGO's goals, got Jameela into trouble.

"When I started the work, people were calling me anonymously because I was talking quite a lot about freedom. They said, 'Why have you come to the Old City?'

"Then there was a letter written to my house owner (I live in a rented house) saying, 'You are giving shelter to a person like her? Send her out of the house.' (When these letters came, my husband went to the house owner and explained. Whenever there's a crisis, he stands supporting me.)

"People attacked my Center 'because you are talking with young girls all the time. You let them sing, you let them dance, you let them do whatever they want.' First,

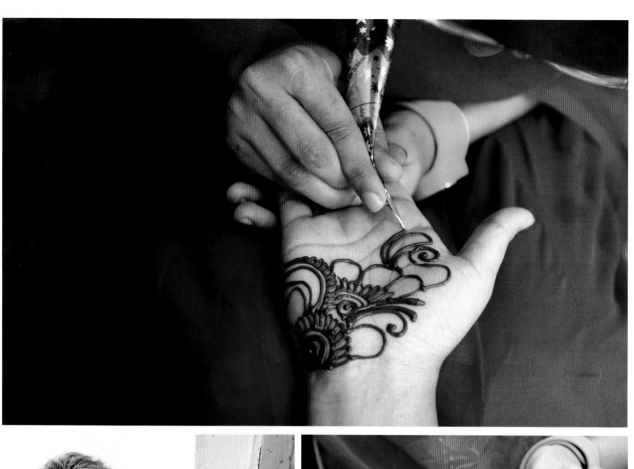

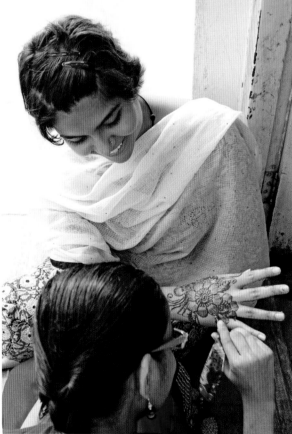

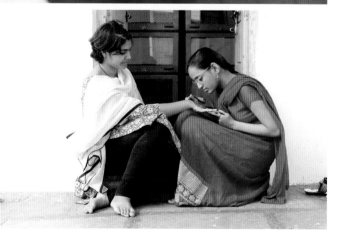

ABOVE: Nida Begum demonstrates henna designs, *mehandi*, which Shaheen girls are taught as a vocational skill.

mothers came who did not care for it.

"After that, 25 men came and sat as if I were answerable to them. They questioned me. I answered them and that lasted from 2:00 o'clock to 5:00 o'clock. Finally, they thought, 'This woman doesn't know religion. She should be taught.' I said, 'OK, this is not an issue. I will learn.'

"Other men thought, 'Let's put a bomb in Jameela's car.' We couldn't do anything about that threat. We ignored it.

"The year 2002 was also a problem for us. The Gujarat riot. So much trauma. All the houses were burned where we were. We had to start work from scratch.

"Whenever there is communal tension in the area, there is no eye-to-eye contact between the girls. Yesterday they were friends but today they don't talk to each other. I wrote plays and we performed.

"Then men came from the mosque. They said, 'You've got a *fatwā*. Now you are answerable to the community.'"

I think of Salman Rushdie, threatened with murder for writing a book, hiding in London, publishing nothing for years. "What did you do, Jameela?"

"We filed a case in court: 'We are unnecessarily disturbed like this.' So we dissolved that issue completely. Fatwā, it doesn't work."

I arrive at Shaheen's office on Republic Day, 67 years after India's constitution went into effect. While almost 200 young girls in their best dresses celebrate in Shaheen's courtyard, I sit in the dimly lit anteroom with staffers and mothers.

Two women catch my eye: one has porcelain skin (bleached inadvertently by a medicine) and the other's nose has been cut off in a domestic violence incident. Hindu and Muslim women chat quietly together. I marvel at the solidarity Shaheen has created.

A volunteer gives each girl a chocolate as she leaves. I get one, too: a foil-wrapped Ghirardelli square. How did that candy, made in San Francisco, find its way to Hyderabad? Suddenly, I feel right at home.

"I conducted a sting operation against a sex trafficking ring."

NIDA BEGUM, 17

WHEN SHE WAS EIGHT, Nida started coming to Shaheen to learn income-producing skills. Now she is so good at *mehandi* (henna designs for weddings and parties) that she teaches younger girls.

While we talk, she draws flowers on my hands. "You've been coming to Shaheen for nine years. What have you done here that you are most proud of?" I ask.

"Two months ago, I conducted a sting operation against a sex trafficking ring run by a sheikh from United Arab Emirates."

"Tell me everything."

"Shaheen does home visits. At one home they found out when and where a young daughter was going to be married off.

"We went there. Two people from Shaheen accompanied me as my 'mother' and 'aunt.' I felt safe because I was with these office people. We went to

the broker's home and put on an act, explaining that I was from a poor family that needed money.

"Within eight days, the broker called to arrange a meeting with the sheikh. Again, my 'mother' and 'aunt' went with me. At that meeting, I observed that one room was very, very decorated, as it would be on a wedding night. I was really scared after seeing that room.

"I had a camera hidden under my dress so I could shoot the whole event. I was nervous carrying the camera; it lost focus so it just shot the ceiling.

"I was one of about 15 girls who were supposed to be married off. The sheikh was 80 or 90 years old. Some girls were 13 years old but they said they were 18 since that is the legal age for marriage in India.

"The Sheikh chose the girls, preferring the girls who said they were age 18. He looked at a girl from top to bottom; what is her chest size; what is her hip size; then her whole body figure. She's on auction. He set a price.

"That amount is going to be shared by the broker who got the girl there—and by her parents. I don't know the exact amounts, but the price is determined by body type. A thin girl would be paid some amount, a fat girl would be paid some amount, it's like that.

"I was one of five who were selected. Inside the

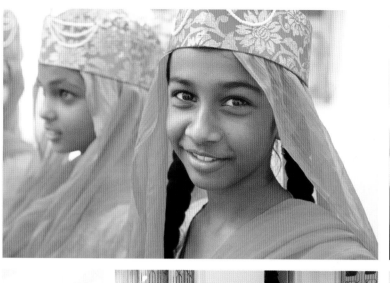
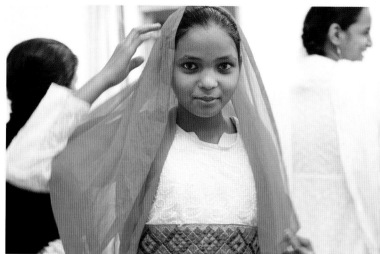
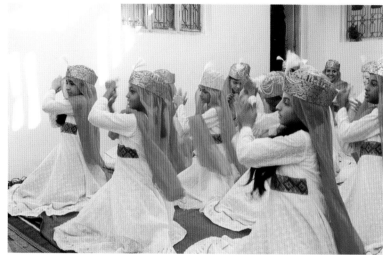

hall, I was given some money that I didn't count. I handed it to the broker who noted down all my details and kept the money. He said, 'Once the marriage is fixed, we will give your mother some money.'

"My 'mother' asked why she would not get *all* the money. The broker said, 'Your family works to earn a living on a daily basis. This is the only way I earn a living. So I keep the major part and you can keep a small amount.'

"When I came back to Shaheen, I described the whole situation to Jameela, who told me not to worry, the broker would contact us later for the marriage, which he did.

"By that time, Shaheen had contacted the media people. Although it is prevalent in Islam that men can marry four or five wives (as the sheikh was about to do), the television people wanted to do a program saying, 'This is not right.'

"Television reporters came with us the next time. They had microphones and earphones through which they could communicate.

"The sheikh doesn't take the girls back with him to Dubai. He keeps them here in hotels. It's a three-month contract. Once a girl's contract ends, she's married to some other man here in India.

"So they have two documents. One is the certificate of marriage and one is the divorce paper. Both of them are signed at the same time. At the moment the Sheikh and I were to sign the papers, the television team entered and caught everyone red-handed. The traffickers went to jail.

"The station broadcast the video eight days later. They blurred the girls' faces. My family still doesn't know I was involved. If my mother knew, she would stop me from coming to the center.

"Because of the television show, many people became aware. They said, 'This is not right,' and tried to stop this practice. It's still prevalent, but now, sex traffickers have gone into hiding.

"Most important is making people aware that child marriage is not right. Informing parents that it is not a good thing. When I teach mehandi at the Shaheen sub-centers, I give that message to every girl who comes to me."

"Have the confidence to fight for yourself."

THAKUR SUMAN SINGH, 18

THAKUR FIRST CAME TO SHAHEEN about a year ago for vocational training, knowing that after finishing 12th grade this year she wanted to be a fashion designer. But the most valuable lesson she learned from Shaheen was not a vocational, but a personal, skill.

"Before, there were times when I was coming home from school and boys used to "Eve tease" [harass] me; I did not talk back. When I was scolded for doing something that was not my fault, I used to put my head down and not react.

"Shaheen conducts meetings where they say, 'If you are being criticized for doing something you didn't do, you should have the confidence to fight for yourself.'"

Thakur, fifth of ten children, has three older brothers who see themselves as her bosses. "An example: I went to my cousin's wedding. When I got home, one brother started questioning me about talking to some guy. I said, 'I did not talk to any strangers.' My brother said, 'No, we have seen it.'

"My brothers got very angry. 'If you don't tell who that person was,' they said, 'we won't let you out of the house to go to school.' I fought, saying I had not done anything wrong. And I won."

Inspired by her bravery, I tell her, "I think it would change the world if women said, 'I will speak up for myself.' It's important."

Thakur tells another story. "My sister-in-law was doing all the work while the others sat. Because of this, there was a lot of tension in the family. When I learned from Shaheen about women's unpaid work, I went back home and convinced my sisters and my mother to divide the work among everyone, including the brothers, irrespective of gender. These arrangements have led to a lot of peace at our house."

"Do you consider yourself an activist?" I ask. Thakur nods, "Yes. I want to make a name for myself by helping others understand what I have learned about equality."

OPPOSITE AND OVERLEAF: Shaheen participants perform songs inspired by sacred Sufi music; poet and founder Jameela Nishat wrote the lyrics and designed the costumes.

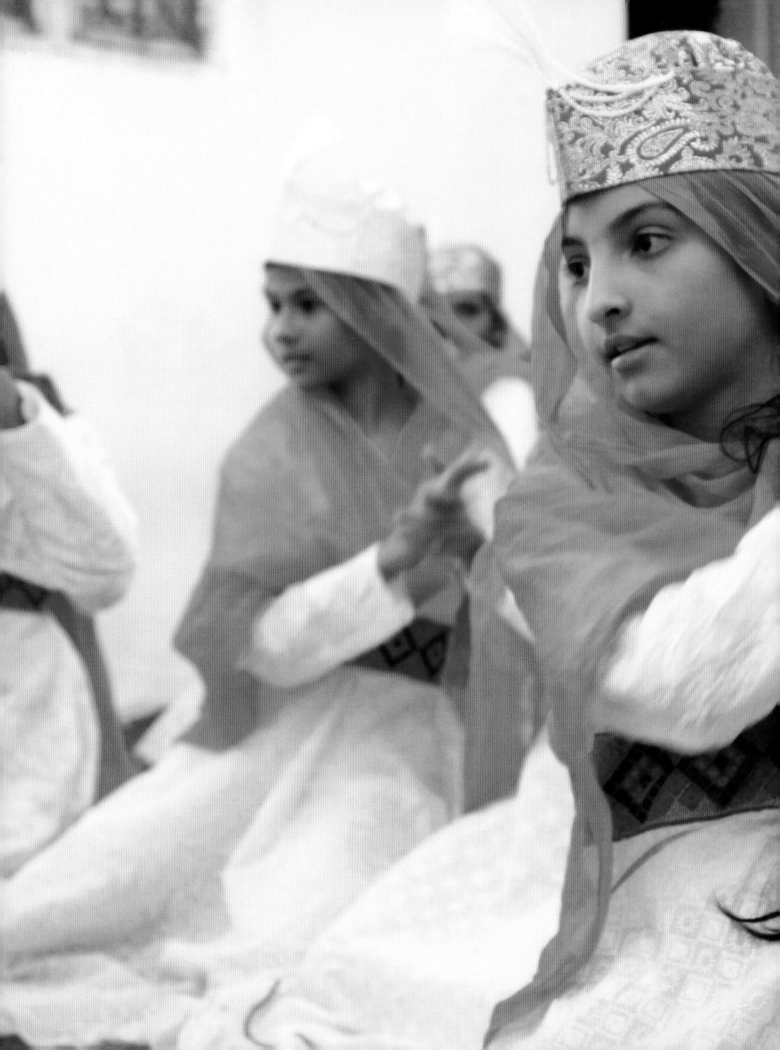

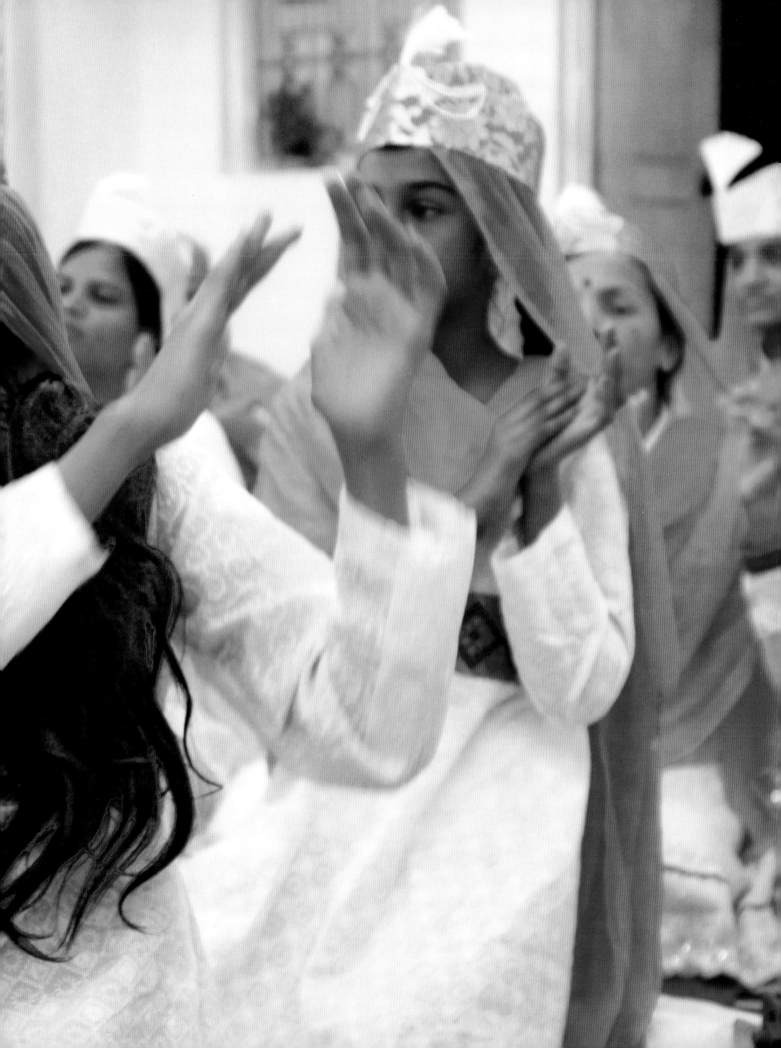

"I have put my foot down... I am not getting married."

NEHA BEGUM, 14

NEHA'S MOTHER TAUGHT HER how to set stones. She now makes bangle bracelets for her aunt to sell to specialty shops like those in Laad Bazaar, where glittering bangles are stacked to the ceiling.

"I design the stones into attractive patterns," she says. She is so quick that she can finish a narrow bangle, which might have a hundred stones, in ten minutes; a wider bangle takes an hour.

"I find the work very restricting. I am not allowed to go outside the house to work and we only earn about 20 rupees (30 cents U.S.) for a set of eight bangles."

Four years ago, Shaheen had a drawing competition and Neha entered. "I took first place. I can draw anything. I also like to do watercolor paintings and tracings."

Neha's artistic ability has reaped surprising benefits. "One day when I was at home with a friend, someone knocked. There was an old lady, a beggar, who dragged us outside. I was brave and bit her so I got away. My friend got trapped. The woman drugged her.

"I ran and informed Shaheen, my mother, and the police. To give them as much information as possible, I drew sketches of my friend and the old woman.

"The police found my friend by the road in a drunken state, abandoned. The police kept her in a women's shelter until Shaheen brought her here to the center."

Domestic violence is a frequent phenomenon in Old City slums and Neha's family has had more than its share. "After my father died, my mother married again.

"Our stepfather kidnapped my sister and me to a neighboring state, Maharashtra, and locked us up in a house. My mother called him, and he lured her to that spot. She came with the head of police and some Shaheen people, who rescued us.

"After that, he tried to sexually harass me. One day, he told me to remove my salwar. I refused. He stripped both me and my mother naked and beat us. With Shaheen's help, we approached the police who came to the conclusion that this man cannot live with us. Now, he lives separately."

Neha has learned to fend off attacks and seek help when she needs it. "The day before yesterday, this man was following me on his bike and Eve teasing me. I turned around and told him to get lost. Uncles beat me, then tell me not to report them to the police or Shaheen. But I do.

"Now, family members are threatening to marry me off because I am a threat in the house. But I have put my foot down and said, 'I am not getting married.' Instead, I still go to school."

"I started to have a voice of my own, and I fought with it."

FIRDOUS FATIMA, 15

FIRDOUS ENJOYS A TELEVISION SOAP OPERA called *Waada,* which means "Promise." "I like it because it is full of good, positive feelings of love."

Perhaps she appreciates the show because she has fallen in love. "He doesn't lie, he understands my feelings and is helpful," she tells me.

"Our families know each other and his family knows we love each other, but my family does not. In India, boys—but not girls—have the freedom to fall in love. I love him but I will wait for the right age. I want to have a love marriage."

Firdous's decision is courageous in a culture where arranged marriages are a tradition. But no one could doubt her decision to wait until she is 18 to marry, since she has mounted two passionate arguments against child marriage...her cousin's and her own.

"I was 14 years old when the first proposal came. The groom was 24. His family came to see me and accepted me. I told my dad that I didn't want to marry before age 18.

OPPOSITE, TOP: Neha, her sisters and mother are working together to end domestic violence in their family.
BOTTOM: J Varsha Janoter jokes with her friends. She hopes to be a policewoman and help end violence against women.

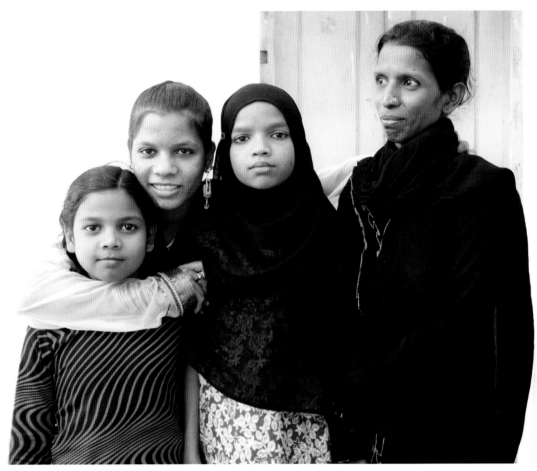

"My dad puts a lot of restrictions on me when it comes to going out alone or in the evening, which he doesn't want because a lot of people are drunkards in our area who Eve tease girls when they come out.

"But when it came to child marriage, my father was very supportive, more supportive than my mother. Mom was married off at 17. I told my mother that my body was not ready to have a baby. I convinced her that I should only be married after age 18, when I am physically mature."

Firdous was not as successful arguing against her cousin's early marriage. "My cousin was married un-der pressure at age 15 to the person her parents got—because she didn't want her parents to know that she loved someone else. She is now 16 and pregnant."

It was the cousin who introduced Firdous to Shaheen, where she is studying mehandi and has completed a tailoring course. ("I know how to stitch women's clothes: frocks, salwar kameez, slacks, and suits.")

"When I came here, I got a lot of awareness. I learned to be independent. I started to have a voice of my own, and I fought with it. I convinced a lot of my friends and their parents not to get into child marriage."

EARLIER JAMEELA TOLD ME, "Mobility is a big challenge. We are making the girls go out and work." Leaving the house is a bold idea, but that change is necessary for economic self-sufficiency.

I had imagined that girls remain inside because their culture cloisters them. But it is also because the streets are treacherous. Shaheen and the girls are working to make neighborhoods safer.

I ride with Shaheen members and staffers in Shaheen's car through the labyrinthine streets of the Old City, windows rolled up. I see men and boys standing around, revving up their motorcycles, and hanging out. Testosterone City!

We are going to the organization's sub-center in Siddique Nagar where 20 girls have gathered to prepare a safety audit, as they have done twice every year since 2012.

Two teams of girls huddle on the floor around big sheets of paper, drawing local maps, each telling her stories of being harassed or attacked and marking the exact location the incidents occurred.

Every girl here has had such experiences; most have had many. On their maps the ice cream shop, hotel, school, and grocery store are soon surrounded by red X marks. Near the arroyo, red X marks form a forest of danger.

The girls sign the back of the maps, which will be delivered to the police. Officers will monitor those areas in an effort to enhance women's and girls' security.

"I am confident that I can bring about change."

JABEEN BEGUM, 15

I ASK JABEEN TO REFLECT on all the things she has learned in the last 18 months since her cousins first brought her to Shaheen. "What has been most important?"

"I have been learning about the issues, and that has helped build my confidence. I used to have Eve teasing when I went to the Shaheen sub-center and my parents wanted to stop me from going. I took someone who works at the center with me to the police, who stopped that from happening.

"Now my parents allow me to go out freely. If somebody tries to convince them not to let me go out, they say, 'That is my daughter. She can do whatever she wants to do.'"

"I also affected the life of one of my friends, an orphan who lives with her grandparents. They were very skeptical about sending her out. Societal pressure influenced their view that she should be protected. I spoke to her grandparents, and now my friend comes here to learn.

"I am now confident that I can bring about change in my own life as well as in others."

OPPOSITE: Shaheen girls create safety maps that document specific locations where they have been Eve teased or assaulted. Local police enhance monitoring of those areas.

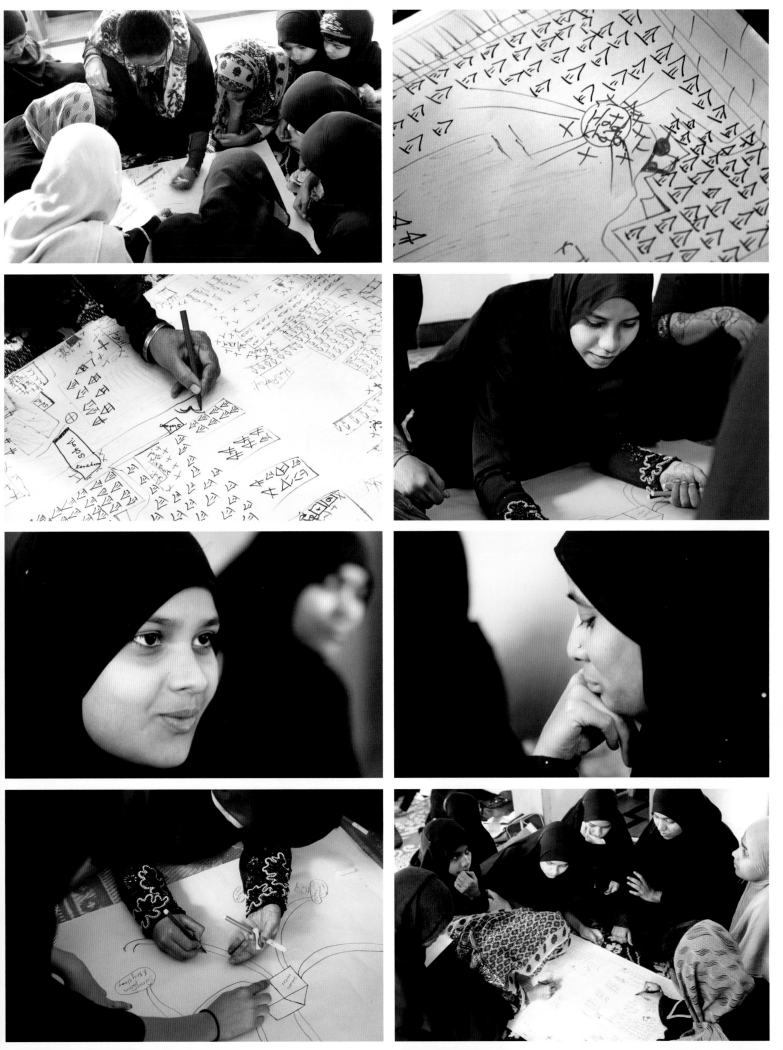

CASTE INEQUITY IS ENTRENCHED, even though the caste system has been illegal for almost 70 years. I understand. In the United States, racial prejudice is rampant although slavery has been illegal for over 140. Everywhere, equality is painfully elusive.

A Dalit research scholar at the University of Hyderabad committed suicide this week in response to institutional discrimination. The next girl I interview is Dalit.

"It is not...appearance—but the kind of human that person is, that will make a difference."

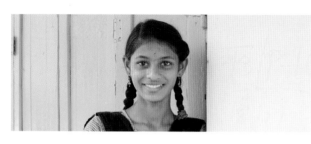

J VARSHA JANJOTER, 15

"I WANT TO BE A POLICE OFFICER, and end violence against women, domestic violence, Eve teasing, and child marriage, so women can come out of their homes and enjoy the freedom.

"I have reported cases of violence to the police twice in my life.

"There were a number of instances in school where boys Eve teased the girls. I felt bad about it. I told my dad some of the disrespectful things they said, but he said he could not help.

"I asked my mother to come with me to the police station and we filed a FIR (First Information Report). The boys were taken into custody and were there for seven days. They were told by the police officers that if they did it again, they would stay in jail for a year. I haven't faced the same problem again.

"I filed the second police report about domestic violence in my own family. When my parents were at work my uncle, my father's brother, used to hit my siblings and me.

"I faced a lot of opposition in the family when it came to reporting a family member to the police. Relatives were asking, 'Why would you do that?' They wanted to marry me off as a child bride.

"I asked my mother and father for support. My parents said, 'File the report and we'll see what happens.' They came with me to the police station so my uncle would not beat us again."

J considers herself an activist and is proud of trying "to make people aware of their rights, and to change the society.

"I started coming to Shaheen at age eight (my mother works here) and I got a lot of awareness from Shaheen about good touch and bad touch; how men are not supposed to violate someone's body; stories about rape and how you can protect yourself.

"At my school girls with darker skin are discriminated against. I try to tell them that it is not the physical appearance of the person—but the kind of human that person is, that will make a difference in life.

"I have been learning how to be equal in society."

THE NEXT MORNING, my last in Hyderabad, I discover 32 girls, teachers, and staff members in Shaheen's courtyard changing into white dresses with conical skirts, orange scarves, and brocade hats. The fabulous costumes, designed by Jameela, are reminiscent of whirling dervishes' clothing.

Traditionally, only men sing the sacred Sufi songs and spin into ecstasy. The Shaheen girls, proud and heretical, take positions to perform.

Jameela and Sultan Mohammed Mirza, who plays the harmonium, have collaborated to create this 20-minute performance of music and poetry inspired by *qawwali,* Sufi devotional music, which originated in India 700 years ago.

The girls have presented this music only once before, for the Minister of Gender. I am honored to

hear it next. I listen with respect (Muslim girls are not supposed to sing) and with pleasure (because it is beautiful).

Soon, there will be a CD of this rhythmic, repetitive, mesmerizing music performed by the girls of Shaheen. Its lyrics extol girls' freedom.

Till yesterday I was no one
Now I am someone
I have to walk with many others
Emerging from the valley of No
I can now be and do
And walk to the far, shining light...

(Excerpted from "I have Walked This Far" by Jameela Nishat.)

How YOU Can Change OUR World

THE CHALLENGE:
In Old City, Hyderabad, India, living conditions for girls are tough. Very young girls are forced to stay inside the house. They have no proper healthcare. They are forced into marriage and they are not able to have an education, which then leads to no career.

THE CHANGE:
Shaheen wants to empower girls to say no to child marriage, to get an education, and to have their own careers. This gives girls and women the freedom to make more decisions and take ownership of their lives. *Shaheen* is a Farsi word that means falcon. Their main goals for girls are to unclip their wings and free them from their cages so they can soar high like a shaheen.

HOW YOU CAN HELP:
★ SHARE EXPERIENCES. Your shared experiences help other girls feel like they are not alone. Have meetings and use social media.
★ DONATE. The Global Fund for Women makes grants to Shaheen. Contribute via globalfundforwomen.org
★ SUGGEST COMPANIES that might like to focus their corporate social responsibility programs on Shaheen.

MORE INFORMATION: SHAHEENCOLLECTIVE.ORG
SPECIAL THANKS TO: Jameela Nishat

EXPOSING CHILD ABUSE

Tonga

IT'S 3:45 on Friday afternoon. Siu and 'Iula disregard the sign on the door that says, "Stop! Do not open while we are on air!" They enter a radio studio that's just large enough for one desk with microphones. This is Radio Nuku'alofa, 88.6 FM, whose tagline promises it is "Blazin' the Nation."

The girls' weekly call-in program, "My Body! My Rights!" blazes the nation by talking about a practice that is ubiquitous, illegal, and—except for this show—rarely discussed: child abuse. Most parents and teachers believe in "educating" youngsters with a disciplinary smack. Too often, the children end up in the hospital.

Originally, the girls planned to start this month-long series on domestic violence by interviewing a police officer about the Family Protection Law that passed two years ago (few know it exists).

However, after interviewing their listeners, they discovered that most don't understand the term "domestic violence," so they decided, instead, to start at the beginning.

Siu and 'Iula sit on stools and arrange their cell phones and computers so they can get texts, calls, and emails from the teens who constitute about quarter of the country's population and live throughout Tonga's 176 islands. Across the desk, Josh, the engineer and disc jockey, tests the sound controls. It's 4:00 PM. Showtime!

Siu invites listeners to share their personal definitions of domestic violence. Josh plays music while Siu and 'Iula take calls and texts. For reasons of privacy and sensitive content, no listeners are ever put on air. Instead, the girls report what listeners say, mentioning age and gender, but not names.

Immediately, they get a call from a boy who provides an excellent, nuanced definition of domestic violence—better than the Wikipedia explanation on Josh's computer. The caller talks about the fact that domestic violence can happen in relationships, in families, between parents and children, between husbands and wives.

Siu repeats the boy's definition on air in English, then in Tongan, and commends him for it. 'Iula adds some statistics. The South Pacific region has one of the highest rates of domestic violence in the world: 77% of all women are beaten. Siu invites listeners to stay tuned to hear three examples. Josh plays a popular song.

A girl calls in to divulge that when she and her siblings don't do the dishes quickly or well, their mother throws plates, cups, forks, and spoons at them and they are afraid she will throw knives.

After the music stops, Siu announces that she thought she had three examples of domestic violence but now she has four. She describes the girl as "Cinderella, who has to do all the housework," and summarizes the caller's story, which is not atypical. Most physical and emotional abuse against girls is doled out by a female relative. Girl callers sometimes report being punched, kicked, dragged, beaten, and choked.

There may be as many as 18 calls during the one-hour weekly show that is funded by U.N. Women and sponsored by a local NGO called the Talitha Project.

When Vanessa Heleta founded the Talitha Project in 2009, she named it for a miracle described in the bible (Mark 5:4). Jesus took the hand of a 12-year-old girl who was presumed to be dead. *"Talitha, kumi,"* he said in Aramaic, which meant "young woman, rise up." The girl stood and walked.

Similarly, the Talitha Project helps girls and young women as young as 12 raise their voices, make informed decisions, and stand strong. Talitha Project girls are tackling diverse issues with activities as varied as advocating, counseling, mentoring, and, yes, the radio show.

OPPOSITE: **'Iula Vi climbs the steps to the radio studio where Talitha girls host a weekly show that focuses attention on Tonga's "undiscussable subject"—child abuse.**

"They say in the Bible you get hit if you do something wrong. I think people take it deeper than the Bible means."

SIUTAISA FAKAHUA, 18

IT IS TABOO HERE to talk about sexuality or violence so, not surprisingly, Talitha's radio program is controversial. Siu tells me later, "80% of youth are for me; 20% are against me. Elders do not support me.

"But guess what?" she continues. "Guys support me more than girls. I'd say our audience is 60% boys and 40% girls. Most boys who text us do not tell us their problems. They are confessing that they did something. They say, 'Sorry! If you are listening to the program, I'm sorry I did this to you.' That encourages me to do more."

The idea of confession and forgiveness shouldn't surprise me. Tonga is the most religious country I've visited. Buses don't run on Sundays; planes don't land; shops, businesses, and restaurants are closed. Legal deals reached on Sundays are declared null and void. Fishing and swimming are not allowed. People who violate laws that govern Sunday behavior risk fines or prison. Sundays are for going to church.

Siu's family, like the Tongan royal family, attends the state church that was founded by the Methodist missionary who helped King George Tupou I create Tonga's constitutional monarchy in 1875.

"My mom's parents are pastors in the Free Wesleyan Church. On Monday and Friday we go at 5:00 AM. On Wednesday, 6:00 PM. On Sunday, it's special so we go from 10:00 to 12:00; there is the children's hour from 1:00 to 2:00; then another service from 4:00 to 5:00."

Free Methodist services feature call and response. "Every time we start with the pastor talking, then we sing; then he talks, then we sing. I went to church with my grandparents when I was growing up and heard the same songs."

I take a walk on Sunday morning and hear glorious hymns and rich a cappella harmonies everywhere. The largest denominations in Tonga are Methodists, Mormons, and Catholics. There seems to be a Christian church on every corner.

The Talitha Project's efforts to end domestic violence face a steep battle against religious beliefs.

Siu explains: "They say in the Bible, you get hit if you do something wrong. I think people take it deeper than the bible means.

"The Family Protection Act makes smacking at school—or at home—illegal. Even at home, if your dad beats your mom, if your parents beat you, if your teacher beats you, even touches your body or says cruel things, that's a violation."

I wonder how Siu explained to the very religious elders in her family that she is working against domestic violence. "I tell them I want to do this to help youth make wise decisions. Teen pregnancy is very high. Sexual violence gets girls pregnant. I really think I should do something because no one is doing anything."

I ask whether children report abuse to the police. "They call me on the radio. They say I know them better than the police. And that older people don't even listen to them."

Last, Siu tells me something that will resonate with activists everywhere. "I wanted to take science but my family liked business, so I took that. I couldn't say, 'I am interested in this.' But now I can stand up for women even if I couldn't do it for myself at home." Personal experience often ignites the will to cause change.

"One of my teachers hit my friend on the head with a stapler for not doing her homework."

'IULA VI, 18

'IULA'S MOTHER ADOPTED HER WHEN SHE WAS TWO MONTHS OLD. She has an older brother and two younger sisters. "I am thankful for a family that accepts me as I am, even though I've made many huge mistakes. They still love and take care of me."

Like many Tongan youngsters, 'Iula knows about domestic violence from personal experience. "I have been hurt a lot when my parents or grandparents come home and things are not as they want them to be. I usually take the blame for it. They say harsh words and sometimes go overboard. I get offended and stay in my room and cry my heart out. That's the only way for me to solve the problem. When I'm done, that's it."

Abuse can also occur in class. 'Iula just transferred to a high school where "one of my teachers hit my friend on the head with a stapler for not doing her homework.

"But," 'Iula explains, "child abuse happens mainly in Tongan homes when the mom or dad comes home tired from work and nothing goes right. The kids get the blame and they get really hurt. Not just a little hurt. They usually end up in the hospital.

"They get hit with all sorts of stuff: sometimes the parent's hand, sometimes a wooden spoon, sometimes a big piece of wood or metal. It's really harsh, especially for younger kids. In Tonga, if you talk back to elders, it usually results in physical abuse."

This country mandates respect for older family members and patriarchy. The *Anga Fakatonga* protects "the Tonga way of culture" and is perpetuated by lawmakers, government, and the monarchy. The oldest man is the head of each family; he maintains complete control and makes all decisions.

Grandmothers are also held in high esteem, although they make no decisions. Respect for seniors is paramount. A child talking back, or violating an elder's directions and desires, is unthinkable.

So I'm surprised to hear 'Iula say, "My grandpa has a soft heart for his grandchildren. He's always giving me advice, telling me how I should be a role model for my younger sisters.

"To me," 'Iula continues, "that means I should try to be perfect, show them what's right and what's wrong. It's quite a challenge. They are 14 and 16. They keep asking the same questions every day, especially when it comes to boys. We'll have a good laugh about it, but I like sharing with them. It brightens up their faces, and they know more.

"I usually tell them I look for guys who don't smoke and drink. I say, 'Look for a guy who respects you for who you are—not just for your clothes and how you look, but for your personality and attitude. And look for a guy who treats his mom perfect; he will treat you the same.'"

'Iula first became involved with Talitha through its camp, Eliminating Violence Against Young Girls. "It's for girls ages 10 to 18, and it was really fun. You get to meet a lot of girls. The stories you hear from 10-year-old girls who are really scared about violence! Girls really got to speak up, without brothers or parents at their sides.

"There were activities like 'My Body: How It Grows as the Years Go By.' We learned about all kinds of abuse: child abuse, cyberbullying, plus sexual, emotional, financial, and physical abuse."

I ask 'Iula to tell me about cyberbullying. "Half your brain says, she's talking about me, but the other half says, maybe she's not. It makes me very insecure, especially when the comments are public. Man, those comments. You just wish you died instantly. I wouldn't want that to happen to my kids or my siblings!"

I wonder how she responds to cyberbullies. "I just forgive and forget. Only God can judge me, not them. If I respect others, it will decrease their jealousy, their hating hearts and minds."

OPPOSITE: **Siu prepares to host Talitha's weekly call-in show by reading** *The Economist.*

"There is no sex education in school in Tonga."

SARAH HELETA, 13

SOME OF THE GIRLS I interview for this book try to snow me. Sarah tries to teach me. She is direct and a truth teller. I learn a lot.

The most astonishing thing she reports is: "There is no sex education in school in Tonga." My first reaction is, "Don't parents tell kids? No? Nobody does? Girls who get their first periods must be terrified!"

Then I reflect: 30% of the schools here are run by the Free Methodist church. Most others are parochial schools of various denominations. Menstruation is the gateway to sexual maturity and many people here believe that sex is a sin.

Apparently reproductive rights and responsibilities are not a consideration. Schools and parents expect NGOs like the Talitha Project to educate their daughters about human biology.

Sarah worries about "girls getting pregnant at a young age, even 12! Their mothers should talk to them about their bodies so the kids can understand. The mothers don't care maybe? They think the kids already know about these things? But they don't, so they go out and get pregnant."

Talitha girls are peer counselors. I ask whether Sarah discusses these issues with her friends. "Yes. Some are disgusted."

Sarah feels strongly about other issues, too. She recently wrote a paper about Susan B. Anthony for a school assignment that required researching a revolutionary, someone who had changed the world. When I ask whether Sarah would like to be a revolutionary herself, she smiles, "Yes."

Another issue that's important to her: "Voting. Women's vote is as important as men's." Tongan women got the vote in 1951 but their political engagement is minimal.

Most seats in Parliament are occupied by nobles (the King's relatives) or by men appointed by the King. Of the 33 seats reserved for Peoples Representatives, 23 are reserved for men. Since women represent half the population, you might think (all things being equal) that women would hold at least five seats of the remaining 10 seats. Wrong.

In 2014, 16 educated, qualified women candidates ran for those ten seats but none won. Sarah's mom Vanessa made a documentary film, *Women's Leadership in Crisis.* Sarah reports, "Mom says, 'Women are not voting for women.'"

Sarah also worries that Tonga has not passed the U.N. Convention to Eliminate All Forms of Discrimination Against Women (CEDAW). Five other countries haven't either: the USA, Sudan, Iran, Somalia, and Palau refuse to approve what many (including me) consider the international bill of rights for women.

In March, Tonga's Prime Minister announced a preliminary decision to ratify the convention "with reservations." It's now June, and nothing further has happened. Who knows when Parliament will vote, if ever?

I ask Sarah what she thinks would help CEDAW pass. "Tell girls not to marry girls. Evangelical Christians oppose CEDAW because they fear it will encourage same-sex marriage, even though there is no mention of same-sex marriage in the Convention." I ask whether there are LGBT people in Tonga. "There are boys who act like girls. *Fakaleitis* are accepted."

Everything about Tonga surprises me.

IT IS TONGAN INDEPENDENCE DAY so Vanessa and her friend, Sipola Halafihi give me a tour of this beautiful South Pacific island, Tongatupu.

Each village has a cemetery, five or six churches, a roadside stand where products are visible behind a wire grid, plantations of papaya, coconuts and bananas—and fields of root vegetables.

OPPOSITE AND OVERLEAF: Talitha's on-air hosts take texts, emails, and cell phone calls from teens who live throughout the Tonga archipelago.

We watch "fishing pigs" snuffling mussels from the bay where Captain Cook landed. We see a huge trilithon that ancients used to mark the longest and shortest days of the year.

We marvel at terraced blowholes. Sipola promises me that if I yell, the stones will spurt water in response. I yell. No spurt. Must not have yelled loud enough.

Men and women wearing *tapa* aprons walk to evening church services. Sipola tells me what convinced early Tongans to convert to Christianity.

"To prove their God was real, missionaries said they would put a man in the ocean and no sharks would bite him. No sharks bit him."

Vanessa has tickets for a Tongan cultural show. A young girl dances, slathered with coconut oil. Siu told me about this: "The 'perfect girls'—virgins—do a traditional dance called *tau'olunga*, in which they show how valuable they are. The girl wears oil all over her body. If the oil doesn't absorb into her skin, she is a virgin. If it absorbs, she is not a virgin." This dancer is as slick as can be.

The final act of the show is exciting and scary: a fire dance. Ultimately, the fire dancers become fire-eaters. Astonishing.

"Bullies don't know me. What they're saying has nothing to do with me."

KATENI "LANI" KAVA, 14

LANI RECENTLY RETURNED FROM A CHURCH-SPONSORED TRIP TO STOP BULLYING. She had never before been off the island of Tongatapu, where 70% of Tonga's population lives. She and her companions educated kids in the outer islands about bullying.

"The first time I was bullied, I had a bad reaction," Lani remembers. "Because I was raised by my brother, I was boyish. I would hit the person. I am strong headed.

"But then I decided to talk about it. Cope with it. I don't let it get to me. Some people don't understand what words can do. Sometimes people don't mean what they say. I decided to ignore it. To just let it be, not let it get to me. Bullies don't know me. What they're saying has nothing to do with me.

"My mom and my brother (who's 27) always tell me positive things so I know my identity. There's a mirror in our hallway and when I was young, we always looked into the mirror every morning and night and said a verse from the bible: 'We are fearfully and wonderfully made.'"

I ask Lani how she counsels other girls to deal with bullying. "Different ways. For example, break the silence. Talk about it. Tell people about the bullying that's happening around you or to you. Pray about the bully, even though he's mean to you. Always understand there might be a story behind why they're bullying. See things from their perspective. Back up your friends. Just say, 'It's ok, it doesn't really mean anything.'"

Except for school, girls here have little experience dealing with boys, much less boys who bully. "In our tradition, we normally don't mix with boys. Traditionally, you can't sleep under the same roof with your brothers. It's changing a little bit now. There are certain things girls wouldn't do that guys would. For example, guys are free to walk around town. Girls are not allowed to go out. We stay at home and help out mom and stuff.

"Sarah invited me to come to Talitha's camp last February. It was three days and two nights. There were maybe 20 girls, age 10 to 20.

"I learned lots of things. Camp taught us about our bodies, how the law protects us, how we could impact the world in a good way, and stop violence by not being a part of it, walking away and stuff. They told us we need to say something. It's not good to hold it in because the person who did something would keep on going and do it to other girls."

Lani is wearing her brother's Los Angeles Lakers jersey; I ask if she sometimes wears traditional clothing. "In our church we believe God doesn't care what we wear as long as we pray and worship him. We can do that by telling people about God. Change what can be changed for the better. Get people ready for when Jesus comes back."

When I ask Lani what else she wants me to know, she offers: "What's good about Tonga is that it's very united. Around the world, people are united even though we are different. That should be remembered."

Sarah and Lani conduct a Skype interview with Alex.

"I believe I should keep my body as a temple of God."

SIMUOKO AFEMUI, 17

SIMUOKO, SARAH, VANESSA, AND I chat over dinner at the Seaview Lodge, where I'm staying. The chef is European, the food delicious, dessert is flambé.

Simuoko lives across from the palace in a house that features a carwash in its front yard. Her five brothers run the business, but she takes care of customers when no one else is home. Her hobbies? "I love playing tennis, running, jogging, cycling."

Simuoko was one of Talitha's first members. "There were five or six girls when I joined Talitha. I learned about how I could protect myself against guys, not go around with guys I'd never met before. I belong to the Mormon Church and going out with strangers isn't allowed. Mom always talked to me about dating the right guy, not having any issues with him. I believe I should keep my body as a temple of God.

"I went to Talitha's camp. I thought it was great. They wanted us to be safe around strangers. They taught us about not texting people you've never met and not going out with men way older than you. That was new information."

I muse, "You have five brothers. How did they learn how to treat women?" Simuoko says, "We have discussions at home, but it's mostly about me, not my brothers. Boys can mostly do what they like."

I ask Simouko, "Would it be possible to convince schools to teach these subjects?" She nods, "I think it should be. It would change teenagers' lives for the better."

TWO WEEKS FROM NOW, King George Tupou VI will be crowned. The Tupou dynasty, which began in 1845, is the longest uninterrupted family dynasty in the world.

This King has actually reigned since his brother died in 2012. Tonga is not a rich country (GDP is $4,400 U.S. per capita) so it has taken three years to accumulate enough to fund an appropriate celebration.

Heads of state from all over the world are expected to attend. The coronation is so important that the United States Embassy in Fiji celebrated U.S. Independence a month early so American officials could be in Tonga on July 4, coronation day.

Expats will return for the celebration. About 106,000 citizens reside on the 176 islands in the Tonga archipelago, but many other Tongans live in New Zealand, Australia and the United States.

Locals are honored by invitations to participate in the coronation personally. The Seaview Hotel chef and his staff will cater dinner at the palace. Civic groups have been practicing for months to perform traditional music and dances. People are gardening and painting their houses. The excitement is infectious.

"He said, 'Women do not matter.'"

SUPI HALAFIHI, 15

"WE WERE JUST DOING A TRADITIONAL DANCE rehearsal for the coronation. It's called a *lakalaka*."

What Supi doesn't say is that in 2003 UNESCO named the *lakalaka* as a "masterpiece of oral and intangible heritage of humanity." *Lakalaka* chronicles the history and traditions of the Tongan people, and celebrates the fact that, unlike all other Pacific Islands, Tonga has never been colonized. These performances of poetry, music, and movement may last 40 minutes and feature 100 people or more, all wearing traditional costumes.

Supi continues, "In Tongan tradition, boys and girls were not supposed to dance together. Somehow, as time went on, that changed. We are going to dance together at the coronation."

Next, Supi talks about a practice that no one else has discussed in any country I have visited: some families in Tonga rent their teen-aged daughters out for sexual relationships.

"My friend's parents want this guy for her, and are trying to pressure her into it. She's underage. Probably this rich guy will give them money. She's a pretty girl."

I ask, "The parents want her to marry him?" "No, just have a relationship with him. It happens in Tonga. I told my friend, 'It's not hard to say no, even though you're afraid to.' She has talked it out with her parents."

I try to reconcile this practice with what I know about Tonga as a profoundly Christian country with a tradition of celebrating virgins whose skin doesn't absorb oil.

Our conversation turns to Supi's concern about domestic violence. "One of my friends was violated by her father. When I went to Talitha's camp, I learned what to do to help her.

"My friend always thought of herself as nothing. She and I talked about how important women are to society and the family. I explained to her that life is a gift from God, especially for us women. I told her I believed in myself and making change so she could use me. I helped her say 'No!' That's especially important for women in this culture."

Thinking about Supi's friend whose father raped her, I ask, "Do children respect parents to the point of doing anything they ask?" Supi says, "Yes, it's a must. That's the culture. You have no choice.

"After I talked to my friend," Supi continues, "I kept on calling her. She had to stand up to her father. I think I helped her a lot."

Like Sarah, Supi is passionate about getting Tonga to ratify CEDAW. She tells me how she advocated for it at Tonga High School, which she attends.

"Every Friday morning we have religious instruction. A pastor from the Assembly of God came to preach to us. Instead of preaching, he said, 'If you believe CEDAW is a good thing, raise your hand. I know that none of us here believe in CEDAW or want to accept it.'

"Everyone was shocked when I put my hand up. He was looking away and everyone was giving me the evil eye. In our school, you're not supposed to go talk to the person, but he couldn't hear me. So I walked to the front. I wanted to share to the whole school, so I picked up the microphone and said, 'I don't believe CEDAW is that bad. Have you read it?'

'No.'

'So you're judging the book by its cover?'

'I am not judging.'

'You are. You don't know it but you are judging it.'

"He was enraged. He said I am a naughty, bad girl talking to him in that tone.

"He said, 'Why do you believe in CEDAW?'

"I said, 'Only 5% of CEDAW runs against our religion; 95% would be good for us women.'

"He said, 'Women do not matter.'

"I'm like, 'You're saying women do not matter? We are all created by God. If there were no women, the role of the men would not be complete. Women were brought to the world to support men. I believe women can also be leaders.'

"He slammed the blackboard and said, 'Men were brought to be leaders, not women.' He kept on repeating that.

"I said, 'So it's time for us to make a change. Why do you think women can't lead?'

"'Because of our culture.'

"I said, 'You are preaching the word of God but you're saying it's the culture? Which side do you take? You have to make it clear.'

"He hated it so much when I was saying the truth. I was not scared to talk to him in that way."

Then Supi introduced property rights into the discussion. CEDAW guarantees women equal rights to own land. Tongan women can only lease land and, when couples get divorced, husbands keep the family property.

"I told him, 'It is mentioned in the bible that women should inherit land, not just men. You're

THIS PAGE, OPPOSITE, AND OVERLEAF: Talitha girls create posters to campaign against violence that targets girls and women. The South Pacific has one of the highest rates of domestic abuse in the world: 77%.

preaching the word of God. Do you know what you're saying?'

"And I said, 'If you had the light, you wouldn't be that angry. Everyone has a right to their own opinion or view. I am just saying mine.'

"He said, 'You have no right to say that to me.'

"I said, 'As far as I know, everybody has that right.'

"He was so mad he ended the session. Everybody was just silent. In Tongan tradition, it's not good to go against someone. But he asked! I don't see that I did a bad thing. I was just showing what I believe."

Coronation cleanup is underway in the district where I am staying. People are raking their yards and painting their fences.

Houses, stores, shipping containers, palm trees, stumps, construction sites, and traffic signals are all covered with homemade *tapa* cloth painted with unique designs. Yards are embellished with flags, lace curtains, and balloons. Gravesites are decorated with huge fake flowers, quilts, banners, pictures of Jesus, statues of gnomes, even Disney's Dopey. One fence is swathed with fabric and garnished with 20 Santa Claus figures.

Families are playing loud music and dancing in the streets, dressed to the nines so they look great when the royals come to inspect the eight-block area that is scheduled for review today.

Walking along the waterfront, I meet a group of children wearing *tapa* cloth skirts waiting to wave at Princess Latufuipeka Halaevalu Mata'aho Tuku'aho as she makes her rounds. The woman in charge of the boys and girls recommends, sternly, that I trade my pants for a skirt before the Princess arrives. While I am in the hotel changing, the Princess comes and goes.

Vanessa, Sipola, and I enjoy one last lunch at the Friends Café. As they drive me back to the hotel, Vanessa hears a woman's voice on a loud speaker far away. She drives quickly to the top of Mount Zion where the first Mormon Church was built in 1845. There, the Princess is addressing her people.

Vanessa and Sipola borrow clothes from women in nearby houses. Sipola pulls a long skirt over her short dress; Vanessa wraps *tapa* cloth over her orange tights.

Since I am not from the neighborhood, I am not supposed to be there at all. Trying to respect local tradition, I take pictures from behind the truck that ferried the royal throne; the truck bed billows with white balloons. Nobody knows I am there.

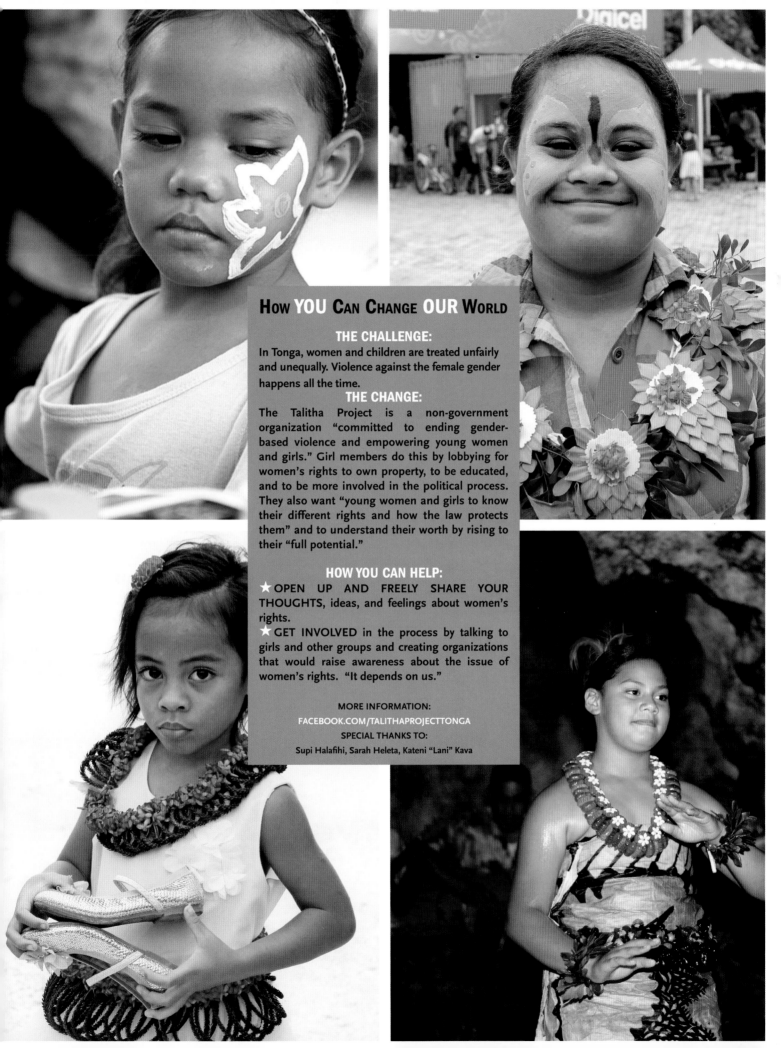

How YOU Can Change OUR World

THE CHALLENGE:

In Tonga, women and children are treated unfairly and unequally. Violence against the female gender happens all the time.

THE CHANGE:

The Talitha Project is a non-government organization "committed to ending gender-based violence and empowering young women and girls." Girl members do this by lobbying for women's rights to own property, to be educated, and to be more involved in the political process. They also want "young women and girls to know their different rights and how the law protects them" and to understand their worth by rising to their "full potential."

HOW YOU CAN HELP:

★ OPEN UP AND FREELY SHARE YOUR THOUGHTS, ideas, and feelings about women's rights.

★ GET INVOLVED in the process by talking to girls and other groups and creating organizations that would raise awareness about the issue of women's rights. "It depends on us."

MORE INFORMATION:
FACEBOOK.COM/TALITHAPROJECTTONGA
SPECIAL THANKS TO:
Supi Halafihi, Sarah Heleta, Kateni "Lani" Kava

MOBILIZING COMMUNITIES

Kenya

WE WALK INTO NAIROBI'S Mukuru kwa Reuben slum. Boom boxes blare. The streets are slick with sewage. Veronica Thamaini, head of Akili Dada's Young Changemakers program, holds my hand so I won't slip. Claris Oyunga, 17, totes my equipment.

I am uniquely white and visible. I feel eyes following me. Veronica explains that "the Kibera slum has many Caucasians working for NGOs, but Mukuru does not."

Veronica has anticipated that I carry expensive cameras, and has hired security guards to accompany us on the 30-minute walk to Claris's project. Four men carrying AK-47's surround us. I have worked in slums all over the world without protection; AK-47's underscore the risk here. Trying to relax, I ask one man, "When did you learn to use that gun?" He glowers. Chatting is not protocol.

It seems foolhardy to flaunt my big, black camera, so I sneak shots with my iPhone, then hide it in my armpit, and keep walking. Snap. Snap. Hope the image resolution will be good enough for publication. Snap. Snap. Keep walking.

"There used to be 300 children and the library could only accommodate 50."

NADINI CLARIS OYUNGA, 17
CLARIS GREW UP IN MUKURU, one of four children. When she was ten, she collected bits of metal and plastic off the ground to sell. I kid her, "We call that recycling." She laughs, "We call it *kuchemba*. I didn't do it to clean the place. I was doing it to get cash. You just get things, sell, get money, and buy a sweet or something."

"Basically," she says, "this area is a good place to live. It taught me to survive. We have thieves, but they do their work at night most of

the time. At least we have peace. The people are very cooperative. The students have a passion for education."

Claris does, too. She left her house at 5:50 AM to reach Gatoto Primary School on time. "We would meet friends at a central place and go to school together so we had some protection. We have security centers on the other side, so you can go there if something happens. It wasn't that safe but God was protecting us."

On her secondary school entrance exams, "I got 369 marks out of 500," Claris remembers proudly. That score and a good interview earned her a high school scholarship from Akili Dada (Kiswahili for "Brainy Sister").

Claris is about to start her junior year at Precious Blood Riruta, a competitive national girls' boarding school in Nairobi. "I know I'll get an A. Then I'll get a PhD in mechanical engineering." (Veronica confides that Claris used to introduce herself as "Claris, Mechanical Engineer" and I'm about to find out why.)

"I've forever liked vehicles, just being around cars. I want to major in vehicles, focusing on motors, making cars. Nairobi has an assembly

OPPOSITE: Akili Dada's scholarship winners like Cynthia Muhonja pledge to become Young Changemakers who mobilize people in their home communities to identify— and work together to solve—a local problem.

plant, General Motors Mombasa, the largest in East Africa. I'd like to empower women. If I can do mechanical engineering and I'm a woman, you can do anything." I am captivated by Claris' vision; "I hope all your dreams come true," I say. She nods, "They will."

When Akili Dada girls accept their scholarships, they commit to conducting a community service project during school breaks. Once home, they identify a local need and organize local people to address it. Akili Dada's Young Changemakers learn leadership—by leading.

Claris' project is a children's library. As a youngster, she learned how valuable books were, and how unavailable. "I was entrusted to keep the Teacher's Box. Here, most schools don't trust children with books so they collect all the books in the Teacher's Box at night and lock it."

Claris didn't own a textbook until she was in the eighth grade. Studying without books was not easy. "I went to the library but I didn't like the situation. It's on the other side of this area. If a mother can't even afford an exercise book, it makes sense that she doesn't have 20 shillings for bus fare. You can't expect a first grader to cross the railway. It isn't safe after 6:00. Most children reached the library by 6:30. There used to be more than 300 children and the library could only accommodate 50. So first come, first serve. Before you even get there, you have struggled. And then you don't even get space."

We are sitting on the couch in Claris' library, which is across a narrow alley from the New Light Learners Centre primary school. Children's voices chanting responses to a teacher's questions almost drown out our conversation. There's no electricity in this little room, but the sun shines through the doorway and, as Claris points out, "The library is only open during daylight hours."

There is no door, but Claris pushes a chair across the opening at night. "The chair is multi-tasking," she laughs. In addition to a couch and chair, there are a desk and bookcase.

"I started this library over the last holiday, in April," Claris reports. "People here know they can be on the same level with the rich only by education. Only education will move you from the slum. Nothing else. I thought, 'If I start a library in this area, I can support children's reading and communications skills, and build on their love of learning.'

"Why I chose this place is that I visited the New Light Learners Centre and found out that the teacher uses one book. The parents don't have money to buy books. Or workbooks: when pupils come, the teacher cuts paper and they use it for a whole week, then he cuts more paper.

"I thought, 'I can mobilize my friends to bring books.' So far, there are more than 300 books: textbooks for class, plus a few storybooks. Last holiday, I bought 150 exercise books. They were distributed to each pupil so at least they had something. We also gave paper for the nursery children so they can do coloring."

I study the three shelves that hold books for kids ages 3 to 14. Textbooks like *Our Lives Today* and *English Aid*. But also, a few titles like *Gulliver in Lilliput*.

Claris tells me, "I come back when I'm on break. I socialize with the kids. Mentor them. Talk to them and learn. I have come to realize that they like their stories. I think I will have to add more storybooks."

She recalls how hard it was to gain credibility when she started her project. She was a young girl, attending school elsewhere, and had no funding. Adults were skeptical; Claris was determined.

The next step was easy. "I wasn't challenged getting text books. People trust me and it was easy to convince them they should do a positive thing, impacting society.

"The main challenge is the cash part. Getting money to buy storybooks is basically my main challenge."

THE NEXT MORNING, Veronica and I set out in an Akili Dada car, arcing northwest toward Kisumu. On the outskirts of Nairobi the buildings are red, pink, chartreuse, Christmas green, bright blue, yellow. People walk along the highway on the Georgia-red earth.

Our car radio plays gospel music: "Jesus, precious name. Hallelujah. Amen." Then a solicitation: "You, too, can help keep Jesus on the airwaves." We pass the Bride of Messiah church. Four words on a truck mud flap read, "Glory Be To God."

Now, cultivated plots of corn and cabbage,

rolling hills, and eucalyptus trees. A roadside stall displays bright Maasai blankets. In the fields are goats, donkeys, cows, and sheep. It's 9:00 AM. Cue blinding sunshine, pine trees, mountains ahead.

We veer off the highway onto a rutted road that goes through Njabini village. Farmland. Open fields. We stop at a small house near the road. The air is pure. Birds sing. Otherwise, silence.

OPPOSITE: **Claris Oyunga grew up in the Mukuru kwa Reuben slum, where she has launched a children's library stocked with 300 textbooks.**

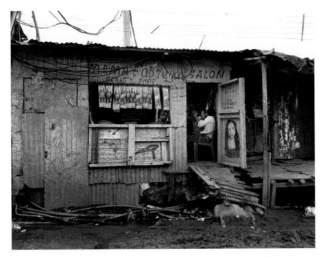

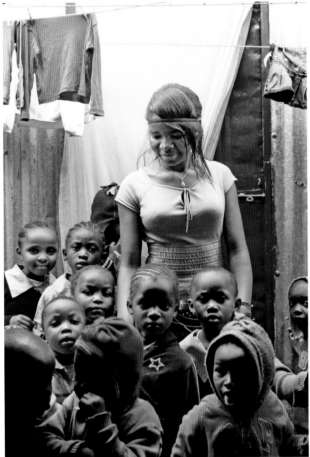

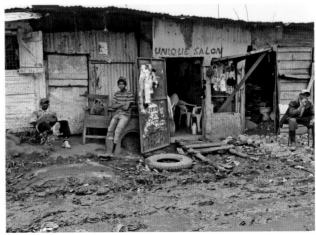

"What can I do with my own capability to help right now?"

HELLEN WAIRIMU, 18

LIKE ALL AKILI DADA GIRLS, Hellen attends one of four national schools in Nairobi. "Every girl wants to go. You have to work very hard and be among the top two or three in your county."

Veronica smiles, "Hellen's school is Kenya High School. People call it THE Kenya High School."

Helen remembers how she started her Changemaker project: "Before you start, you ask yourself some questions. 'How do I study the community to know there is a problem—a problem I can solve myself even though I am in school? How do I finance it? Is it a help to society?' I identified many needs. I had to think, 'What can I do with my own capability to help right now?'

"At my home, we have kale. People come and ask to buy it for 10 shillings. You think, '10 shillings (10 cents U.S.) for only one bunch—and you have a big family?' I asked Mom, 'Why don't people plant their own kale? This is a fertile area.'

"Then I realized they can't. They don't own land, they just rent stalls to live in." Ironically, to feed their families, farm workers must buy vegetables— even though they plant and harvest vegetables everyday."

Hellen now teaches people to do Sack Gardening, reusing the ubiquitous polypropylene bags that typically contain sugar, beans, flour, or feed. "I use a sack, put in manure and soil, and grow vegetables on top." It's an idea she found in a newspaper article and refined after consulting with her mother, who is a farmer.

Hellen's vegetables are meant to complement "*ugali,* the staple food here: maize flour mixed with boiling water. That's what most people can afford. They need green, leafy vegetables to go with it. If you grow kale, cowpeas, or onions, the only thing you're buying is maize flour and cooking oil. You can save your money for paraffin, school fees, school lunches..."

Hellen set up a demonstration Sack Garden before we arrived. As we talk, she cuts kale stalks with her *pango* (machete) and sticks them in the sack of dirt to take root.

I tell her that in my country kale is an expensive gourmet vegetable. Not here. Hellen says, "People here only eat carbohydrates. But kale provides vitamin K, which is important for young girls with growing bodies. It's nutritious, simple to grow, matures fast, and can be cooked many ways. Shred the leaves and fry them. Or cook them with steam."

When a family agrees to do Sack Gardening, Hellen negotiates landowner approval before she and her siblings and friends install sacks in his compound. Then she teaches participating families how to set up and maintain the sacks.

That's not the end of it, she reports, "I have to start afresh many times when I come for holidays. Their homes are not fenced, so the sheep come and eat everything. I once went to a home after two weeks and found everything had dried up. I had to tell them, 'Once I set it up, it's yours. It belongs to you.' I talk to the kids and tell them, 'Water it every day. When it dries up, go get other branches and plant them.'"

Hellen is always addressing challenges. "We have a problem about insects. I want people to set out many sacks, enough that they have vegetables to sell. Once you are able to sell, you will have enough money to buy insecticide."

Right now, only three families are doing Sack Gardening, but Hellen has ambitious expansion plans. She says, "I know things can come to reality."

Hellen's confidence grows from her success as a student activist. "We started with the election of Prefects (senior students who enforce discipline). Before, the teachers used to vet them and give us the names of the ones who were going to be Prefects. During a *baraza* (meeting), we told the teachers, 'We, the students, know whom we are living with. We know their character. You have to involve the students through elections.' Now we have a uniform way of electing Prefects across all schools in Nairobi."

When I ask what makes her proudest about her two years as an Akili Dada Changemaker, she says, "To stand out as a leader: to let people hear my voice, my views, my opinions."

Hellen, who is now in her final year of high school, plans to continue her Sack Garden project through her gap year until she starts university. But that's just the beginning. She also expects to mobilize the girls in her village to raise money for metal cans to put in school bathrooms for the disposal of sanitary napkins. She also wants to conduct a voter education project.

And she hopes to pressure members of Parliament to better serve their constituents. Squinting ruefully at the rutty road, Hellen observes, "This road is supposed to be repaired. We need to elect people who can put dreams into practice."

WE DRIVE THROUGH ROLLING, green farmland toward Ol' Kalou, the capital of Nyandarua County, where 47% of the population live below the poverty line. We arrive in the village of Thaba, expecting to hunt for the community library and its founder, Akili Dada scholar Leah Kibe. No need to hunt. A carefully lettered sign tells us that the library is downhill to the right.

Leah welcomes us into a mud brick building crowded with people. Old and young (including some of her relatives), sit on benches reading books. This is not a typical mid-day library rush. She has created a photo opp!

"It doesn't matter how old you are, you can definitely make a change in the whole world."

LEAH KIBE, 18

LEAH DOESN'T JUST ENJOY BOOKS, she writes them. "I thought if I could read, I could also write. I started writing novels, plays, and poems when I was 14. I write about my own life but I put it in fiction form. I try to make my books sound or seem like those I read. I particularly admire Ngugi Wa Thiong'o's writing; it is so authentic. I love writing, especially when I get emotional. I just write, write, write. That's how I get rid of my anger, and express my feelings."

Leah's father finished eighth grade, and her mother, sixth. Their ten children are all in school. Like Hellen, Leah attends (The!) Kenya High School. She grew up speaking Kikuyu but began learning English when she was eight. By the eighth grade, she was reading *Romeo and Juliet* and *The Merchant of Venice*.

Leah's library, which she started a year ago, includes 74 books, mostly fiction written in English for teenagers. A dozen locals, including her parents, comprise the committee she organized to run the library while she is at school in Nairobi.

She tells me, "The project started with my brother, who's in class 3 right now. He couldn't read at all. I thought of buying him a small storybook so he could start to read English. I could see that he was improving. I visited three schools and examined what kind of reading materials they had. They had very few. I thought buying books for the community would help people improve their English skills."

She got off to a rocky start. "The first fundraiser was a disappointment. We invited very many people from the government, from everywhere. They all promised to come. But only a few turned up. They did what they could: contributed some money, a few promised laptops, a few gave books. The people who came loved my project but the event was not a success."

Leah's family lives in a mud-brick house adjacent to a one-room chapel that was only used on Sunday mornings. Leah convinced the minister that his church could be her library the rest of the week. She installed a bookshelf. Pews provide seating.

"I got funds from CDF, Community Development Funds. They give money to people who want to do great things for their community. They gave me about 30,000 shillings ($30 US) for library books."

I tease Leah that in ten years, she might be receiving the Nobel Prize for literature. She looks at me gravely, "That could happen."

Then she tells me what she actually expects to be doing: "Probably I will be a pilot." I am surprised, "What?" "I want to travel the world and meet people everywhere. It's a passion." Inspired by "a book called *Air Bridge*, I realized flying is adventurous, and I love adventures. I will study at Nairobi Aviation College. I want to fly for Kenya Airways. From what I've seen in books, Australia seems like a great place. I want to fly there first."

On the way to the car, we walk through a plot of tree seedlings. It turns out that Leah is running a second, concurrent, Changemaker project. "Many

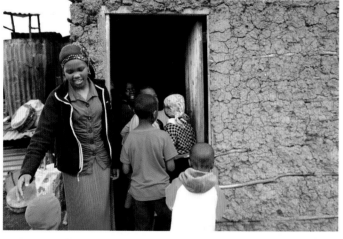

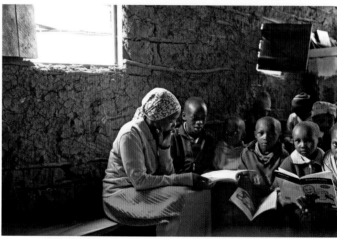

Leah Kibe writes fiction. She and the people of Thaba, her village in rural Kenya, started a library with 74 storybooks. She expects it will inspire children to love reading as much as she does.

trees have been cut in this area; we are working on reforestation."

I ask Leah if she is a feminist. "I think women should have leadership positions in companies and government. Men are all over the place. I want a

society where females are also allowed to lead."

Leah concludes, "It doesn't matter how old you are, which background or country you come from. You can definitely make a change in the society you are in, and in the whole world."

WE STAY OVERNIGHT IN NAKURU, a city of 300,000, at a new hotel in the Muslim section. I wake up as the *muezzin* calls people to prayer.

The Great Rift Valley abounds with cultivated land. This area seems more prosperous than

Leah's. A man, his bicycle prodigiously burdened by five jerry cans of water, pedals slowly along the highway. Another cyclist holds a hand mirror and sticks it out when he needs a view of the traffic behind him. Ingenious.

"When they see we are doing something great, they will apologize."

BRENDA JEMATIA, 17
BRENDA JEMATIA LIVES IN THE ELBURGON section of Molo. She, her mom, and three brothers only recently moved here. When Brenda promised Akili Dada to mobilize people in her community, she actually knew no one in Molo. Her solution: recruit an existing group.

She convinced 70 youth group members at St. Peter's to construct a shed as a chicken coop in the churchyard. About 20 young people now watch proudly as Brenda gives me a tour.

The place smells like fresh-cut wood. The floor of the coop is suspiciously immaculate: nary a feather or dropping. The hens and roosters are silent. I suspect that Brenda and her team moved 16 chickens into the coop about the same time we drove up—just as Leah organized neighbors to populate her library; just as Hellen set up a Sack Garden especially for me to photograph. The Akili Dada girls' initiative is impressive.

Brenda's project goals are ambitious: "Most of the youths in this club are between 15 and 21, free and idle. This project is to make them do things, generate income and become independent. The project will provide food, scholarships, and help reduce drug abuse and early pregnancy." To me, this sounds like a magic bullet disguised as a chicken coop. I invite her to tell me more.

"We had a meeting. I said, 'I want us to start a

community project. Can we keep chickens?' They said, 'That is a good idea because it will not take a lot of space. At the same time, getting building materials will be easy. You look for timber, metal sheets, wire mesh, and you come up with a chicken house.'

"In December, we started to build it, but didn't finish. In April, most of the members were not here but we still continued building. This time around, we finished, and I told them, 'We must get chickens and see our project moving on.' We agreed that each member of our group would contribute one chicken."

The roosters are starting to crow. I ask Brenda to describe her next steps. "You need fresh kale to feed the chickens and we have a patron with a farm that can provide that. You need water. Dry maize. Plus some commercial feed; each member will contribute 50 shillings (50 cents US) and we will choose a leader to buy feed."

"This school break ends soon," I note. "What do you expect will happen between September and your next break in December?" "Some of our members have finished secondary school; they will come take care of the chickens. The hens will lay eggs and hatch more chickens; the coop can hold 60. I think these 16 chickens will be sold. Each should bring between 600 and 1,000 shillings ($6 to $10 U.S.).

"What will you do with the money?" I ask. "We were thinking of planting a garden. Then we'd grow kale and sell it to raise money to feed the poor or sponsor a boy or girl from the local slum to go to school. Secondary school costs 7,000 shillings per year ($70 U.S.).

Brenda reflects on her experience running this project: "I am learning more that helps me cope

with the problems. The most difficult part has been lack of cooperation from the members. Maybe even though you are doing right, some people condemn you. I just said to the others, 'Let's move on. When they see we are doing something great, they will come and even apologize.' That has happened."

Brenda's project seems multi-layered and complex. I wonder, "How will you measure success?" "After a few years, by seeing what we have achieved—and not achieved—from the start. How much money have we made, how many students we have sponsored, how many youth are doing income-generating work. Our project is moving along. It will be bigger next year. It is going to be something great."

I ask what Brenda will be doing in ten years if all her dreams come true. "I will be first woman Governor of the Central Bank of Kenya." I salute her. "I hope that happens," I say. "It will," she assures me. "Hard work will make me reach there. And belief in myself."

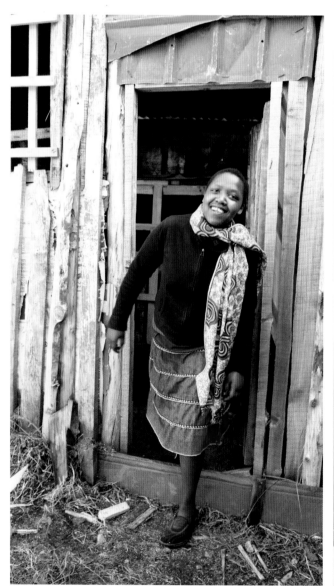

WE DRIVE ON TO KISUMU past sugarcane, round thatch-roofed huts, rice fields, even a saddled camel. Later, standing at my hotel window, I watch sun rays reaching through dark clouds to touch Lake Victoria.

ABOVE: Brenda Jematia's chicken coop project aims to provide local youth with scholarships and income. "It is going to be something great," she predicts.
OPPOSITE: Hellen Wairimu is teaching people who do not own land to farm nutritious vegetables in re-purposed polyurethane feedbags.

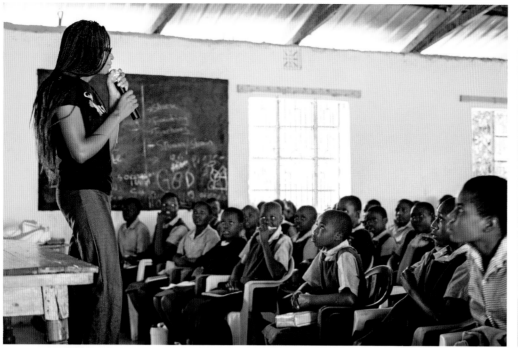

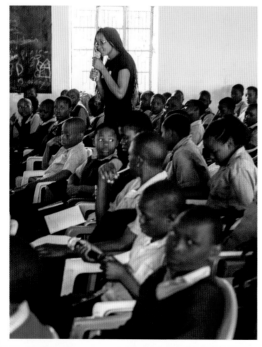

"If you really want to help, and love education, do something in Nandi."

CYNTHIA MUHONJA, 19

CYNTHIA MUHONJA, AN AKILI DADA SCHOLAR who has graduated from high school, will conduct a mentoring session today as part of her gap year community service project. Although she is a year older than the oldest girls in this book, I want to learn what Brainy Sisters do next.

When Veronica and I get to the village of Serem near the South Nandi Forest, the school where Cynthia plans to teach is quiet. Worrisomely quiet. Five girls meander in, not the 50 Cynthia expected.

Put yourself in Cynthia's shoes. Veronica, who supervises all the Akili Dada Changemaker projects in the country, has come to watch Cynthia in action. An American has traveled across the world to feature Cynthia in her book. And there are only five girls! Cynthia goes into high gear.

She calls the director of a nearby boarding school where many students remain on campus during vacation. She speaks on her cell phone in speedy Swahili. I can't understand her, but I can imagine her sales pitch: "It is Saturday. Your students have nothing to do. I can motivate them to stay in school and set goals that will change their lives. I can do that for free, starting in 30 minutes. All you have to do is round up the kids."

By the time we drive over, the school auditorium is packed with boys and girls. Cynthia dismisses those younger than seventh grade, and begins a "Dreaming" session.

OPPOSITE: Cynthia Muhonja mentors middle and high school students to stay in school and set life goals. Younger kids spy on the sessions, wishing they could participate.
OVERLEAF: Claris Oyunga celebrates books with the school children who use her library, which is next to the New Light Learners Centre in Mukuru.

"If you don't have a dream, you are aimless. What will you do with your 86,000 seconds a day?" Every child in the room names a dream career. Policeman, nurse, writer, lecturer, radio host, lawyer, engineer; the list goes on.

Cynthia encourages them: "You can raise your chances 80, 90, 100% by goal setting." The children write a description of their lives now and in the future, then define the goal that will help them bridge today and tomorrow.

A youngster from Nandi stands to share his goal: "Now that I have been to school, I know about electricity. I would like to bring electricity to my village."

Cynthia, whose own education was threatened time and again by a lack of money for school fees, invented a program, Life Lifters, to motivate youngsters to stay in school. "The main thing I'm trying to counter is dropping out. If they come to school next year, I have done my job. If the students say, 'I'm happy; I learned something,' I feel I can go to another school, and another, and do the same thing."

After she finishes University in Ghana, Cynthia hopes to "work for one of the biggest banks in the world. And I will be the unique lady who goes back to her community and holds the hand of that child who has lost hope, saying, 'You can make it!'

"I want Life Lifters to be a big organization. I want to challenge people to finish school and go back to their communities to do something—start a school, open a library—so when you die, you leave someone crying and saying, 'She's gone but she left something. I want, I really want, to be like her.'"

To Cynthia, even the readers of this book are potential converts. She wants you to know, "If you really want to help, and love education, do something in Nandi. It will be great."

Cynthia will fly back to Nairobi with Veronica and me to attend an Akili Dada leadership workshop. There are big doings at the airport. President Uhuru Kenyatta has been in Kisumu to close the annual music festival. His Kenya Air Force plane is parked at the gate next to ours and is scheduled to depart at the same time we do.

Traditional dancers sit, wearing outfits decorated with fur and feathers. Singers in red and green dresses wait to perform for him. The Japanese Ambassador is expecting to greet him. The head of the majority party flies in via helicopter. Using whisks, lackeys sweep the red carpet again and again. Cynthia has never flown before. I hope all her airport visits are this exciting!

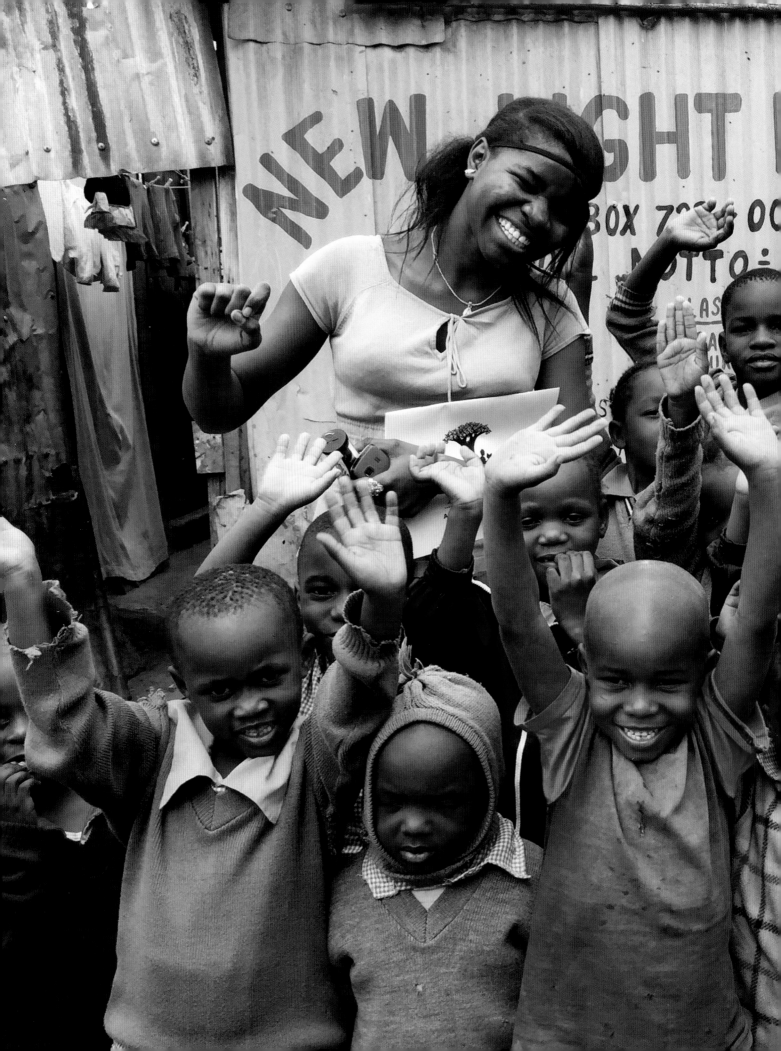

"Our contribution is teaching girls to own their own lives."

PURITY KAGWIRIA, EXECUTIVE DIRECTOR
CURRENTLY ON MATERNITY LEAVE, Purity welcomes Veronica and me to her home for tea. As we talk, her one-month-old son, Ari Ahadi Muchri, nurses, sleeps, and makes baby noises.

Purity was raised by her grandparents. She didn't think her family was poor until she was sent home so often to get school fees that she realized, "Eh! I think we are poor!" Her grandmother borrowed money to pay school fees, but before she could pay one loan off, more fees were due.

When Purity was accepted to university, "My grandmother was hysterical. It cost $50 but to her, that was $3 million. At the end of the service that Sunday, the pastor called me to the front. He said, 'This girl needs to go to school. I need 50 people to give $6 or $7.'" They did. Purity remembers, "I spent a lot of time at school being helped by my classmates. I shared a bed for three years. Half the time I didn't have food, but I was focused: 'Books before food.' I lived on bananas."

It seems to me that Purity is the perfect Executive Director for a nonprofit organization that awards scholarships to intelligent, needy girls. She is also a natural successor to Wanjiru Kamau-Rutenberg who founded Akili Dada to give back because she had gone to school on scholarship.

Akili Dada is a leadership incubator whose vision anticipates having "African women leaders actively participating in key decision-making processes across sectors." The NGO not only awards high school scholarships to exceptional girls aged 13–19, but also provides them with training and mentoring.

Since the NGO was founded in 2005, 99 girls have graduated from secondary school on Akili Dada scholarships and 52 more are currently attending high school. On school breaks, each one runs a community project like the ones I've just visited. In 2014, Young Changemaker projects impacted 20,000 people in communities across Kenya.

Purity says, "Part of our contribution is exposing girls early to a lot of information and resources. Teaching them to own their lives. To know they can make their own decisions, not only in leadership but also in reproductive health. Or what they choose to study at university. Or who to marry. We want our girls to grow up knowing you don't have to marry someone because you got pregnant. You don't have to get pregnant because you can use contraception.

"Those little things add up, and in another couple of years we'll have more women making independent decisions. Having aspirations. Knowing they can be what they want to be. Our work is halfway done."

ABOVE: **Leah Kibe and her parents play traditional instruments to entertain the children who have been reading in the library Leah launched in the church next to their house.**

How YOU Can Change OUR World

THE CHALLENGE:

In Kenya, women's voices were not being heard in government and other policy spaces. Decisions that directly affected women and girls were made by others. High and influential positions require strong education that women and girls from impoverished backgrounds usually can't afford.

THE CHANGE:

Akili Dada was founded in 2006 in order to enable "young African women to pursue educational and leadership opportunities" and "take their rightful places in society." They provide the scholarships and leadership experiences that give young women in poverty the skills to become change makers.

HOW YOU CAN HELP:

★ DONATE. You can give with peace of mind through One World Children's Fund. Checks should be made out to "One World Children's Fund" with "Akili Dada" in the memo line and mailed to:
Akili Dada, C/O One World Children's Fund
1016 Lincoln Boulevard
San Francisco, CA 94129
★ Be aware that if adults want to donate, many employers will match charitable contributions so you get to double your donation!
★ Become a mentor and pay it forward. You will get access to exclusive announcements and events. Check out the website for more information.

MORE INFORMATION: WWW.AKILIDADA.ORG
SPECIAL THANKS TO: Veronica Thamaini and Purity Kagwiria

CHANGING POLICY

United States

THERE WOULD BE NO Day of the Girl in the United States if it weren't for School Girls Unite, an organization run by girls who live near Washington, D.C.

When SGU members learned that Canadian high school students were working with their government to convince the United Nations to establish an International Day of the Girl Child, they launched a similar initiative in the U.S.

They invited members of Girls For A Change to collaborate, and began snail mailing, texting and emailing elected officials all over the country. Mayors of cities, commissioners of counties, and governors of states declared October 11 as The Day of the Girl.

But the SGU girls dreamed of negotiating a proclamation for the entire country. They sent a formal request to President Barack Obama à la the Declaration of Independence and signed in ink by members. Their appeal ended, "It's time to show the world that our nation stands for girls' rights everywhere."

Seventh grader Frederique Keumeni was one of the signatories.

"Feminism is wanting boys and girls to be equal and have the same opportunities..."

FREDERIQUE KEUMENI, 14
"WE HAD BEEN EMAILING during the government shutdown in October 2013. We had to email and email and email with Avra Siegel, Deputy Director of The White House Council on Women and Girls.

"She did a lot of work because during a government shutdown it's hard to get stuff done. She sent the proclamation through the next person and the next person and the next person and it finally got to the President and he signed it. We were ecstatic.

OPPOSITE: School Girls Unite members in Maryland coordinate a visit to Washington D.C. to convince elected officials to vote for U.S. policies that support girls' education worldwide.

"She invited us to the White House to receive the signed proclamation from the Council on Women and Girls. About a dozen of us went. I wore a blue dress. I wanted to look fancy; we all did. The Principal of Hammond Middle School and Robyn Page, our teacher, went with us.

"We toured the White House first and then received the signed proclamation from the Council. That was the most fun I've had with School Girls Unite!"

Frederique was born in Cameroon and moved to the U.S. when she was three. "My father came here first to earn money to bring us. He is a software engineer. In this country, he had to do some pretty odd jobs: construction worker; door-to-door salesperson." Frederique, her parents, and four siblings now live in Maryland.

Frederique joined School Girls Unite because she was a feminist. "I think people really get feminism mixed up. The word has been twisted so much. People just think of overpowering women who want to be more important than men. They think feminists want girls to be higher up than boys."

"Many feminists try to call themselves 'equalists.' That's basically what feminism is. It's like wanting boys and girls to be equal and have the same opportunities as each other and to basically have a fair shot at life.

"School Girls Unite appealed to me because it actually does something about it. You can say you're feminist and sit there not doing anything, but I wanted to be an active feminist."

And she is.

"This year we did a Day of the Girl rally. It was cool. We went to a park and made posters and signs. We wrote facts about girls all around the world. As people walked by, they'd read them and we'd direct them to the next point on the circuit. It was odd at first: people kept thinking we were holding up homeless signs! But I think it was pretty successful. We heard their responses, and they were like, 'Wow, I didn't know that!'"

School Girls Unite not only advocates for universal girls' education, it puts its money where its mouth is, raising scholarship funds to send girls to school in Mali, a West African country that ranks 178 of 182 on the UNDP Human Development Index.

School Girls Unite's partner organization is Les Filles Unies Pour L'Education (Girls United for Education) based in Mali's capital, Bamako. Girls in SGU and Les Filles connect via Skype with the help of a translator.

Their relationship is reciprocal: Malian girls learn academics in school; American girls learn how girls live in the developing world—knowledge that animates their meetings with U.S. policymakers, and enriches their efforts to educate the public.

The combination of advocacy and action is what attracted Giovanna Guarnieri to join (and later help perpetuate) School Girls Unite.

ABOVE: Frederique Keumeni and Gigi Guarnieri, like all SGU members, raise scholarship funds for high school girls in Mali and, in exchange, learn about barriers to education in developing countries.

"To make change, you have to be educated and aware."

GIOVANNA "GIGI" GUARNIERI, 17

"THIS STARTED IT ALL FOR ME: in the seventh grade, I did a school project on the first women's rights convention in the US, the Seneca Falls Convention. Elizabeth Cady Stanton, Lucretia Mott, other women and a few men signed The Declaration of Rights and Sentiments. In the mid-1800s, there was social stigma against those who viewed women as equal and thought they should have the right to vote.

"After completing my project, I saw that there was a club at my school that advocated for girls' rights and sent girls to school in Mali. I remember at my first meeting, printing out the story of Kakenya, a girl who walked miles to get water every day. She didn't go to school. She wasn't treated the same as young boys in her community.

"Even as a seventh grader, I knew 'This isn't right. This shouldn't be going on.' I thought, 'If there's anything I can do, as a human being I have to do that.' It really got me going. It's helped shape who I am and what I value. It's really important to me.

"What did you do as a seventh grade SGU member?" I ask.

"I wrote letters to Congress. We educated ourselves and our community. We had a core group that created a game called *Global Equality Now,* a bunch of facts about girls' rights that would make people say, 'Wow!' We used facts like 'one in every three girls in the developing world gets married before age 18.' Of course, people said, 'Wow!'

"After we finished middle school, I was part of a team that started a SGU chapter at Reservoir High School. That was a big step for us. We named our group Global Equality Now, A Chapter of School Girls Unite. Yes, *Global Equality Now* was the title of our game, but it was also what we were really going for.

"To get members, I would tell people, 'Girls younger than me in Africa and other parts of the world are forced to drop out of school, have husbands who are in their 40s, have children, and do housework. They never have a chance to go to school or live their own lives. They have no choice. That's just horrible.'

"In addition to girl members, we have a few boys. It means a lot to us to have support from our male peers. They are our friends. They support our cause and attend events.

"Starting the high school group was like seventh grade again, in terms of spreading awareness of the issues. To make change, you have to be educated and aware. That's the first step to anything."

Gigi's SGU experience has led to deep civic engagement. "By now, I'm the student member of the County Human Rights Commission and I'm interning for the League of Women Voters and for the County Council. You get to see behind the scenes in local politics. It's really interesting and it means a lot to me."

IT'S JULY 16, 2015 and the U.S. Congress is considering momentous issues. Two days ago, the administration reached a nuclear agreement with Iran, which the Senate must approve if it is to go into effect. At the same time, a controversial education bill will come up for a vote in the House.

Even with all this, SGU girls secured appointments. Jessica Kerry tells me later, "Lindsay Allen and I sent a letter to Representative John Sarbanes. We drafted it together on Google Docs. I live in his district, so I had written him before and had the letter's format fresh in my mind. Our biggest challenge was not saying too much." Meetings were confirmed with two senators and two representatives.

Twenty School Girls Unite members travel from Maryland to Washington, D.C. on commuter trains. I join them now in the food court of Union Station where they pull Baskin-Robbins' ice cream chairs together for an organizing meeting.

Gigi and Lindsay Allen distribute "talking points" about universal girls' education. Each girl selects one or two arguments to present and defend. The girls remind each other that if the elected officials have to go vote, senior staff members will relay their opinions.

The girls divide into two teams, each of which will lobby one representative and one senator. They stand, form a circle, stack their hands in solidarity, give a shout, and set off for The Hill.

"Education opens your world to anything."

JULIA MOYER, 12

"WE LEFT THE TRAIN STATION and walked about 10 minutes to a huge building with many congressional offices. I was amazed at how big it was.
"We walked in, through security. Just security alone was big. Bigger than I thought. Amazing.

"We went up a bunch of stairs to Congressman John Sarbanes' office. He is a Democratic representative from Maryland. We took a picture with him. He went to vote, and we met with his Aide for Education and talked to her about everything we want her to discuss with him. We asked him to join the new International Basic Education Caucus.

"I delivered a petition that we wanted him to sign. We got his education aide to sign it, and got one more signature, which was great.

"I felt that was the most successful meeting of the day because the aide was so engaged, constantly looking at who was talking. To me, it looked like she, herself, thought education was a really great thing to be lobbying Congress about. She looked like she was definitely going to talk to John Sarbanes about it.

"I had heard about lobbying Congress, but I didn't know I could do it as a 12-year-old girl. I don't know anyone else who has been to talk to a congressman. It's an amazing opportunity. I look forward to talking about it in class. I don't know how other people would get to go, but they could join SGU and lobby with us!"

Walking to our next appointment, Julia describes what her School Girls Unite group did during one school week. "We made a video on fund-raising and another one about SGU itself. Everyone looked very engaged watching them. It was amazing.

"We showed videos about global education initiatives so people could see how many girls don't go to school. Everyone was shocked.

"At the end of that week we played the SGU game. It was like facts and statistics, and you answer questions. Just seeing everyone's face, they were so surprised! Especially about child marriage! They were like, 'Wow, I would be married that young? I'm in school right now. That would be really weird.' So it was really fun seeing how shocked they were.

"We did a one hour Walk Run around the school to raise money for the SGU scholarship fund. It represented the walk the girls in Mali do every day to get to school. Every single student in our school—there are 500—plus staff, walked around the school.

"We raised $600. A scholarship is $75 a year, so we earned eight scholarships!"

SGU girls love to talk about education, so I ask Julia if she agrees with the adage, "Educate a boy, educate one person. Educate a girl, she will change the world."

Julia ponders. "I agree with the part about the girl. A girl can educate her community and her kids, generation after generation, which changes everything.

"I don't totally agree with the part about the boy. A boy could work to educate everyone…and he might. Education for girls is a problem all of us should be concerned about.

"If I have an education, I think everyone else should have a chance. It opens your world to anything."

NEXT STOP: MARYLAND SENATOR Ben Cardin, a Democrat on the Senate Foreign Relations Committee who is deeply involved in the Iran nuclear debate. We meet with his legislative assistant.

I look around the conference table and marvel as these poised, racially diverse girls ages 12 to 18 mount articulate arguments for universal education. Few would suspect that girls who look so young could be so powerful.

One says, "The U.S. allocates $800 million a year for education all over the world. That amount would cover education in one *county* here. The budget for education where I live, Howard County, Maryland, is $700 million all by itself."

Senator Cardin's legislative assistant argues that more than money is needed to help girls in the developing world attend school. She says many intractable social and economic barriers must be removed: poverty must be eradicated, child marriage stopped, and gender equity established. For starters.

The girls listen carefully, then rebut her position, suggesting that she has the cart before the horse: they say that it is education that will end poverty, stop child marriage and kindle gender equality.

Later, Jessica Kerry debriefs me.

"Best was feeling like our voices mattered; like people were actually listening to us."

JESSICA KERRY, 16

I SAY ADMIRINGLY, "When you responded, you turned her arguments upside down. It was like watching karate!"

Jessica smiles. "As she was talking, I was looking at my talking points. One was, 'What will education do for the future?' I had made notes on it. Almost everything she said was on my list."

Jessica joined School Girls Unite when she was in seventh grade but there was no SGU chapter when she got to Hammond High School. She and her friend Emma Denlinger lobbied Emma's older sister to find a teacher sponsor and file the papers required to start a club. "She was incredibly helpful and we were very grateful."

"We changed our name to Global Equality Now, hoping to get guys to join. We have one guy member right now; last year we had two. It's everyone fighting for equality for everyone."

I ask what about SGU has been most fun for Jessica. "A lot of things! We did a summit at the Maryland Women's Heritage Center in Baltimore to celebrate Day of the Girl. There were SGU girls from other schools I'd never met before. We each did a page about a girl's situation today and what her future might look like after education changed her life. I liked that."

"What was most difficult about being part of SGU?" I ask. Jessica responds, "Feeling so overwhelmed by the problem. It's worldwide, and we're just helping girls in Mali—one country. Sometimes I feel like this will not ever get any better! But then, always, something works, like you go meet a senator."

"How did you feel about meeting in a senate office yesterday," I ask. "It was really cool! I've been to D.C. for various reasons but I'd never been there to talk to anyone. I just took Government, so it was putting all those things I learned into practice. I really enjoyed it. Best was working with all the other girls and feeling like our voices actually mattered, like those people were actually listening to us."

"In Middle School we sent a letter to President Obama, asking him to make October 11 the National Day of the Girl. We pestered him. We asked, since he has two daughters, how would he feel if they didn't get to go to school and were treated as inferiors?

"We sent letters to Sasha, Malia, and Michelle Obama. The letters weren't finished by the time our meeting was over, so I volunteered to type them during lunch one day, which meant I was the one who signed them. Michelle sent her response to me. It was, of course, a robo letter, but I still have it.

Yesterday, Jessica brought pens and printed follow-up letters to mail to the congressional staffers whom SGU visited. She asked the girls to sign in ink. "I thought it would mean more if we signed in handwriting."

ABOVE: **Having fun: Julia Moyer at the library and Jessica Kerry at her school.**
OVERLEAF: **School Girls Unite teams lobby U.S. senators and representatives after researching issues, securing appointments, and framing convincing arguments to defend education for all.**

"You can't always see the change, but it's happening."

LINDSAY MARIE ALLEN, 17

LINDSAY CARRIES HER CAMERA as we visit members of the Senate and the House. "I want to interview girls with the Capitol behind them. Even to shoot some video in the congressional meetings. I'm going to say, 'Don't mind me.'

Lindsay explains, "Filmmaking is my big drive. I have my own YouTube channel, just for fun stuff like fashion and beauty. I collect vintage cameras. The Newseum in Washington is a favorite place. I want to do broadcast journalism. I'd love to travel, see the world through my lens, and do documentaries. And I hope to open a charity for young film-makers who are not as fortunate.

"I've started researching advocacy filmmaking. I had no idea there was this type: fighting for a cause. It's a sub-category of photojournalism. It's what I'm doing for School Girls Unite.

"I'm working on a 10-minute documentary for SGU. It will also be in SGU's tool kit to help other people start chapters and advocate for girls' rights and education. Girls other places may not be able to get to D.C., but they can reach out to their law-makers via email or when they visit their home districts."

"The film is called *Proud, Powerful and Passionate.* I threw out the title idea to the other SGU members. We thought of 'proud' because the Mali girls are passionate and powerful, trying to get their rights. We want people to understand they are no different from us. Go them!

"Miss Lesko wanted a short trailer for the web-site. I decided to use the trailer as the introduction to the entire documentary. You want to keep watching. That's what I think all videos should do.

"I use music to catch younger girls. Music is a big communicator. At first I was using royalty-free music; it was like elevator music: boring! Miss Lesko put me in touch with some people who do Mali music. I want to integrate some music from America and some from Mali to show they're not any different from us."

I ask how Lindsay got involved in photography. "Gigi and I went to middle school together. When they started a School Girls Unite chapter in high school and were trying to get new members, they threw a camera in my hands…a little flip camera, nothing up to my standards. I even had to pull out my phone. But I said, 'I've got this.'

"At the end of tenth grade, we did a SGU summit with a bunch of chapters from all over Howard County. 'Bring your camera!' they said. I said, 'Got it!'

"Sometimes I sit in Chemistry and think, 'I'm so lucky to have this education. We have it, so why can't we help others get it.' Maybe I can make a difference here and change things somewhere else. You can't always see the change but it's happening, from little things to big things.

I ask Lindsay to reflect about her past two years with SGU. "What has been most fun?"

"To discover that I'm an activist. That I have a voice. To step out and use my voice. It's helped me build courage and fight for things."

Lindsay screens the trailer of her SGU documentary film for me. It opens with Diana Halikias standing at a podium proclaiming, "Girls are the future…"

"When we lobby, we have a strong, assertive voice you don't expect from high schoolers."

DIANA HALIKIAS, 17

"I WAS ONE OF THOSE GIRLS who was skeptical of feminism. I was—I won't say ignorant, but there were a lot of global issues I wasn't knowledgeable about.

"Julia Fine and I are neighbors. She told me, 'I'm President of this club you would really enjoy.'" (Julia entered CNN's essay contest and wrote about how SGU's work parallels Malala's. Malala Yousafzai, who judged the competition, gave Julia first prize.)

"The first time I went to an SGU meeting," Diana continues, "was May of my freshman year. We lobbied in May. I came out of my shell for the first time. Saying things to these powerful people was organic but I wasn't expecting that; I was really scared.

"We walked into the room with the legislative aides, and there was all this information pouring out of me. I didn't worry about how good it sounded because I felt so passionate. When we lobby, we have a strong assertive voice that you don't expect to come from high schoolers. All the research and work we do, everything comes together when we lobby. I'm proud of that.

"That year, I was on the Senate team, so I visited Cardin and Mikulski, the two Maryland senators. We visited Senator Collins from Maine. She's a Republican, kind of not our scene, but it was one of the most successful meetings we've ever had. Her aides were responsive, enthusiastic, genuinely interested. They were like, 'Come back and intern with us.' It was amazing when we least expected it.

"I fell in love with School Girls Unite's cause. I fell in love with the people this organization attracted, who really understood me. We connected on an intellectual level as well. After that, I became very informed.

"I love being a student. I love school. I don't think anyone should be deprived of it. Because I'm in STEM, I'm used to being the only girl in my class, a social disconnect. The situation in Mali is like that social disconnect—to the billionth power.

"First of all, you have to pay to go to school and your family is telling you it's not wise to go to school, it's wise to get married at 12. Most of us don't understand the intricacy or the personal issues in Mali. Not having sanitary products is a roadblock to going to school. To me, that is unimaginable.

"I became president of School Girls Unite. During my term, we worked on making the program a lot more personal for the Mali girls with scholarships. We made personalized journals for every girl in the program.

"We have an event every year for Day of the Girl. In 2013, we got local restaurants to donate food and we had 10 booths, each focused on a special issue. Mine was Women and STEM; another was Women in the Media. There were petitions you could sign on the spot. Girls performed songs about strong women. A spoken word poet read an incredible poem. We had really great speakers.

"We had way more people than we ever expected. The football team! At first, we thought they were there for the food. But they stayed and went to the booths and they were learning. It was a really proud moment, an amazing event.

"I passed down the president's title but I remain a very active member of the club at school, help throw events, recruit a lot. I tell incoming freshmen what we do is real. There are real results. We run a scholarship program. We learn about the issues. Everything we do has a positive effect. In high school in general, people are part of clubs that will look good on their transcripts. I talk about the fact that SGU is larger than that. It's a lifelong commitment to a cause.

"When Day of the Girl was emerging as an independent organization, I joined their action team. Many Day of the Girl leaders were with School Girls Unite when they were in high school; most are now in college. Day of the Girl has an active social media presence on Twitter and Facebook year-round. This year on October 11, we helped facilitate nine rallies around the country, each focusing on a specific local issue. It was great.

"It's a sad reality that today when we hear about a nonprofit that works abroad, we are immediately skeptical. We should be; the issues are complex.

"But School Girls Unite is unique because we really make an impact. This is far more than an activity for your résumé. It is a philosophy to live by, a cause to stay wedded to for the rest of your life."

OPPOSITE: **Lindsay Allen at home and Diana Halikias at a neighborhood cafe.**

TEN MEMBERS OF SCHOOL GIRLS UNITE are meeting this morning to begin writing an action guide that SGU will offer online, free, to girls across the country who want to lobby national leaders to increase financial support for universal education.

It's a muggy day in Maryland, but SGU co-founder/coordinator Wendy Schaetzel Lesko's home is full of colors so bright and lively that nobody feels loggy. As the girls work, Wendy and I talk.

"There is no minimum age for leadership."

WENDY SCHAETZEL LESKO, DIRECTOR

"**I WAS DEPRESSED** when the U.S. decided to go to war in Iraq. I just had to do something positive. If the world stopped spending on the military for just eight days, we could provide 12 years of free education to every child on the planet!"

Wendy, seven 12-year-old girls, and a handful of adult women (some from Mali) launched School Girls Unite in 2004. Today, it has over 200 members in ten middle and high schools throughout Maryland, and is poised to expand nationally.

Their work is much needed: globally, 31 million girls under age ten have never been to school. Education reduces HIV-AIDS, child marriage, and early pregnancies, and lifts families out of poverty, so SGU girls work hard to make schooling possible.

Congressman Chris Van Hollen acknowledges them: "School Girls Unite students are very persuasive with many members of Congress. The last increase of $200 million for international assistance (Education for All) was due to your efforts."

Because schooling ends for girls around the world when they are forced to marry young (28 girls become child brides every second), SGU girls delivered 100,000 letters to 100 senators, each package tied with a bow and accompanied by a hand-written note that encouraged them to consider the International Protecting Girls by Preventing Child Marriage Act.

Education is especially crucial to changing Mali's future, where 300,000 school-age girls are not enrolled, and only 15 out of 100 can read. For 12 years, SGU members in the U.S. have raised funds for Mali scholarships by doing everything from selling waffles from food trucks to asking people to guess the number of jellybeans in a jar.

SGU funds pay for tuition, tutors, books and school supplies. Their scholarships have sent 75 girls from five villages to high school. That's about 500 years of education.

Wendy knows from experience, "There is no minimum age for leadership."

P.S. The first U.S. Day of the Girl was celebrated on October 11, 2013.

OPPOSITE AND BELOW: School Girls Unite members brainstorm ideas for *The Activist Gameplan*, a guide that is now available free, on their website.

PAGES 112-114: The girls meet with Maryland's Democrat Congressman John Sarbanes and his Aide for Education, then present their case in Maryland Senator Barbara Mikulski's office.

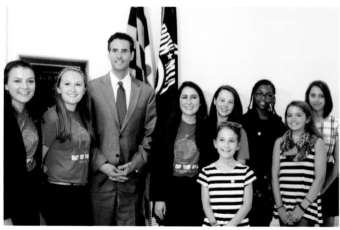

HOW YOU CAN CHANGE OUR WORLD

THE CHALLENGE:

Around the world, 60 million girls don't have access to education. In Mali, Africa, over 50% of the population does not have an education and "only 1 in 4 girls makes it to seventh grade... Even fewer make it to 8th grade." To make things worse, young girls are being married off very young, some as young as sixth grade.

THE CHANGE:

School Girls Unite, founded by a few empowered 12-year-old girls, was started to "push for education for all." They also believe that education is a necessary way "for girls to grow in ways that only they can imagine." They campaign for important girls' causes for example, education and ending child marriage. They created The Day of the Girl, October 11th. School Girls Unite believes education is "the best way to end poverty, improve global health, and bring about a more peaceful world." Who doesn't want that?!

HOW YOU CAN HELP:

★ DOWNLOAD *The Activist Gameplan* from the SGU website and put *your* passion into action.
★ DONATE. 100% supports scholarships for Mali girls. Select SGU as your charity on Amazon Smile.
★ SEND a snail mail to members of congress. Handwritten notes get attention. U.S. Representatives and Senators have letters on their walls, not emails.
★ Adults can help by LISTENING. They "need to wear invisible duct tape over their mouth and they need to grow a third ear." Kids are the present and in the driver's seat now.

MORE INFORMATION: SCHOOLGIRLSUNITE.ORG
SPECIAL THANKS TO: Julia Moyer, Wendy Schaetzel Lesko

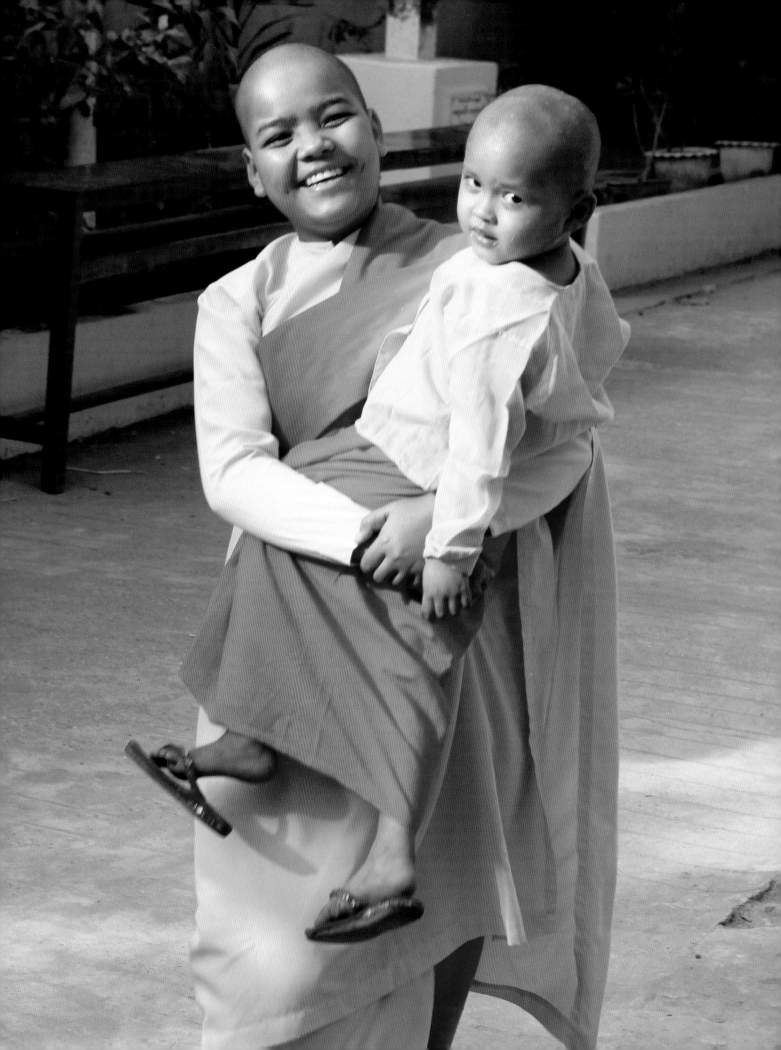

LEADING CHANGE

Myanmar

BROOKE ZOBRIST, FOUNDER OF Girl Determined, and I meet for dinner at a restaurant in Yangon where I am surprised to see a Christmas tree lavishly decorated with blinking lights and ornaments. "What is going on? Most people here are Buddhist, and Christmas was last month."

Brooke smiles, "People see Christmas and its adornments as a sign of modernity, something new and international."

It is January 2016. A new and modern future is underway in Myanmar. But it's also uncertain. Will the military, whose generals ruled for 50 years, yield to the civilians whose National League for Democracy triumphed in the election three months ago?

The NLD won a similar election in 1990, and the generals refused to relinquish power. Even now, the military remains influential; the Constitution reserves a quarter of the Parliament's seats for them.

It also prohibits the NLD's popular leader, Nobel Peace Prize winner Aung San Suu Kyi, from becoming President because she married an Englishman long ago.

Few women hold decision-making roles and those who do are subject to persistent ridicule and fear. One girl told me she wished the police would crack down on sex trafficking. When I offered to mention her suggestion in this book, she whispered, "I am afraid of trouble. A girl was just beaten to death." (It turns out that the girl's boyfriend killed her, but people here have reason to dread brutality from the authorities).

The mood in the country now is both anxious and hopeful. We discuss the many serious issues— ethnic tensions, poverty, inequality, inadequate education and health care—and I cross my fingers. The possibilities for real improvements are tantalizing; the chance that they might not happen is terrifying.

OPPOSITE: Nanda Wadi, a young Buddhist nun who belongs to Colorful Girls, intends to improve education and healthcare in her community in Shan State after she completes school.
RIGHT: Traditionally, girls in Myanmar are not supposed to play sports. The Colorful Girls are changing that.

"What was unimaginable a few years ago is now possible."

BROOKE ZOBRIST, FOUNDING DIRECTOR

BROOKE REFLECTS: "At this critical, historical juncture, girls have the opportunity to truly influence change. What was unimaginable a few years ago is now possible. Girls can speak out, meet with government officials, organize awareness-raising events, and ask openly for change."

Brooke, an American who speaks Burmese, worked for six years with migrant Burmese women at the border with Thailand. She co-founded the NGO, Girl Determined, in Burma in 2009, collaborating with Thazin Min, a member of the Karen ethnic group.

"No justice, law, recourse, or protection for girls exists here," Brooke explains. "We foster the skills girls need not only to avoid the incredible risks they face, but to effect long-term change that can impact generations."

Girl Determined's program, Colorful Girls, is a two-year, activity-based curriculum for 12 to 17-year-old girls of many ethnic and religious backgrounds. All participants live in poor communities in peri-urban and rural areas.

In 2009 and 2010, supported by small grants from grassroots grant-making groups and the Embassy of the United States-Rangoon, Brooke and

Thazin presented their program to monks who were running schools that focused on child-centered learning. Many greeted them skeptically: "What can a couple of spinsters teach our girls?" Some admitted to starting programs so they wouldn't have to teach girls about menstruation.

In 2009, Girl Determined ran Colorful Girls programs in two schools on the outskirts of Yangon. In 2016, 2,000 girls across the country participated in Colorful Girls Circles, which are conducted in local languages.

Brooke remembers, "At first, parents said, 'Girls only? So strange!' They expected their daughters to learn sewing." Instead, the girls learned about reproductive health and women's rights as well as communication, creativity, confidence, and critical thinking skills that will equip them for the tsunami of transformation underway.

"People are frantic with the rapid rate of change," Brooke says. "They moved straight past computers to smart phones. Thirty-three million people (out of a population of 53 million) have them, and everybody texts because there is almost no Wi-Fi and telephone calls are expensive."

She anticipates that the Internet may blindside girls. "They have no experience with news or pornography. It is a critical moment for Internet safety and security. I wish I could find a technology company to help us prepare them!"

I ask Brooke whether in this chapter, I should use "Burma" or "Myanmar," and she explains, "Experts identify the two words as synonyms that have been used interchangeably throughout history. Burma is more colloquial and Myanmar, more formal."

THE FIRST GIRL I AM TO INTERVIEW, who is 17, is teaching debate at a tutoring center on the outskirts of Yangon. Debate itself is a sign of the times. In an environment this repressive, holding an alternate view can be heretical and arguing to defend it can be life threatening. Schools teach by rote memorization. Critical thinking is activism.

My interpreter, Ei Ei Phyo Lwin and I discover that the tutoring center is accessible by a single road that is half-occluded by stalls on either side that sell tangerines, colorful plastic baskets, and clothing. People swarm the street, which has no

Phyu Nwe Win applies a natural cosmetic that girls and women make from *thanaka* wood and water, then wear as sunscreen.

sidewalks. They squash themselves between the stalls as one car drives through at a time, brushing merchandise as it goes.

We turn in, creep along to avoid children and shoppers, and halfway down the block, find ourselves hood-to-hood with a truck going the opposite direction. Local volunteers help us back out, yelling advice and beckoning. We hover on the highway until the truck comes out, then try again.

The tutoring center is an open roadside stall with all three walls stacked, floor-to-ceiling, with books. It has two desks with chairs and a mat-covered floor where students can sit. The only decoration is a photograph of Aung San Suu Kyi, and I assume that it means I am among friends.

Wrong.

A woman materializes the minute our car stops. I teeter on the curb, sandwiched between the car and its door, balancing my heavy equipment bag. She has blocked me in. "The director will not allow you in his center," she says. I may see myself as a benign grandmother, but obviously, that is not her view.

Although no one bothers to introduce themselves, we sit on the floor mats for almost 40 minutes discussing the situation. I say, "No problem! I will interview the girl at a tea shop down the street and photograph her in the market," but my offer assuages no one. They simply want me to leave.

Finally, the young girl standing nearby, who has been silent so far, gets the director. His fury surprises me, since I have read that it is bad form to show anger here. He speaks heatedly to my interpreter, "How *dare* you bring a foreigner here at this sensitive transitional time? My board members have seen the car and are very upset."

I apologize to the girl, saying that I had no intention of putting her in a difficult position; she responds calmly that I am welcome to talk with her at her home.

After we leave, I telephone Brooke, worrying that I have created a problem for Girl Determined. She laughs. "Sounds like the old Burma! Foreigners create suspicion. When I first came, a man on a motorcycle was paid to follow me every day just because I looked American. One morning, I stopped the car and asked if he would like to ride with me since we were going to the same place. He was nonplussed."

I now understand how edgy Myanmar is. Fortunately, this story has a happy ending. A few days later, I visit that young girl, Phyu, and her family.

"Don't accept criticisms. Believe in yourself, the work, the goal."

PHYU NWE WIN, 17

SHOES OFF AT THE DOOR; sit on the floor with soles facing behind you (it is disrespectful to point the bottoms of your feet toward others).

Phyu's home is welcoming, the exact opposite of the tutoring center. Her mother gives me a bag of peanuts as a present. Phyu shows me how to make the natural cosmetic that women and girls wear on their faces as sunscreen. She rubs a stick from a *thanaka* tree against a wet pumice stone, then spreads thin liquid on her cheeks and mine.

Phyu has three younger sisters, two of whom sit with us. Her best friend records our conversation on her smart phone so they can listen to the English later. Phyu's English is so good that she manages without much help from Ei Ei.

Because Myanmar students finish high school at age 16, Phyu is already attending university, majoring in physics. "Here," she says, "girls have to get higher scores than boys on university entrance exams if they want to study physics, technology, and medicine."

"Why is that?" I frown, suspecting discrimination. Her answer surprises me: "Universities want the same number of boys and girls. If boys had to get the same scores as girls, there would be fewer boys."

"Are girls smarter than boys?" I ask. "No," Phyu replies, "they work harder."

"Who has the power in this society," I ask, "men or women?" "The power is in men's hands, but it is changing a little. Girls are gaining power."

Phyu joined Colorful Girls when she was attending eighth grade at a monastery school. "Before that, I wanted to be a boy. I joined the activities and learned about gender. I learned to talk about my feelings. I chose to feel proud of being a girl."

Since there was no Colorful Girls Circle at her high school, Phyu attended Colorful Girls' Summer Camps over the next three years. One thing campers learn is how to conduct three-day social change

projects called Girl Led Campaigns.

"My campaign was about the chemicals used in food. People like to eat red bamboo shoots colored with dye. We wrote a pamphlet about the impact of food coloring and chemical preservatives. We put pamphlets in the sacks that are used to package fruit and vegetables. We also walked around and distributed the booklets.

"Unfortunately, the effect of the chemicals happens in the long term, so most people didn't care about this problem," she admits ruefully.

In addition to teaching debate as a volunteer at the tutoring center ("I love debate!"), Phyu teaches children age 5 to 12 who like books. "I love to read and I love to teach," she tells me. "I would like to be a university professor, and also open a school to give education free at the primary level."

Suspecting that she can teach us all something, I ask Phyu what message she would like to give the readers of this book. She offers four:

* "The meaning of the word 'smart' is to know one's self.

* "When we do work we believe in, sometimes we are criticized. Don't accept the criticisms. Believe in yourself, the work, and the goal; you can make a difference.

* "When someone asks you something and you don't know, don't have enough evidence, or are not sure, stay silent.

* "We all have a right to reach for opportunities."

"I want women to participate in every educational, economic, and political opportunity."

ZAR CHI WIN, 17

ZAR'S GIRL-LED CAMPAIGN knocks my socks off. It was inspired by riding buses that are jam-packed during rush hour. "Once a man behind me reached around and tried to touch my breast," Zar tells me. "I pushed him away, stomped on his foot, and glared at him. Most women are afraid to do that."

Zar knew that many women are molested. She decided to do something about it. "After we attended a Colorful Girls training, five of my friends and I organized at my school. We got 25 volunteers to help; five were boys.

"We went to the bus station, the market, and taxi stands, and gave out 300 whistles to women and girls. Our idea was that when men tried to touch them, they could make a loud noise to get everyone's attention.

"Our message was 'Stop abuse on public transportation.' We printed up a pamphlet. We also designed and made t-shirts and posters with that message.

"We had some trouble getting permission from the local authorities to put up posters. But we found an incoming NLD official who gave us approval.

"Another challenge was that people said, 'This kind of behavior is very common.' They couldn't imagine how it would be possible to change it.

"Some women supported us. Some even helped distribute the whistles. Some asked, 'You are doing this for women and girls, so why are boys involved in your work?'

"Boys and girls are not supposed to be together in our tradition. But I wanted to be inclusive and to let the public know that boys are also supporting this. And since the buses are very crowded, it is easier for boys to push their way onboard and talk about the campaign quickly.

"We had two forms of whistles. One was a key chain to be kept in women's purses. The other, worn like a necklace, was visible to men on the bus who knew that if they did something, the woman would blow the whistle loudly. We didn't expect that just wearing a whistle would make men stop, but it did."

Zar, who graduated from high school, is now working in a clothing factory where 1,000 women employees commute to work on public transportation. She wishes she had the time (and whistles) to repeat her campaign.

But she has a bigger dream, too: "In Parliament, there are very few women. I want women to be equal to men. I want women to participate in every education, economic, and political opportunity." Zar does not intend to become a politician but, like all the Colorful Girls I interview, she reveres Aung San Suu Kyi.

OPPOSITE: **Zar Chi Win's girl-led campaign stopped men from molesting women on crowded buses.**

SPORTS ARE A RADICAL ACTIVITY FOR GIRLS. To wear pants, run, laugh, and yell is simply not socially acceptable. There are no sports in schools. But today, sports are acceptable at a Colorful Girls event held on the grounds of a nunnery south of Yangon.

Standard Chartered Banks' GOAL program and Girl Determined have codeveloped a sports curriculum to teach financial literacy.

I watch as about 50 girls learn to keep money safe (guard the ball from players who want to steal it), invest money (make a goal and get points), and understand time management (race each other using different styles and paces).

Many skin tones and ethnicities are represented here. Most of these girls have learned from the Girl Determined module about discrimination, which teaches girls to read signals about different religions and cultures, and respect them.

The coach today is Phyu Phyu Thein, who was a member of the Myanmar national volleyball team. She taught volleyball for the Ministry of Sports, and now works for Girl Determined. She wears tights. Many Colorful Girls follow her example and are clad in leggings, slacks, and short skirts as opposed to the traditional *longhi* (sarong). One girl wears a Che Guevara t-shirt.

For two hours, I watch the girls play games with volleyballs. Then they race: first by duck walking, then galloping, then slaloming through a line of other girls.

They are uninhibited and free. I wish I could bottle the sounds as the girls learn how much fun it can be to compete and play, as opposed to acting quiet and shy. The courtyard of the nunnery has probably never before witnessed such exuberance.

"My dream is to teach about diversity."

THEINT THINZAR KYAW, 12

AGAIN, EI EI AND I DRIVE to the edge of Yangon, this time to a slum section where refugees from many ethnic groups live, having migrated to the city from other states.

A Colorful Girls Circle is just ending in the local school, a roadside shed built of sticks with a thatched roof. Without electricity, the interior is dim; tables with benches fill the long room. A few girls are finishing art projects.

The headmaster welcomes me and gives me a cup of tea. Neighborhood children surround me curiously: boys and girls, tots and teenagers. They ask questions in many languages, a cacophony. Ei Ei suggests that for privacy, we interview Theint inside our car. Perhaps 30 children press their noses to the windows as we talk. Even Thient's mother holds her new baby up to the glass for a glimpse.

Theint tells me, "I joined Colorful Girls this year because I heard that the organization talked about girls' issues. So far, the lesson I liked most was about menstruation; it taught me that periods are normal and natural." This is an unusual view. Many girls, who have been taught nothing about their bodies,

fear they are dying when their periods begin.

Theint then makes a fascinating connection between menstruation and patriarchy. "Mostly, only men can be leaders in Myanmar. In previous times, men went out to find food and were attacked by lions; they bled. When women had periods, men were very surprised that they didn't die from loss of blood. In ancient times, the men didn't want women's blood to get on the pagodas, so women were not allowed in the inner sanctuaries."

"Do you think a woman could run this country today?" I ask. "Of course," Theint responds. "Aung San Suu Kyi can run this country if she gets a chance."

I ask whether Theint expects to have an equal relationship with her husband when she marries. "If not, I will try to make it equal."

"And if you have a son, how will you teach him to treat girls as equals?" I ask. "My Dad taught me with stories. I think I will teach my son by telling him stories.

"My dream is to teach about diversity," Theint offers. To have such a dream in a country long riddled by ethnic violence, seems daring. To capitalize on her experience living in this community with people of so many different traditions is visionary. Leadership, I think, starts with imagining such a possibility.

Before we leave, the headmaster asks me to take a photograph of him standing under an Aung San Suu Kyi campaign banner that stretches the length of the school. It is so long that I have to change lenses and cross the street to fit it into one shot.

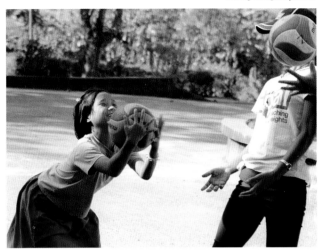

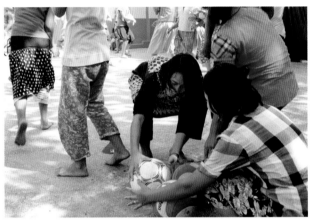

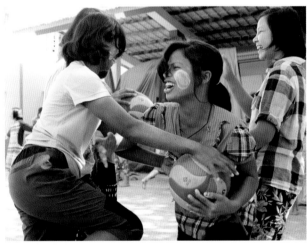

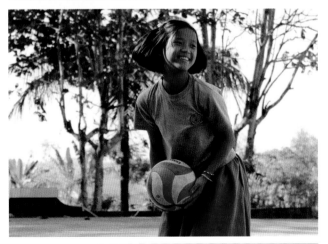

I INTERVIEW TWO GIRLS at a monastery school in the countryside. They are best friends. Both belong to the Palaung ethnic group and use the honorific, *Lway,* which means "Miss." They grew up in the same village in Shan State and love to sing pop music. Both are concerned about social issues and hope to do something about them. Awareness is the precursor of activism.

PRIOR PAGE. OPPOSITE AND OVERLEAF: Colorful Girls spend a day with coaches competing in races and ball sports that teach financial literacy.

"Poverty should be stopped. Then trafficking will stop."

LWAY KYI KYI KHAING, 14

KYI KYI EXPLAINS, "My mother died when I was a little girl; and my father left to work in another community. I haven't seen him since; I hear he died. Two years ago, my uncle brought me here to continue my education."

I ask Kyi Kyi what has been most fun for her about Colorful Girls. "Last year, we did role-playing. They asked us who wanted to be daughters and sons; everybody raised their hands. Nobody wanted to be the mother. I stood and said, 'OK, I will.' I was happy to play that role."

"Thinking about all the problems girls have in Myanmar, what is the most serious one?" I ask. "Girls are trafficked. Sold. I lived for a while with a family that sold their niece. That happens often in my village. Many are very poor. Some move to China to find jobs. Some sell family members. Poverty is the problem. Poverty should be stopped. Then trafficking will stop."

She also worries about domestic violence. "The headman in my village and his wife were fighting. He ran after her with a knife. I would like to have told him, 'Don't do this; it is very awful.' Domestic violence is happening because of men. If we can train them, we can end violence against women."

Kyi Kyi, now in the eighth grade, has dropped out of Colorful Girls to study for the government's high school entrance exam in July. "I want to finish high school and go to university. After that, I want to do things for children like me. I want to go back to my home village and be a teacher."

"I teach the little girls that it is nothing to be afraid of."

LWAY CHAW KALYAO, 15

CHAW IS IN THE SIXTH GRADE. "I am an only child. My parents were divorced when I was little. My father remarried; my mother has a son with another man. One of the villagers brought me here to continue my education.

"I joined Colorful Girls because it talks about the human body and domestic violence.

"There is a house near here. The youngest child is a boy. Every day, the little one has to collect rubbish and trash. Every day, the family beats him. I see him crying. I always want to talk to him, to make a friendship, ask how he feels, what are the causes. But the family might complain to the headmaster and there could be problems. So it's just an idea right now.

"When I started my periods, there was no one to teach me about it. I put a big stone on my tummy to make it feel better, and I was very scared. Colorful Girls taught me about periods.

"Now I teach the little girls that it is nothing to be afraid of. In Myanmar, we have traditions about periods. We do not wash our hair. We do not eat spicy things. We don't eat sour things. When a little girl asks, 'Can I wash my hair or eat this or that,' I tell her, 'It is fine.'"

I ask whether Chaw considers herself an activist, but there is no such word here. She does consider herself a leader; she heads the team that prepares breakfast every morning for 658 students and monks.

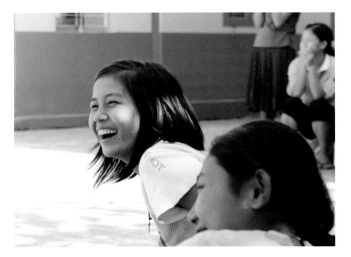
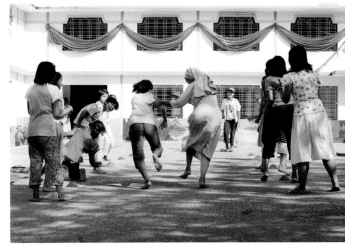
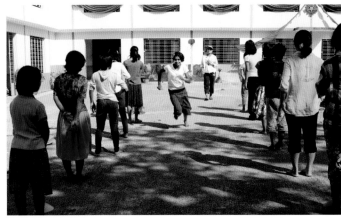
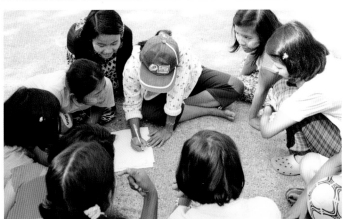

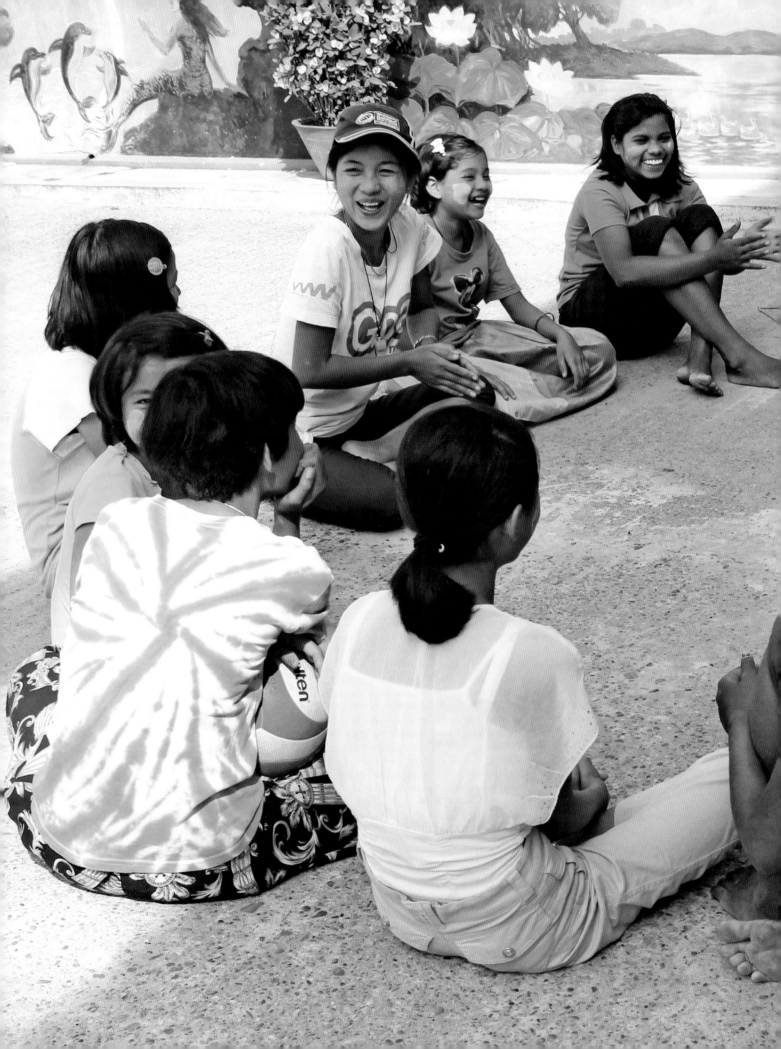

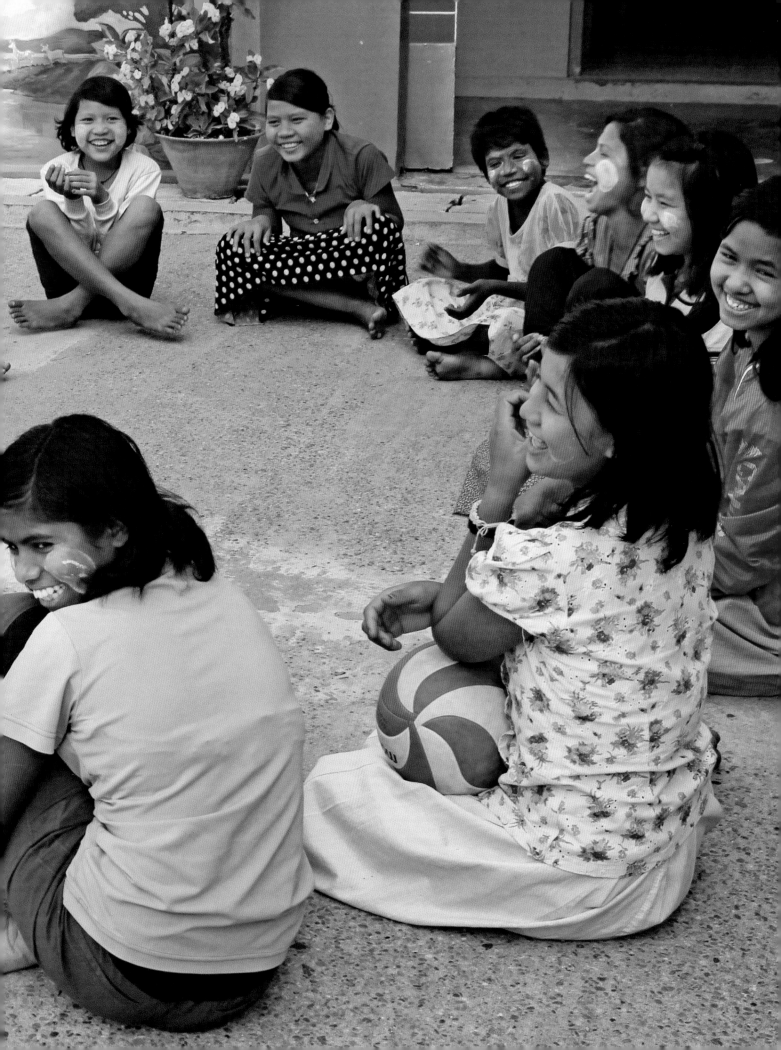

"The important thing is to learn from each other, respect each other and increase understanding."

NANDA WADI, 14

COTTAGES LINE A LANE with trees and flowers. There are 154 nuns here, some as young as five. Girls and women wearing traditional pink, golden brown, and orange nun's habits sweep down the little lane. They laugh together at a two-year-old boy dressed up in a pink habit pretending to be a nun.

Nanda joins us in a quiet chapel where a statue of Buddha looks down on us. A kaleidoscope of blinking neon bulbs twinkle around his head: an appropriate way to represent enlightenment. A nun delivers a tray with a white porcelain teapot and cups, plus a plate of tangerine sections and coconut jelly slices to be eaten with tiny silver forks.

Nanda was born in northern Shan State, one of nine children. After her father died, her mother brought her here to continue her education. She has been here since she was nine, meditating, studying, and helping with chores. She tells me, "I may not want to be a nun for the rest of my life but for now, I want to be peaceful and study the *samanera* (Buddhist scripture for novitiates).

"In my village, education is very rare. I like math best but I want to study everything. I joined Color-

ful Girls two years ago when I discovered that they teach empowerment.

"I attended a Colorful Girls workshop and planned to do a girl-led campaign to promote educational opportunities for young women. I tried to organize ordinary people, but it is not allowed for nuns to go into the community so I had to cancel my activity."

Bogyoke Aung San (father of Aung San Suu Kyi) is Nanda's hero. "He was a peace lover who tried to stop war in Myanmar."

Nanda has six brothers. Now, she lives in a community of women and girls. "My older brothers always told me, 'Don't do this; don't do that.' Here, I have space to talk and gain confidence.

"In my village, there are no doctors. Many people die. The health center is very weak. As for education, there are only a few government schoolteachers. In rural areas, people have few opportunities to know what the world is like. I want to teach there and also help with health care."

Nanda has attended two Colorful Girls summer camps. "There is no discrimination there. The important thing is to learn from each other, respect each other, and increase understanding. If we do those things, we can achieve peace.

"If I could tell girls all over the world one thing, I would say 'Believe in yourself. Try to become a leader. There are now women leaders all over the world.'"

LEFT: The nunnery where Nanda Wadi lives includes 154 nuns, some as young as five, who dress in traditional pink habits.

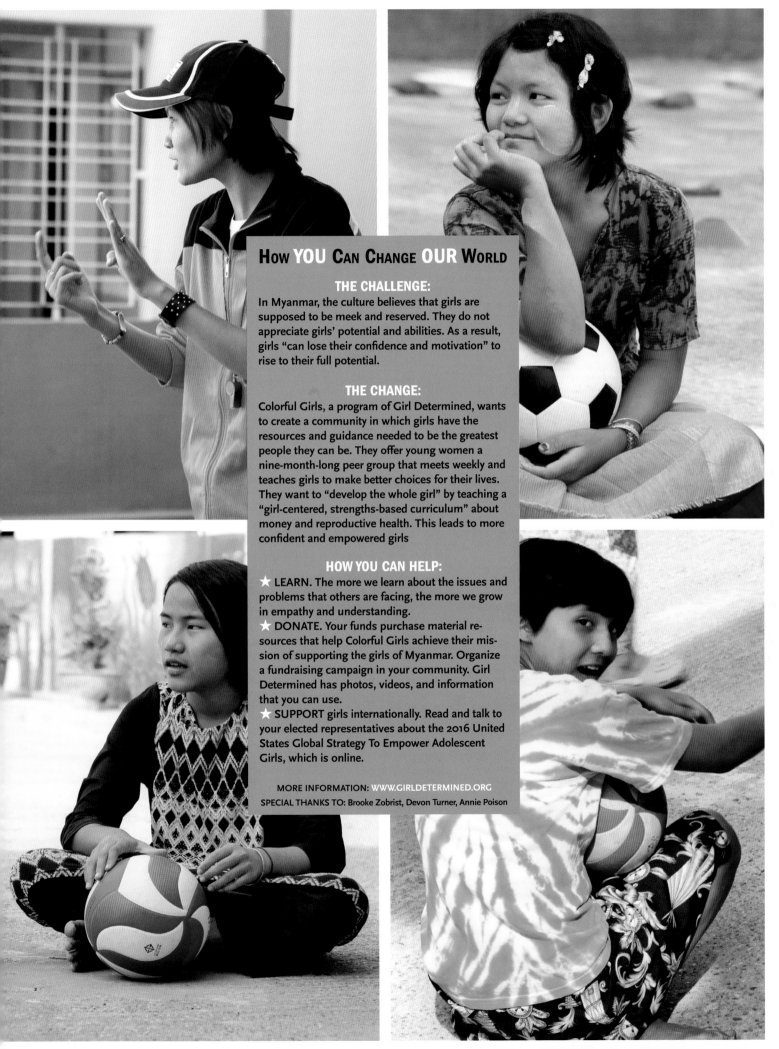

How YOU Can Change OUR World

THE CHALLENGE:

In Myanmar, the culture believes that girls are supposed to be meek and reserved. They do not appreciate girls' potential and abilities. As a result, girls "can lose their confidence and motivation" to rise to their full potential.

THE CHANGE:

Colorful Girls, a program of Girl Determined, wants to create a community in which girls have the resources and guidance needed to be the greatest people they can be. They offer young women a nine-month-long peer group that meets weekly and teaches girls to make better choices for their lives. They want to "develop the whole girl" by teaching a "girl-centered, strengths-based curriculum" about money and reproductive health. This leads to more confident and empowered girls

HOW YOU CAN HELP:

★ LEARN. The more we learn about the issues and problems that others are facing, the more we grow in empathy and understanding.

★ DONATE. Your funds purchase material re-sources that help Colorful Girls achieve their mis-sion of supporting the girls of Myanmar. Organize a fundraising campaign in your community. Girl Determined has photos, videos, and information that you can use.

★ SUPPORT girls internationally. Read and talk to your elected representatives about the 2016 United States Global Strategy To Empower Adolescent Girls, which is online.

MORE INFORMATION: WWW.GIRLDETERMINED.ORG

SPECIAL THANKS TO: Brooke Zobrist, Devon Turner, Annie Poison

GENERATING JUSTICE

New Zealand

ENTERING THE CLASSROOM of Westlake Girls High School in Auckland, I face a phalanx of girls in red uniforms chanting in Māori. They look threatening. I stop cold.

"Haere mai, e te manuhiri tūārangi e, haere mai rā," Molly Pottinger-Coombes beckons me. I have no idea that this is a *karanga,* a traditional ritual that Māori women use to determine whether visitors have come in war or peace, or that I am supposed to call, *"Karanga mai rā, e te iwi e, karanga mai rā."*

The girls chant a tribute to the ancestors. Apparently, my silence signals that I revere their forbearers and have come in peace. Molly tells her tribe, still in Māori, that I am not an enemy.

If I were a rugby fan, I might recognize *karanga* as the women's equivalent of *haka,* a war chant that men enact with terrifying faces. The All Blacks, New Zealand's rugby team, perform it to start every game.

The largest girls' high school in New Zealand has over 2,000 students and the largest chapter of Amnesty International in the country, which is why I am here. Two hundred girls actively support the organization's mission to defend human rights around the world.

Amnesty, which won the Nobel Peace Prize, carefully researches incidents of human rights abuse and mobilizes its seven million international members to write letters, sign petitions, and protest against the most egregious violations, pressuring governments to resolve the cases. The organization's credo is the United Nation Declaration of Human Rights.

OPPOSITE: **Members of Amnesty International's largest student chapter in New Zealand prepare for an action to promote human rights.**

Girl leaders in the Westlake High School chapter decide which Amnesty cases they will champion. Currently members are collecting signatures on a petition to demand help for a pregnant ten-year-old girl in Paraguay whose stepfather raped her. Her mother went to the police for help, but they imprisoned her for failing to protect her daughter. The stepfather ran away.

Paraguay's law allows abortion only if the mother's life is in jeopardy, which runs counter to the U.N. Convention on the Rights of the Child that requires access to abortion when little girls are raped. The World Health Organization has issued warnings about the dangers of giving birth so young.

Amnesty International plans to petition Paraguay's Minister of Public Health and Attorney General to make an exception to the country's abortion law, investigate the case, find the stepfather, and hold him accountable.

Today, Amnesty members at Westlake Girls High School will present a noon-hour event, an action that will culminate in inviting the audience to sign this petition.

The theme of the noon program is Breaking the Silence, which is also the title of an Amnesty International campaign that underscores women's reticence to speak about sexuality, reproductive rights, and more.

Fifty girls arrive for dress rehearsal and swap their school uniforms for black tights and tops. They are as diverse as the school population, which includes students from places as far-flung as Japan and Iraq. Some girls put on accessories that represent their ethnicities, religions, or cultures: a Muslim *hijab,* an Hawaiian sarong, an Indian shawl, a Palestinian *keffiyeh.*

The "duct tape committee" meets in one corner, identifying the issues women in some societies don't feel they can discuss: Love. Identity. Religion. Peace. Freedom. They write the words with felt tipped pens on duct tape, then cut it into strips just long enough to cover their mouths.

Romy, a percussionist, sets up her kettle drum and distributes titi torea sticks to the performers.

Five dancers pull on matching t-shirts that say Girls for Human Rights. Anushka, a spoken word poet, practices. Molly, who will open the program, looks at her notes one last time.

Then Shona McRae and Kay Brown, teachers who coordinate this Amnesty chapter, slide open the walls between classrooms, and students pour in to find seats.

"I really enjoyed...feeling there was something I could do to help."

MOLLY POTTINGER-COOMBES, 17

MOLLY OPENS THE ACTION in Māori with "a *mihi*, an introduction that pays tribute to all the things that are important in the Māori culture, the spirits, people who've gone before and will come after." She translates her next words into English:

"Women throughout the world are having their human rights snatched from them. When we stand united, we can show the world that women are worth more than this. Much more. As the Māori *whakatauki* [proverb] says, 'What is the most important thing in the world? It's the people, it's the people, it's the people.' We gather today not only with those who are present but with women from every nation and all walks of life. We hold them in our hearts and in our minds. We are united here to break the silence."

In 1987, Māori became an official language of New Zealand, but I am amazed that Molly, who is not Māori, has such command of the indigenous tongue. Later, she tells me, "Most children grow up learning a few words, even in kindergarten: colors, 'Hello,' 'How are you?'

"At Westlake, you choose two languages. When the cycle changed to Māori, I thought, 'This is amazing!' It was very different from what I learned at primary school. Now, it is my favorite class. You learn about the culture, the language, and about your country at the same time."

Molly reflects on her involvement with the Amnesty group. "This is my third year. We are a little bit sheltered and isolated here in NZ. There's not a lot we can do to help people in other countries who are suffering. I really enjoyed learning about everything and feeling there was something I could do to help.

"At the end of my first year there was an opportunity to apply to become a leader. We had to write a letter about what made us want to lead and why we would be good. I wrote about loving being part of Amnesty and wanting to take that to the next level: talking to the younger girls about it, passing that knowledge on."

Molly is one of the leaders of this Amnesty chapter; her position as well as her expertise with Māori made her the logical one to launch today's Action.

"I thought I should push the boundaries."

OLIVIA HALL, 16

FIVE DANCERS WITH DUCT TAPE covering their mouths take center stage after Molly. Romy, the drummer, sets the four-four beat: pum-pum-pum-pum (beat) pum (beat) pum. The Amnesty members who surround the dancers punch up the cadence, hitting their titi torea sticks together.

The dancers start with constrained movements, then move with increasingly-free dance expressions drawn from contemporary, hip-hop, and fusion styles. They do high-energy kicks, splits, jumps, plus some provocative steps. Ultimately, they rip the tape from their mouths and perform a joyful finale—literally by leaps and bounds.

OPPOSITE: Amnesty girls list words on a whiteboard, identifying rights that are denied in some cultures.

Olivia created the choreography for this dance. After the action, she tells me she's been dancing since age four. "I used to boogie around at home. My mother started me off with ballet and jazz, but I've gone through all the genres over the years. Did tap for quite a while. Now I do pop and contemporary."

I ask how she approaches choreography. "I just use moves I know already and see how I can change them, imagine the formation, how the dance will work with other people, and keep in mind what I'm trying to show.

"When Miss Brown [one of two adult Amnesty club leaders] talked to me about it, she said she wanted to represent every way we express ourselves: motion, music, words (including Māori, the symbol of our culture)—the visual and the verbal.

"With a theme of breaking free, I thought I should push the boundaries, not have small little moves. I wanted to show unity with everyone moving together—as well as one person dancing and the others joining in. I wanted to make it visually interesting at different levels, so some moves are done sitting or lying on the floor to show that wherever you are, you can express yourself.

"My idea from the start was that the dance would build. We wouldn't do any jumps until the end. Then, we'd be like, 'Everyone is free, doing their own thing, speaking out, not oppressed anymore.'

"We practiced twice a week for a month, whenever we could get the dance room. I'd teach the dance and ask for input."

Last, I ask Olivia how it was to dance to Romy's drums. "She is the leader of our Year Twelve Amnesty group. She's an amazing musician. We had not worked with her before. When I approached her, she just asked for the date and time, came and did it."

"Two different mindsets help me be more open-minded."

ROMY LEE, 17

ROMY'S MUSIC NOT ONLY GUIDES the dancers but also unifies the entire action. The beat she improvises is unusual and compelling. She delivers it with such confidence that I assume she's been rehearsing with the other performers for weeks. Not so.

She tells me later, "I just love music. I think it's great. It's one of the most wonderful forms of art in the world. I started drumming when I was like ten. I love performing. I play double bass in the orchestra. And it's mandatory that every musician plays the piano and the guitar, of course."

I invite Romy to tell me about herself. "My parents were born in South Korea and immigrated to New Zealand 20 years ago. I was born here. For me, growing up was really difficult. At school, I had all Kiwi mates but at home, it was so traditional and Korean. I think those two different mindsets help me be more open-minded and recognize other people's perspectives.

"Even though New Zealand is multicultural, there are inevitably a lot of stigmas. Many a time I have been undermined because I am, and look, Korean. It's just discrimination, I guess. When I was little, people were like, 'Just another Asian. Go back to where you come from.' Some people have xenophobia."

Romy is a member of U.N. Youth Organization as well as Amnesty, so is familiar with the United Nation's Declaration of Human Rights. I ask which of the 30 rights she cares about most.

"Number 21. 'Everyone has the right to vote in regular democratic elections...' This is really important to me. It does irritate me a lot that many 18-to-24-year-olds don't exercise their right to vote. Ideally a government works for the people. So the people have to voice their opinions. The number of 18-to-24-year-olds voting is definitely miniscule. A select group takes an interest but the majority of that age group doesn't really know what's happening.

"I'm running a workshop next term about democratic government and why it's important to vote. New Zealand is a great country but everywhere there is change that needs to be made. If we can make New Zealand a better place, the world can follow. That's not going to happen if you sit at home not doing anything.

"The same applies to social justice and human rights. You can't just complain about things. You have to be active. Have to do something. You get a lot of cynics who think that a bunch of high school students can't have an impact. What they don't know is that we really do.

"Throughout my high school life, I've tried to get other students involved. That's been my main mission. I use social media a lot. I frequently share on Facebook so the hundreds of friends I have can see what I think is important and think, 'Maybe I should look into it.' Or someone might see me wearing an Amnesty badge. Raising awareness is a first step, which is what I try to do as much as I can. Even if it's just one more teenager, that really can make a difference.

"Girls think, 'Oh, I'm just a teenager, young and inexperienced—nobody's going to listen to me.' But when young voices unite, it becomes something spectacular. In my Amnesty group, I have 30 girls. That's 30 letters already. That just piles up. It becomes something that actually does have some leverage.

"We are one school divided into five 'houses'— communities, families. I'm the student leader of 400 students from all grades who are in our house. We have weekly assemblies. I talk a lot about getting involved. A lot of students see me as a role model. You have to show people you're enjoying what you're doing and it's actually having an impact. If you live what you believe, it's a catalyst to get others involved."

I ask Romy what she does as a leader of an Amnesty group. "It's like a friendly, fellow-student-facilitating kind of thing. We have meetings every two weeks. I am responsible for the Year Twelve students, second to last year of school. There are 30 kids in the group. When Amnesty has an issue to deal with, we pull it apart during our 50-minute lunchtime meeting. We ask 'What is happening; what is the problem?' By the end of it, we've done at least one action."

Actions, it turns out, take many forms. "We do a lot on social media. Facebook is an easy way

OPPOSITE: Amnesty International coordinator, Shona McRae, invites Social Studies students to make costumes for a fashion show titled Super Heroes for Human Rights.

to showcase an issue. We use hash tags. Do letter writing. Sometimes we make posters we can post around school."

I ask Romy, "Of all the Amnesty actions you've been involved with, which one seems most important?"

"I think the one that you photographed has got to be the most important so far. Before, the largest number of people we could reach was our families, people in Auckland and New Zealand. But through your book, we will reach a much larger audience around the world."

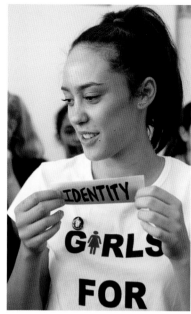

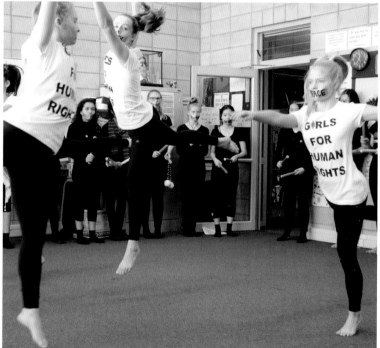
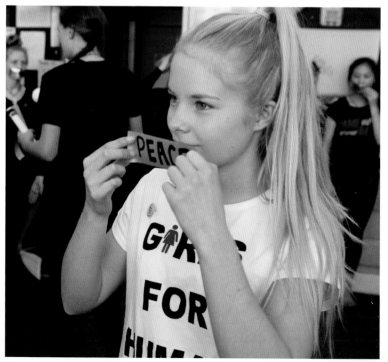
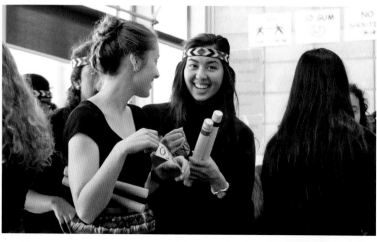

"Refugees come from terrible circumstances. They are just turned away."

RAHMA MAHDI, 17

TWO AMNESTY LEADERS, Rahma Mahdi and Yuri Lee, stand center stage and present the plight of the girl in Paraguay. They urge the audience to sign a petition. I stop taking pictures and volunteer to be the first to write my name. Amnesty members with clipboards pass copies of the petition to the audience row by row, as if we were in church collecting an offering.

After the performance, I talk with Rahma whose parents moved here from Iraq 20 years ago.

"This is my last year of high school. I really want to help in Syrian refugee camps as an optometrist. I'll have to work hard. I think only 60 are accepted into optometry at the University of Auckland. I considered universities in Australia and Jordan, but the education is better here."

Rahma joined Amnesty because, "I was always interested in helping, doing humanitarian things. In Year Twelve, I decided to apply to be a leader and I got it. There are about 12 in Amnesty's leadership group, all seniors. *Amnesty Magazine* tells us the issues they are focusing on. We pick issues that effect younger girls and teenagers so our members can relate. We also look for issues we can discuss and debate, which gets members more involved.

"Auckland is extremely multicultural. I think that's why we have so many debates. Your parents,

your culture, religion, and personal experience. It is definitely not black and white here. You have to think about a lot."

For example, Rahma has been thinking about "gay marriage, which is a big issue here. We had a conservative party leader come talk to us. He tried to make it seem that the definition of marriage, a religious concept, should not be changed but that a civil union has the same rights as marriage. I am extremely undecided on this. I do think you can like the same gender, but it's against my religion. It's a very hard concept to think about.

"Lately, we've been looking at capital punishment. Another leader, Hara Jeong, and I are responsible for Year Eleven students, ages 15 and 16; they want to learn. The other day we were talking about the death penalty and asked them to stand in a line arrayed from 'agree to disagree.' We had them tell us why they held their opinions. Got quite a debate going. Let them understand the other side, too."

Knowing Amnesty contends that the ten-year-old girl in Paraguay needs an abortion urgently, I ask whether women's choice is a contentious issue in New Zealand. "Abortion is not talked about here. We do have a lot of girls here who get pregnant, but they tend to keep the babies. The grandmothers are super involved in bringing them up and there is lots of support."

I ask Rahma which single human right she feels most passionate about. "Equal rights. In a multicultural society, it's more open and free. It's ridiculous that in other places you don't have equal rights just because of the color of people's skin or religion."

She also feels strongly about the right to seek asylum. "A lot of refugees try to come to Australia and New Zealand but they're not let in. Refugees come from terrible circumstances, and are so determined to make a better life for themselves. They're just turned away. New Zealand has a regulation that limits immigration to 750 a year but a lot of times, it's more like 500 a year.

"Educated immigrants have to start their degrees all over again. That happened to my father, who had an architectural degree. He went back to school in computer programming. A lot of his friends ended up moving back home because of the problem with degrees."

"Have you personally ever been a victim of a human rights abuse?" I ask Rahma. "No. I am really privileged here. No one ever comes up and says anything. It's super-open and super-accepting in New Zealand. People realize I'm just the same as them."

OPPOSITE AND OVERLEAF: **Students prepare to perform a noon-hour action using dance, music, poetry, and petitions to break the silence on human rights.**

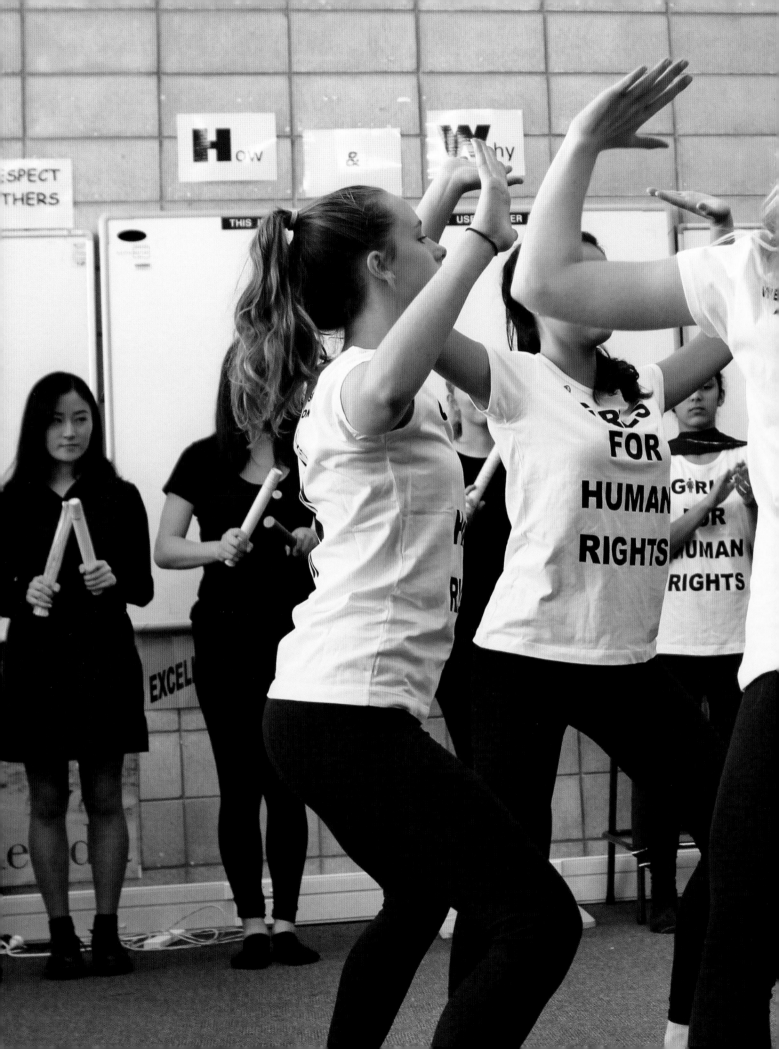

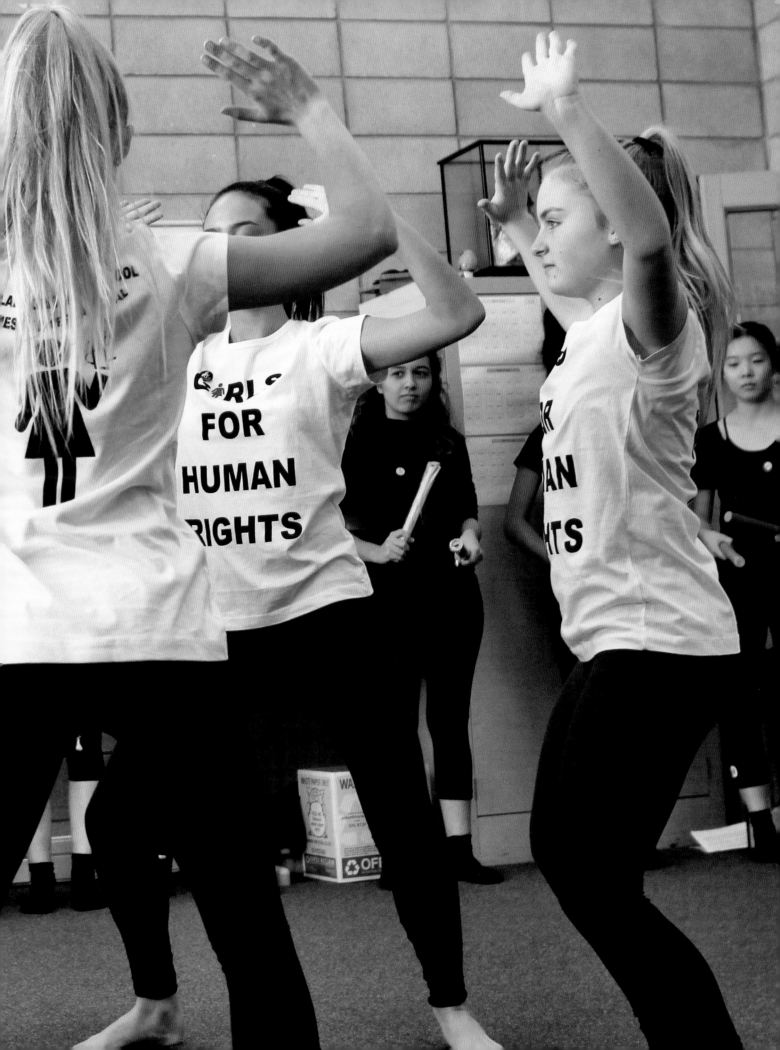

"The greater the number, the greater the impact."

HOMAYRA SHAFIQ, 17

AMNESTY MEMBERS surround the performers at the noon-hour action, standing in a U-shaped configuration. Some girls sport accessories that signal their heritage. Homayra wears a sunset-red scarf over her hair and shoulders.

That afternoon, I interview her. "I was born in Bangladesh. Lived there for two or three years before I came to New Zealand as an immigrant in 2001. My father was a student here so he had been here a lot longer than my mom and me. He thought that with citizenship for us all, it would be a better future.

"My family is dispersed. My cousin, a doctor, lived in Palestine and worked with World Vision. It was just awful there. No water, no proper sanitation. They had a breakout of a disease. He gave them injections and helped them get fresh water. He was killed. To have a man whom I didn't even know, had never heard of, tell me that my cousin got caught in crossfire, was really life changing.

"The last time my cousin and I talked, many were dying around him of disease, and he had no funds for more medicine. He was desperate but he was like, "I have to do everything I can to help them out. I don't care if what I am doing is minimal, I have to do it." That's what really got to me. That's why I joined Amnesty.

"When I first came to Westlake, Amnesty was really big. But it seemed to me that all we did was write letters. Ever since year before last, there's been a humongous change. Now I'm passionate about it. I'm a leader this year and it's just great.

"Westlake School includes levels Nine through Thirteen. Amnesty leaders split each level into two, according to last name order. We have like 10 different rooms going on…with two leaders in each. It's great to see how enthusiastic people are!"

I ask what will happen to the Paraguay petition everyone signed today. "We send petitions off to Amnesty headquarters. They have a quota…1,000 signatures or something…then they will send them off. The greater the number, the greater the impact. They publish the results on their website, which we monitor so we know what happens.

"My guess is that no one in Paraguay is taking a stand for that little girl. If the government sees lots of signatures, maybe that will cause them to act."

I wonder which Amnesty action has been the most gratifying for Homayra. "We did one on women in Saudi Arabia. They wanted to drive and become independent. The men were so opposed that they resorted to extreme violence. A woman was stoned to death. One nearly got killed by her husband. Another nearly got murdered by her brother. It was gender inequality in the most extreme form.

"We signed a petition to promote women's education. Amnesty was educating Saudi women, teaching them human rights, releasing them into the workforce. I thought that was really, really powerful. We were giving them freedom after having been oppressed for so long.

"Also one in Papua New Guinea reminded me of witch hunts during medieval times. Old, helpless women who made something out of vegetables, were thought to harbor dark spirits and were called witches. There was no evidence, just superstition. Two old women were beaten and killed. We encouraged the government and local police force to do something about it. Within a couple of weeks, we got a video in which a policeman stopped a 'witch' from being executed.

"Some people think Amnesty is an organization that doesn't really change anything and that being part of it is just to satisfy yourself that you're doing something. But that's not true. It works.

"We've made significant progress in human rights, equality, and racism. We've tried our best to stop bad things like rape. We have freed people, enacted new laws. It's rewarding to help a mother, father, or child avoid persecution. Being part of it is not a pointless waste of time."

OPPOSITE: **Amnesty International's student members spark conversations about human rights, then ask their audience to sign a petition to pressure Paraguay's government to act on a child rape case.**

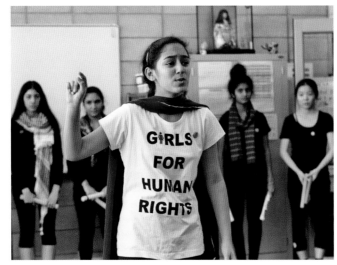
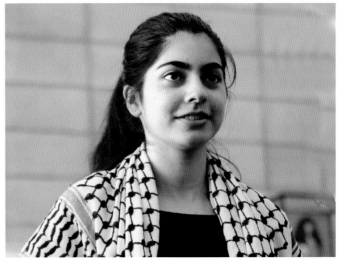

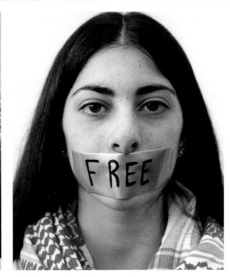
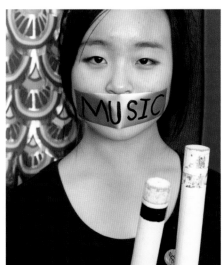
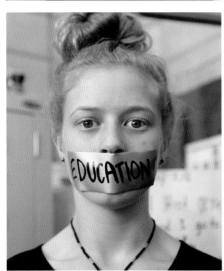
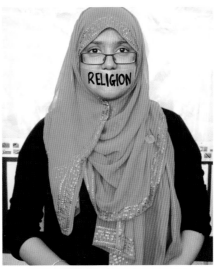

"I want to change the definition of 'girl.'"

ANUSHKA KHARBANDA, 14

ANUSHKA STEPS TO CENTER STAGE and strips the duct tape off her mouth so she can perform a spoken word poem she composed for the action. Later, I ask Anushka how she felt as she performed the poem. "As if there were rays, vibes, coming off me and going to the audience."

Anushka is one of eight children who immigrated with their parents from India two years ago. She won an award for her first poem about feminism, which was inspired by an incident in 2012 that outraged people around the world: Jyoti Singh, a 23-year-old medical student, was gang raped, beaten, and tortured on a bus in New Delhi; two weeks later, she died.

"There was an uproar for months after that and the politicians were saying, 'It was her fault because she was wearing immodest clothes and was out at such a late time.' This was not true; there are other women who are modest, completely covered, and rape still happens. You can't just blame the victim.

"People said, 'OK, it was 80% their fault and 20% hers.' I do not believe that. It was 100% their fault. If a child draws on the wall, you can't blame the crayon, you have to blame the child. Make stricter rules. That is what is definitely needed."

Here are a few lines from that earlier poem, which Anushka addressed to men who violate and abuse women:

You people are the reason women do not grow up, they grow down...
I don't know about you, but the next time I face them, I will dress up
In the bangles of courage, the cloak of strength, the shoes of confidence.
I will dress up to show them that we are the pretty pink berries with a soft outside but a hard inside.
There is a lot of strength to find.
We have to enhance the power of womankind because this mankind...is not at all kind.

Anushka recalls growing up in India, "Many women and girls there are oppressed. To stay away from all the catcalling, I stayed in (except for going to school) and didn't go out to buy stationery or play.

"My mother was a stereotypical daughter-in-law who served the whole family. Even exhausted, she just kept going. I don't want my life to end up like that. I want to be equal. That certainly is not found in most Indian families.

"I don't want to be feminine like girls are supposed be, doing knitting and acting like they are really delicate. As soon as the word 'girl' comes up, people think, 'Pink, make up, dresses.' I want to change the definition of 'girl.' When you think of boys, you think, 'sports, power.' Power is a good thing, and should not be associated with one gender. Girls should be associated with power as well.

"I decided I would break stereotypes. I try to demonstrate strong properties so other females can see them. I am really interested in physics and engineering, robotics and math—fields which boys are mostly interested in. For the past five years, I have done karate and have my black belt; I am training for first dan rank right now.

"I want to do unique things with my life. I love cosmology, the study of the universe and the stars. I want to go into that field because we know almost nothing about it. It is so vast and there is so much to be discovered. Not many people choose it.

"My grandfather is passionate about girls being powerful. He encourages me and is the proudest in my family.

"There is a quote I really like. I think Mahatma Gandhi said it: 'Don't follow the paths that others follow. Chose a new one and leave a trail behind.'"

Local people claim, "New Zealand has five days in one." This morning, the sun was dazzling but now thunder booms, lightening slashes, and rain hammers on the roof so loudly than no one can hear what anyone says.

Amnesty co-leader, Shona McRae, is teaching Social Studies. The lights blow out. Unflappable, she says, "It's last period. Let's have some fun." She distributes newspapers, scissors, and tape, and assigns the girls to create costumes. "In 30 minutes, we'll have a Superheroes for Human Rights fashion show," she promises.

The girls work fast and then model newspaper dresses and tresses, capes and wings. They flounce and pose and laugh and clap. Westlake Girls High School is full of superheroes for human rights.

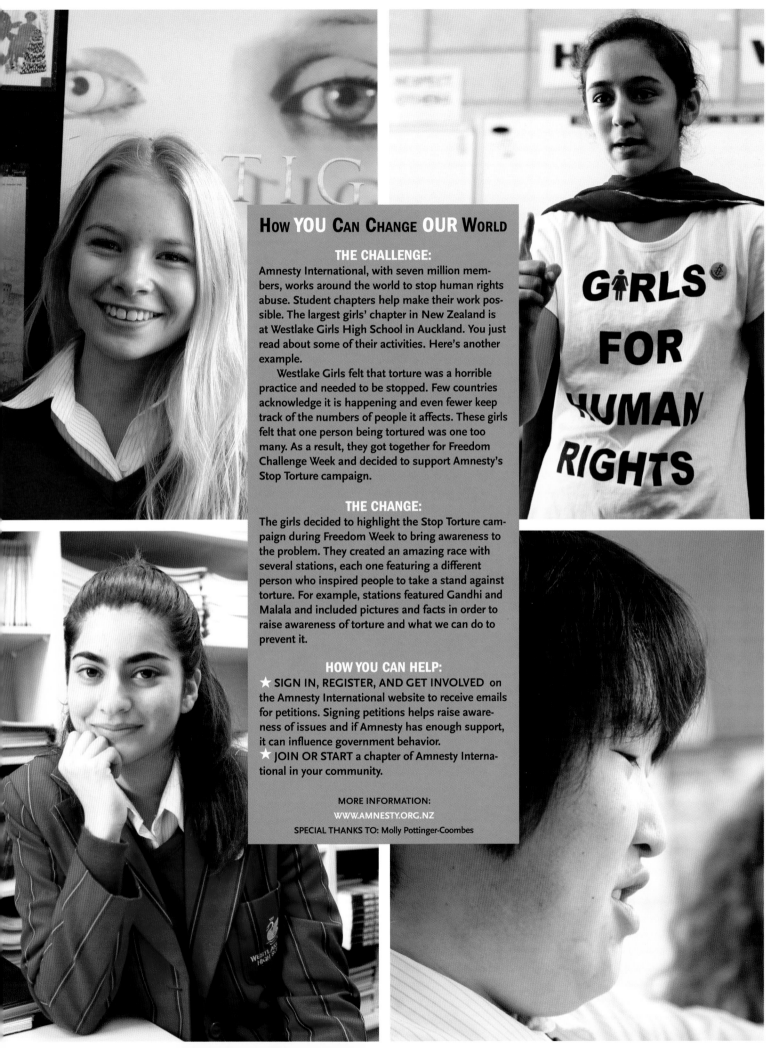

How YOU Can Change OUR World

THE CHALLENGE:

Amnesty International, with seven million members, works around the world to stop human rights abuse. Student chapters help make their work possible. The largest girls' chapter in New Zealand is at Westlake Girls High School in Auckland. You just read about some of their activities. Here's another example.

Westlake Girls felt that torture was a horrible practice and needed to be stopped. Few countries acknowledge it is happening and even fewer keep track of the numbers of people it affects. These girls felt that one person being tortured was one too many. As a result, they got together for Freedom Challenge Week and decided to support Amnesty's Stop Torture campaign.

THE CHANGE:

The girls decided to highlight the Stop Torture campaign during Freedom Week to bring awareness to the problem. They created an amazing race with several stations, each one featuring a different person who inspired people to take a stand against torture. For example, stations featured Gandhi and Malala and included pictures and facts in order to raise awareness of torture and what we can do to prevent it.

HOW YOU CAN HELP:

★ SIGN IN, REGISTER, AND GET INVOLVED on the Amnesty International website to receive emails for petitions. Signing petitions helps raise awareness of issues and if Amnesty has enough support, it can influence government behavior.

★ JOIN OR START a chapter of Amnesty International in your community.

MORE INFORMATION:
WWW.AMNESTY.ORG.NZ
SPECIAL THANKS TO: Molly Pottinger-Coombes

ENDING EXPLOITATION

Tanzania

YOU LIVE IN A VILLAGE near Tanzania's Lake Victoria. You're six. Your parents, who struggle to put food on the table, want a better life for you. They can't afford to send you to school.

But your auntie comes to the rescue. She invites you to live with her in the city of Mwanza, and promises to send you to school there. You yearn to go to

school, so you accept, unaware that you may never see your parents again and that you're about to become a domestic worker, a slave laborer.

WoteSawa ("We are equal") is a nongovernment organization led by Angel Benedicto, a former child domestic worker. It shelters these girls, trains them to do work that enables them to gain financial independence, and teaches them their legal rights. WoteSawa's staffers, all ex-child domestic workers, educate girls, parents, employers, and community leaders to respect these rights.

"No one can force you to do what he or she wants. We are equal."

ANGEL BENEDICTO, DIRECTOR
ANGEL, ELDEST OF SEVEN CHILDREN, grew up on the island of Ukerewe, a three-hour ferry ride from Mwanza. Climate change had devastated its economy, which relied on fishing and agriculture.

When Angel finished secondary school, her father said, "You are an adult. Find somewhere to live—or get married so I can get some cows." (The bride price, paid by a groom's family for an educated girl, can be 20 cows.)

Angel applied for jobs in businesses and the military. No luck. Finally, she found domestic work. "I was glad to do it," she remembers, "instead of getting married."

Angel's typical working day: "Wake up first,

OPPOSITE: **Agnes Benedicto leads a WoteSawa meeting. The organization includes 300 child domestic workers who advocate for their rights, educating employers, parents, and government officials.**

go to bed last. Prepare breakfast. Walk children to school. Clean the house. Do dishes. Wash clothes. Collect children from school. Go to market. Prepare lunch. Fetch water. Do more dishes. Prepare dinner. Not feeling well? Take aspirin. If you don't collapse, your employer assumes you can work."

Her employer, "Mama, was an abuser. Everything I did was bad. She promised 30,000 shillings a month ($14 U.S.), but paid 20, 10, or nothing.

"I found another, nicer employer, but her husband would come home at midnight and want me to get up, prepare food, get water. When he ate, he wanted me nearby. He'd touch me. He knew my sister and brothers depended on me. He offered money. I said, 'I can't have a relationship with you.' He told his wife, 'Find another domestic worker.'

"In 2010, Maimuna Kanyamala, Executive Director of Kivulini Women's Rights Organization, which specializes in domestic violence, sent me to the East Africa Human Rights program in Nairobi. Afterwards, I was confident about human rights. Every person must respect you. No one can force you to do what he or she wants. We are equal.

"I became chairlady of WoteSawa, which was a project of Kivulini. Maimuna asked, 'What do you want this organization to do to help you?' I said, 'I want to go home to care for my brothers and sisters.'

"Then she asked, 'But what is your dream?' 'I want

to be an activist for child domestic workers' rights,'

"Then she asked, 'Is home where you will be an activist?' 'Yes, I have no other place to live and no way to survive.'

"Maimuna counseled me, 'Don't allow someone to interfere with your dream. Your employer's husband is trying to make you suffer. Today, people listen to him, tomorrow, no one will. Show that you will not suffer. The only one to fulfill your dream is you. Let's talk about Kivulini, instead of him.'

"Maimuna helped me start a new life. I learned entrepreneurship, computer, and facilitation skills. I sold chickens and water. I earned money and lived independently."

Angel wrote a constitution for WoteSawa and registered it as an independent organization in 2011. Mama Cash, an Amsterdam-based fund that supports women's and girls' nonprofit groups, gave WoteSawa its first grant.

Today, WoteSawa has 300 active members—though many more child domestic workers need help. Mwanza's population is 2.7 million and at least one third of all households employ children.

"That's how people live here," Angel explains. "When a woman comes home, she watches TV, chats, and directs the child domestic worker. She calls, 'Dada (sister), come here! Bring me lunch; bring me dinner; the child is crying over there!'"

Although Tanzania's Minister of Employment ordered that domestic workers be paid at least 40,000 Tanzania shillings per month ($20 U.S.), few receive it and most work 24/7.

Angel explains, "The Child Act of 2009 states that anyone who employs a child younger than 14 commits an offense—yet child domestic workers are hired at age 12, 10, 8, and even 6."

WoteSawa stresses girls' rights with parents, government officials, and employers. It sues violators; runs a shelter for girls who've been abused; trains girls to do other jobs; and advocates for laws like the International Labor Organization's Convention 189, which would protect domestic workers' rights around the world.

In July 2015, Angel was one of 60 people from the Commonwealth who traveled to London to accept the queen's Young Leaders award at Buckingham Palace. She describes her evening:

"We heard music. I saw people wearing beautiful clothes singing to us. Diplomats watched like they wished to be among us.

"After the awards, we were photographed. And the Queen came. She visited with people, then went away. We entered another room for a reception.

"Suddenly, she returned! I was with a Kenyan colleague, and she spoke to us, 'Ladies, how are you?' I thought, 'Am I really talking with the Queen?' 'Where are you from?' she asked. 'Tanzania,' I replied. 'Have you been there?' 'Yes!' 'Would you like to come again?' 'I'd love to.'

"Before sleeping, I went to my Facebook page and discovered a photo of the Queen and me. When I saw it, I was....!" She laughs, speechless.

Angel is now 28. Mama Cash financed her university education. The law firm, Baker McKenzie, provided a scholarship to attend law school.

Angel dreams of becoming a lawyer who defends child domestic workers—and a Member of Parliament. And she hopes to marry and have children. "Will you hire a child domestic worker?" I wonder. "Yes, and I will be a responsible employer."

We drive into the hills above Mwanza. A white fence topped with black spikes protects WoteSawa's shelter. There's a playground and a garden.

Nine children introduce themselves. My interpreter and I follow the director to a private room. A statuesque girl in a rainbow-colored dress joins us.

"The policewoman called WoteSawa, and Angel brought me here to the shelter."

SARIAT IDRISA, 15

"I AM THE OLDEST in a family with five children. We lived in the Bukoba district. When I was in Standard Six (sixth grade), my father's sister came from Mwanza for a funeral. She told my father that she would take my sister and me to Mwanza, since there are more good schools there.

"While I was waiting to start school, my father died. When I went home for the funeral, I asked my cousin, 'Auntie promised school, but I'm still staying with her, and no school. Now what?' My cousin responded, 'That is none of my business. Ask her.'

"When I did, she said, 'There will be no school. I never mentioned school to your father. You must work for your cousin as a domestic. Maybe one day you can go to school on your own.'

"My cousin refused to pay me, since I was a relative. I was assigned to do all the domestic work, washing, cooking, and caring for her three children.

"One day, my relatives in Mwanza called a family meeting. There, I saw a stranger. 'He is your fiancé,' I was told. 'You aren't going to school. You're a domestic worker without money. You should marry.' I started crying.

"Auntie said, 'If you are not ready to marry, you are not going to live with me or your cousin. You have to find your own place.' I didn't have money and didn't know anyone, so I agreed to marry.

"Auntie prepared for the wedding. He was 32, I was 14. He paid my auntie the bride price, 500,000 shillings ($228 U.S.).

"I started thinking: how to escape? When I told a neighbor how I was treated, instead of helping me, she told my auntie, who beat me and locked me up.

"Auntie lied to my mother, said I didn't want to go to school and had decided to marry. My mother came to Mwanza, and I told her everything. But, since her husband was dead and Auntie was her husband's sister, she couldn't help me. She just cried.

"Since I am Muslim, there was a henna ceremony one day before the wedding. I went into the henna room and an older woman came to explain how to take care of my husband. I asked to go to the toilet, and ran away.

"While I was running, an elderly man stopped me. 'Where are you going? You look like you're getting married.' I told him everything. He felt sorry for me, asked me to go back, promised to help me on the wedding day. He informed the police, gave them directions to the wedding and told them when it would happen.

"On the wedding day, the police, the man, and some activists arrived. Seeing them, Auntie convinced me to say I was 18 and had decided to get married of my own free will. The police questioned me. At first I lied, but when they threatened to take me to the station if I didn't tell the truth, I told them everything.

"The man who called the police took Auntie to the police station, and she was locked up. The policewoman responsible for girls' cases called WoteSawa, and Angel brought me here to the shelter.

"The groom's family wanted the bride price back, and said I'd have to marry if they didn't get it. My mother came to the shelter to convince me to get married. I refused. She said, 'You are never going to see me again,' and returned to Bukoba.

"The groom and his family told my cousin they'd kill me if they met me. My cousin also tried to convince me to marry him. I refused.

"Angel told the police, and I haven't heard anything more about Auntie or my cousin, and I've been here seven months."

Sariat leaves the room and returns with embroidered cotton placemats. "When WoteSawa asked what they could do for me, I said I wanted to learn tailoring. Now I can sew. I sell sets of 12 for 25,000 shillings ($11 U.S.). At first, WoteSawa bought the cloth and thread but now I buy my materials so I can make what customers want."

OPPOSITE: **Angel Benedicto, former domestic worker, now Director of WoteSawa, received the Queen's Young Leaders Award at Buckingham Palace.**

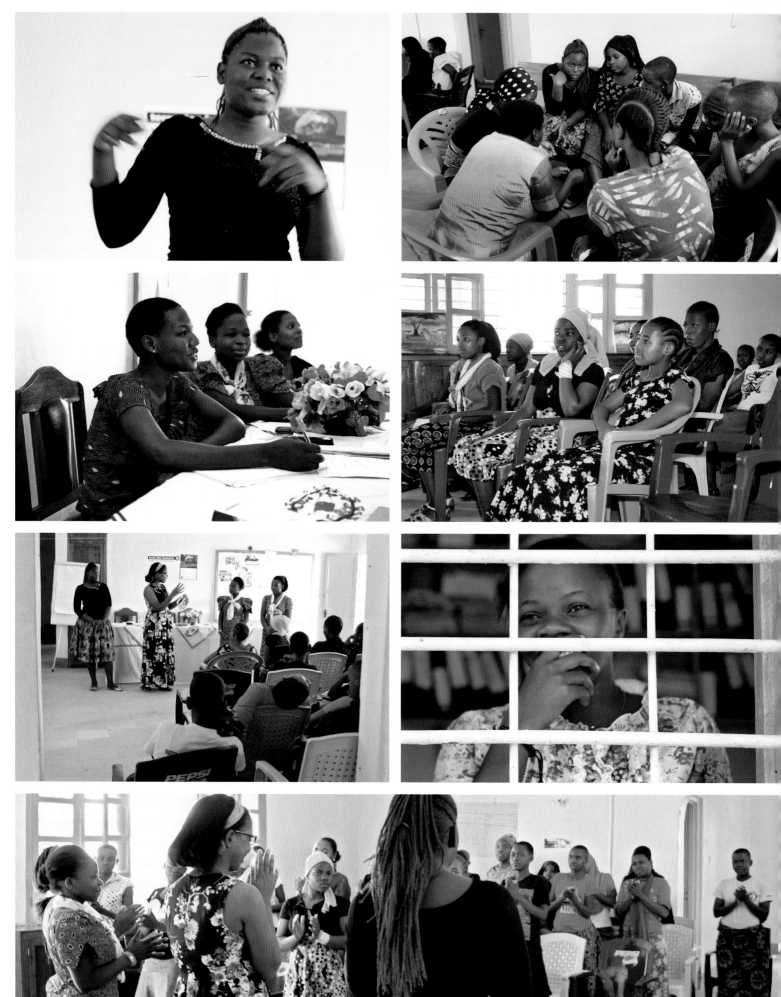

"We must speak out so employers can be punished."

DORIANA MELKIADI, 16

WHEN DORIANA'S MOTHER DIED, her father suggested that she take her brother and sisters to Mwanza and find domestic work. A woman hired Dorian to care for her house and children, and hired her brother to care for livestock.

Doriana remembers, "Mama said, 'If I am taking care of all four of you, I am not going to pay you anything.' One day, she said, 'You are eating too much. You are too many, so I'm taking two to work elsewhere.' She didn't say where. Later, she said, 'I don't want you two here. My children can care for themselves.' So we became street children.

"I met the owner of a café. She hired me to cook for 2,000 shillings a day (less than $1 U.S.). One day,

when I was going to the market to buy food, my former employer intercepted me and said, 'You stole my clothes and shoes.' She took me to the police, and demanded that I be jailed until I repaid her.

"The police asked me to explain, then let me go. As I left, Mama began shouting, 'Thief, thief!' Some people began beating me. Others saved me. I asked them to find out where my brother and sister were. Mama refused to tell them.

"I returned to the café owner, and she asked the police to help. They suggested WoteSawa, which offered to let me stay in this shelter.

"WoteSawa took the police and me to my former employer, who finally told them where my brother and sister were. We found them, and now we're all here.

"Angel said, 'Society needs to know how child domestic workers are treated, so we can improve their situation. Will you tell your story on television to help other girls?' I told it on a Mwanza station that can be seen around the country. We must speak out so employers can be punished."

ABOVE: **A young girl at WoteSawa's shelter that serves domestic workers who have been abused.**
OPPOSITE: **Current and former child domestic workers hold a weekend workshop at WoteSawa to plan strategies to stop abuse.**

ANGEL ASKS. "Can you walk for 20 minutes?" I say yes, but nobody tells me that we'll be walking straight up. Lydia, my interpreter, carries my equipment, and we follow a WoteSawa staffer.

The gravel road morphs into boulders. Soon the path ends. We must rock climb. Not for nothing is Mwanza called "Rock City."

It's hot. I pause to take pictures (and catch my breath). We pass pigs, goats, stone houses perched precariously on the cliff. A woman greets us in Swahili, "Jambo!"

We hike through a community where Kurya tribe members live. I'm amazed to discover so many houses; at night, this hill is dark. There is no electricity or water. At the end of the path, steps lead uphill. Pendo, whom we will interview, lives and works in the last house.

A tot plays in the dirt. He never takes his eyes off me. Lydia finds a jerry can and I sit, glad to rest.

Lydia guesses that Pendo has gone to the market, leaving the boy because she can't carry him in addition to her purchases. Women and girls climb past us carrying firewood, water, vegetables, and packages. One carries her water jug on top of her firewood on top of her head. Amazing!

After an hour, Pendo arrives and spreads *dagaa*, tiny silver fish, on a tray to dry in the sun, then cuddles the tot, David. A woman walks past and hands Pendo a girl's polka-dot dress; they exchange a few words, and she leaves.

Pendo explains that David has never seen a *muzungu*, white person. I lean toward him, "You and I have different skin colors but we both have two eyes, two ears, ten fingers and ten toes." David is skeptical. He counts his toes.

"I explained her rights. I directed them to a village leader for help."

PENDO ANTHONY SHIJA, 17

FIRST, ABOUT HER NAME: Her father was Anthony; her grandfather was Shija; and Pendo means, "love." She's the oldest of seven children and has worked here since she was 15, doing "all the domestic chores and caring for the children."

The family includes a mother who owns a café, a carpenter father, and sons ages 2, 10, 11, 16, 20, and 26 (the eldest two are in college and are only home on holidays). The house is small, but Pendo has a separate room, which is a relief to me, given the family's seven males.

"I went through Standard Seven and was selected for secondary school, but my parents couldn't pay, so I do domestic work. I'm paid 20,000 shillings a month ($9 U.S.). I send some money home and use the rest for clothes and shoes."

I ask Pendo to describe a typical day. "I wake at 6:30, fetch water, clean the house and surroundings, then go to market to shop. I prepare lunch. Then I rest and feed David while I wait for the ones who've gone to school, who'll eat together. Then I wash utensils from lunch. Then I do tailoring. I have a sewing machine, and will be doing tailoring until I prepare dinner—and clean up after dinner."

Two things impress me: We're meeting when she usually rests; she has a freelance job.

"After getting tailoring training from WoteSawa, I went to another school to build on the experience. I then started tailoring here. My employer loaned me the sewing machine since she was not using it. I've done tailoring for three months.

"When I started, I put the sewing machine outside so people passing by would notice. Some bring cloth for a dress or skirt. Some are like the lady who brought the polka dot dress for alterations. I earn 5,000 shillings a day (about $2 U.S.) from tailoring and am trying to collect enough money to buy my own machine."

Meanwhile the machine she uses is beautiful: black with butterfly designs, made in China. It's clear why WoteSawa has acknowledged Pendo's employer as an "Ambassador," one who sets an example for other employers.

Pendo, herself, is a WoteSawa Ambassador, who educates other domestic workers about their rights. "I see others at the market, where I get water, and around the houses where they live and work.

"One day when two other domestic workers and I were coming from the market, one said her employer had beaten her the night before. After getting the whole story, I explained her rights as a domestic worker. Since it was hard for me to help her, I directed her to WoteSawa. But these girls didn't know where WoteSawa was located. So I directed them to a village leader to ask for help. When I followed up, I discovered that the girl no longer works for the family that treated her badly."

Pendo shares her hopes. "I wish that one day I will own my own business so I can stop doing domestic work. I dream of having a garment shop at the center in Mwanza that will be big enough to hire other domestic workers and teach them tailoring, just as WoteSawa taught me. I am thinking of employing both those who have been—and those who are still—domestic workers so they can decide on their own, whether to continue domestic work or to do tailoring."

OPPOSITE: Pendo Anthony Shija works for a family that lives on a rocky hill above Mwanza. She and her employer are both WoteSawa ambassadors.

OVERLEAF: Sariat Idrisa in her room at WoteSawa's shelter, displays the embroidered placemats she learned to sew to earn money, instead of working as a child domestic laborer.

PALM TREES SHADE a tidy bungalow on a busy thoroughfare. It holds WoteSawa's offices. There's a terraced garden behind and a smaller building that's being remodeled. I talk with the girls in an empty office where their voices compete with a cacophony of birds singing, horns tooting, roosters crowing, traffic roaring, gardeners mowing, plus hammers and saws.

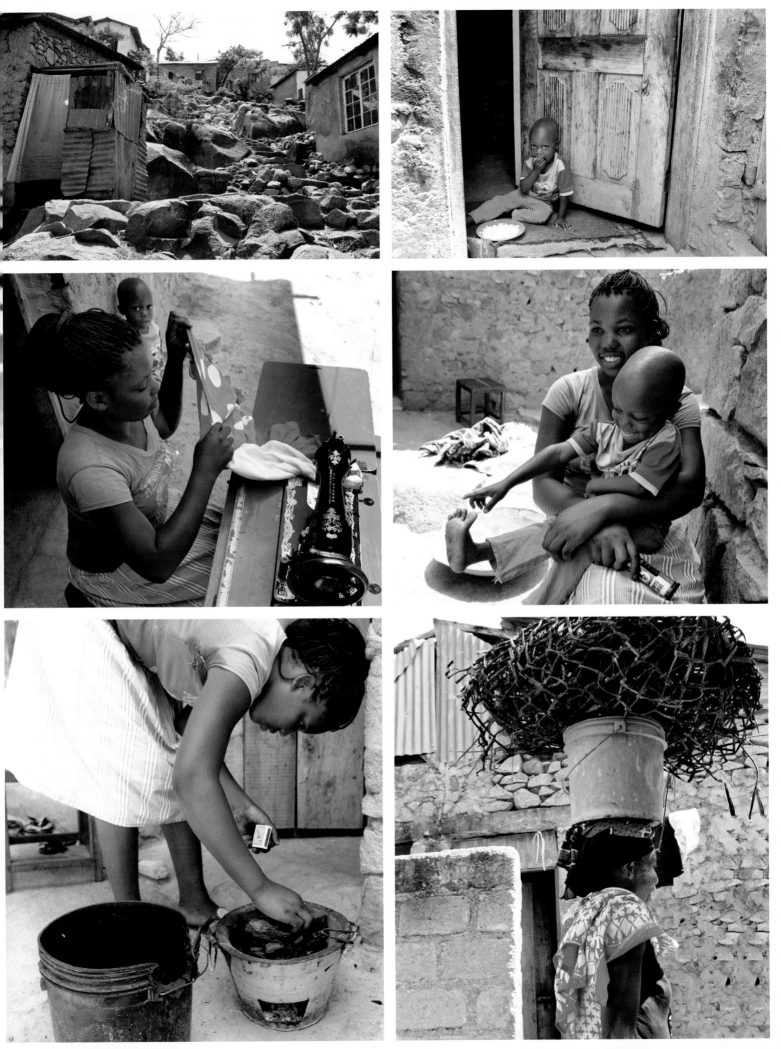

"I educate other child domestic workers about how to be leaders."

DIANA JOHN, 18

DIANA WAS SIX when her parents died and her older sisters moved away. "I decided to look for a job and was hired as a child domestic worker. I worked for that Mama until I was ten," Diana remembers.

"But you were only six! Just a little girl!" I protest. "What did they expect you to do?"

"I took care of the baby and did cleaning. After four years, my employer refused to pay my salary. Maimuna took me to an organization that helps domestic workers, and together, they forced my employer to pay.

"Today, six of us child domestic workers live with Mama Joyce: three boys and three girls. We started a business together in 2010. That allowed me to pay my own school fees since government school tuition is 20,000 shillings ($9 U.S.). Now I have finished Form Four [high school].

"WoteSawa taught us how to start a business. We go to people who have cows, buy milk, and sell milk and yogurt. We sell by the jar and cup. At first we worked from Mama Joyce's kitchen because milk doesn't stay fresh without a fridge and you can't have dust.

"We'd go to the place where there are lots of people in business. Our customers are men, women, children, everybody. We'd take a jug and cup, sell, and come back again. At first, people stole from us because we wandered around with money in our pockets.

"Now we have a place with a fridge. Customers come to us and we keep watch on them. Before, we asked two men to sell for us while we were at school. Now some of us have finished school, so we run it ourselves.

"I got education from that business. I can educate other girls. I can employ them.

"We are starting a second kitchen. If we get a yogurt package, we will sell yogurt as take-away. We are looking for a cup with a lid, but we didn't find it yet because of money. With that, we can get many people to come."

Diana is proud that, when the business could afford it, they gave milk free to people with HIV-AIDS. "They took one cup each. It helps to have proper nutrition. Yogurt is also used to treat asthma," she says, and then she shares her dream: "I want to be a nurse."

Her interest in helping others shows. "I educate other child domestic workers about how to be leaders. When I have free time, I give advice about how they can get their rights. I teach them how they can handle situations and escape frustration. I say they have a right to be paid fairly and on time. I say employers cannot have a girl of nine or ten do things that are too hard for her." Sadly, Diana is the local expert on these issues.

THIRTY-FIVE GIRL DOMESTIC WORKERS have convened at WoteSawa for a weekend meeting on reproductive health. I marvel that they could negotiate two days off given their time constraints. All arrive wearing their best skirts and dresses. Some take notes.

Morning discussions are run by girl leaders including Agnes Benedicto. She sits with another child domestic worker and a board member at the head table, which has a cloth and flowers. The three of them organized the meeting.

"Sit with the mother or father...and explain your rights... A village leader or an elder could go with you."

AGNES BENEDICTO, 18

"I WAS BORN ON UKEREWE ISLAND, the fifth of eight children. I have seven brothers. My parents were poor farmers. My father didn't want to educate us, so my mother worked in houses and on farms to send us to school.

"My father didn't want to do anything, so three of us went with our mother, planting and harvesting cassava, potatoes and maize. The other children ran away from home and came to Mwanza looking for work.

"The school I attended was far from my home, so I walked five kilometers [three miles]. I finished elementary school and was accepted to secondary school. My mother sold some cows to send me to school. When I finished Form Four [high school], my results were not good enough for Advanced Level.

"My father said he was not going to take care of me. He introduced me to a family in Mwanza that was looking for a domestic worker. I was 15. I took care of their six-month-old baby and did all the chores, washing, cooking, everything. I was paid 15,000 shillings ($6 U.S.) a month. I woke up early and went to bed late, sleeping in the sitting room. I ate only if there was food left after the family finished meals.

"One day, the Mama complained that the baby had not been cared for well. She beat me and made me sleep outside. The next morning, she expected me to be gone but I was still there. She chased me away. She didn't want to see me again.

"A neighbor helped me find another job, where I was treated even worse. The neighbor directed me to WoteSawa so they could counsel me about my rights.

"Angel asked, 'What do you want from WoteSawa?' What came to mind was that I wanted to go back to school. One day, Angel called and said an opportunity had come up to continue to Form Five and Six.

"Instead, I asked if I could attend a teaching college. Everyone agreed, and I started studying to teach nursery school and kindergarten. WoteSawa paid my college education with a grant from Mama Cash.

"Now I have my diploma, and in September, I will learn to teach primary students at Mwanza Polytechnic Institute. Someday, I want to start my own school for children ages five to 15."

I ask Agnes whether she considers herself an activist. "Yes! I am helping WoteSawa explain domestic workers' rights to others. I am passionate about this because I was not treated well as a domestic worker. If you came to me, I would advise you to sit with the mother or father of the family and explain your rights. Or I would recommend talking to a village leader, or an elder who could go with you to that family and advise them on domestic workers' rights."

I ask, "How do families react, when they learn that domestic workers have rights?" She responds, "80% don't agree. They normally ask, 'Where is it mentioned that you have a right?' And we say, 'The Law of The Child, which passed in 2009.'"

After each interview, I ask if there is anything else to share. Agnes surprises me. "Angel advised me to tell my family that I am quitting domestic work and returning to school. When they heard this, my parents decided I should live with my 33-year-old sister, who is not treating me well." Her eyes swim with tears. It's a disturbing end to our conversation.

YESTERDAY, The WoteSawa Board of Directors met and Grace Cosmas served them (and me) a delicious lunch of rice with tomato sauce, spinach and noodles, and tilapia fish.

During the domestic workers' meeting today, her kitchen hummed as she cooked for 35, stirring cauldrons that bubbled over fires on the floor. She served chicken with tomato sauce, white rice with carrot chips, plus hot greens. Grace had help from four former domestic workers. "I taught them to cook," she tells me proudly, "and after gaining experience, they found their own jobs other places."

OPPOSITE: Diana John, who began working as a child domestic worker when she was six, is now an entrepreneur who sells milk and yogurt.

"I am proud of myself...I have learned a lot by owning my own business."

GRACE COSMAS, 18

"I WAS BORN IN KAGERA and came to Mwanza to be a domestic worker when I was ten. I became part of my employer's family. The children shared the work. The family found a school for me.

"My days were normal. We woke up together, cleaned house, prepared breakfast, prepared ourselves, and went to school. When we came back, it depended on the pending work…maybe cooking or washing utensils…then we did homework, and in the evening, other work, maybe fetching water. Then we would start cooking and rest. I was treated like the family's other kids.

"One son got married and asked his parents if I could work for his new family. There, I was also treated well. After completing primary level, I went to college where I completed computer and secretarial courses. I did no more domestic work until after I finished college.

"Then some relatives came to live with the family, and started saying bad things about me. I decided to stop doing domestic work. My employer agreed and found a room and rented it for me. I moved in and live alone there until today.

"About that time, WoteSawa announced a job opening for a cook to prepare food for the staff and people who come for meetings. The cook could hire other girls to help, or do the work herself. I applied and got the job."

At the end of the day, Grace requests a meeting with Angel. She and her kitchen team want to participate in meetings tomorrow, but their normal duties would make it impossible. So Grace tells Angel that she and her team have decided to stay late this evening, and prepare and refrigerate tomorrow's food, which will allow them to join the sessions. I marvel at Grace's leadership: identifying the problem, solving it with her colleagues, then reporting to her boss.

When I ask Grace how it feels to work for herself in her own kitchen, she says, "I am proud of myself because, so far, I have learned a lot by owning my own business. I keep on getting more experience every day and meeting new people. I am happy about that."

In addition to running WoteSawa's kitchen, Grace advises child domestic workers who are facing challenges, telling them that they can employ themselves and move on with their lives. In fact, someday, Grace wants to have her own organization to educate domestic workers about their rights.

Longer term, she hopes she will be employed by the government.

THERE ARE NO RELIABLE STATISTICS about how many girl domestic workers there are in Tanzania. International studies only hint at the problem.

In 2013 the U.S. Department of Labor reported that 25% of Tanzanian children (age 5–14) work, and that Tanzania is a source, transit, and destination country for child trafficking—especially internal trafficking for domestic service work arranged by family members who promise education in the cities.

Other research is old and incomplete: in 2004, Anti-Slavery International found that 43% of the child domestic workers interviewed in Tanzania said they'd been beaten, denied food, forced to remain outdoors, or fined for causing "damages." A 2005 report published in the UK concluded that low (and no) pay put child domestic work in a human rights category "close to slavery."

Tanzania ratified the United Nations Convention on the Rights of the Child in 1991, which guarantees protection from exploitation and maltreatment—and Tanzania's Law of the Child Act of 2009 effectively made the U.N. Convention national, unifying many scattered statutes that previously governed children's rights.

But without local statistics to identify Tanzania's specific problem, implementation of these two laws is lax.

Angel aims to train Mwanza's child domestic workers to conduct research to quantify the issue so officials will prioritize putting the laws into practice.

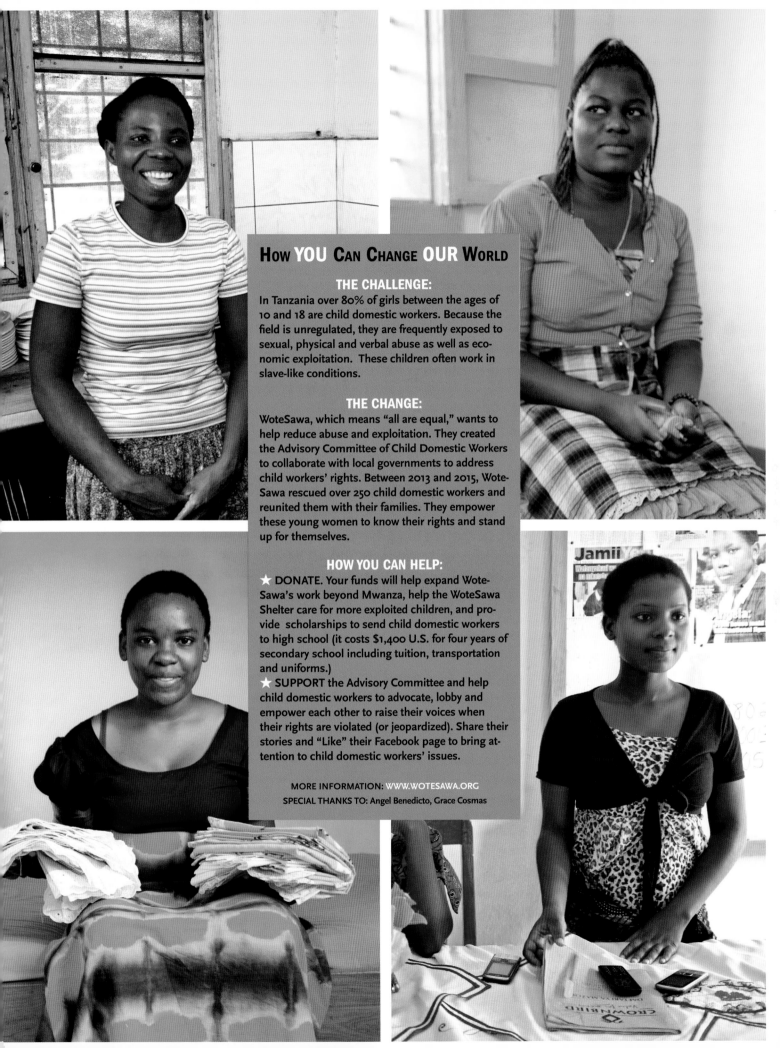

HOW YOU CAN CHANGE OUR WORLD

THE CHALLENGE:

In Tanzania over 80% of girls between the ages of 10 and 18 are child domestic workers. Because the field is unregulated, they are frequently exposed to sexual, physical and verbal abuse as well as economic exploitation. These children often work in slave-like conditions.

THE CHANGE:

WoteSawa, which means "all are equal," wants to help reduce abuse and exploitation. They created the Advisory Committee of Child Domestic Workers to collaborate with local governments to address child workers' rights. Between 2013 and 2015, Wote-Sawa rescued over 250 child domestic workers and reunited them with their families. They empower these young women to know their rights and stand up for themselves.

HOW YOU CAN HELP:

★ DONATE. Your funds will help expand Wote-Sawa's work beyond Mwanza, help the WoteSawa Shelter care for more exploited children, and provide scholarships to send child domestic workers to high school (it costs $1,400 U.S. for four years of secondary school including tuition, transportation and uniforms.)

★ SUPPORT the Advisory Committee and help child domestic workers to advocate, lobby and empower each other to raise their voices when their rights are violated (or jeopardized). Share their stories and "Like" their Facebook page to bring attention to child domestic workers' issues.

MORE INFORMATION: WWW.WOTESAWA.ORG
SPECIAL THANKS TO: Angel Benedicto, Grace Cosmas

CHAMPIONING EQUALITY

Kyrgyzstan

YOU ARE A 16-YEAR-OLD GIRL walking home from school. A car pulls up. Four boys jump out. They are drunk. They assault you, throw you into their car, and race to one of the boy's homes. His family members try to put a white scarf on your head, which means that you have agreed to marry him.

You struggle. They want you to abandon your education, give up a career, spend your life with someone you've never met, move in with their family, do housework, have babies.

The mother is old; she needs help with chores and wants her son to perpetuate the family line.

You are one; they are many. You try again and again to wrest the scarf from them but they force it onto your head. Your fate is sealed.

If you leave, you will shame your own family by violating tradition. Aishoola Aisaeva, 17, reports: "People believe that you will never get married; you will never have babies. If you divorce later, society requires you never to marry again. You are not pure."

Bride kidnapping began long ago as a celebratory ritual between families, long before it turned violent. Research by non-governmental organizations shows that between 40% and 75% of all marriages still start with bride kidnapping (the higher percentage comes from rural areas).

"If you steal a goat, the penalty is ten years. If you steal a girl? Three!" Baktygul Rakymbaeva, 14, tells me. Dariya Kasmamytova, 17, says, "Feminist organizations and powerful girls said, 'What the hell? We are not animals!' and rallied in protest. A lot of parents pressured for a new law because girls were threatening suicide."

In 2013, the government increased criminal penalties for bride kidnapping, which has long been illegal. Prison sentences were changed from three years to a maximum of seven (ten, if the abducted girl is younger than 17). But "Everyday in Kyrgyzstan, someone is kidnapped," Baktygul reports.

Trying to enforce the Convention on the Rights of the Child, the United Nations expressed consternation about this practice, which they define as "forced marriage."

The Kyrgyzstan Constitution guarantees gender equality but that means little in this patriarchal society that's shaped by cultural tradition, the Muslim religion, and Russian values (the country was part of the USSR until 1991). Gender roles have ossified.

Heterosexual marriage is sacrosanct. Police officers admitted to Human Rights Watch that when women report domestic violence, it is protocol to try to get the couple to reconcile.

What would it take for a woman to get real help? Human Rights Watch interviewed a survivor whom the police had told, "Call me when he tries to kill you."

Patriarchy has endured for hundreds of years. An ancient yurt is on display at the State History Museum. The wife's half contains pots and pans; the husband's half contains hunting gear and animal skin coats.

Kyrgyzstan's government recently set forth a "National Strategy to Achieve Gender Equality by 2020," but in the judgement of the United Nations' CEDAW Committee, the country's responsible entity, the Department of Gender Policy, lacks the necessary authority, capacity, and financial resources to develop and implement gender-equal policies.

Enter the *Devochki-Acktivisti* (Girl Activists). They have their work cut out for them. They are fighting for equality as well as for a world without violence, hate, injustice, or discrimination. The chalkboard in their office lists the Five Most Important Issues for

OPPOSITE: Girl Activists of Kyrgyzstan use dance, music, art and poetry to change attitudes that perpetuate gender inequality.

Girls. All five seem intractable.

I take a cab through Bishkek, the capital, where there are wide boulevards with blocks of Communist-style buildings in between, and large, leafy parks.

The cab cuts away from a commercial street and navigates a labyrinthine residential enclave where dirt roads are flanked with high, solid fences. No yards or houses are visible. Dariya is waiting in front of the gate. We enter a courtyard with fruit trees, a cultivated vegetable garden, and a little cottage that the Girl Activists share with the Bishkek Feminist Initiatives. Dariya greets me, "Welcome to our playhouse!"

"If you have a friend, even one friend who supports and listens to you, you become strong."

DARIYA KASMAMYTOVA, 17

"I LOVE MY COUNTRY even with all the stupid buildings and stupid stereotypes. There is beautiful nature, beautiful sky, fresh air. I hope in the future my children will live in the best country in the world."

We walk along a garden wall that's spray-painted with members' stenciled, feminist graphics and Dariya describes how the Girl Activists of Kyrgyzstan began.

"At the very beginning, I attended a camp right here, organized by the Bishkek Feminist Initiatives. I thought it would be very boring since most of our camps are USSR style. My brother, 23, also an activist, told me, 'Just go and see; you can leave the next day if you want.'

"First day, it was a little like school. Lectures about reproductive health and girls' rights. But I started understanding many things. For example, I didn't notice before that I have gender inequality at school. That people think a girl is a "thing"—a thing that cleans house, does whatever she is told.

"We created a small group to meet each week and discuss. After that, we did our logo, our website, Facebook and Twitter, and we made this happen. We felt support from the Bishkek Feminist Initiatives, and from my mother and brother. We had 24 members.

"Parents of the village girls said, 'What's this? You mustn't know about reproductive health.' Here, we have the culture of shame. It's a shame to know your body. You have to be a virgin when you are married or you are defective. Those parents no longer let their daughters come to Bishkek. It was a very hard period when nobody was coming. We felt our organization was breaking.

"In that difficult period, we didn't know what to do. Last June, we wrote an application to Global Voices in simple, simple words. 'We want to do this…, make this…, our goal is…' We won a grant to make our activism. I was shocked! It was our first project!

"We decided we didn't want to be an organization with all the documents and official things. We decided to be more of an arts group, creative girls doing things we know how to do and want to do. After we realized that, our group became more powerful.

"We had posted serious stories about girls, using facts and statistics. Then we realized that only adults were reading. We wanted to change minds of other teenagers so our generation will be more tolerant and stand in solidarity.

"We thought: *we* are teenagers; what do we like? Now we are going to make a funny site that laughs at stereotypes, patriarchy, and inequality. We want to make jokes, like, about xenophobia. Videos. Comics.

"There are some funny things. My cousin was kidnapped. She was a basketball player. Big. Strong. When she was kidnapped, three guys tried to force her to come with them. She was so so so angry that she fought with them all. They were like, 'Oh my God, we don't *want* her!'

"Now, Girl Activists has four coordinators. Other girls come and hang out with us. Once a month we screen movies that focus on girls' rights. Tomorrow, Swedish artists are coming to teach 25 of us to draw cartoons of superheroes.

"We have an idea to change schoolbooks for math, geography, biology, and other subjects. I do not see even one woman scientist. The books say 'he,' not 'she,' even if you are reading about a girl. We want to take a schoolbook and make it into handmade art. There will be corrections, marginal notes, stickers, new pictures. Maybe we will give our book to the Minister of Education. We will say, 'You must make books gender sensitive. Here are our recommendations for all the schoolbooks.'"

Girl Activists are also tackling tokenism. Dariya reports, "On International Girls' Day, I attended a conference in Almaty, Kazakhstan, about reproductive health and violence against girls. When I stood to speak I said, 'Look around. Whom do you see? There is only me, one girl at a conference about girls.' There

was silence. Then one woman said, 'We are adult girls.' They cannot feel the problems of girls, experience what girls experience, if they are not girls.

"We think 'girls,' the word, means 'up to 18 years old.' In the beginning of our blog, Our Stories, Ourselves, we asked coordinators from the villages to collect stories from their friends and classmates. When girls tell their stories, it's the truth and it's powerful."

Dariya understands how difficult it is to cause change. "We are patriarchal girls, born in this society. We try to throw this patriarchal rubbish away, but it is in our veins. If my father doesn't help me with heavy luggage, I think, 'You're a man!' I try to

remember to think, 'I can carry it myself.'"

I ask Dariya what she'd like to tell me that we haven't discussed. She names two things: "Gender equality is not only for girls to fight for. Boys have to do this, too. This is our 'together work.'"

Second, "The main thing about activism is friendship. If you have a friend, even one friend who supports and listens to you, you become strong. I love my friends and colleagues from the Girl Activists of Kyrgyzstan and the Bishkek Feminist Initiatives! And I love my mother so so much. She and my brother support and inspire me. When the people around you stand with you, it gives you power."

RIGHT: **Baktygul Rakymbaeva and Sezim Sultakaeva create lyrics:** "If she doesn't wear a dress, will she be a boy?" they sing.

THE NEXT AFTERNOON the girls are working in the cottage library, which is furnished, as homes here are, with a colorful, handmade felt carpet and bright-covered mattresses instead of chairs.

Dariya is drawing a portrait of Frida Kahlo, then cutting it into a stencil that she plans to spray paint onto the garden wall. Sezim and Baktygul are huddled over laptops writing lyrics for a song they plan

to record and post on the Internet:

If there is no equality in society, could there be friendship?
If she doesn't wear a dress, will she be a boy?
If a man does girls' housework, could something bad happen to him?
We will not stop working for gender equality!

"We are struggling for a world without restrictions, where boys and girls are equal..."

BAKTYGUL RAKYMBAEVA, 14

I FIRST SAW BAKTYGUL in a YouTube video that the Girl Activists made for International Day of the Girl, October 11. Wearing traditional clothes and long braids, she sat, poised and alone in snow-covered mountains chanting in the penetrating, rhythmic style of the national epic, *Manas*—but converting the hero's poem into an anthem for girls' activism:

We are girls defending our rights.
We are struggling for a world without restrictions,
where boys and girls are equal...
We are here.
We are ready to act.

Women and girls are not supposed to read *Manas*, which Baktygul has been doing since she was four. Most children don't read anything at that age, and this type of reading is more challenging than usual.

"Reading" *Manas* requires memorizing the epic's 550,000 lines (it's 20 times longer than the *Iliad* and the *Odyssey* combined), and performing it in your own words, maintaining the original style and meter.

Typically, men are *manaschi*. Baktygul recalls, "Everyone discriminated against me. They said, 'Girls are not strong and brave enough to read *Manas.*'"

Proving them wrong, she just took first place (again) in public competition. She has finished memorizing two books in the trilogy, having won all three volumes as prizes.

I invite Baktygul to tell me about her life. "I live with my mother, no brothers or sisters, no father. My mother was kidnapped when she was 17. I was born when she was 42. She never told me who my dad was, and I don't care. It's the women who are important in my life. My aunt taught me to read and write while my mom worked from morning to night as a seamstress. I have many sports and hobbies. At school, I am the most clever student."

Baktygul is the youngest Girl Activist. "When I was 12, I spent the summer picking strawberries to pay for my education. The next summer, I browsed the Internet and found an advertisement for a youth camp sponsored by the Bishkek Feminist Initiatives. It was for 14 to 28-year-olds. I was only 13 but I decided to apply. On each question, I wrote 200 words, which was very big for me.

"Everybody there said, 'You are so small, so young!' We discussed many important issues like the Beijing Plus 20 platform. Every day after camp I had a headache. But I got acquainted with Dariya, and she invited me to join her group. I said, 'Cool!' From that time, I have been an activist."

Since she is so familiar with the nation's legends, I ask her about something that puzzled me when I was researching this chapter: "Does Kyrgyz mean 40 tribes—or 40 girls?" Without a pause, she responds, "Girls!" Then she regales me with stories about Kyz Saikal, Janyl Myrza, even Roza Otunbayeva, who became the first woman President of Kyrgyzstan in 2010.

Baktygul has two goals: to write a book (she has been creating stories and poems since she was small) and to become a politician. "The first thing I want to change is people throwing rubbish on the streets. I want bike paths. A very important thing for me is to have quality education. And I want every person to be equal. I participated in the first National Women's Forum in Kyrgyzstan last month. I said that there should be 50% women and 50% men in The White House [the presidential office building]."

Last year, Baktygul represented the Girl Activists in the seven-kilometer Bishkek marathon, racing on foot and bicycle. She says, "I came in 300th but I finished; I was strong."

I wonder what makes her strong: "My mother says I have always had a strong character. I do everything I can to get to my goal. I don't compare myself with others. I just try to be responsible and independent."

WE TAKE A BREAK from interviews while the girls help post Dariya's graffiti outside. They have a formidable collection of spray cans, and select colors thoughtfully. "Graffiti is illegal here." Dariya explains, "We use stencils so we can post images quickly, with one swipe." I am amazed at the nuanced illustration produced by her intricate stencil. So amazed that I forget to ask how she knows about Frida Kahlo. Central Asia is not so far from Mexico after all.

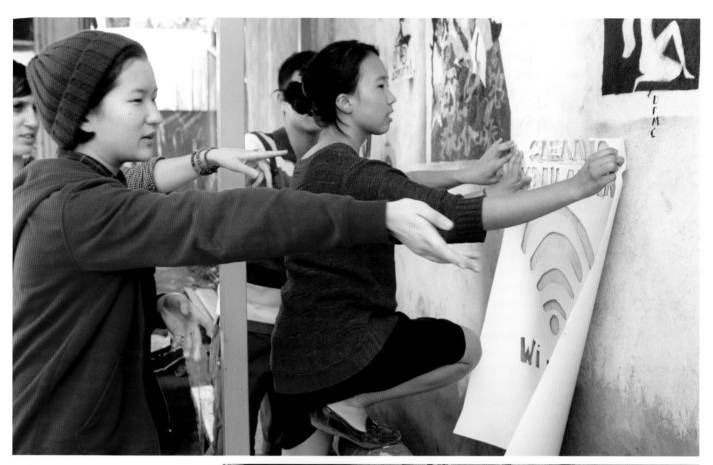

ABOVE, OVERLEAF, AND PAGE 167: **Girl Activists create graffiti, which they test on their clubhouse garden wall.**

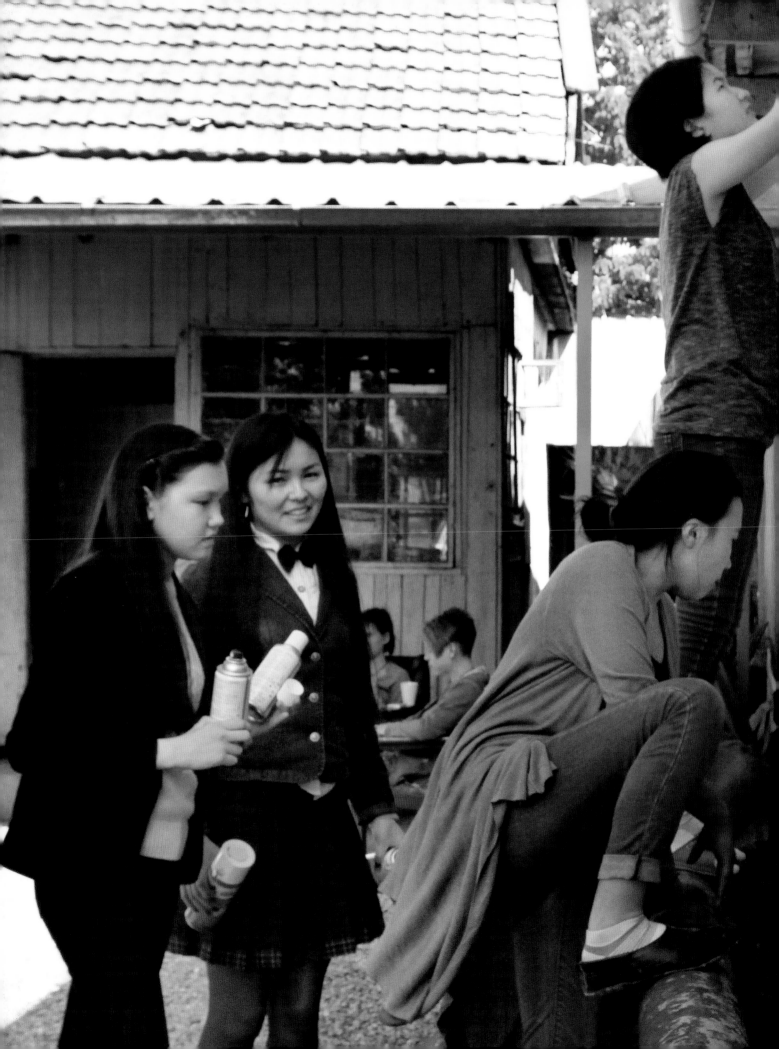

"Girls' rights are human rights."

SEZIM SULTAKAEVA, 16

GROWING UP, Sezim bounced back and forth between Bishkek, where her mother worked, and rural villages where she stayed with relatives. Her story reminds me of how many ways the personal is political.

"Living with my aunt and uncle, there were always restrictions. They had conservative, patriarchal minds. There was no freedom. I had to do housework and look after the children. I didn't even have time to do schoolwork.

"Bishkek was more modern. But there, nobody spoke with me. They said, 'She's from the village with red cheeks and short hair.' I was wearing trousers, shorts and t-shirts, not skirts. Everybody said I was crazy and didn't look like a girl. I also didn't know Russian (it's not spoken in the villages).

"In Bishkek, my mom gave me more freedom. She told me, 'We are friends. We are equal. You can say whatever you want to me. There should be no secrets between us. I will tell you about sex, menstrual cycles, and so on.'

"Soon, I found out that nobody told my friends and classmates about those things. They didn't know what to do if they got their period. When I explained, they said, 'No, no, no, don't talk about that. It is shameful.'

"Even now, when relatives come to our home and hear about my activism, they tell my mom, 'You do not control your daughter. She is making propaganda for shameless things.' My mom cannot confront older people. She just sits and listens. When they are there, she is always acting serious and saying to me, 'Do your homework.' But when I am alone with her, she gives me freedom of activity and speech."

Recently, the Girl Activists presented a talk in Sweden, telling feminists there about their work. It wasn't easy for Sezim to get permission to go. "My mom asked my grandparents, who said, 'Why are you going? You are a girl, it might be very dangerous!'

"I really wanted to go and I said, 'This is my life and I will do what I want to do.' There had to be documents saying my mom allowed me to go, but nobody required a document saying that all my relatives allowed it! I went.

"Before I became a Girl Activist, I had already done activism. It was important for me to stand up for every girl in my class. When somebody put down a girl, I stood up and said, 'Girls' rights are human rights!' Every day, I did these things. It was in my heart and I didn't even know it was activism."

I ask Sezim how Kyrgyz girls are expected to behave. "Everybody has to be similar. You have to be beautiful, cute, kind. To listen to what men say. You have to be silent. You have to be polite. You have to wear clothes that are not open or sexy, or people will say, 'She is a whore.' Society pressures you, and society is always around you.

"At my school, every boy says, 'Girls don't need math and science. You will sit home and do housework in the future. You just need to know how to do makeup and wear beautiful clothes.' Even the teachers say that. One always separates our class into girls and boys. He said, 'Boys, you have to be strong and masculine. You have to do a lot of hard work. Girls, your life will always be easy so don't worry. You just have to listen to your husband or father, that's all.'

I said to him, 'You're not right! People are equal. You cannot say that one has more privilege than the other.' Many classmates were very angry. One friend stood up with me. We said, 'We are for gender equality, for human rights.' But when we saw how aggressive the students were, we were like, 'We—are—for—gender—equality.' We were afraid of them.

"After I said, 'No, you're not right,' the teacher hated me. He said, 'This is all because of the West.' When people talk about feminism, LGBT, progress, safe abortions, many other things, people in Kyrgyzstan say, 'Those opinions are from the United States and Europe. Don't bring those opinions to our country.'

"At one point, my friend and I were crying. He is a boy, and all the other boys said, 'Stop crying. You look gay. You are not a girl. Only girls cry.' I didn't want to cry; I wanted to stand like a strong woman. It was very hard."

When I ask Sezim about her dreams for the future, she admits, "I used to want to be an astronaut. Everybody said, 'That's a kid's dream. It only happens in cartoons and movies.' But I will do my best to have a better life. I will never give up. I want to visit other countries and see how their feminist movement is built and discuss these problems with them. Then I will come back and cause change."

BAKTYGUL AND AISHOOLA are re-choreographing the national dance, which individuals usually perform alone moving like a horse (horses virtually shaped the history of Central Asia). The girls believe the dance should be done as a couple, with equal roles for boys and girls.

I watch in awe: no dancers ever looked more authentically horse-like, shrugging and spreading their shoulders, rolling their feet, virtually galloping. I marvel at the way the Girl Activists use their opponent's power, tradition, to inspire change.

"If you have to fight for bread...you will never think about human rights."

AISHOOLA AISAEVA, 17

AISHOOLA'S EYES ARE SWIMMING WITH RAGE as she describes a family in which all four daughters had been kidnapped, yet the mother still encouraged her only son to abduct a bride. She saw it happen.

"I was at home. I live on the main street. I was preparing for school and heard screams. I went to the window to see what was going on. A car came, grabbed a girl and left so fast that her bag still lay on the street. I thought it might be different with the new law, but that boy gave money to a policeman who said, 'Hey, we understand; everything is fine.'"

Then, she shares a story with a better ending: "One girl who was kidnapped started posting on Twitter from the car. She was like: 'Hey! Hey! Help me!' Everyone knew. Everyone was coming. Now she is free and the person who kidnapped her is in prison."

Aishoola reflects, "There is a pressure on men to find a woman. In the summer, a lot of village families go to the high places in the mountains to graze cows, sheep, and horses. Parents send their sons. But that son couldn't even make a meal for himself. Which woman would agree to live in a yurt? Nobody wants that. So the boys kidnap someone from the village. Next day, she is taken to the mountain, never mind that they never met before. Girls in the village don't know how to use Twitter."

I ask, "What can Girl Activists do to be sure the new law is enforced, even in the villages?" Aishoola responds, "I'm really thinking about it. If you have to fight for bread for your family, you will never think about human rights.

"We could go to the villages and hold meetings with the girls to inform them. We could say, 'Girls, don't be silent. Scream to the whole village: 'There is a law that will send them to prison.' Scream at the boys: 'You will be imprisoned!' Maybe when they hear about prison, they will be scared."

I muse, "Does anyone around here *not* get married?" Aishoola responds, "That would be a real problem. I know a woman who is 40 and not married. *All* people talk about it. My father says, 'Feminists are ugly women who can't get married.' Lesbians cannot come out; the society would not accept it. My cousin is 25 and has no boyfriend. Her mother is saying 'Can you fix her up?'"

Aishoola and the other girls have been working on a documentary about boys, which Girl Activists plan to post online next week. In it, many different boys describe their feelings and experiences. Aishoola translates the edited interviews for me and explains, "The idea is to show that there are many different kinds of boys; they are not all brutes. And to show how they are affected by this culture."

In the video, one boy says, "It is not OK for boys to show feelings. I cannot cry." One boy says, "If I am not home for two days, it's OK." ("Oh my God," Aishoola exclaims, "If I weren't home for two days, my family would take me to the doctor to find out if I am pregnant. When you get married, your parents must assure the boy's parents, 'She is a virgin.'")

"The message the documentary will communicates to boys is: 'Be yourself, an individual.'" In this culture, that message is heretical.

SINCE I CAN'T SEE THE GIRL ACTIVISTS until classes are over, I spend the morning in Ala-Too Square, where hundreds of students are rehearsing the parade that will celebrate the 70th anniversary of Victory Day, when the allies accepted Nazi Germany's surrender.

OPPOSITE: **Aishoola Aisaeva and Baktygul Rakymbaeva re-choreograph the national dance (usually performed solo) so that partners, a girl and a boy, have equal roles.**

This is an important national holiday. At the time of World War II, Kyrgyzstan had a population of 1.5 million; of those, 363,000 fought, and 160,000 were killed—one from almost every family.

Women played a powerful role during the war. Kyrgyzstan was a major agricultural resource for the USSR, and much of the responsibility for farming fell to women. There was a jump in agricultural production: cotton and sugar crops far exceeded what was called for in the national plan. Women sent 100 wagons of relief food to Leningrad, donated clothes, gold and silver jewelry, and contributed enough money to pay for 200 airplanes.

Now, hundreds of girls and boys march past the statue of the legendary national hero, Manas, each wielding a scarlet flag, honoring earlier generations.

This afternoon, the Girl Activists have invited me for tea. We sit on the porch outside the cottage. To thank them, I give each girl a digital watch that displays the time when she snaps her fingers. Three girls sport the watches on their wrists; Baktygul's blinks from her running shoes. She sits cross-legged and reads Manas for me, speaking Kyrgyz in a bold, firm voice.

In anticipation of Victory Day, someone has rigged a red flag from the roof. It shades us from the late afternoon sun. Suddenly, these irrepressible girls run to the other side of the scarlet cloth to create shadow puppets: rabbits, horses, dancing figures. It is wonderful.

BELOW: The Victory Day celebration features students carrying the national flag of Kyrgyzstan. The irrepressible Girl Activists create shadow figures on the scarlet cloth.

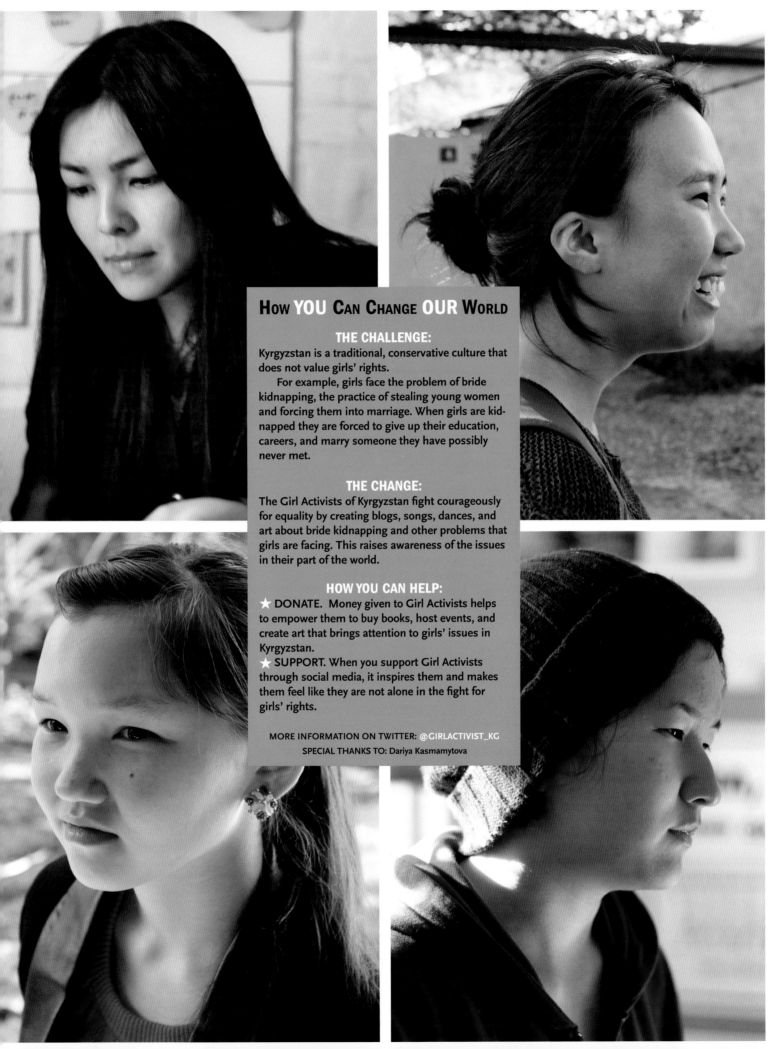

How YOU Can Change OUR World

THE CHALLENGE:

Kyrgyzstan is a traditional, conservative culture that does not value girls' rights.

For example, girls face the problem of bride kidnapping, the practice of stealing young women and forcing them into marriage. When girls are kidnapped they are forced to give up their education, careers, and marry someone they have possibly never met.

THE CHANGE:

The Girl Activists of Kyrgyzstan fight courageously for equality by creating blogs, songs, dances, and art about bride kidnapping and other problems that girls are facing. This raises awareness of the issues in their part of the world.

HOW YOU CAN HELP:

★ DONATE. Money given to Girl Activists helps to empower them to buy books, host events, and create art that brings attention to girls' issues in Kyrgyzstan.

★ SUPPORT. When you support Girl Activists through social media, it inspires them and makes them feel like they are not alone in the fight for girls' rights.

MORE INFORMATION ON TWITTER: @GIRLACTIVIST_KG

SPECIAL THANKS TO: Dariya Kasmamytova

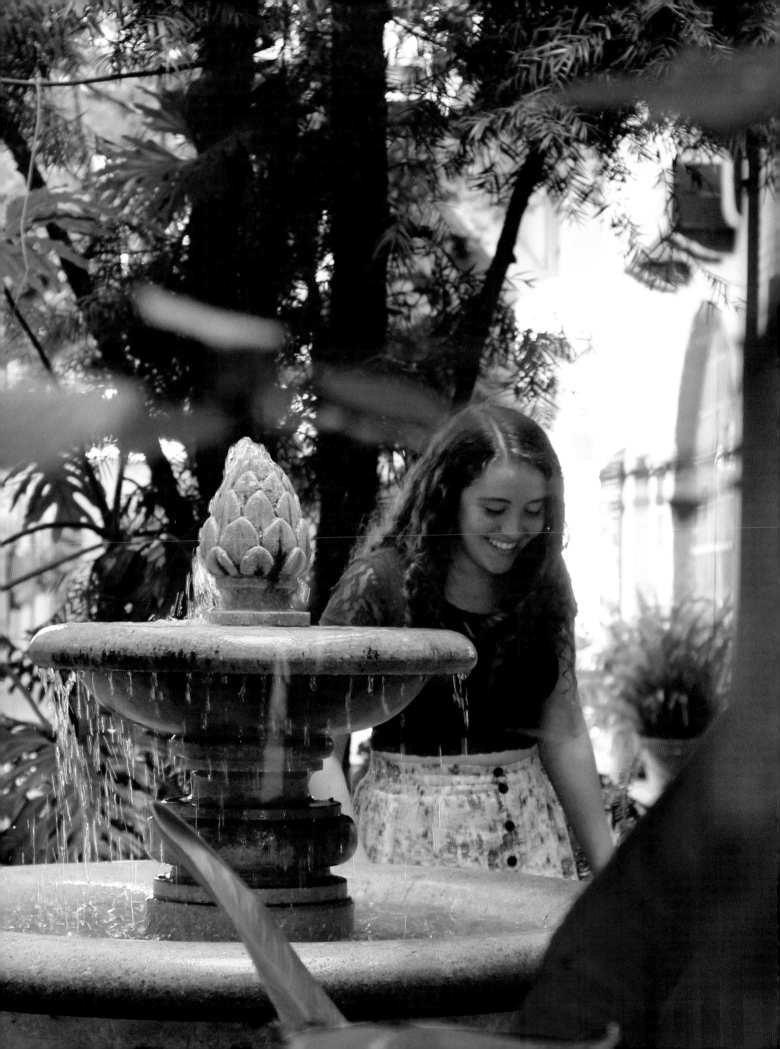

IGNITING ISSUES

United States

"WHERE IS IT, ALEX?" We're lost, wandering through a woodsy courtyard, past a fish pond, fountains and benches searching for Get Lit's office. And I'm counting on my pathfinding granddaughter to find it.

Of all the Get Lit poetry recitals we've watched on YouTube—at the Hollywood Bowl, the White House, *The Queen Latifah Show*—one poem strikes us as especially pertinent: "Somewhere in America."

"We're here, Grandmother!" Alex has come through again, this time by exploring the full length of the second floor balcony. Whew!

Get Lit started in 2006 to stem drop out rates and increase teen literacy for participants who grew up in families that struggle with addiction and homelessness in Los Angeles' roughest neighborhoods.

Today, Get Lit helps over 30,000 teens a year to transform their lives and communities by writing and performing three-minute poems.

"You know from personal experience that it works. That makes you fearless."

DIANE LUBY LANE, FOUNDER/DIRECTOR

"AS AN ACTRESS in my early 20s in New York, I was writing monologues: short, dramatic pieces. We put on a show. Viveca Lindfors came. She was probably 72, silver hair, Swedish. She said, 'Why don't we all start doing poetry together?' I thought she was so cool, but she was turning out to be an old lady if she wanted to do poetry.

"She started by performing Walt Whitman's poetry, and it was unlike anything I'd ever heard. Then she transformed herself into Anne Frank, a 12-year-old child, receiving her first kiss. We all decided we *did* want to do poetry. We started performing classic poems throughout the city. That was one of the most extraordinary experiences of my life.

"Later, in San Francisco, I connected with James Kass, who started the whole spoken word movement and I saw young people doing spoken word for the first time. Blew my mind."

By now, there are spoken word groups all over the United States, but Get Lit is unique in that its players perform original poems in response to classic poetry and literature.

Diane wanted to start Get Lit programs in local high schools. "If you go to Compton and bring Emily Dickinson, people say, 'That's not going to work. You don't have the right poems.' But what other people say is completely irrelevant, because you *know* from personal experience that it works. That makes you fearless.

"Take Dostoyevsky. My high school didn't offer his work to me because I wasn't in Advanced Placement or Honors English class. They decided, based on grades, who was capable of understanding great work and who was not. That's all wrong. You can be a Title 1, English as Second Language student with mediocre grades, and understand literature better than those who are teaching it. Maybe you even need it most. It's a major injustice.

"The Walt Whitman Continuation School is right

OPPOSITE: **Miriam Sachs in the courtyard below Get Lit's offices. Students age 13 to 19 write spoken word poems as responses to classic literature, and kindle teen literacy and social consciousness throughout Southern California.**

by my house. After many schools hung up on me, I called them. A woman said, 'Oh it would be such an honor to work with you; our kids feel like they know you already.' She thought I was the actress Diane Lane. I hung up and cried. But I showed up and taught that class. It was a major success."

Get Lit launched at that school, then John C. Freemont High School, then Fairfax High School, and more. Today, almost 100 schools use their curriculum.

Diane explains, "We have something called the Classic Slam. Each poet or team starts by performing a classic, then responds with their own spoken word poem, which is generally three minutes or less. Spoken word poems are often personal, about your own life. Judges score the poems, usually between 7 and 10. The highest score wins.

"Fifty schools participate in our citywide, three-day Classic Slam festival. In LA, we don't have anything else like this. In fact, it is the only 'classic' slam in the country. Many of the participants have never been in a theater.

"Imagine you're in a busload of students. You roll into Los Angeles Theater Center. Such a mix of cultures! Some are from Harvard Westlake, some from South LA. There are surfer kids. Kids from the San Fernando Valley. All in the 9th to 12th grades, all there to share stories. It's incredible.

"After the Classic Slam we invite the most talented poets to audition to join the Get Lit Players, an award-winning classic poetry troupe, all 13 to 19 years old." They perform annually for more than 25,000 of their peers, igniting a passion for literacy and social consciousness in schools and communities. Nearly 100% of all Get Lit Players go on to college and almost 75% receive scholarships.

"The first time Get Lit Players were on the national finals stage, we got third in the world. Awesome! That team of Get Lit girls came from Performing Arts High School. They felt they were in their rightful place. Rhiannon was one of them."

"Be gentle with yourself."

RHIANNON MCGAVIN, 17

"I JOINED THE SLAM TEAM, and it was the most amazing experience because when Get Lit comes into a new school, it's usually the first time the kids talk about their feelings. It makes you cool because you're not just crying in public, you're writing poetry!

"In LA, we have a public school system that could use a lot of improvement. So much emphasis is placed on science and math! I love biology as much as I love writing, but they function in different parts of the brain and to be fully human, you need to be rounded.

"Not everyone will be able to go on to be an activist but everyone can write a poem. And sometimes, when someone reads that poem, it makes them feel better.

"My big message is: Be gentle with yourself. You don't have to wear make up. Or starve yourself. Be gentle. Treat yourself like you were your younger sister. You wouldn't want to see her hurting herself because she couldn't fit some silly beauty ideal or because she was getting bullied at school.

"We did really well at the city competition and I was selected to represent Los Angeles internationally at Brave New Voices 2014, which is the big slam poetry competition.

"A scout saw us perform and we were asked to be on stage at the Hollywood Bowl during John Legend's tribute concert for Marvin Gaye. Oh my God, it was amazing. It was so amazing.

"Belissa Escobedo, Zariya Allen, and I were at the Hollywood Bowl like the second day of our junior year. So it was kinda like, 'Oh, what are you going to do tonight, homework?' 'No, we are going to perform at the Hollywood Bowl…'

"There were 20,000 people in the audience and 100,000 were watching the online live stream. I thought that I was going to have an aneurysm! I got on stage and thought, 'Wow, I'm gonna die right now. I'm never going to have a first kiss, I'm just gonna die right now. This is fine, it's been fun. I could go right now, it'd be cool…'

"There, a scout from Queen Latifah saw us and invited us to be on *The Queen Latifah Show*. We did our 'Somewhere in America' poem and then she interviewed us and talked about school and creative writing. It was so good!

"Gladys Knight and Gloria Steinem were on the same show. That really hammered home the work that we are doing…not just with poetry, but within our own communities and neighborhoods. It demonstrated to us the collective power of activism and feminism.

"I talk about that with my girlfriends all the time. We hate it when, on the cover of *Time* magazine, there is just one, singular woman, like 'This is the face of feminism.' I'm like, 'What are you talking about? Half the people on the planet are women. You can't have one singular face.'

"So having all three of us be on the show with Gloria Steinem and Gladys Knight showed us the power of everyone coming together, working together, not just doing their individual thing.

"At *The Queen Latifah Show*, there was someone in the audience named Brian DeShazor, the radio host on KPFK, our local NPR station. Brian thought, 'Oh, I have to get these girls on my show.'

"He works from the radio archives where they have hundreds of famous poets reading their work. Maya Angelou, Gwendolyn Brooks…everyone! It was the old poets' recordings and the new poets speaking live, everyone coming together to share the beauty of poetry. It was wonderful.

"While we were on the show a woman named Grace Cavalieri called in and asked us to come to Washington, D.C. For about 30 years, Grace Cavalieri has had a radio program out of the Library of Congress called 'The Poet and the Poem.' Oh my gosh, she's the nicest person in the world.

"Ten minutes later, another woman called into Brian's radio show and sponsored us! Paid for our plane tickets and hotel room so we could go to D.C.

"So last March, we went to the Library of Congress. I brought Miss Cavalieri lavender rosemary from my garden. She asked us to do the poems we read together; she asked for poems we'd written individually. It was so…amazing.

"To be so young and to have so many opportunities, and to know that these opportunities are coming both because you work hard and because people love you and want to see you succeed…is wondrous."

OPPOSITE: Rhiannon McGavin and Miriam Sachs polish a spoken word poem during a Saturday working session. The first time Get Lit poets were finalists in a competition, they placed third in the world.

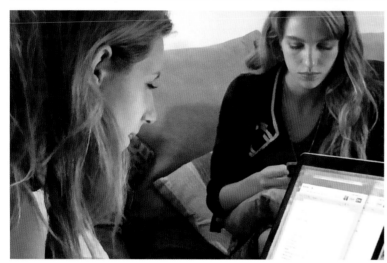

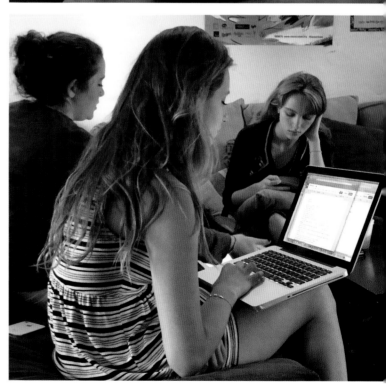

Get Lit Players pour their hearts, souls, minds, and experiences into the spoken word poems they perform at slams, open mics, schools, and on television, at The Library of Congress, The Hollywood Bowl, and the White House.

"I aim at social justice issues but personalize them, always writing what is true to me."

JESSICA ROMOFF, 16

ALEX AND I WATCH RHIANNON AND JESSICA rehearse a poem titled, "Fruit," which Jessica wrote. It's about waiting at the bus stop where she confronts an old man "whose eyes are drooling down my thighs." Their voices bark with contempt and rage: "We are human. You are cannibal!"

Alex frowns, "Did that really happen to you?" "Yes. Older men being really creepy. Gross, right? Not good. Keep your cell phone and a friend with you at all times."

Jessica explains, "I write about situations that have happened to me that I've noticed are trends with other girls. Things I think should not have happened. I aim at social justice issues but personalize them, always writing what is true to me.

"Normally, what I write is about men and boys. I want to illuminate for them how incorrect it is to take advantage of girls just because they can.

"I recently wrote a poem that's about being at a party and how guys treat women. The whole date rape thing with drugs, a situation when I was really true to myself. Sometimes when I write a poem I like to conceal the story with a metaphor, say what I'm

saying—but not really. This is the first time I've been really honest.

"Each time I'm on stage I start shaking. But you get this feeling in your stomach that you can't do anything else. I have a love-hate relationship with performing.

"I like writing most. That's when I pour out my thoughts and feelings and can see them on the page. I was an awkward seventh grader, more a math person. I used to be afraid to raise my hand in class.

"One time in English class my teacher showed us a video of spoken word. I liked it. That's the first time I felt, 'Oh, someone gets me!' Then I got goose bumps and thought, 'OMG, this is amazing.' I got really interested. I went home and watched the video again. I cried. I fell in love with poetry.

"That changed my life completely. I was planning on playing volleyball, focusing on that in college, but I didn't love it. When I heard my first poem, I found something I actually loved.

"Get Lit came to my school. I started going to open mics. Diane said, 'You should go to the workshops on Saturday.' They took videos of me. You could barely hear me.

"Now, I *have* to say what I'm thinking. Getting people to listen and understand has boosted my confidence. I project now. Take myself seriously.

"And I have a community. Here there are so many different people, but we all understand each other, and have so much in common. It's opened me up to a new world. I really like it."

"Our job is to foster teen literacy."

TASHI BROWN, 18

"I HAVE BEEN WRITING POETRY since I was six, right after my cousin molested me. It was like: I didn't know how to deal with it so I wrote about it. I didn't even really know what poetry was.

"My teacher found a way to input Get Lit into the school curriculum. It took me a year to get

into it. I mostly was a dancer before I began really actively pursuing poetry. I was also a cheerleader. And a tennis player. And a belly dancer. My mom figured I needed to be active to keep me out of trouble. So she put me in all kinds of things like that.

"But I figured, I can do something besides make myself an object. So I decided, 'OK, I'm not gonna dance anymore. I'm gonna write instead. And go to open mics and perform my pieces.'

"Writing is the hard part. You have an idea. It's in your head. But it's really hard to execute it. You want it to be perfect. But it's not always like that. So you just write it to get it written, not to get it right. When we write our poems, we try to make sure they

sound as raw and real as we can without being too unsettling."

Tashi's poems are inspired by her life. "It's not an easy one. I had to take care of my grandparents because they couldn't take care of themselves. So I didn't really have much of a childhood. I did whatever I could to help my grandparents: cook, clean, wash, scrub the walls. Then just bring home good grades at the end of the day—that was my job.

"Our job as teen poets from different socio-economic backgrounds is to help foster teen literacy in Los Angeles, which has the lowest literacy rates among at-risk youth that you will ever hear of.

"Performing is my favorite part. Making connections with the audience. The first show I did was for kids about your age, Alex. I took a lot of time with the piece, "I'm as Old as Dirt," and with my performance work. That the kids related to me meant a lot.

"This year, my classic poem was 'Imagination Does Not Exist' by Hafiz:

You should come close to me tonight, wayfarer, for I will be celebrating you.
Your beauty still causes me madness...

Tashi's Spoken Word response to the Hafiz poem is titled "Monster." She recites it for us now:

My beauty caused you madness.
Your darkness reminded me of a murder of crows spreading amongst Katrina wreckage.
I should've run, Converse pounding against concrete, heartbeat like hummingbird wings with Hell-hounds on my heels...
It's not in your nature to learn that no means no.
Since you were born, you've been taught that this world and everything in it belong to you including Eve's daughters...

I ask how Tashi knew that a flock of crows is called a murder. "Heard it on *The Simpsons* when I was about six."

Of all the poems she's written, Tashi is proudest of her spoken word response to a girl named Senna, an indigenous, teen-aged Peruvian poet featured in the documentary, *Girl Rising,* who is pursuing her education even though it is illegal. Tashi recites part of that poem for us now:

I am the voice of minorities and one day we will realize there is nothing minor about us.
We refuse to continue telling our six-year-old girls their voices are minor, those same girls running rampant in schoolyards trading skinned knees and double Dutch for STDs and double standards...
Who knew ink would cut just as deep as a knife?
It taught me to turn my pain into art...marching to the beat of my own drum...on a mission not to preach but to teach all these girls...that there is a way out...
We will pay less attention to boys and more to books. With our words, we will rip the fabric of this nation and weave a tapestry of liberty, equality and femininity.
"This is a man's world?" [maniacal laughter] *This is my world. This is your world. This is our world. It always has been.*

Alex asks Tashi, "How do you hope your audience will change after seeing your Get Lit performances? What would you like them to do or think differently?"

Tashi says, "I want them to think there's hope out there. I dealt with a lot—personal battles with child molestation, eating disorder, self harm—I want audiences to think that if I can do it, given where I come from, you can. You have no excuse."

Tashi Brown (LEFT) and Mila Cuda (RIGHT) rehearse in the Get Lit office.
OVERLEAF: Get Lit Players enjoy a pizza break during a Saturday rehearsal.

"We are poets for progress."

MILA CUDA, 15

MILA WEARS BUTTONS AND BADGES. Two say "Folk Punk Forever" and "Fine Ass Feminist." When Alex asks her to tell us about herself, Mila says, "I have two dogs, Mugsy and Finnegan. I like Frida Kahlo's mind. I sing and dance in my room for fun. I say poetry in the shower.

"The feeling you get when you recite a poem for the first time is the most passionate feeling you can ever have. When I write a poem, it is usually an urgent thought, something I'm dying to say and finally took the time to write it out eloquently.

"When you go up and perform it, get that all off your chest, it's a fantastic feeling. It's like you're opening up and there are rushes of wind. It's a light, airy, nice, feeling.

"I'm probably most known for a poem I wrote for my best friend for her birthday. It's called 'Dakota.' She's African American and Native American.

My skin looks like milk and lilac candles. My skin is easy to wear on my shoulders like a light breeze... My best friend's skin looks like incense and caramel sundaes in summer...It is smoother, like pressed coffee poured into your favorite mug on a sick day off from work.
I have never witnessed bullets. The word, oppression, has never leapt from my tongue...

My best friend is afraid of the dark. Not the monsters that hide in shadowy hallways but the injustice that comes when the world decides to turn its light off.
My mouth knows how to say, "I'm sorry." Her mouth knows how to swallow the truth. But we have both become familiar with the taste of silence.
Once we were waiting at a bus stop near her house and a lady walked up and asked if she could sit down on the real estate ads and the cold metal.... that lady started whispering to herself about the nerve of incense caramel sundae and coffee skin: "How dare someone like her think she could sit next to me!"
That same day we went to Chinatown and got cat-called on the street but we just kept walking...
A man asked us how a white girl and a black girl could be friends. Silence took us by the hand and once again we just kept walking ...
I'm sick of letting fear get in the way...There's no difference in our laugh, no difference in our style because we both share a passion for thrift shop flannel pants...We both grew up with an understanding of how to treat one another....
Even on a sunny day, when the world has decided to turn its light on, milk and caramel sundaes will always taste right.

Mila performed that poem at Get Lit's Classic Slam and, with her team, presented poems about mental illness and school shootings. She describes what it took to get to the finals—and win.

"My team and I were staying after school until 6:00 every day, performing, going to open mics. Doing the same poems, getting them perfectly done, perfectly done. We were all very proud of each other for doing it. We were so nervous! A lot of us had never performed in a slam, ever!

"We were a first-year team of all females. It was not expected that we were going to win. Our Get Lit team is called up to the stage. That feeling on stage! There are five of us, plus two coaches. We're all up there holding hands and they're going to call out the winners.

"The minute they say our name, my good friend just breaks down into tears and picks me up and twirls me around. A fantastic feeling. Definitely one of the most fun moments with Get Lit—or in my life. It was fantastic."

Mila reflects on her team's activism: "We are poets for progress."

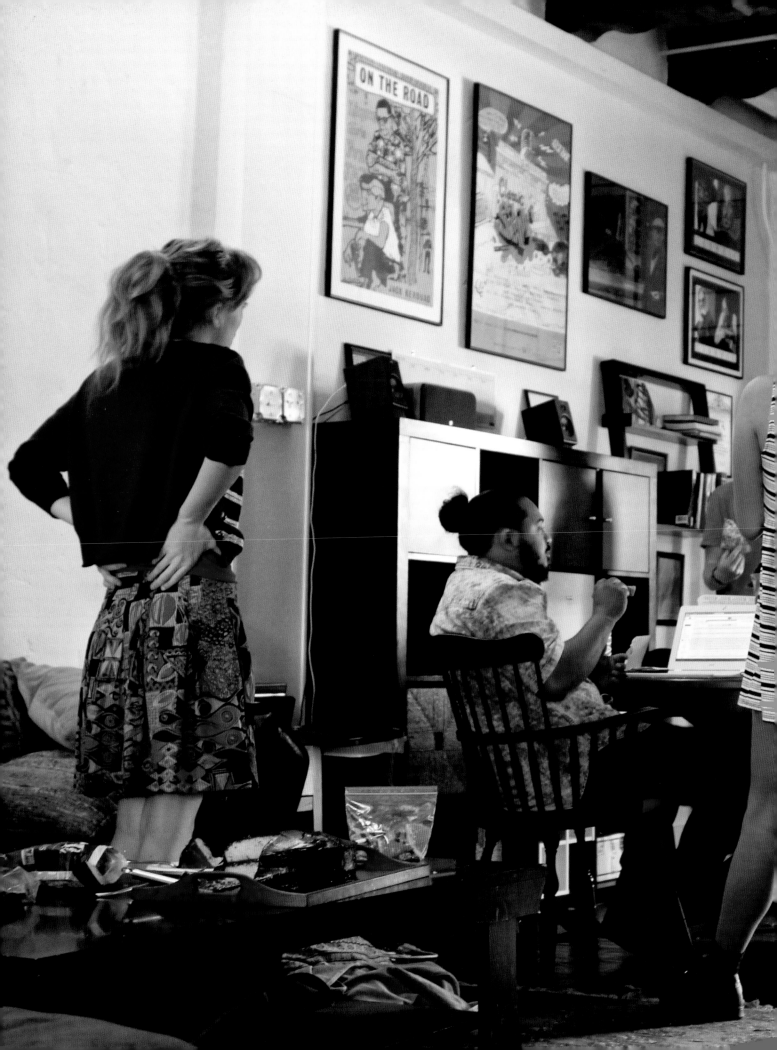

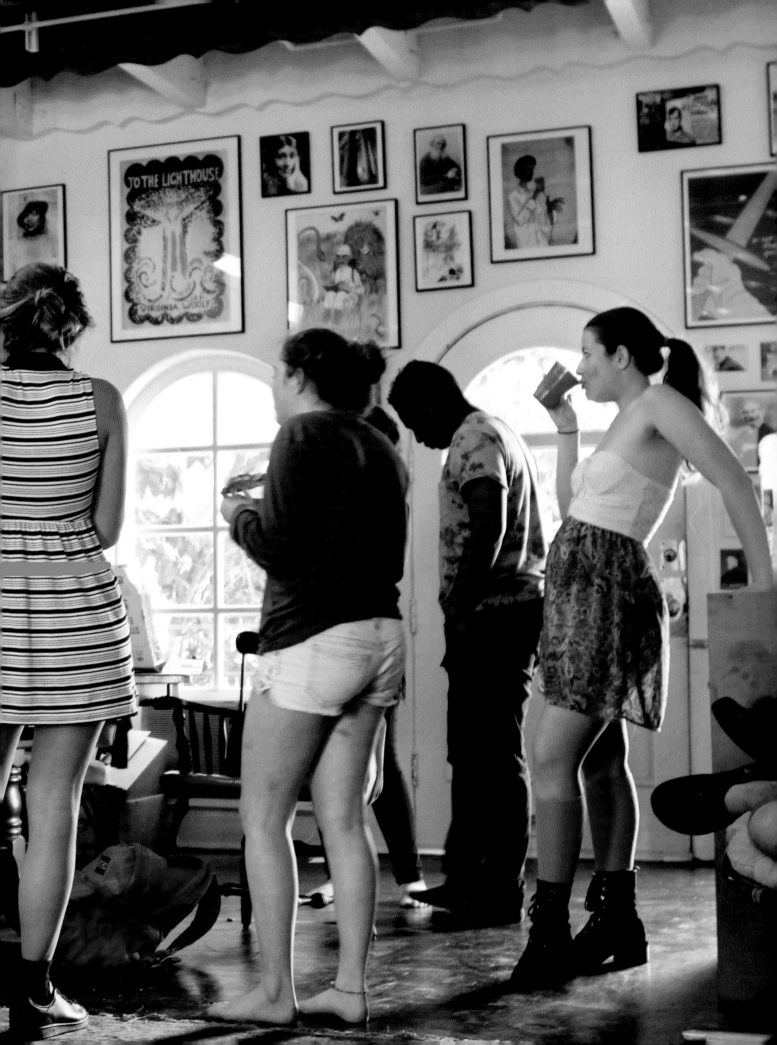

"Your face doesn't define you. Your skin doesn't define you. Your beauty is within."

JAMIAH LINCOLN, 17

"I'VE BEEN WRITING POETRY for a while, maybe since I was 10 or 11. At that age, I developed this skin problem that you see here. Doctors didn't tell me how it happened or what to do to make it go away. I used to write about it all the time. I put my feelings on paper.

"I am sure there are other people with disorders—or something that makes them insecure—and they don't think they're going to climb out of it. I know how it feels to not fit in. I feel obligated to change other lives.

"It's really, really important for other young girls to know that it's going to be OK. Your face doesn't define you. Your skin doesn't define you. Your beauty is within.

"I found Get Lit on the Internet. I went to an open mic. The first time I was on stage in front of people, I didn't think it was the right place for me. I forgot my words.

"They snapped for me. They said, 'It's OK! You can do it; you can do it.' I restarted my poem and I killed it. I probably got the best applause of the night. That poem was titled "The Thirteenth Amendment":

*Free me! The constitution says we're equal but that
cannot be. You beat, I cry.
There are no reasons to take away innocent lives.
Why?
I'm just like you. Just with extra pigment received
from the sun.
Why can't this be done? Peace. Equality. Rights. But
we walk around doing wrong...*

We ask Jamiah which Get Lit experience was most fun for her. "Gonna say Dodgers Stadium. We had a fundraiser there. I performed in front of 300 people. It was really exciting.

"We wrote a poem about how you have all these opportunities because you're alive. You want to be an astronaut. You want to have a family. You can do that because your heart is beating and you're alive.

"Working on the classic poem, let's say there are lines you don't understand. You look them up. You read about the author. The author's childhood. You learn not only history…but they say history repeats itself, so you learn the future.

"At last month's slam, we were responding to 'All I Gotta Do,' by Nikki Giovanni.

*all i know
is sitting and waiting
waiting and sitting
cause i'm a woman
all i know
is sitting and waiting
cause i gotta wait
wait for it to find
me*

Jamiah Lincoln has been writing poetry since she was 10 or 11.

"We researched what she was talking about. She's sitting and waiting for her rights. On our team there were an Asian, Caucasian, and two black girls. We found somewhere in the middle where we could all meet, not just the culture or color of our skins. That was very important to us.

"We responded in a manner that other girls could understand: that we felt oppressed. Here in America, at school, in our own homes. We connected her poem to ourselves, and at the end we said, 'You know what? We don't have to sit and wait for things to be handed to us. We can earn them, work hard, get our rights ourselves.'"

Alex asks which Get Lit experience Jamiah is proudest of. "Yesterday we had a blitz at a school in San Diego. At the end, a little girl came up to me and said, 'You're an amazing person. It's so good that you can stand up and change lives and speak for yourself and the issues in America. I'm proud of you.' For her to say, 'I am proud of you,' really means a lot.

"This is what I love to do. Where I feel most comfortable. It's great that you can help yourself and others at the same time. I had to find somewhere to put my feelings. Now, I have some place. I can express myself through power."

THE GET LIT PLAYERS HAVE PIZZAS delivered for lunch. They eat standing, talking about Daveed Diggs, former Get Lit teaching artist who is about to open in *Hamilton* in New York, playing both Lafayette and Thomas Jefferson.

"Poetry is how we connect."

MIRIAM SACHS, 17
"I DID MUSICAL THEATER for four or five years with a theater company called Encore. *Charlie Brown. Peter Pan.* Then I realized I couldn't really dance and I wasn't that good at singing; acting was my favorite part.

"That got me on stage and not nervous—but it was very different from performing poetry. It's sometimes hard for me not to go over the top 'cause on stage you have to be big. Poetry is more internal, more like a conversation.

"In fifth grade, I used to write poems in class instead of doing my homework. One day, the teacher said, 'See me after class.' He was like, 'Here's my college textbook for creative writing.' It was *Writing Down the Bones.* Two years later, one summer morning, I read the entire book in one sitting.

"After that, I started keeping journals like Natalie Goldberg said in the book. I have 25 or 30 journals that I've kept since seventh grade. It's been therapy for me, my way to deal.

"Putting my thoughts and experiences into words made me more aware of what they were. It's sort of like prayer. When you say something to your journal, your friend, your mom, or God, it helps. You can see your thoughts, look at them. They're not just rumbling around in your head.

"At first, my journals were just free writing. Slowly that evolved into poetry. Then I began to craft it into something more intentional."

When Miriam won the classic poetry competition at her school, two teachers told her, "The way you perform, you would love Get Lit." In the middle of her sophomore year, Miriam traveled for 45 minutes to attend a Saturday morning Get Lit session.

"But they had just moved. Their website was super behind; no new address. So I was like 'No, this is not happening.' Then I thought, 'No, I need to do this!'" She located them via Facebook.

Alex wonders, "Are kids who like poetry considered super smart? Nerdy? Cool? What?" Miriam laughs, "I think it's a mixture of nerdy and cool. It's like anything. If you really like to herd sheep and you're great at it, people will be like, 'You go, shepherd!'

"Poetry's the same way. If you write bad poems, people think, 'What are you doing with your time?' Poetry is hard to be good at, but if you're prolific and passionate, people will respect that.

"Get Lit taught me about working with other people. It was really hard for me. You just have to detach yourself and be open to changing and editing and editing and editing. When you try to create something together, it can be a very tough process. 'I want this way.' 'I want that way.' You produce something, in the best cases, that is the best of both worlds. And that is awesome."

This morning, Miriam has been rehearsing her poem, "Nightmare," which she will perform with Max Toubes (yes, there are boys in Get Lit). "There is an intention in every poem. With this one, we

want you to feel the Holocaust. We want people to know that the Holocaust can not be forgotten."

But this train is a savage monster, licking its lips, grinding its teeth, opening its jaws, and consuming our whole village.
But mom made sure we brought our jackets. "God will make sure we get there safely. A work camp with better conditions, shelter from the war."
But it's too dark for feeling. We are not human in here, but cattle.
There is no room, there is no food, there is no water, there is no air, we are not human in here, but compost.
Holding his hand is the only home I have.
No sun, no moon, no rise, no set, just one long evening. Surely it was a nightmare.
The smell of coal is replaced by sweat. The soldiers shove. Their black rifles dictate. We file into two different lines, heel toe.
This is how they try to divorce us from ourselves. Cut my hair from my head. Cut my clothes from my shoulders. Cut my culture from my bloodline. Cut

my name from my lips. Cut my God from my soul. Surely it was a nightmare...We were too numb to feel pain...

Miriam considers a phrase on the Get Lit website: "Poetry is the soul talk of a culture." "I'd say poetry is soul talk, period. If I come from a Jewish background and have respect for what has happened in Jewish history, I bring that forward in my poetry. Someone from a different background brings their life and culture forward.

"When you write something that's truthful, it's bound to be truthful for somebody else. Despite our differences, everybody has a soul. Poetry is how we connect."

BELOW: Although the writing process looks tranquil, Get Lit's activist poets help more than 30,000 teens a year transform their lives and communities.

How YOU Can Change OUR World

THE CHALLENGE:

Teen illiteracy is increasing. Teenagers are not being educated well and don't know how to participate in their communities. Illiteracy can lead to low self-esteem and minimum wage jobs that negatively affect their kids.

THE CHANGE:

Get Lit promotes literacy to youth in LA. They expose kids to classical poetry and encourage them to write their own poems as responses. Every year, they host a fundraiser at Dodger's Stadium where they invite celebrities that they have written about. Get Lit wants to make it totally rad for kids to learn poetry by participating in Classic Slams and open mic nights. Slams promote literacy because, "Oh, that's really cool! I want to learn—I want to do that. I want to stay in school."

HOW YOU CAN HELP:

★ DONATE. Get Lit needs funds to expand their amazing programs to more schools.

★ GIRLS CAN GET INVOLVED by writing poems and going to age-appropriate open mic nights. "Anybody who feels like they can do it should be able to do this."

★ "ENCOURAGE [girls]... to find their own voices and path, do what they love to do and change the world in their own way."

MORE INFORMATION: WWW.GETLIT.ORG

SPECIAL THANKS TO: Rhiannon McGavin, Diane Luby Lane, Mila Cudo, Jamiah Lincoln, Tashi Brown, Jessica Romoff

DEVELOPING SOLUTIONS

Mexico

TODAY, MARIA MAKAROVA, a Russian who hails from Siberia, gives Alex and me a tour of her adopted city, Guadalajara, Mexico. As we explore, we learn about one of her passions.

"I imagine, I invent, I engineer."

MARIA MAKAROVA, REGIONAL COORDINATOR
MARIA IS ONE OF A HANDFUL of women leaders in Guadalajara's thriving technology sector. And she is passionate about adding to their number.

"The cultural stereotype says boys should do technology and girls should do design. I don't believe it."

Her life proves her point. Maria's father is a physicist and her mother, a chemist. "When I joined Computer Science Club in high school, it never occurred to me that I was the only girl."

In 2013, Maria launched Mexico's chapter of Technovation, which teaches teams of girls to create mobile apps that address social problems. These teams will participate in an international competition called the Technovation Challenge.

Each team identifies a problem, quantifies the demand for a solution, programs an app for Android mobile phones, creates a prototype, writes a business plan, and presents it in a regional competition.

The teams' scores are entered into a global system, and the ten highest scorers participate in an international competition in San Francisco, California. The finals are called World Pitch. Its judges are information technology executives and it awards $10,000 prizes to the winners of middle school and high school divisions. Winners typically use the money to launch their apps.

Technovation chapters offer 12-week programs in 87 countries and have engaged over 10,000 girls in grades 6 through 12 since it began in 2009.

Maria mentored Technovation girls in the San Francisco Bay Area after she earned her PhD in Electrical Engineering at Stanford University. She moved to Guadalajara when her husband, an executive at Oracle, convinced the company to open a major software development lab there.

Maria talked with Tara Chklovski, who founded Iridescent, Technovation's nonprofit parent. Tara urged Maria to launch a Technovation chapter in Mexico. The program had just been tested in California and Brazil; "It's ready to go!" Tara said. "Here! Take it to Mexico!"

After she moved, Maria had a baby (first things first!). Then she gathered a group of women engineers at Oracle in Guadalajara. "They already wanted to participate in some kind of community project, and when I described Technovation's program, they were all for it. 'Yes!' they all said. 'Let's do it!'

"We posted signs at Oracle saying, 'If you know a girl between 14 and 18, invite her to an information session at Oracle.' That was the beginning. We got 60 or 80 girls from all over the city because somebody they knew worked at Oracle. We got girls from private schools, public schools, all different economic levels. So that was a very fun first group.

"We did the first Hack Day, which is a workshop where the girls make their first programs for cell

OPPOSITE: **Technovation-Mexico's Team Saffron competes at World Pitch 2015 where judges will award a $10,000 first prize for creating the best mobile app and business plan to solve a social problem.**

phones. They write code on the computer and send it to their phone, and go, 'Wow, my phone does what I told it to do!' Today, we have 50 teams across Mexico; that's about 250 girls.

"We also have 100 volunteer mentors, two per team, young professional women who do this because they want to. It's the mentors who coach the girls, and help run events. Some of them translated the entire curriculum into Spanish.

"Usually, we find mentors by networking. But we did speak at a local university that encourages entrepreneurship. Sad to say, we were the only women on the stage!"

Technovation's mentors are the secret sauce. Sofia Lorena Romero Tamayo, for example, is the technology mentor for Team Saffron. Sofia teaches in English since the competitions occur in English. She chats about algorithms, the series of rules that govern a function, then assigns the girls to write an algorithm for going to the bathroom.

The girls giggle. Sofia reads their algorithms aloud, with comments and kidding: "You opened the door to the bathroom, but you didn't close it. What if someone wanders by?" "How would your algorithm be different if you were a boy?" Laughter. One girl tells me later, "Sophia always knows how to make us smile."

Maria tells Alex and me more about Technovation's program. "After the teams have picked the problems they want their apps to solve, we sponsor Idea Night. Everyone presents their ideas. They pass out their market research questionnaires to be sure their ideas appeal to other girls. They get motivated when they see each other's ideas, which are always cool. They give each other suggestions, 'Please make this app! I'd like to have it.'

"Sometimes we do a Master Class for Girls, with speakers who talk about marketing and logo design. And of course, Technovation conducts finals at the end of the 12-week programs, with prizes from local companies."

With luck, a Mexican team will qualify for World Pitch in San Francisco.

"When Team Saffron won the Mexico finals last year," Maria recalls, "the girls got to go on the radio. It was a big boost for them. They thought, 'What I am doing *is* cool; and people are recognizing it.'"

Maria is passionate about involving girls in Technovation's program for many reasons.

"For me, the goal is that girls become familiar with technology. If they're a doctor and know what they can do with technology, they can be a more effective doctor.

"It's important to encourage girls to do more than just follow directions. They should do crazy, wacky things, which the traditional school system has kind of eliminated.

"In Mexico, people see a problem and say, 'That's just the way things are.' Technovation forces girls to think of ways to solve real problems.

"I want the girls to believe that they can do what they want. Generally, they want to do really good things.

"Technovation gives girls the tools to use if they want to start any kind of business.

"The program helps develop confidence. Girls here don't have freedom and encouragement to pursue their dreams.

"The girls and their parents are not aware of technology jobs. It's not something they ever considered as an option."

I would add that the competition teaches girls perseverance. In 2015, Team Saffron, a middle school team from Guadalajara, presented their app in San Francisco at World Pitch. The team was elated to have gotten that far, but disappointed when Pentachan, a team from India whose app encouraged recycling, won the $10,000 prize.

Yet almost all of the Team Saffron girls are participating in Technovation-Mexico's 2016 program. I ask Maria what she said to encourage them to try again. "You didn't lose because you weren't good; everybody was good! The winners went for a problem that would have the biggest impact on the judges. But your idea was cool, too. Keep going!"

Technovation-Mexico's TechNational Team (TNT) is meeting at Sucursal Sotano, a bookstore and café that provides something its members can't do without: WiFi.

Two mentors set up their laptops on the Mexican-tile-topped table, and pull up cane-backed chairs; Citlali González Morales, the business coach, and Miriam Vega Ortiz, the technology coach, grab cups of coffee as the girls begin to gather.

Five middle school girls file in: Luz Ximena, Ximena Fernanda Ortiz Carstensen, Sandra Marlene Cobian Aquino, Sofia Garcia, and Karla Sofia Hernandez de la Vega (whose Technovation t-shirt reads, "I imagine, I invent, I engineer.")

OPPOSITE: While their families wait, Team Unbreakable Technology, a two-girl team, meets with their technology and business mentors (professional women who volunteer) at Oracle's offices in Guadalajara.

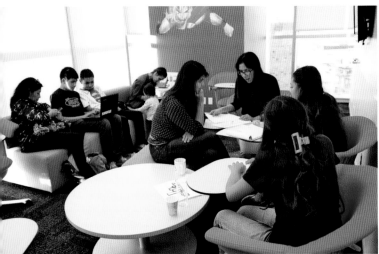
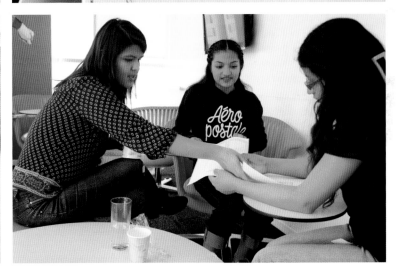
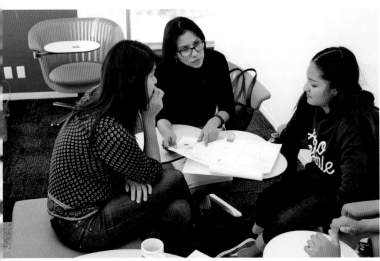

"Girls can do this! There are still people who don't believe that."

SANDRA MARLENE COBIAN AQUINO, 14

ALEX AND I SIT ON THE BALCONY and talk with Sandra. Mentor Blanca Janet Moreno Gallegos has come to translate, but Sandra (who has cousins in Southern California) speaks English *muy bien* and *muy rapido.*

"At Hack Day, they taught us how to program. It was fast. I did like three apps. One was like a crystal ball: you shake your phone and it was like: 'Yes, no, maybe!' Another was like a bowl of paint, happy colors, and you draw. I was amazed how easy it is to make an app.

"I really like technology and computers—-knowing things they don't teach in school. When I showed my parents the apps I did, they were like, 'Oh my God, how'd you do it?' And I showed them the buttons and they were like, 'Did you really understand this?' I did! It was really easy! So I got trapped in it."

Sandra tells Alex that "the most important thing Technovation does is to motivate girls to take action—because girls can do this! There are still people who don't believe that. And there are girls who do nothing about it. Convincing girls to do something is really important!

"Your teammates all have to agree. You cannot just do what you want. You have to get organized, not just say ideas out loud. Once you've passed that, it's easy. You just communicate. In technology, there's a whole backstory. You have to learn graphics…logos. I've learned a lot.

"There's this feeling that's very good, when you're going to help someone. And you're going to do it on your own! It's like a little movie. You know how they call you up to the front at school when you do something important, like you have a ten in the math competition or in spelling bee? I would like it if they said: 'They got all the way to San Francisco!' *That* would be really cool!

"The ultimate objective is to make the world a better place. There are boys who would like to help. And they know a lot of technology and programming. Some boys always want to be leaders and tell us what to do—they're like dictators. (Girls can be, too.) If there were boys on the team, it would be a little harder to come to an agreement about what

the app would do and how to develop it. But I think if you are committed and want achieve your goals, you can surpass those disadvantages.

"I want to, like, make a difference. After this app, it's not just 'I made an app, I'm a girl, I am cool.' I would like to take action on other things and try to help with other problems. One day you could look at the App Store and say, 'Oh my God, I love this app. Who made it?' I made it! That would be really cool!

"If we have the opportunity to develop another app to solve a different problem, that would be awesome. We could make the world a better place! It's true!"

Team TechNational's App

SANDRA: Teenagers have access to drugs and other substances that can cause addictions. Their friends can offer them substances, even. We were like, "This is just an app. An app can tell you, 'Hey, stop drinking, you don't need it.' But it's not able to motivate, be concerned about you, or make you change your mind." So we had to find out what would make you stop. We talked to Hermena's mom, who is a psychiatrist. Contacts that her mom had, helped, too.

If you are falling into an addiction or already have that addiction, our app can help you by giving you tips. You can read stories from ex-users about how they recovered. Get professional help from doctors and psychologists.

You can configure the app to call your parents or a psychologist. If you are in a bar and think you are gonna fall—you are panicking—so you ask for help. You might have a relative, a friend, or a teacher who knows you and wants to help. You could do an anonymous chat; doesn't have to be people you know.

We have a glossary; we call it *Drugapedia;* you choose, for example, marijuana and it tells you the effects it has on your body and which organs, long and short term, will be impacted.

The app will be free. Revenue will come from professionals who will advertise on it. We will promote it with social media because that's where teenagers are. Also, we will be introducing it to schools, and to groups that help people with addictions.

The name of our app is *HelpApp.* Our team's name is TechNational Team, and we used the initials. I think I gave them the name: HelpApp by TNT.

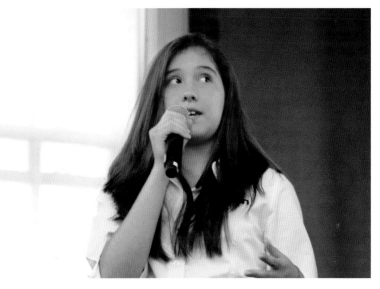

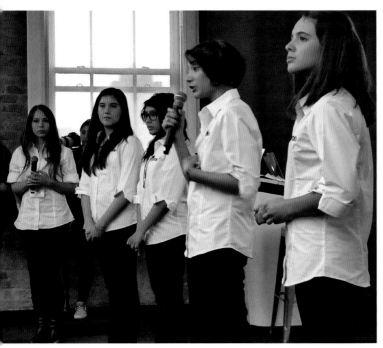

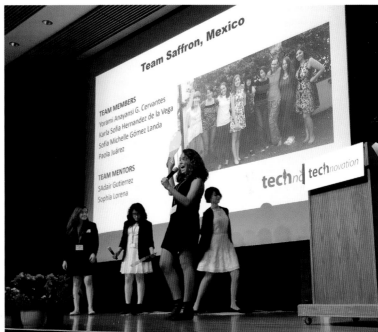

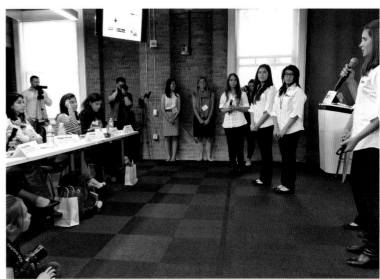

At World Pitch 2015, Mexico's finalists present their mobile app to stop child obesity.

THE UNBREAKABLE TECHNOLOGY TEAM meets in a conference room at Oracle headquarters, a skyscraper with superheroes painted on bright walls and coffee machines that offer lattés and cappuccinos.

Two mentors, Zariá Casillas and Ariana Medrano, welcome Raquel Ortiz Nava and Dülcë (Abby)

Ramírez Jiménëz. They pull chairs into a circle. Both girls are home schooled and their families have accompanied them to the meeting.

"Girls should have the same opportunities as boys."

ABBY RAMÍREZ JIMÉNËZ, 14
"YES, MY FAMILY IS HERE. My mother is with my baby sister, who is one year old. The boy with the Superman shirt is my brother, he is 11. My dad works at Informatics doing programming. When I was little, I liked that, so my mom thought Technovation would be good for me and would help me decide what I will do when I grow up.

"I went to six Hack Days. Usually girls only go to one, but I went to all of them. If you don't know programming, you learn it, step by step.

"I told my friend and said, 'Come participate with me' and she accepted. We are a two-person team,

Technovation's smallest. My friend and I like to hang out and work together.

"Technovation helped me to work in a team. My friend and I have differences. At the moment, I am doing the logo design. She prefers pastel colors but I don't. The mentors help us resolve disagreements."

"What I want everyone to know is this: Girls should have the same opportunities as boys. That's important if you are a girl or if you are tall, fat, no matter what. And…if girls set a goal, they can reach it."

We walk across the sprawling campus of The University Marista de Guadalajara, and climb to the second floor computer lab. Mentor Sofia Lorena Romero Tamayo is meeting with Team Saffron, which, last year, won the Mexico Finals and competed at World Pitch in San Francisco. Three members of last year's team, plus one new participant, settle in front of computers. The new team member is our first interview. Passionate and animated, she speaks fast, fluent English.

Team Unbreakable Technology's App

ABBY: It will help the kids who have diabetes. In Mexico, there is a lot of obesity and obesity is a cause of diabetes. It's easier to buy a hamburger than to make a healthy sandwich.

We will have two versions of the app, one for the mom and one for the kid. The mom can see when the child got an insulin injection and the child can record what he ate that day. There will be games for the child so he can learn how to take care of himself.

I designed the model (with the team) and the logo. I made a questionnaire. My mother got a doctor to help us and we asked some questions, He told us to check out a similar, existing app, and we researched it. He helped with nutritional information.

If we don't win the award, we will be sad because we made an important thing. If we win, we will use the $10,000 prize to continue to develop the app— or maybe donate it to an organization that's working on diabetes.

"Boys should have the same opportunity as girls."

ALEJANDRA "SAORI" TANAKA ACEVES, 14
ALEX INVITES SAORI to "tell us about yourself," and she replies, "My parents are divorced. I live one day with my mom and one day with my dad. It is really complicated; I have to take everything to school. I like to hang out with my family…my friends…people I love and care about. I really like biology and

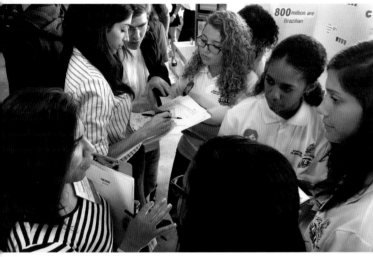

physics. I am really good at math and stuff like that.

"The first day our Technovation team met, I didn't know anyone. I was like, 'Oh my God!' I was so nervous! I told my mother, 'No! I don't want to be here!' She was like, 'No, you're strong. You can do this.' I was so nervous that I thought I would cry. 'I don't know anyone, I am so alone.'

"It turned out OK once I met my team. It was really amazing. They were so nice to me. They said, 'We really want you on our team.' I was like, 'Oh. OK. I am fine.' We are all like equal. If someone has a problem, we are like, 'Oh, I'll help you.' That's cool, too."

Alex asks, "What was the most fun?" Saori replies, "To get to know my teammates' qualities. To get to know them better. For example, Sofia is really kind. I like her attitude. She has a beautiful soul.

"Before, I was like, 'Eh? Just a computer!' But now, it's really interesting. I know how the computer and programs work. I'm like, 'Oh! How can you DO that? I want to know that!' I like to learn.

"I really like the way our mentor thinks. She says it's really important that we act like a team and not just individuals because every job has to be done equally or someone can feel bad and things like that.

She is really, really smart. She knows a lot of things. I'm like, 'Whoa, she knew that?! OK!' It's really impressive because it's hard to understand some things. She says, 'Oh, this is easy,' and she explains.

"One of the things I have learned besides programming, is teamwork. It's really important because we are human beings. We are not made for work alone. We are made for society, for community. That's the only way to make great things. You cannot make it really great by your own self. You need different perspectives. How other people think, is really cool!

"Technovation is like a really cool institution because it makes women have good opportunities. I told a friend, a boy, (before I knew Technovation was only for girls), 'Hey, you're really smart! Come!' Then I went, 'Oh, I'm sorry, it's only for girls.' I think boys should have the same opportunity as girls. If Technovation wants to support only women, it's OK, but I think it would be fun to have boys. The girls think one way, and boys have a different perspective. Well, really, even girls have different perspectives. But I think boys would think about different app ideas because they have different problems from girls."

"Learn new things...see things a new way."

SOFIA MICHELLE GOMEZ LANDA, 14
"IN MY SCHOOL WE HAD A ROBOTICS CLASS. We made robots that did sumo wrestling. There, they told me about the Technovation competition.

"From Technovation, I learned that you don't just say to computer, 'Do this!' I realized it's more complicated than that. I learned to be tolerant with people. I learned to make presentations in front of a lot of people. I learned programming, of course.

"We have lots of confidence in our mentor. We feel close to her. She is 21. She is very realistic. If we tell her we have an idea and she knows it's not going to work, she tells us."

"What is the biggest contribution you made to the work, personally?" I ask.

"To maintain the team's focus. Everyone did equal parts of the project. We are all hyperactive so it was hard to express our ideas and, at the same time, respect others' ideas. And to focus on one idea. And to speak English."

Alex wonders, "Of all the things Technovation can inspire girls to do, what is most important?" "To learn new things," Sofia says, "and, maybe, see things in a new way."

"Tell us about World Pitch in San Francisco...."

"One thing that impressed me was how the engineers dressed. Bright hats, some braids. It was beautiful. What was most fun were the jokes between us. And to make the public presentation. I noticed I am capable of presenting. I was no longer shy on stage. I learned that I am capable of doing many different things, and I learned some English.

"Before, I didn't know what I wanted to do and study in the future. Now, I have an idea about what to pursue. I want to focus on software development."

RIGHT AND OVERLEAF: TechNational Team (TNT) meets at Sucursal Sotano, a bookstore café that provides something the girls can't do without: Wi-Fi.

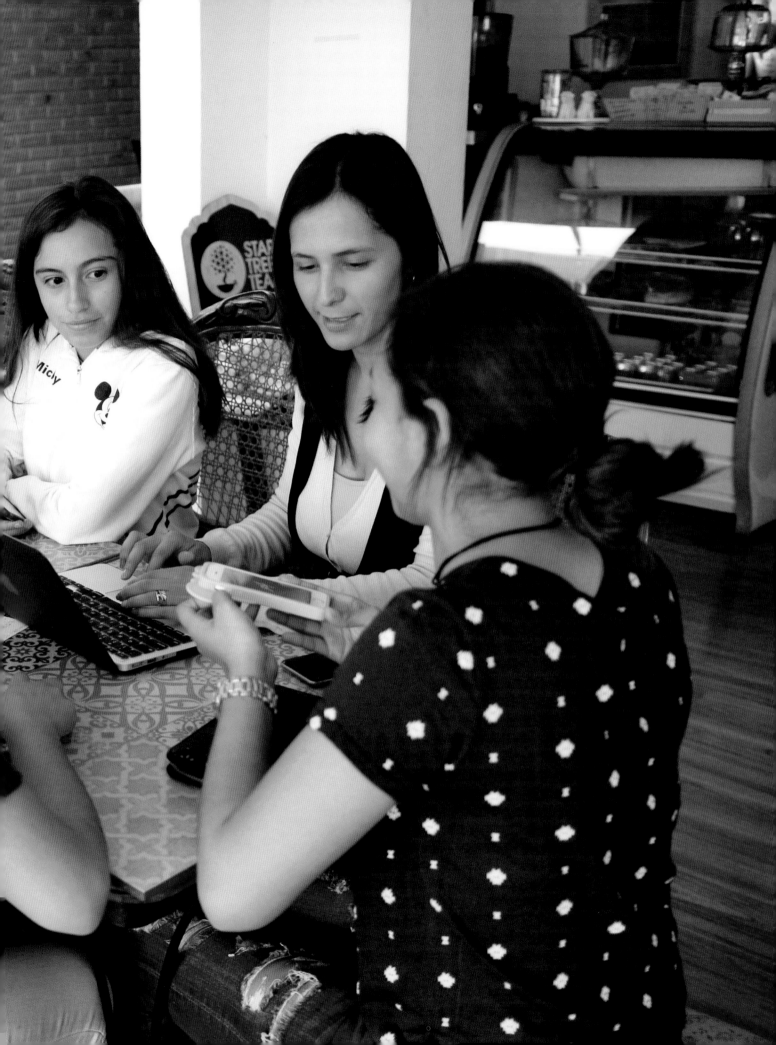

"Keep your priorities straight."

"TATI" YORAMI ANAYANSI GOMEZ CERVANTES, 15
"MY FATHER IS A LOCKSMITH and my mother keeps house. I have three brothers and a sister. For fun, I listen to music, read, and watch TV shows. I love my family and I love pizza.

"Last year, I was in robotics class with my friend, Alejandro Perea Eguia, who encouraged me to participate in Technovation. There, I learned to write code (including C++ and Java script), how to write a business plan, and how to work in teams. When we have a problem, we discuss it, talk it out. Because we are girls, we never fight or stuff like that. Girls respect themselves. Women care about each other and are more harmonious than men.

"When I talk to programmers, many have travelled to other countries. If I become a programmer, I will get to travel."

Alex asks, "Speaking of travel, you competed in San Francisco last year. What did you learn?"

"Well, I learned to bring lots of sweaters to San Francisco! Also, that it's important to get to the airport on time to come home. Technovation's prizes for participating teams were Gap cards. The girls wanted to buy clothes at The Gap before going to the airport. Ada (Adair Gutierrez), one of our mentors, and I stayed at the hotel to take the bags to the lobby.

"When the girls got to the hotel, we took Uber to the airport, but they had already closed the gate. We missed the flight to Guadalajara! We panicked. We were crying. Ada gave us her shoulder to cry on. It wasn't easy when everyone needed emotional support at the same time. What did I learn? Don't go to The Gap," she laughs, "And don't be too anxious to buy stuff. Keep your priorities straight."

"Here's how we got the idea for the app that won. We started with brainstorming. Everyone pitched in crazy ideas...like an app to paint your nails. After we had a list, we started eliminating, finding ones we could implement, ones that actually matter. Our criteria were that the app should be useful, that people will like it, and that they will download it."

Team Saffron's App:
2015 Mexico Middle School Winner

TATI: The problem we wanted to solve was obesity and lack of exercise by teenagers. All the members of the team at one time felt fat and didn't like their bodies. We didn't want other teenagers to feel that way. The society projects the idea of a beautiful woman who is very thin. Women want to look like those models.

The app gave exercises so you don't have to go to the gym; you could do them at home. We talked to professionals...nutritionists and personal trainers. We had some recipes for eating more healthy.

Ada (our mentor) and Karla Sofia Hernandez de la Vega (who was on the Saffron Team last year) created a Facebook page for the app. People found out about it and we got lots of likes. We decided to offer two versions...one free with advertising, plus a premium version for $1 without advertising. If you search Android's Playstore for the app Healthy Life by Saffron, you can see how many downloaded it and how we did.

PAOLA: We wanted to help young people create a healthier lifestyle, develop a culture of taking care of their bodies and exercising. At the moment, in Mexico, this culture doesn't really exist. Right now people eat a lot of tortillas and fried food and don't realize it is not healthy. It's a problem that's present for adults and for children. We tried to use technology to solve this problem because young people are attracted to technology so maybe they will listen. The app had a portion counter and examples of portions, plus a timer to measure each exercise...like a personal trainer.

SOFIA: You could click on the body part you wanted to exercise, for example, the legs, and it would give you exercises that would strengthen your legs.

PAOLA: I was the programmer on the team. I was also in charge of the interface. Other people did the survey and the business plan. But we all participated in everything.

OPPOSITE: **Team Saffron meets in the computer lab at the University Marista de Guadalajara, and begins creating a mobile app for the 2016 competition.**

"We are like the butterfly wings that created a tsunami in another place."

PAOLA ITHZEL JUAREZ RODRIGUEZ, 14

"I LOVE MATH. I AM GOOD. I help people with math. When I was six, my father brought home a computer and I got interested, but I just played games and drew things. I am part of the technology generation. My brother went to a technical high school. And my father is involved in telecommunications.

"I like helping other people more than anything. There is a public library close to my home. I work there in the summer with children ages 4 to 14, doing art activities and reading books. Last summer we drew a mural in a park nearby.

"I was beating the boys in the robotics competition. It might be cool to have boys on mixed Technovation teams so they can see that girls can do all the things that society tells us are the boys' jobs.

"Before doing an app, you have to define the problem. We don't have many of the third world's awful problems because we live in the upper middle class. It's difficult to find a problem that will appear very important to other people. Some may seem superficial.

"This year we will do an online survey using Survey Monkey to see what problems people want solved. One of the questions in the survey asks where they think there are more problems—in the area of environment or health. It's important for an app that people want to have it!

"Technovation has opened lots of doors for me. I like technology; it keeps advancing every day. It makes people's lives easier, and I want to be part of the engine of change.

"In addition to learning programming and what I want to do as a career, I learned it's not easy to work with people I barely know. But also, that there are lots of people who care and want to make the world a better place. I grew as a person, with new interests and experiences. I learned to be grateful for the opportunities I have in Technovation because we live in the Silicon Valley of Mexico."

Alex asks, "Thinking about your experience at World Pitch, what was most fun, what surprised you most, and what did you learn?"

Paola smiles, thinking back. "This was an experience so beautiful for me. It's hard to describe with words what I felt about all of this.

"We bonded in San Francisco when we slept in the same hotel room. We are more a family than a team.

"The most fun was to meet people from other places. When you live in Mexico, you only think of Mexico. You're not aware that people living in other countries have their own problems. Becoming aware was surprising.

"The last night we did a sleepover with girls from India and Boston, and that was fun! Two girls had birthdays, so we made them a cake with pop tarts and cookies and sang them the Mexican birthday song, 'Las Mananitas.'" (Paola sings it for us, and ends with a rousing, "a la bio, a la bao, a la bim bom ba, rah rah rah!")

"I learned many things. I learned that I have to work hard and do my best. Even if it seems hard, I have to work hard. I learned about the world, how big it is, and that we're just a little tiny bit of everything. And we can do a lot.

"We live in an age with all these tools. We are little particles that can move people—but we have to start with ourselves. If we want to create change, we have to change. Like the butterfly wings that created a tsunami in another place."

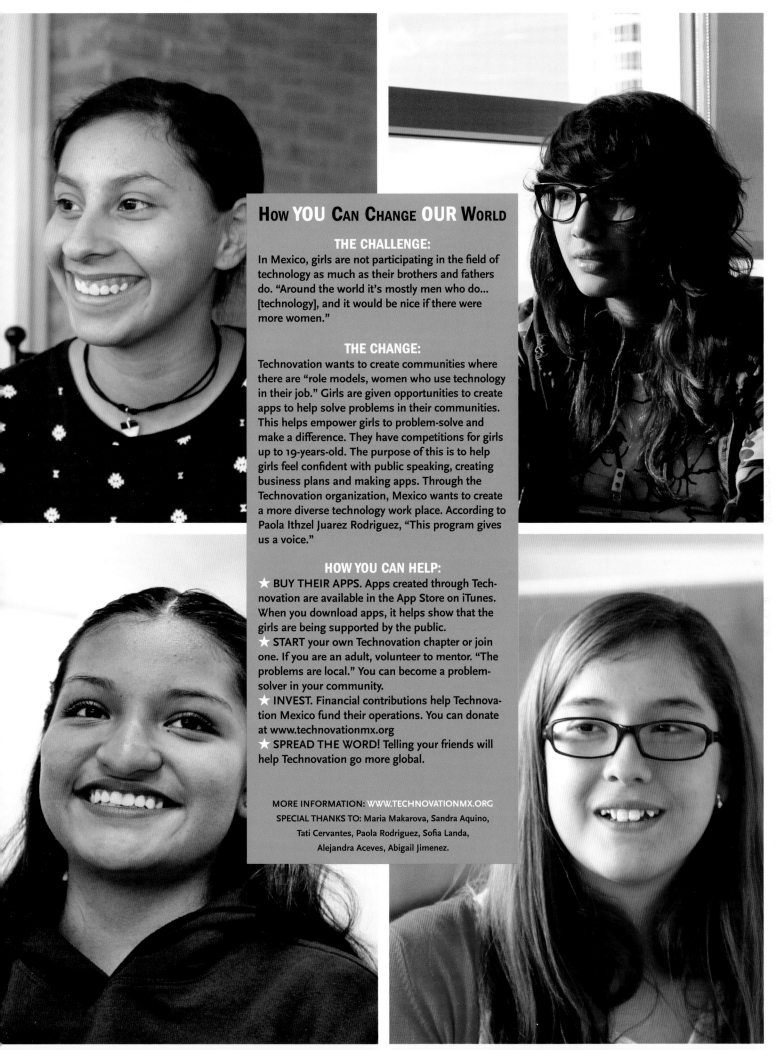

How YOU Can Change OUR World

THE CHALLENGE:

In Mexico, girls are not participating in the field of technology as much as their brothers and fathers do. "Around the world it's mostly men who do... [technology], and it would be nice if there were more women."

THE CHANGE:

Technovation wants to create communities where there are "role models, women who use technology in their job." Girls are given opportunities to create apps to help solve problems in their communities. This helps empower girls to problem-solve and make a difference. They have competitions for girls up to 19-years-old. The purpose of this is to help girls feel confident with public speaking, creating business plans and making apps. Through the Technovation organization, Mexico wants to create a more diverse technology work place. According to Paola Ithzel Juarez Rodriguez, "This program gives us a voice."

HOW YOU CAN HELP:

★ BUY THEIR APPS. Apps created through Technovation are available in the App Store on iTunes. When you download apps, it helps show that the girls are being supported by the public.

★ START your own Technovation chapter or join one. If you are an adult, volunteer to mentor. "The problems are local." You can become a problem-solver in your community.

★ INVEST. Financial contributions help Technovation Mexico fund their operations. You can donate at www.technovationmx.org

★ SPREAD THE WORD! Telling your friends will help Technovation go more global.

MORE INFORMATION: WWW.TECHNOVATIONMX.ORG

SPECIAL THANKS TO: Maria Makarova, Sandra Aquino, Tati Cervantes, Paola Rodriguez, Sofia Landa, Alejandra Aceves, Abigail Jimenez.

RAISING VOICES

United States

THE SUN IS SHINING, but it doesn't seem to be doing much good. The temperature is 22 degrees and the Windy City is windy. Two teams of girls stand in Chicago's Millennium Park videotaping. They stop men who are African American, white, and Latino, old and young, students and professionals. GlobalGirl Media is literally conducting "man in the street" interviews.

Che'mari Kent is glam. She describes herself as "model material," and styles her hair in a confection of curls and braids. But she's also a star student who graduated from eighth grade among the top in her class. On camera, she challenges the men: "Do you consider yourself a feminist?"

She tells me later, "Some men know what a feminist is, but don't care. Some didn't know but said they were feminists after I explained it. One said he thought men and women were equal; that kind of made me want to stop the interview. If everything were equal, we wouldn't be out here discussing it."

GlobalGirl Media, founded by filmmakers and journalists Amie Williams and Meena Nanji in South Africa in 2010, is a nonprofit that works with girls age 14 and up. GGM News Bureaus operate in Chicago, Los Angeles, Oakland, Morocco, South Africa, Kosovo, and London. Participants apply for the program, receive stipends, earn certification as digital journalists, and may win paid internships.

The Huffington Post quotes Amie: "Worldwide, only 24% of news stories are about women." Far fewer are by or about girls. But thanks to GGM, girls' interests, issues, and voices now reach a broad audience.

Teenaged girls, all from under-resourced communities, create blogs and videos that they post on GGMN.tv. GlobalGirl Media teaches them about technical video, writing, storytelling, media literacy, and women's rights.

They meet weekly to discuss the events and ideas that matter most to them, then plan and produce their projects. The girls do more than report. They ignite change.

Most GlobalGirl Media-Chicago participants are African Americans and Latinas who live in Chicago's inner city or South Side where gangs war over drugs, turf, and dominance.

Tobie Loomis, GGM-Chicago's Program Director, tells me, "We have girls who can't go to the corner store because of the violence in their neighborhoods. When you are 12, and your community is scary, you're raised on fear. After two or three years with GGM, girls become less fearful, more vocal. They notice that the world is larger. They start to participate.

"They understand that the media stereotypes them because they don't have opportunities to tell their stories themselves, and that they can create them. Their voices have power, they have something to say, and they can make a difference."

Despite the poverty and violence in their communities, most GGM girls go to university, often the first in their families to do so.

OPPOSITE: **GlobalGirl Media participants, African Americans and Latina high school students from Chicago's inner city and South Side, report via blogs and videos. Their interests, issues and voices reach a broad audience and cause social change.**

"[In my ideal world] there would be less crime, more in school, fewer homeless, equal pay, and equal rights."

CHE'MARI KENT, 15

"I WANT TO GO TO HOWARD UNIVERSITY and study broadcast journalism. A lot of people say, 'Northwestern,' but I don't want to be in the Chicago area. I want to get a PhD some day.

Che'mari discovered GlobalGirl Media-Chicago on the Internet. "When Tobie called my mom, she had no clue what it was about but she thought, 'OK, we'll have an interview.'

"I wanted to be a music journalist until GGM took us to ABC Channel 7. That visit changed how I watch news. I decided I'd like to be on camera, go to places where things are happening, talk to witnesses."

I ask Che'mari who her favorite woman newscaster is. Christiane Amanpour? Gwen Ifil? Erin Burnett? "All of them. They're paving the way. I wouldn't be thinking about being a newscaster, except for them."

Since GGM girls intend to cause social change, I invite Che'mari to tell me whether she considers what changes she wants to cause when she's planning a story. "Yes. I try to ask open-ended questions so people will elaborate, and then I can give feedback that will change their answer. Lots of people don't know men and women aren't equal. Interviews like we did today help increase awareness. Guys we interviewed will talk to their friends. Maybe if we repeat the interviews this summer, more will say they are feminists."

"Which of your reports are you proudest of?" I ask. "The LGBTQ video I worked on last summer. I was the only reporter who went to one interview so I had an opportunity to question someone whose perspective made people watch the whole video. He was a man who was married with kids, but he transgendered to a woman. He divorced, but still takes care of his kids who call him Miss Daddy."

Since we're talking about gender issues, I ask what's on her mind at the moment. "At school, sports are co-ed. If girls don't want to play football, the PE teacher says, 'You can just walk around.' If he says, 'Five laps,' he says, 'You girls can do two.' This gives boys a reason not to respect you. If it's a co-ed class, you should make everybody do the same thing. I don't like basketball because I don't want to break a nail, but I do it. If I can do sports, everybody should."

"What would your ideal world look like, Che'mari?" "There would be less crime. More children growing up in school. Fewer homeless people. Equal pay and equal rights for men and women."

"We have to work together to make the world a place without violence, inequality, injustice, and fear."

AIMEE RODRIGUEZ, 15

AIMEE HANDLED A VIDEO CAMERA during the interviews in Millennium Park. She describes herself as a tomboy. "I love competing. I'm on the varsity track team. My favorite sport is soccer. I do karate. I'm the only girl on the boys' wrestling team." I invite her to tell me about that.

"When I started, I felt like I needed their approval. The first time I told one of my friends, a guy, that I was going to join, he was like, 'I don't want girls to join.' I was like, 'That's being sexist.' He said, 'All right. If you're going to join, you better lift as much as I can.' I said, 'All right!' On my first day I had to wrestle him. I didn't know anything. He slammed me.

"After a while, I won my first match against a girl from another team. That's the moment they approved me. I walked to my team, and they held

OPPOSITE: GlobalGirl Media reporters interview at Honey Pot Performance, where the dancers juke to house music (and sometimes poems). The girls give the performers feedback about a piece that is in development.

- What does she look like & What does she look
- like?
- What do her people wear?
- What is her environment?
 - vibrant, curly hair, She looks different in em
 - Iconic + Gorgeous Show
 - Loud/Diverse
 - Beautiful, Funny, Loud, dirty
 - paired her 1c
 - Beautiful, Funny, Protective

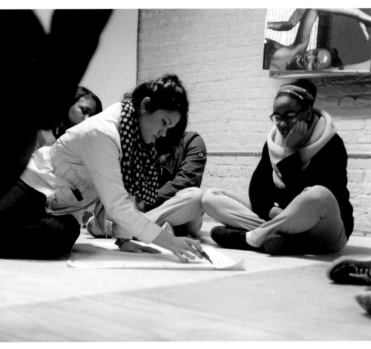
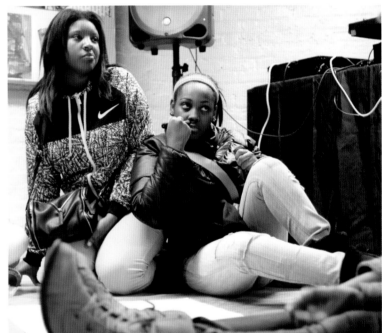
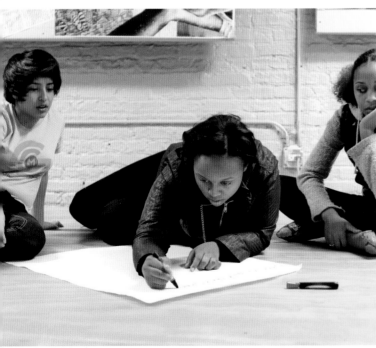

out their hands. They were like, 'Welcome to the wresting team.' Like I wasn't on the team before! I wasn't going to let what they were saying affect the fact that I'd just won a match. I just concentrated on the fact that I'd won.

"My first video for GGM-Chicago was a dance video. We asked if there were a certain kind of dance for boys and a certain kind for girls. One guy said, 'Boys get cooler, upbeat dance. Girls get girly dancing that's not as cool.' We asked if he was feminist and he said, 'No, but I'm in favor of equal rights for girls and women.' It made me think, 'He doesn't know what he's talking about.'

Aimee, who has been named a GGM intern, enjoys creating both videos and blogs. "Blogging is like a journal to me. When I started, I felt my experiences could relate to others going through the same thing. When I got my first comment, this girl was like, 'I can really relate to that.' I was proud someone read it and reflected on their life."

Aimee is about to demonstrate how deeply motivated she is by her conviction that others can relate to her experiences. Weeping, she tells me about her family.

"I began taking care of myself when my dad started getting sick. He went through lots of testing, and they didn't really know what it was. It was highly unlikely for someone to get what he had.

"When I was little, he was like, 'I'm your best friend. You can tell me anything you want.' Then he turned into a little kid who didn't understand what was going on in my life. Everything was pulled from under me. I had to walk behind him to be sure he didn't leave the stove on.

"I had to start being a mom for my dad and my brother because my mom was working. I had to cook and clean. I grew up too fast.

"We had always had an allowance; suddenly it stopped. Mom couldn't afford the rent. No matter what we tried, we couldn't stay there. So we moved in with my grandma.

"My dad got better, but he was abusive, so my mom didn't want him in the house. They got a divorce.

"I didn't have to take care of my dad anymore, but his family didn't want to either. I feel bad for him. There's nothing I can do.

"You are the person I can tell this story to, so you can put it in your book and other people will know they are not alone."

GlobalGirl Media's videos all end with: "This is our world and my voice." I ask Aimee what she wants viewers to understand when they hear this. "That it's my voice speaking out for everyone who's felt injustice. This is our world, so we have to work together to make it better, without violence, inequality, injustice, and fear."

"I want to make change; I blog about controversy."

RAVION CLAY, 15

"I WAS BORN WITH CRACK COCAINE in my system so I was taken away from my mother. I've lived with my grandmother my whole life.

"I got lead poisoning when I visited my mother's house and had it in my system for two years. I have two sisters and the same thing happened to them. My sisters forgave her, but I can't. I don't want a relationship with her.

"I want to be an Ob-Gyn in the military. When I get out of medical school, I will help bring new life. There are more and more women joining the military. Teen pregnancy is rising. A few of my friends are pregnant and they tell me they don't feel com-

fortable around their gynecologists. I can make patients comfortable.

"I'm going to the Conference of Future Medical Leaders in Boston. I got a letter from Harvard University with a certificate of nomination. Tuition is $900, but travel and hotel came up to $1,054. I set up a GoFundMe account. I didn't expect even $100 but I raised $1,110! I was like, 'These people really want me to go!' I am so excited! I'm going to meet Bill Clinton's personal physician, and witness surgery at Harvard Medical School. There will be lots of people with the same ambition as me. It's hard to find friends who share that."

Ravion worked in the journalism department at the McCormick Foundation. As a cyber journalist, she did fact checking, among other things. "Just because it's a headline doesn't mean it's true. It's all about sources." After McCormick Foundation people sat in on a GGM-Chicago meeting, Ravion knew, "I want to do that!"

Ravion blogs for GGM-Chicago about many issues. I ask what has her attention now. "I want to

ABOVE: **At the Honey Pot Performance studio.**

make change; I blog about controversy.

"I blogged about Lent. (You can't just say you're giving up chips for Jesus!) I blogged about campus rape. I'm thinking about doing something about the fact that my school, Christ the King Jesuit College Preparatory School, is 100% black with only one black teacher, the band director.

"I'm really close to my dad. He pushes me hard to do well academically: 'I hear you have a 3.4. That's OK but do you want to drive a Lamborghini? You have to get that 3.4 up!' He lets me make my own decisions. At first, I had no freedom because there was fear and they were really protective. I was like, 'Why can't I go places?' then I understood: it's bad out there, and they care about me.

"My grandmother always tells me she skipped from fourth to sixth grade. She is really strong. I

think that strength kinda got passed on to me. I'm a great student. I'm considered a leader. I always try to build awareness and start things.

"I'm proud that I'm starting a feminist club at school. It's not limited to girls; it's for boys, teachers, staff, everybody who wants to get educated about women and feminism. Boys need it the most. Boys have to think about the fact that, 'Your mother is making less than a male would make. How does that make you feel?' Or, 'Your daughter will make less than men when she grows up.' For boys, you have to put it into everyday life. I think I could get to them.

"I want to go to Tulane in New Orleans; they have an Ob-Gyn program I can major in…but I want to minor in journalism."

"Make decisions based on what will benefit you."

YESENIA GUTIERREZ, 18

"MY SON, LEO ARTURO, is about to be one. My boyfriend and I are getting married in December. We have disagreements, but it's working out.

"Balancing is hard between homework and personal life. Me and his father split the days so I have some days to catch up with school. I tend to get stressed out and over-think things. Then I think I am making excuses for myself. But I push myself for my son. He's walking. I have to stop what I'm doing to care for him. When he grows up, I hope he'll appreciate the challenges I went through.

"My boyfriend is in college. When the baby's there, he has to stop what he's doing. It's hard. My high school has a high rate of teen pregnancy. Usually the father is in prison; he is not there. My school can't believe that my boyfriend is there, helping me. It's sad that it is not typical in my neighborhood. I got a bonus that my boyfriend is like that."

Yesenia's cousin participated in GlobalGirl Media-Chicago and told her, "Participation opens your mind about women and men." Yesenia gives her own examples, "I learned you need to love your physical self, not look at somebody and wish you were them. If you want to become better, work on it for yourself, not because you want attention.

"I was surprised to learn about trafficking women. It's heartbreaking that a girl could just be taken when she had other plans for the future. GMM went to a meeting of Chicago Women Take Action and we found out it happens here. It could be happening next door.

"I was also surprised by men who abuse women. How women can't find a way out. How men think they are in power and women will do anything. There are lots of moms who stay home and don't work in my community, and the men come home and don't care. Kids say their dad beats their mom, and they're scared, 'Where will she go. She doesn't work!' I counsel my friends, 'You can call the law as a last resort.' If everyone thinks abuse is OK, kids will grow up to be just like that."

Yesenia is a blogger. "I love to write. Most of my blogs are about whether what people do is based on their culture and what society says. I try to break that; no one should follow what others say. I tell people, 'Make decisions based on what will benefit you.'

"One blog on nature vs. nurture: The theory was that my mom was a teen mom, and this explains why I got pregnant. Actually, she had me in her mid-20s. It wasn't true that I did the same. I talked to my psychology teacher about this. She told me, 'It's Mexican culture to get pregnant, then get married.' I said, 'Yes, I am Mexican, but no, I don't want to get married because it's a Mexican tradition. I just want to get married because it feels right. And we don't have a son together because it's a Mexican tradition, it just happened.'

"Another blog: My community is mostly run by gangs. If you grow up in it, most likely the men will join gangs and the women will earn minimum wage. The theory was that people who grow up in my community will stay there. That was where I had the issue. You can say, 'I have goals and I'm going to get out of here.' And help other people get out of here. That was one of my posts. I got lots of likes for it.

Yesenia wants to be a dentist. "In my community a lot of people can't afford to get braces. Hopefully, I can open a clinic here. Most residents don't have papers so they can't get insurance to pay for check ups. I want to help them."

I wonder what Yesenia's ideal world would look like. "People who have ideal worlds have no idea what's happening on the other side. There's nothing I would change about my world. I appreciate what I have. I like what I'm going through. Everything happens for a reason."

OPPOSITE AND PRIOR SPREAD: GlobalGirl Media does "man in the street" interviews in Chicago's Millennium Park, asking passersby whether or not they are feminists.

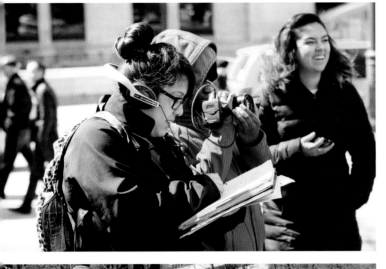

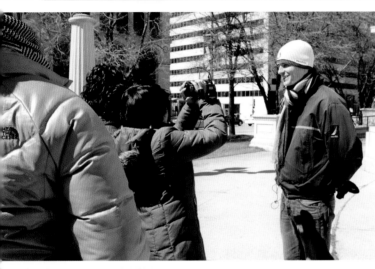
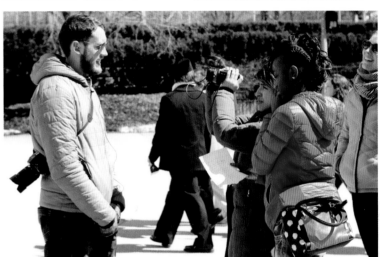

"Getting my voice out there, giving a different opinion, I do that all the time."

TEKA JOHNSON, 16

"I HAVE TWO BROTHERS, 15 and 18, and I would do anything for them. I love hip-hop, rap, pop and R&B music. My favorite subject is math but I love to write poems even more, especially acrostic poems."

I assume Teka must enjoy writing blogs since she writes poems, but it turns out, "I love video! I like to interview and ask questions and edit. We high school girls are still young and learning. But I hope the viewers of our videos will be educated by them.

"My favorite video was the one about teen homeless shelters. I interviewed a girl who slept on the street. After school, she had nowhere to go. That touched me. I would be devastated to be on the street. At one point, my mom and I slept in a car and took baths at friends' houses. Not everyone is blessed. This is what it's like in the world.

"I've been part of GlobalGirl Media since June 2014. At the GGM interview, I was asked how I feel about getting my voice out there, giving a different opinion. I said, 'I do that all the time, whether people like it or not!'

"I've made friends here. It's like a little family.

I have a hand on my shoulder. I'm the only girl in my family, and my mother didn't have my back."

GlobalGirl Media's website talks about "Changing the face of media by putting girls behind the camera and at the center of the story." It takes a lot to stand bravely at the center of your story. Teka does it. Here are excerpts from her July 2014 essay, "What Does Violence Mean to You?":

Violence is the core of everyone's pain. Violence means tragedy. Forty percent of gang members are juveniles. They could be scientists, doctors, lawyers, dentists or teachers. But they are going down the wrong path and they are taking our communities with them. I lost a friend due to violence. He was shot in his back in an alley. I also witnessed my mother get verbally and physically abused by my father. As a result, I did not trust boys or men and thought that they were only out to hurt me. So if you ask me, "What does violence mean to me," I'll tell you that it means destruction.

Although Teka is sometimes depressed, her generous spirit thrives. "I like helping people. My seven-year-old cousin is autistic. I love him to death. When you see a person 24/7, you know what he wants. If he says, 'Milk,' I tell him to say, 'I want some milk.' He's learning to use sentences.

"When I grow up, I want to be a pediatrician. I want to be able to say, 'Hard work pays off' and really mean it.'"

"Whoa! You can change it! You can cut the chains!"

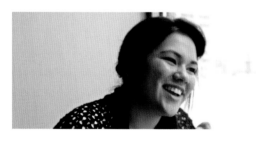

GABRIELA PEREZ, 16

GABBY IS THE YOUNGEST OF FIVE CHILDREN. The three oldest were born in Mexico, the younger two in Chicago. Her father died when she was eight.

"Being the youngest and a girl, I grew up with machismo, Mexican culture. My mom raised me with cooking and the idea of getting married. When I was growing up, my brother would tell me,

'Oh, you're cocky.' Those words were always in the back of my head. Even now, he's like, 'Man, you talk too much. Be quiet.' My family experienced a lot, and they take it out on me."

The brother nearest Gabby's age had a friend who participated in GlobalGirl Media. "That girl said, 'Tell your sister! Maybe she will like this!' I was going to coach cheerleading for children at the park that summer, but I thought, 'Let me get a sense of this.' I expose myself to different experiences so I'll know what I want when I'm older.

"Since I joined, I've grown a lot. When I started, I was not comfortable being in front of the camera or talking to someone. It's like a gain of confidence.

"My older brother doesn't talk much. He'll buy me an iPad instead of saying he's proud of me. An

iPad! Out of nowhere! I tried to tell him 'I appreciate everything you do but I think it's better if people *tell* me that they're proud of me.' Sometimes I say, 'Why don't you tell me stuff?' He's like, 'I was raised different.' I was like, 'Whoa! You can change it! You can cut the chains! I'm not saying the way you were raised is bad, I just believe in communication.'

"I blog. The post I got most likes on was titled "Little Lies Add Up." I wrote about the first time my boyfriend lied to me. I was a naive freshman, and he was a junior. It became a continuous thing. I tell people, 'It will start adding up, a domino effect.' I was like, 'Oh, he's going to change.' I made the relationship seem loving, but it wasn't. There was more sadness than happiness. I learned from my mistake. I feel there are readers out there who are similar to me, and I try to make them realize that 'one lie and he will do it again.'

"I also wrote about my APT score. It was not good. But my academics are good. My counselor would say, 'You can't apply here; you can't do this; this is not for you…' But I'm like, 'It's worth a try!' GGM-Chicago exposed me to mentors and helped me with college applications. They said, 'We'll see how it goes.'

"I plan to be the first in my family to graduate with honors. I was heading to become a lawyer when I was younger. But now GGM has exposed me to becoming a journalist. Now I may become a politician, a chemical engineer—or a journalist.

"Our voices are powerful. What are we going to do if we don't have equal rights, equal pay, equal everything? With our voices, we can fight without literally fighting. Our voices: that's the only way we can solve things."

"It is time we mold ourselves into a different brand of exceptional women."

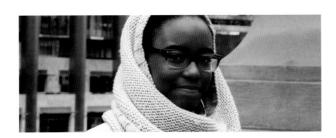

EBONY MARSHALL, 17
WOMEN'S ENEWS IS ABOUT TO REPRINT two blogs with the byline, "Ebony Marshall, GlobalGirl Media-Chicago Commentator." The youngest of nine children, Ebony is a junior at Young Women's Leadership Charter School. A junior. What did she write that captured Women's eNews' attention?

First, she had the gumption to take on Beyoncé. You or I would have to work tirelessly and accept the fact that we still may not achieve equality whereas she would just have to show her face and have instant privilege… It is time we mold ourselves into a different brand of exceptional women. A brand of women who get back to the deglamorized roots and real meaning of our fight for equality.

Second, Ebony blogged straight to the heart of the abortion debate.

I am pro-choice because I am pro-woman. The pro-life argument is to stop the termination of innocent fetuses. Yes, the baby is important, but so is the woman. For teens, sex is everywhere but contraception is almost unheard of…If a woman has access to contraception and Plan B, there will be no pregnancy to make decisions on.

Ebony confesses, "I like blogging but I feel like

I am more comfortable with digital journalism. I am particularly proud of the videos we did on sexting with teens and on violence in teen relationships. Before we made them, half of our GGM girls didn't know the laws or the statistics. Once we are informed, we can inform other people. That makes everybody more empowered.

"We're creating a video series called *Let's Hear it from the Boys*. We ask boys about women's issues: equal pay, women's rights, reproductive rights. We want to hear their perspectives and why they think the issues are as important as we do.

"Change is something we take into account when we're forming the questions, planning the shots, and editing the video. We want to put things in a sequence that delivers the message and makes people think."

One advantage GGM girls have is their youth. Ebony grins, "It's not every day that you see a 17-year-old girl with a microphone walk up to you and say, 'Hey, could I interview you about violence in teen relationships?' People are stunned that we know how to advocate for ourselves and ask questions coherently. Bit by bit, they're like, 'OMG, you guys are so great! We should do this again!'

Ebony has decided that's a good idea. "I want to major in media studies so I have expertise in print and broadcast. I do want to work for a news source, I'm not sure what kind. I've fallen in love with media over the past year. I love it as an agent of change, something I can harness in my everyday life, something that helps me understand more about myself and the world around me."

GLOBALGIRL MEDIA-CHICAGO arranges field trips that provide fodder for blogs and videos. I accompany a group to a rehearsal at Honey Pot Performance. We catch an elevated train (an "L"); I grew up in Central Illinois and always wanted to ride the L. At the turnstile, we share a card, passing it from person to person. We climb up to the platform.

A train screeches to a stop, and we board. Skyscrapers blur as we whizz south. The girls giggle, listen to their iPods, slurp Pepsi from giant cups. We pass the University of Chicago, near where the Obamas used to live. We clamor off at 47th Street.

We're escorted into a hall with brick walls and a hard bench covered with theater bulletins. Honey Pot used to be considered a dance group, but now they're better described as performers who juke (bounce) to house music (a Chicago specialty in the 1980s). They also dance to words (sometimes their own, sometimes Audre Lorde's or Nora Zeale Hurston's).

These womanists are powerful, graceful, indefatigable dancers whose shows may run two hours without intermission. Now, three of them pull up chairs to answer the girls' questions. The interviewers scribble furiously in their notebooks.

On the L ride back, I chat with Tobie Loomis, the award-winning writer, director, producer, and activist who runs the GlobalGirl Media-Chicago program.

"Now is the best time ever to change how women and girls are portrayed."

TOBIE LOOMIS, CHICAGO PROGRAM DIRECTOR
"THE SECOND YEAR GGM WAS HERE, we brought girls to Chicago from South Africa, Morocco, and Los Angeles for a one-week global summit. We partnered with the Op-Ed Project, which teaches how to write opinion pieces and editorials. They taught our girls and had a write-off. Then we just gave them space and time to get acquainted and learn about each other. Once they discovered, 'We're not alone; the struggle is everywhere,' it made them stronger.

"We train 15 to 20 girls a year. We want to be able to work with more. Money is the biggest struggle for us. We train and mentor too few girls."

I ask Tobie to envision GlobalGirl Media-Chicago in five years. "Vibrant, moving, doing—in more areas of the city. Going into the neighborhoods and partnering with organizations. We want to provide programs in the schools. We want to offer reporters whom we train here opportunities to travel to other cities and countries, to see that the issues they struggle with are, in many ways, similar."

Then Tobie returns to the present. "We are aware of changes happening in the digital landscape, technology, jobs, where the girls are, where they will be, and what they need for the future."

Perhaps she's contemplating the opportunities these changes create when she smiles and says, "Now is the best time ever to change how girls and women are portrayed."

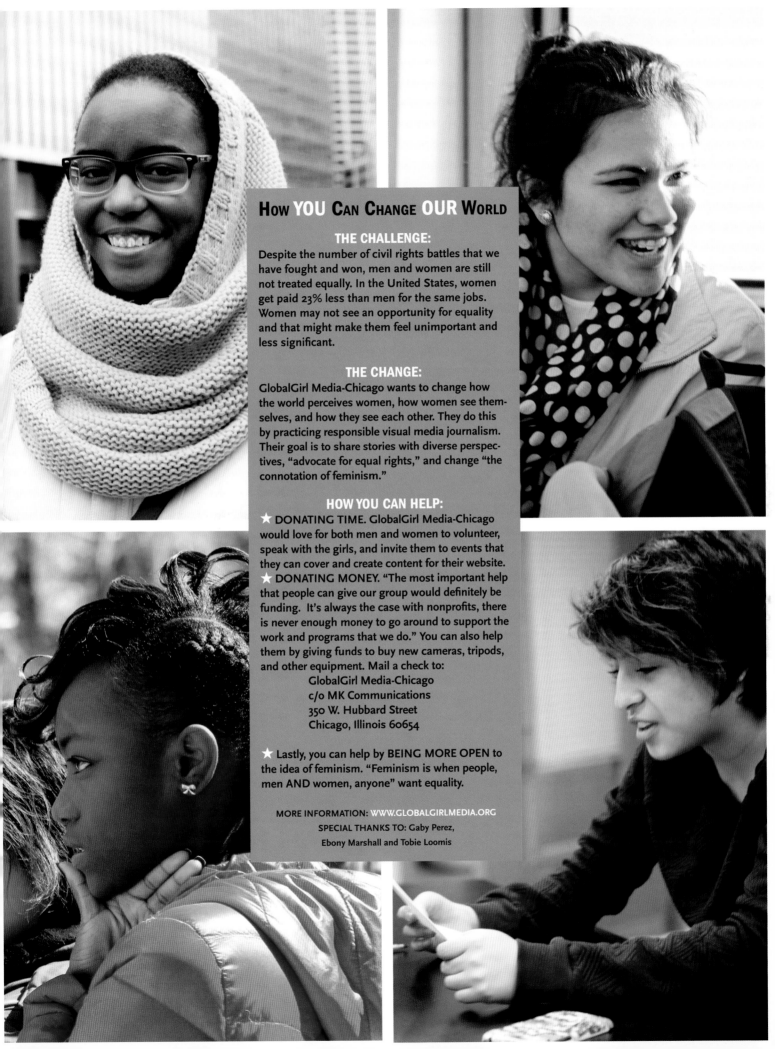

How YOU Can Change OUR World

THE CHALLENGE:

Despite the number of civil rights battles that we have fought and won, men and women are still not treated equally. In the United States, women get paid 23% less than men for the same jobs. Women may not see an opportunity for equality and that might make them feel unimportant and less significant.

THE CHANGE:

GlobalGirl Media-Chicago wants to change how the world perceives women, how women see themselves, and how they see each other. They do this by practicing responsible visual media journalism. Their goal is to share stories with diverse perspectives, "advocate for equal rights," and change "the connotation of feminism."

HOW YOU CAN HELP:

★ DONATING TIME. GlobalGirl Media-Chicago would love for both men and women to volunteer, speak with the girls, and invite them to events that they can cover and create content for their website.

★ DONATING MONEY. "The most important help that people can give our group would definitely be funding. It's always the case with nonprofits, there is never enough money to go around to support the work and programs that we do." You can also help them by giving funds to buy new cameras, tripods, and other equipment. Mail a check to:

GlobalGirl Media-Chicago
c/o MK Communications
350 W. Hubbard Street
Chicago, Illinois 60654

★ Lastly, you can help by BEING MORE OPEN to the idea of feminism. "Feminism is when people, men AND women, anyone" want equality.

MORE INFORMATION: WWW.GLOBALGIRLMEDIA.ORG

SPECIAL THANKS TO: Gaby Perez,
Ebony Marshall and Tobie Loomis

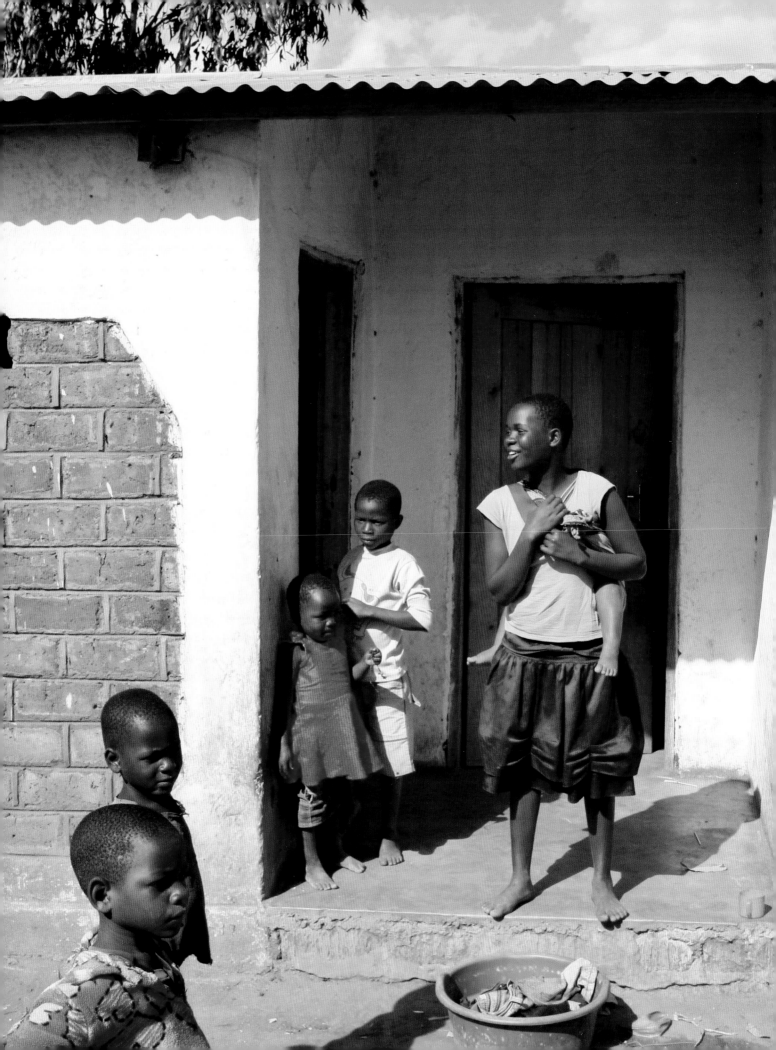

STOPPING CHILD MARRIAGE

Malawi

THE RESTAURANT IN the Ryalls Hotel in Blantyre Malawi has celadon-colored walls and amber glass chandeliers. It serves wine from Australia and crème brulé. It opened in 1921; old ads framed on the walls promise, "We cut the crusts off our toast." I have never been as aware of the gap between rich and poor as I am eating dinner in this elegant restaurant.

On the sidewalk outside, 14-year-old girls stand every evening. Orphaned by AIDS, they have no families. They are naked, except for capes that they open as headlights approach, hoping that the men driving by will pay for sex so they can eat. Those girls haunt me.

"To me, education was everything."

JOYCE MKANDAWIRE, CO-FOUNDER
THE ONLY WOMAN I'VE SEEN DRIVING in Malawi is Joyce Mkandawire, Rise Up's Country Director and co-founder of the Girls Empowerment Network.

One of nine children, Joyce grew up in her aunt's house and did housework in return for the privilege of attending school. "I worked like a donkey," she tells me. "Worked so hard my sister cried when she visited. But to me education was everything. I knew

there was nothing I could do if I was not educated." Joyce excelled in school, was accepted to university, and studied community development.

At age 18, she had sex for the first time and was astonished to discover at a routine check up, that she was eight months pregnant. ("No one had told me anything about sex or protection.") Her aunt sent Joyce home immediately, since she could no longer "work like a donkey." The education she cared about so passionately was interrupted.

Joyce's first job was at a local NGO where she was paired with a colleague, Faith Phiri, to interview young girls for a UNICEF research project. "For me," Joyce remembers, "that research caused a real U-turn in my thinking." They heard stories about teen pregnancies, stories about interrupted educations, and more.

Joyce and Faith realized that the stories they were hearing mirrored their own experiences as poor, naive girls for whom education was an almost-impossible dream. They talked all night. By dawn, they had decided to do something about it.

OPPOSITE: **Christina's baby was born when she was 13. She is an active member of the Girls Empowerment Network (GENET), a girl-led initiative that caused Parliament to pass a law to stop child marriage in Malawi so girls can complete their schooling.**

"I thought a lot about girls who had been abused and discouraged."

FAITH PHIRI, CO-FOUNDER

FAITH AND I MEET FOR COFFEE. She tells me, "Growing up in Kasungu, lots of girls were dropping out of school. There were pressures on me to drop out, and rape attempts at home and at school. But I survived. From that moment, I thought a lot about girls going through the same challenges, girls who had been abused and discouraged."

She still worries about parents who pay their debts by giving their daughters in marriage. And about primary teachers who defile girl students ("It is common"). She has reason to worry: 63% of Malawi girls have had a child by age 19; one in five girls in the country are sexually abused before they reach 18.

Just before she and Joyce had that all-night discussion, Faith had won a $1,600 prize online. She asked herself, "How can I use this money to change somebody's life?" She conducted a girls' empowerment program. Now she thought, "Why can't we make this program formal and have a board?"

In 2008, Joyce and Faith launched a girl-led NGO called the Girls Empowerment Network (GENET). They envisioned that GENET would empower girls to fight for their right to education…and against those practices that make education impossible.

Many in Malawi believe that if you are old enough to menstruate, you are old enough to be married. Tradition has long encouraged child marriage, but an additional catalyst is poverty: 74% of the people in Malawi live on less than $1.25 U.S. a day.

In Southern Malawi, when you marry off your daughter, her husband comes to live with your family and helps support everyone. If you live in Central or Northern Malawi, your daughter moves in with her husband's family, and you'll have one less mouth to feed. In either case, your family will probably receive a bride price of much-needed cows, goats, or chickens.

Child marriage makes economic sense to parents, but it spells the end of a girl's education. It spells the end of her hopes for financial independence. And, if she gets pregnant when she is too young, childbirth may spell the end her life.

Until February 2015, girls could be married at age 15 in Malawi…and many were. Half of all girls in the country were married by the time they were 18. Fifty percent!

The campaign against child marriage took years. GENET is a grantee of Rise Up, whose Let Girls Lead initiative trained girl members to be leaders and advocates. GENET girls engaged village chiefs, group village chiefs, traditional authorities, girls, parents, and grandparents.

They found allies among other civil society organizations who helped conduct marches, walks, radio programs, and awareness campaigns. They rescued girls from child marriages and made them ambassadors and role models in the fight.

Until the very last minute, Parliament refused to consider the issue. The girls won support from Patricia Kaliati, Minister of Gender, who was determined to get the bill on Parliament's calendar.

Finally, frustrated, Kaliati stood in Parliament and threatened to take her clothes off unless the bill was scheduled for vote. If a woman removes her clothes in public, it is a profound insult, an expression of extreme contempt. The bill was scheduled.

GENET girls, who had refused to leave the Parliament building until the bill came up for vote, flooded the Members of Parliament with tweets.

The bill passed unanimously. All 26 female MPs waved banners that said Stop Child Marriage. Outside the chambers, girls beat drums in jubilation. Triumphant, the girls sang and danced with joy.

The President signed the Marriage, Divorce and Family Relations bill into law in June 2015. It imposes a ten-year prison sentence on men who marry girls younger than 18.

The law is an impressive accomplishment, but no one is naïve enough to think it will stop child marriage just because it exists.

GENET and Rise Up have already trained 37 girls to speak with public officials and demand that the law be implemented and enforced.

They are educating the public and the judiciary about the bill, hoping to get it translated into the indigenous language, Chichewa, and creating strategies to amend the Constitution, which contains a big loophole: girls may still be married at 15 "with parental consent."

Daily, Joyce drives me the 18 miles from Blantyre to the village of Chitera. I learn a lot about the country on these rides. We pass a market where women sell tomatoes stacked into perfect pyramids. A motel billboard shows a woman sleeping in bed, her breasts exposed.

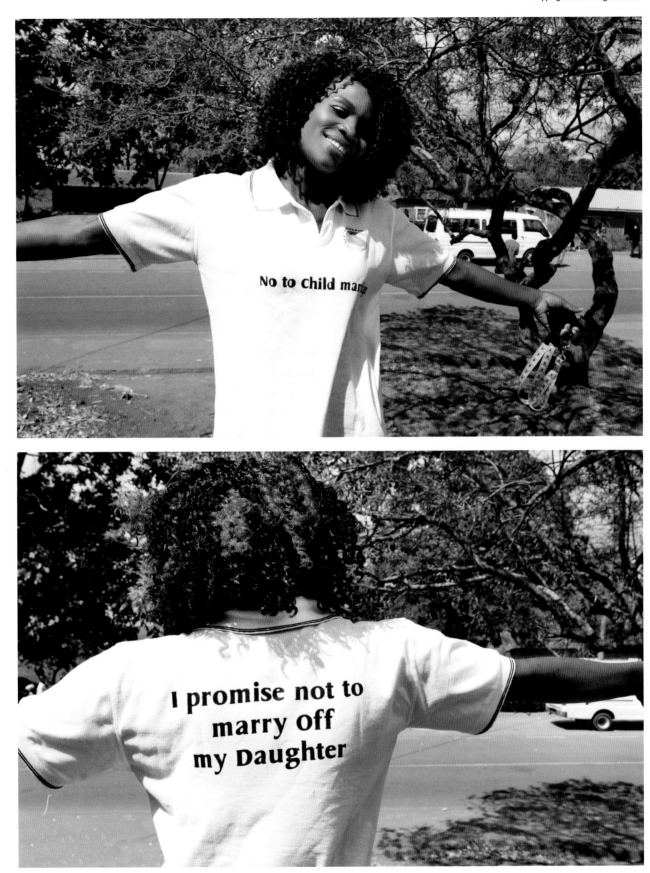

ABOVE: Joyce Mkandawire, co-founder of GENET, sports a
t-shirt that the girls used to promote their campaign against
child marriage.

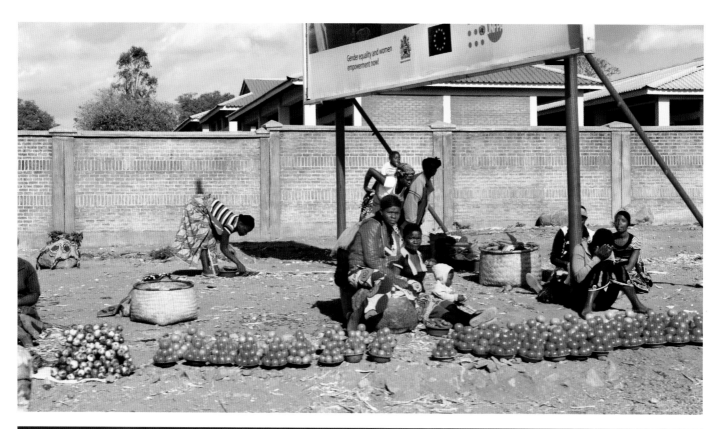

ABOVE: Women's roles in Malawi are apparent as you drive
along the highway between Blantyre and Chitera.

We pass a truck filled with people seated around a coffin singing gospel music for someone who died of AIDS. Children orphaned by AIDS live on the highway meridian; girls beg there, get robbed there, get raped there, give birth there.

We turn off the highway onto an unpaved road. Joyce steers us between rocks, potholes, and crevasses, barely avoiding the ditch. This road was not made for cars. The only other vehicle we see all week is an ambulance. People walk on this road to get to the fields.

Joyce spots a friend standing among the corn stalks and calls him over to show me what he is collecting for dinner. He reaches into his cloth bag and holds out a handful of mice. "Braised with the fur on, they are a delicacy," Joyce assures me.

About a thousand people live in Chitera. There are a school, a clinic, a court of justice, two wells, two cemeteries, and a few businesses. Chitera has no electricity, although wires carrying power to Blantyre go straight through the village. A man sits outside at a treadle sewing machine making clothes to sell. On summer afternoons, the barbershop doubles as a theater, its TV set powered by a rebuilt car battery; some little girls wear their Sunday-best to watch the shows.

"I put 21 as the right age for marriage...enough time to finish school."

SENIOR CHIEF ADA ALI, 74

ONE OF GENET'S ALLIES in the fight against child marriage is the Senior Chief of Chiradzulu, the district that includes Chitera. There is no road to her house. Joyce wrestles our rented blue sedan over the stubbly field, aiming for a modest home downhill.

We enter the Chief's yard through a gate, a corrugated metal sheet with a broken latch. I struggle to hook it from the inside so the chickens and goats won't escape. Nobody but me seems worried about the animals' departure.

A flock of pigeons, startled by our entrance, whirls over us en route to the dovecote that's next to five velour armchairs, their upholstery ripped, rumpled, and stained with schmutz and twigs from a canopy of sticks above.

Tots with runny noses vie with chickens to play among the potatoes on the ground. A stout, barefoot woman removes a seat cushion, bangs it against its chair, puts it back, and motions for me to sit next to her.

Strands of grey hair stray past the edge of her shocking pink headscarf. Her age doesn't slow her down. I am still fumbling for my digital recorder as she explains that she oversees 8,400 households, 9 group-headmen, and 103 village chiefs. All five of her children went to school and one is a Member of Parliament. She has 101 grandchildren. Ada Ali "was crowned Traditional Authority in 1983, and Senior Chief in 2013."

Having become pregnant at age 12, the Chief never went to school. "When I was crowned, I saw that my first assignment was to encourage girls' education. Where there are five boys, there should be five girls."

Sometimes the Chief sells the goats she is paid when people break her laws, then uses the money to pay school fees for girls whose parents cannot afford them. In 2009, she dissolved a child marriage for the first time and sent the girl to school. "But I did not end there.

"That gave me strength to start a committee of women and men to stop child marriages. After a young girl died at the hospital with a child in her womb, the committee started work immediately." Her committee of church ministers, school principals, chiefs, and traditional leaders monitor the region of her chieftaincy.

"The coming of GENET gave me more strength. I thought it was high time that I make a bylaw. I put 21 as the right age for marriage, which is enough time to finish school. This was applicable only to the people I look after. That day, I called the district commissioner to come authenticate it."

Parents who marry their daughters off before they are 21 must pay penalties to the Chief. "If you commit a crime," she warns them, "you have to pay the consequences. Enough that you would not do it again. A goat. A cow."

The Chief has groomed other chiefs throughout Malawi to create bylaws and stop child marriage. "Every time the Minister of Gender wants to have a meeting, I go. We are teaching other chiefs. I do that happily.

"I will not keep quiet and I will not stop. Whenever I hear about marriages, I ask, 'How old are you?' and if they are underage, I dissolve it right away. I tell them to their faces, 'If you love each

other, get married later.'

"I make sure that I'm in constant contact with the churches, because marriages are blessed at church. Presbyterian, Muslim, Catholic, Jehovah's Witness, Church of Christ, Apostolic. All of them agreed we should go forth as one."

In 2010, GENET girls began working with the Chief to abandon "harmful traditional practices." That's a euphemism for *kusasa fumbi,* which means sexual cleansing—plus other pernicious activities, some of which take place at the annual initiation camp.

A girl's aunts, her father's sisters, decide what year a girl should attend initiation camp. She might be sent at any age between 9 and 15. As part of the camp curriculum, she will be prepared for marriage by initiators who teach her how to please a man sexually.

Having sex with a man called the Hyena is like the final exam for initiates and yes, he grades the girls on their performances. The role is played by a local man, sometimes by one who doesn't know he is HIV positive. He visits the girls serially as they wait in the dark on cots enclosed by curtains. He is paid by the girls' families "to remove the childhood dust." Families sell chickens, maize, and tomatoes to accumulate $3 U.S. to pay the initiators and the Hyena.

The Chief says, "The practice of sexual cleansing used to happen a long time ago. I have made sure that it is gone. Finished. Nobody does it. Nobody. Today, girls in the camps are only taught good manners and taught to respect their elders. I value those traditions."

However. Some GENET girls tell me that they have shamed their families by refusing to participate in sexual cleansing. Perhaps the practice is not totally extinct.

In contrast to "initiation camps," GENET runs "summer camps" where girls learn about HIV-AIDS prevention, family planning, and personal hygiene during menstruation, none of which are taught either by families or schools. Knowledge is power.

ABOVE: Women and girls carry water home from a community pump in Chitera.

TWENTY-FIVE GENET GIRLS meet in Chitera twice a week to help each other with homework, to plan strategies to convince other girls to insist on—and stick with—school, and to convince parents to allow—and pay for—school. Elementary tuition is free but uniforms, shoes, books, and supplies are a big investment if you live on $1.25 a day. High School tuition costs $36 a year, a whole month's worth of money.

Some of the GENET girls have gathered at the Women's Resource Center. Joyce has counseled me to give each an orange soda as a thank-you gift for interviews. "It may not seem like much to you," she said, "but it is to them. They may get a bottle of Fanta for Christmas—and sip it all day."

"My future is not limited by anyone. I, myself, have responsibility."

CHRISTINA, 15

TWO YEARS AGO, Christina gave birth to a son named Praise. She was a single mother—and after the baby arrived, her own single mother abandoned the family. That left Christina, her newborn, and four younger siblings in a hut with a holey thatched roof. They got soaked every time it rained.

GENET's adult leaders contributed money out of their own pockets and girl members organized the Chitera community to build Christina a mud-brick house. Today, Christina earns money to feed her family by carrying water to men who use it to make mud-bricks.

Even though her own education was interrupted by pregnancy, Christina has just finished her second year of high school. She admits, "I only find time to study when the baby is sleeping. I work hard because I want the cycle of poverty to end with me, and not extend to my baby. I wish better for my son."

Christina, whose delivery at age 13 was "difficult," hopes to become an obstetrician and practice in Chitera. She plans "to save women in my community. I want people to say, 'This girl—she went back to school and now she's a doctor. Right here.'"

She is an active member of GENET. When I ask what her experiences taught her, she sparkles, "I learned that my future is not limited by anyone. I, myself, have responsibility for my future. I work as hard as I can so what I dream about will come to pass."

She can't translate the English words on her t-shirt, but they seem perfect: "Just Do It."

"Tradition is the law here. But I believe it is possible to change."

MATRIDA, 18

"I CAN BOAST TO YOU TODAY that I personally managed to rescue a 14-year-old girl who was married off," says Matrida, who's been a GENET member for four years. "GENET's training gave me strength. The girl I rescued was my best friend. I took this as my own issue, not her issue. I feel I am responsible for my friends, just as my friends are responsible for me.

"I talked to her parents: 'I know you have arranged this. I know the arrangement violates her rights. Please allow her to go back to school so she can help you later on.'"

Matrida also talked to her friend's 16-year-old husband, who confided that he actually felt he was not ready for marriage. "It was not easy but finally they understood me. The marriage was dissolved. The girl is now back in school," Matrida reports.

"A few have applauded what I did. The rest still think what I did was bad. Not only was this girl rescued, but her friends—who were also about to be married off—are still in school because of me. They said, 'No, you are not going to marry me off like so and so.' It's never something good when you refuse your parents. I have a few who supported me, but a huge number did not."

Matrida's passion about education drives her dream of going to university in China. "I have read, and heard in school, that China offers the best education in the world. Also, just to be straight, there are scholarships. I know girls with good grades who have gone there to study on Malawi government scholarships."

Matrida's independence was evident when she attended initiation camp in 2013 and refused to participate in sexual cleansing. "I was advised by my mother that this is what would happen. She told me, 'You should refuse.' Other girls take this as excitement and cannot say no. I said no." As the middle child in a family of seven siblings, Matrida "made sure that, at least in my family, that practice ended." She observes, "Many in the community look at me as a disgrace.

"Tradition is the law here. But I believe it is possible to change this practice. Before initiation camp, we already know which girls are going. They should be told what is going to happen. The parents should also be advised of the dangers, the consequences, of sleeping with the Hyena."

When I take her picture, Matrida chooses not to smile. "These are serious issues," she says. "There is nothing to smile about."

"Education leads from poverty to prosperity."

LYDIA, 16

WE ARE TO MEET AT LYDIA'S HOME. Joyce navigates our sedan along paths that are barely wider than it is. Christina rides with us and tells us where to turn. "It is near," she keeps promising. But it isn't.

Finally, we come to a cluster of mud-brick cottages. Lydia's mother hurries to greet us. She kneels to express the respect due to people my age.

This family's house differs from the others in two ways: spindly bushes flower in the front yard, and there is a solar panel on the roof of one of the compound's buildings. That panel powers a television set, and watching it has inspired Lydia to study journalism at university so she can work for the BBC or Al Jazeera.

Lydia joined GENET five years ago at Senior Chief Chitera's suggestion, and became avidly engaged in the campaign to end child marriage, not only at the national level, but also in Chiradzulu District. "I am the one who told the Chief that we want 21 as the age of marriage in the bylaws even though the national age is 18. For me, 21 is much

better. At least girls will have written their high school exams."

The most important lesson she learned from GENET: "I have an independent mind. I have a voice and can use it when I want to." She has used it often to advocate against child marriage. "I saw a lot of girls going back to school because I told them that the only passport for them is education. Without education, you are dependent on a man. Education makes you independent."

I invite Lydia to pretend I am a young girl's mother and convince me to send my daughter to school. She focuses. "When you force girls to marry, they get pregnant. I have heard that girls die at the hospital because their bodies are not ready, not strong enough, for a child. Please, if you love your daughter, help her to go to school. With or without money, you can approach organizations that will help with expenses. Do not force her to get married now. Let her stay in school."

Lydia chose not to attend initiation camp. "People still tell me I should go. My relations still tell me that. But I know the bad practices that go on there. I do not want to get HIV-AIDS.

"Education leads from poverty to prosperity," Lydia says, using such a smart a turn of phrase that I ask Joyce, who's translating from Chichewa to English, whether those are her words or Lydia's.

"Lydia's," Joyce says. I say: "Get ready, BBC!"

"Whatever has happened to a girl in village X, we mobilize to save our sister."

GRACE, 16

WE SIT IN AN OPEN PAVILION above the village, which serves as the court of justice in Chitera. Birds' songs echo as they flit around the ceiling.

Five years ago, Grace belonged to the group of girls who organized to become GENET. "I was told about the training and that inspired me. I wanted to become a better person."

Since 2011, she's seen progress: "At first girls were just getting married, getting pregnant, and

dropping out of school. But over the years, I have seen that when girls drop out of school because they're pregnant, they return to school after giving birth—and girls getting married are now rescued, and going back to school."

Change has not come easily. "The girls in the GENET group come from eight villages. They are spread out. Whatever has happened to a girl in village X is discussed in our meetings. We mobilize to save our sister. Sometimes a representative from the Chief's committee of elders comes; their job is to see that child marriage is not happening.

"Sometimes we walk long distances. It has taken a commitment to reach those girls. I have faced a lot of challenges. People say, 'Why are you coming this far, just to talk to this girl? Why can't you stay home?' I am never discouraged with the bad comments. I am motivated to help other girls and I am at peace."

Grace understands what she's up against: "We live in big families. The groom is looked upon as a savior because most men at least know how to read and write, so they go to the city to work and bring money back."

I invite Grace to pretend that I am a 12-year-old girl (which takes a lot of imagination) and convince me to attend school. She summarizes her argument: "You are holding the keys to your future. The key is education. Please, my friend, please, my sister, go back to school. Don't be like your mother who has never gone to school."

She adds, "I also go to the mother and say, 'If you want a good life, invest in this girl so she will help you.'" Grace elaborates, "Wives can commute to Blantyre and work as house helpers. But only if they can read."

School is not just the focus of Grace's advocacy, but also of her dreams. She plans to study nursing in Blantyre when she graduates from high school, and be the first in her family to attend college.

She is aware that she is a role model. "My training and passion have helped save girls who have learned the benefits of education through me." Then she adds with a smile, "I even have relatives who have decided to go back to school."

"I hold my dreams. The light, the power, is within me. No one can take it away."

ALINAFE, 16

"I WAS RESCUED FROM A CHILD MARRIAGE. I had been living with my aunt, who was not giving me support to go to school. My boyfriend got me pregnant. I was 15 when my baby was born. We had no food a lot of times because my husband was not working.

"Thokozani, who is chairperson of GENET's group in Chitera, saw me suffering. She advised how beneficial it would be to join the group, which convinced me to move out of my marriage and go home so I could work hard in school. My husband moved to another district. I don't miss him.

"When I was married, my friends had nothing to advise me. They were all married girls who have children. Through GENET, I shifted to a new set of friends who helped me learn that there is no one sitting on my dreams. I hold my dreams. The light, the power, is within me. No one can take it away.

"My baby's name is Monica [I love that name!]. She and I now live with my mother, who takes care of her when I am in class. Every day when I am at school, I wonder how she is doing.

"I have big dreams for Monica. I want her to have all the resources she needs to go to school. Every day, I work hard so she will not face what I faced. I want to be an accountant in Lilongwe."

Alinafe has never seen Malawi's capital city, but she says, "I imagine Lilongwe is very beautiful. With tarmac." No wonder this girl who lives in a village accessible only by a rutted road, imagines paved streets.

Alinafe is a member of the 25-girl GENET team that meets twice a week in Chitera. "We work as community watchdogs. We look around…who has been forced to marry? We are immediately tipped off and we try to dissolve the marriages or rescue girls from getting married."

She reflects on the new, national law that prohibits child marriage. "This is the best thing that ever happened to us. I am very excited about it, because now we have something to work with. But in the villages, girls have not finished high school yet. The age 18 may be a good starting point, but it should really be 21," like the Senior Chief's bylaws. "I admire the Chief. She stands for sending us girls to school. She is annulling marriages. She is my model."

Like the Chief, Alinafe advises girls not to marry early. "I tell them my story. I tell them, 'I have done this. It did not work for me. Now I am in school.' And I tell them the beauty of education."

OVERLEAF: Lydia celebrates the news that child marriage is illegal in Malawi, a triumph for the Girls Empowerment Network and their allies.

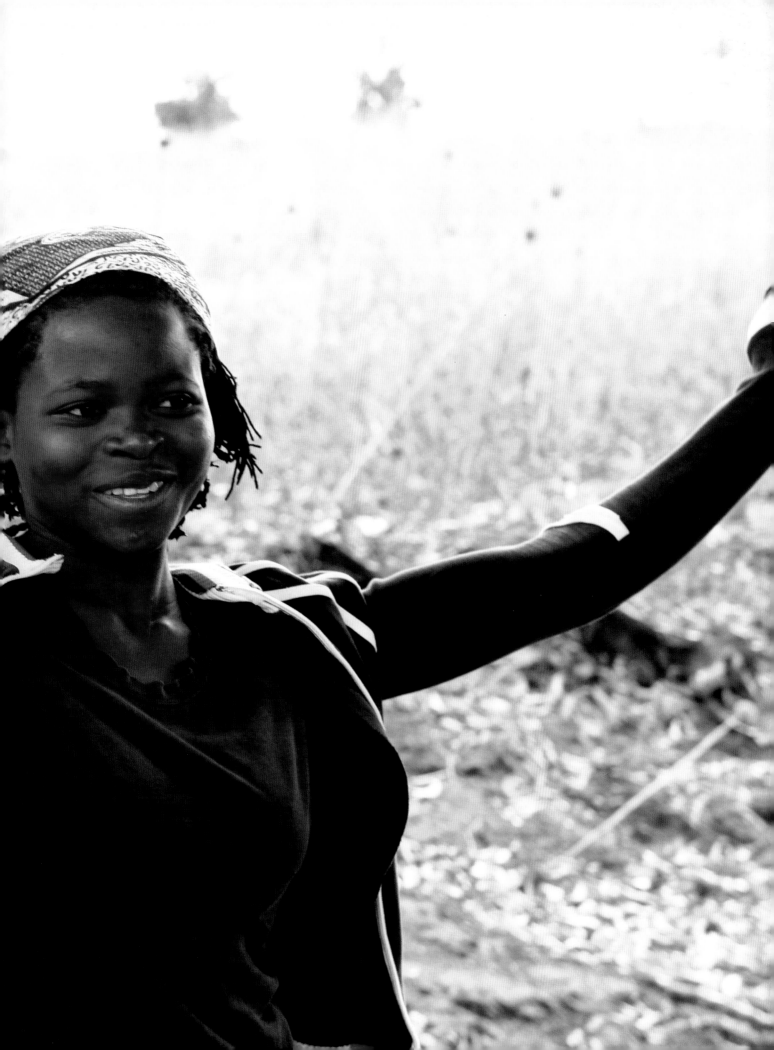

A GIRL NAMED MEMORY was distraught when, after initiation camp, her 12-year-old sister became pregnant. The experience compelled her to lead the Stop Child Marriage campaign in Malawi, starting by mobilizing 12 GENET girls in Chitera.

In March this year, one month after Parliament passed the child marriage bill, Alex and I interviewed Memory over dinner in California, which she visited after she addressed the United Nations in New York.

In May, Memory presented a TED Talk that went viral and already has more than 600,000 views (and climbing). Google "I Will Marry When I Want, TED Women," and watch. It will make your heart sing.

Despite her superstar status, Memory is unaffected, and I've been looking forward eagerly to seeing her again. I can't wait to tell her that even girls I interviewed in Tonga were cheering about Malawi's child marriage law.

Joyce and I drive to Chancellor University in Zomba, an hour north of Blantyre. Memory is about to celebrate a birthday; my co-author Alex has sent her a t-shirt that seems perfect. It says: "To Do Today: Wake up, Turn 18, Be Awesome."

"I want to be the lawyer who assists girls so they are able to access justice."

MEMORY, 18

WE THREE DRIVE TO A RESTAURANT above the campus that serves lunch on picnic tables outside.

While we're waiting for our food, I ask Memory how she learned to be an advocate for girls' rights. "GENET taught us leadership, communications skills, gender, girls' rights, advocacy…a series of trainings to groom me, Grace, Toko…so we could stand."

Grace Kaimila-Kanjo, Rise Up's Africa Regional Senior Advisor, conducted those trainings, which she calls "girling up sessions."

"I wish we had these sessions with all the girls out there. I have seen tremendous transformation. The girls change. They brighten up. They become confident. They can prioritize needs and articulate issues. They become very active, working together on how they can surmount problems and deal with the issues they encounter."

Memory recalls, "Our first advocacy was with Chief Chitera. We also talked to a Member of Parliament, met him face-to-face, then had a second meeting. From there, we went to the national level. It was actually the first time young girls had been politically active as a group."

I ask what it was like to work with Senior Chief Chitera. "She is a great woman. A role model, not only for girls, but our mothers. She has taken it upon herself to cause change. She has said over and over, 'I am not educated, but that should end with me. This generation should be different.' She stands her ground and says 'education first.'

"When you are a traditional leader, you have the power to defend your relatives. One of her relatives, a chief, impregnated a teenage girl. Instead of defending him, she said, 'You have gone against the law of our community.' He was sent to prison. As girls, when we saw that, she gave us courage."

Memory answers a phone call from her sister, and asks me to talk so her sister can practice English. Now 16, her sister has had three babies with three husbands, and been divorced three times. "So she has given up on all that," Memory reports.

Her sister is now living in Northern Malawi with their mother, who takes care of the children because—Memory is elated to announce—"I've been talking to her and she has enrolled in school! That is the perfect news. She stopped for almost two years. She passed her entrance exams. She went straight to secondary school!" Memory is using some of her own scholarship money to pay her sister's tuition.

I ask what Memory's aunties said when she, herself, refused to attend initiation camp. "They told me, 'You are stubborn, you are stupid, you will not be a woman enough'—because if you don't go to initiation camp—even when you are as old as Joyce, you are considered a child. Most girls think they have to go. Aunties tell you, 'When you come out of the camp, there will be a beautiful celebration; your parents will buy you a new dress; you will get to eat meat and chicken.' But more and more GENET girls are refusing to go."

CLOCKWISE FROM TOP LEFT: Senior Chief Chitera, Ada Ali, of Chiradzulu District; Olivia Mapemba, village headwoman; Joyce and Memory in the botanical garden in Zomba; the road to Chitera; Lydia at home; Christina and her baby, Praise; Memory shops for dinner.

I ask how Memory imagines her future, and tell her that I will happily vote for her to be Malawi's president. "Not politics. I want to pursue law because I want to stand up for girls' rights. One of the discouraging things for girls is that they have no one to speak for them when they are violated. I want to be the lawyer who assists girls so they are able to access justice."

The idea that Memory would become a lawyer makes sense. She is already an impressive public speaker. I ask how it was to address the U.N. "There were girls from all over the world. It was so good to see the leaders listening, eager to see what girls are facing and what the U.N. can do. Leaders and founders of big organizations were there. For the first time, I was given a chance to tell them what we young girls want. Girls could contribute to the 2015 Sustainable Development Goals. It was very much incredible. One leader said, 'You know what? This has never happened in the history of the world, that young girls are changing a law.'"

The New York visit wasn't all work and no play. When Alex asked Memory last March, "What was most fun about the visit?" the answer was: "Snow! Footprints. Crunching and sliding. We had never seen snow!"

I ask Memory how it was to present a TED Talk. "It was not just about practicing. It was about standing up and talking about your inner feelings, what is inside of you; what my sister faced and how that became a stepping stone for me to speak out on behalf of my sister, myself, and other girls in my community.

"By the end of the day, I saw that not only was I talking on behalf of girls in Malawi, but on behalf of a lot of girls worldwide. I thought it was just a story about my sister, a small story, but it turned out to be a larger story. It was so amazing to see people being inspired and motivated. It was beautiful."

Memory is an Advisor to The Girls Empowerment Network, and attends as many GENET events throughout Malawi as her studies allow, then reports to the Board about the issues and trends that are underway.

I ask whether her life has room for anything except studies and advocacy. "I have a beautiful diary. When I am alone, I love writing poetry." She shares a poem.

WHISPER OF A CALLING

Young woman!
You are young.
You are a young vision.
A young vision for Africa.
You are Africa.

.......Strong......................
Majestically she flows.
She flows like a peaceful river
Giving meaning and purpose to her home,
Pumping vital blood to her home.
The community looks up to her,
A backbone of a society

With a whisper of a calling
I call you.
Speak, I say,
Speak young woman.
Why are you quiet?
Speak for your daughters.
If you don't, they will.
Show Africa that you are her backbone.
She stands strong because you are strong.

With a whisper of a calling
I call you
......speak....................
Breakaway from the silent tears.
Don't you know you are strong?
Break away I say.
You are the young blood of hope,
A hope to all the daughters of Africa.

Note: Girls Empowerment Network and Rise Up have policies
that disallow the use of last names for girls 18 and younger.

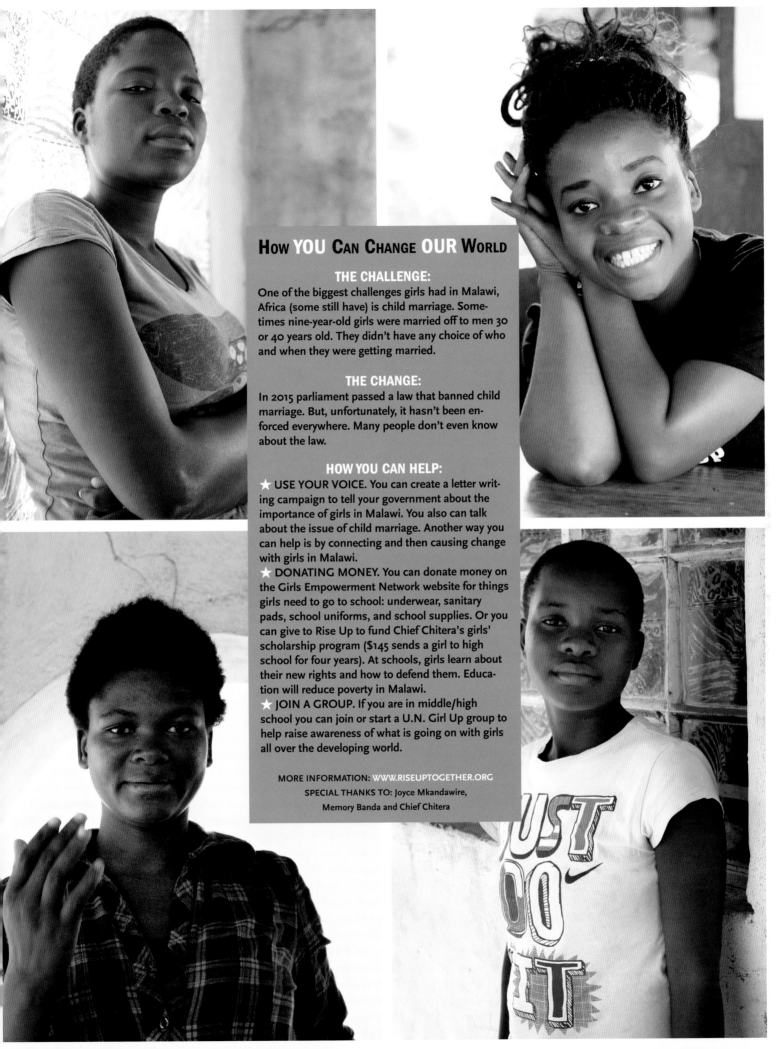

How YOU Can Change OUR World

THE CHALLENGE:

One of the biggest challenges girls had in Malawi, Africa (some still have) is child marriage. Sometimes nine-year-old girls were married off to men 30 or 40 years old. They didn't have any choice of who and when they were getting married.

THE CHANGE:

In 2015 parliament passed a law that banned child marriage. But, unfortunately, it hasn't been enforced everywhere. Many people don't even know about the law.

HOW YOU CAN HELP:

★ USE YOUR VOICE. You can create a letter writing campaign to tell your government about the importance of girls in Malawi. You also can talk about the issue of child marriage. Another way you can help is by connecting and then causing change with girls in Malawi.

★ DONATING MONEY. You can donate money on the Girls Empowerment Network website for things girls need to go to school: underwear, sanitary pads, school uniforms, and school supplies. Or you can give to Rise Up to fund Chief Chitera's girls' scholarship program ($145 sends a girl to high school for four years). At schools, girls learn about their new rights and how to defend them. Education will reduce poverty in Malawi.

★ JOIN A GROUP. If you are in middle/high school you can join or start a U.N. Girl Up group to help raise awareness of what is going on with girls all over the developing world.

MORE INFORMATION: WWW.RISEUPTOGETHER.ORG
SPECIAL THANKS TO: Joyce Mkandawire,
Memory Banda and Chief Chitera

ACKNOWLEDGEMENTS

From Alex:

I would like to thank my mom, dad, and my sister Avery for supporting and loving me. I would also like to thank my friends, teachers, and Laurence School, who taught me to "Keep kind in mind."

Last but not least, I would like to thank my grandmother for letting me have the opportunity to write this amazing book with her.

From Paola:

October 11, 2017, the release date of this book, is the United Nation's International Day of the Girl Child, an auspicious occasion worldwide. I'm grateful to our publisher, powerHouse Books, for organizing their schedule, staff, and suppliers to make certain that *Wonder Girls* would be ready to salute and celebrate girls everywhere.

I smiled when I read Alex's thoughts above because, as usual, she got it exactly right. I loved working with her and appreciated her talent, time, ideas, intelligence, and energy, which helped bring this project to life. I am also grateful to her parents, Scott and Michelle Sangster, who arranged family plans to accommodate book work, helped tackle technology issues, networked to help contact groups, took time off to travel with us, and cheered us on. I also appreciate my younger grand girl, Avery, who was willing to wait until next time to do a project with grandmother.

People always ask how I find the groups in my books. Identifying the most interesting stories consumed about a year of research, exploring leads, and asking for introductions from people and organizations around the world. Four grant-making nonprofits went all-out to help:

* Rise Up/Let Girls Lead introduced me to the Girls Empowerment Network in Malawi and Rhythm of Life in Uganda.

* One World Children's Fund and their Board Member, Karim Ajania, introduced me to Akili Dada in Kenya.

* Mama Cash introduced me to WoteSawa in Tanzania.

* The Global Fund for Women's program officers identified lists of grantees to consider, then introduced me to the Executive Directors of the four I selected: Girl Activists of Kyrgyzstan, Girl Determined in Myanmar, Shaheen in India, and the Talitha Project in Tonga. (GFW had previously funded the Girls Empowerment Network in Malawi and Akili Dada in Kenya).

Although a surprising number of wonder girls speak English, in some places talented interpreters were invaluable; they knew the girls, the projects, and the local culture. They were: Nusrat Ansari (India), Allan Busby (Uganda), Dariya Kasmamytova (Kyrgyzstan), Maria Makarova (Mexico), Joyce Mkandawire (Malawi), Ei Ei Phyo Lwin (Myanmar), Lydia Peter (Tanzania) and Veronica Thamani (Kenya). We couldn't have collected these stories without them.

The process of creating this book was a rich collaboration between the co-authors and the featured groups. The texts for every chapter were fact-checked by all the nonprofits' Executive Directors and often, also by the girls we interviewed. The book is more accurate for their attention and expertise.

I am grateful to Kathleen Buckstaff, Susan Krieger, Estelle Freedman, and Rob Sangster for reading and commenting on sections of the manuscript. All are authors with several titles to their names; I appreciate their wisdom and suggestions.

I am honored that the President and CEO of the Global Fund for Women, Musimbi Kanyoro, contributed the Foreword. Her understanding of girls' lives and her insight about girls' issues, uniquely enhanced this project.

Joseph Guglietti created the basic layout and design for *Wonder Girls*. He was the designer of the hardcover edition of my first book, *In Her Hands, Craftswomen Changing the World*. It was a pleasure to work with him again.

Krzysztof Poluchowicz designed this book, and I am grateful for his creativity and equanimity, taste and talent.

Will Luckman line-edited *Wonder Girls;* he is the spelling and punctuation expert of all time.

Whitney Johnson, Deputy Photography Editor at *National Geographic,* taught me more about editing images than I've ever known. How glad I am to have attended her session at the Santa Fe Photographic Workshops.

Liz Spander and Florigna Bello at Casto Travel get kudos for creating detailed itineraries that most people in their business wouldn't bother tackling: airline tickets and hotels accommodations paid for with my frequent flyer miles.

Finally, I am grateful to my writer/creative director husband, David Hill, for editing the manuscript. I had to gather my gumption to ask him for help since he has been writing almost three times as many years as I have. He honored my trust. He weeded out chapter drafts, pruning so well that I couldn't figure out what words he deleted. He has an unerring sense of my intention and voice. I had fun working with him.

Many who helped create this book are named in the stories. But the generous individuals on the list below are not. Books like this one would not happen without the help of people who let me take pictures in their homes and offices; friends who shared an idea, sent an article, pulled strings, introduced me to an expert; drivers who guided me through places where I would otherwise have been lost; experts who offered insight and advice. The following people contributed in those ways and more:

Israela Abrahamson, Assimwe Claire, Marian Babbs, Madhavi Bhasin, Shaheda Begum, Peter Block, Lori Bonn, Renee Brewster, Kay Brown, Tom Brown, Olga Budu, Patricia Savitri Burbank, Brian Callahan, Meg Cangany, Ben Cardin, Guadalupe Cervantes, Kayrani Chibade, Sangeeta Chowdhey, John Clark, Craig Cohen, Joanne Conelley, Madelief Crezee, Bonnie Dahan, Emma Denlinger, Nancy Deyo, Aneta Dezoete, Paula Dragosh, Barbara Dudley, Denise Dunning, Susan Ely, Stephan Emanuel, Seth Fearey, Julia Fine, Ginna Fleming, Mira Fleming, Mary Lyn Fonua, Pesi Fonua, Mariam Gagoshashvili, Blanca Janet Moreno Gallegos, Leander Ganzert, Leah Garey, Meghan Gafferty, Leone Gianturco, Nancy Glasser, Lorena Gomez-Barris, Tessa Gordon, Lynn Grefe, Emily Hagerman, Sipola Halafihi, Dr. Robin Harar, Anita Harvey, Sally Havens, Steph Allie Heckman, Jill Heppenheimer, Irene Hoff, Maria Janush, Rebecca Kafuma, Martha Kaufman, Anna Killius, Jean Lave, Pyone Lay, Marty Lohman, Barbara Lotti, Olivia Mapenba, Silvia Marjeyeh, Camille Matson, Mike Maulidi, Nicky McIntyre, Janis Miglavs, Barbara Mikulski, Jill Miller, Ignatius Miwanda, Edna Mitchell, Muigai Maria, Derrick Musinguzi, Claire Mysko, Nakakeeto Saidat, Molara Obe, Voula O'Grady, Robyn Page, Sarah Parle, Ann Peden, Gail Perkins, Erik Peterson, Ellen Picataggio, Janice Porter, Daniel Power, Samantha Quist, Natascia Radice, Nancy Ramsey, M. Aoil Najih Reza, Eko Riyanto, Rikki Roger, Sara Rosen, Randy Roussel, Ko Sai, Frances Salles, John Sarbanes, Sara Schenning, Arja Schreij, Helen Shears, Tina Singhsacha, Molly Sterling, Sofia Lorena Romero Tamayo, Tamara Pels Idrobo Tapia, Jessica Theroux, Elena Tkacheva, Lala Vllabh, Chris Van Hollen, Christine Waldron, Cercia Wallace, Helen Wamala, Elizabeth Weiss, Chyah Weietzman, Amie Williams, Nancy Williams, Ashley Wilson, Ella Wilson, Elvira Wijsen, Nancy Young.

BIBLIOGRAPHY

PROTECTING THE PLANET: INDONESIA

Christensen, Polly. "Plastik Tidak Fantastik (Plastic Is Not Fantastic)." *Indonesia Expat,* July 1, 2014. indonesiaexpat.biz/tag/plastik-tidak-fantastik/.

"Governor of Bali Signs Memorandum to Minimize the Use of Plastic Bags." *Bamboo News,* February 10, 2015.

Newsham, Louise. "Bali Trash Tidal Wave: Forget Cats and Dogs, It's Raining Trash." *Coconuts Bali,* December 12, 2014. bali.coconuts.co/2014/12/12/balis-trash-tidal-wave-forget-cats-and-dogs-its-raining-trash.

Wellington, Katy. "A Trash Problem." *Public Policy Indonesia,* January 13, 2015. msppindo2015.wordpress.com/2015/01/13/a-trash-problem/.

CREATING PEACE: ISRAEL AND PALESTINE

Abuelaish, Izzeldin. *I Shall Not Hate: A Gaza Doctor's Journey on the Road to Peace and Human Dignity.* New York: Walker Books, 2012.

Ben-David, Shoshana. "Runners without Borders." Huffington Post, January 22, 2016. www.huffingtonpost.com/shoshana-bendavid/runners-without-borders_b_9047706.html.

Ben Solomon, Ariel. "Is the Government Quietly Executing the Prawer Plan for the Negev's Bedouin?" *Jerusalem Post,* November 6, 2015.

"B'Tselem's Initial Findings on Nakba Day Incident at Bitunya: Grave Suspicion That Forces Willfully Killed Two Palestinians, Injured Two Others." *B'Tselem,* May 20, 2014.

Elar, Shlomi. "IDF Killing of Palestinians on Nakba Day a Warning." *Al-Monitor,* May 16, 2014.

Euronews. May 15, 2014. www.youtube.com/watch?v=ikvlTDuG6C4.

"Getting from Gaza to Israel by Underground Tunnels." *New York Times,* July 22, 2014.

Hatuqa, Dalia, and Gregg Carlstrom. "Palestinians Mark Nakba Day amid Violence." *Al Jazeera,* May 15, 2014.

Haywood, Phaedra. "As Mideast Conflict Rages Back Home, Women Learn to Be Leaders in Peace." *Santa Fe New Mexican,* July 20, 2014.

Human Rights Watch. "Israel: Killing of Children Apparent War Crime." June 9, 2014.

Jews for Justice for Palestinians. "Two Dead Boys—Power of the Camera." June 22, 2014. jfjfp.com/?p=60065.

Khoury, Jack, Chaim Levinson, Nir Hasson, and Gili Cohen. "Two Palestinian Teens Killed at Nakba Day Protest in West Bank." *Haaretz,* May 15, 2014.

Livingstone, Molly. "Running without Borders: The First Step to Peace?" *Voice of Israel,* March 2, 2015.

Moore, Kamilah. "Israeli Attacks on Al Quds University Give New Meaning to Academic Freedom." *Mondoweiss,* November 17, 2014.

"Report: Autopsy Finds Live Fire Killed Palestinian Teen during Nakba Day Clashes." *Jerusalem Post.*

Rinat, Zafir, and Jonathan Lis. "A Guide for the Perplexed: Israel's Bedouin Resettlement Bill." *Haaretz,* June 25, 2013.

Tolan, Sandy. *The Lemon Tree: An Arab, a Jew, and the Heart of the Middle East.* New York: Bloomsbury USA, 2007.

FLYING FREE: INDIA

"Dog Squad, Women Daredevils Will Make the Sixty-Seventh R-Day Celebrations Unforgettable." *Hyderabad Times,* January 26, 2015.

Nishat, Jameela. *Butterfly Caresses.* Partridge India, 2015.

Shaheen Women's Resource and Welfare Association. *Shaheen Annual Reports,* 2013–2014 and 2015. shaheencollective.org/Shaheen%20Annual%20Report%2014-15.pdf.

"Varsities Shut over Vemula's Death." *Times of India,* January 28, 2016.

EXPOSING CHILD ABUSE: TONGA

Amnesty International. *Sexual and Gender-Based Violence in the Pacific.* www.amnesty.org.nz/sexual-and-gender-based-violence-pacific.

"Family Protection Act in Force by Mid-2014." *Matangi,* November 13, 2013.

Kaeppler, Adrienne L. *Lakalaka: A Tongan Masterpiece of Performing Arts.* Nuku'alofa, Tonga: Vava'u Press, 2012.

Munro, Peter. "The Friendly Islands Are No Friend to Women." *Sydney Morning Herald,* July 11, 2015.

UNICEF. Tonga Statistics. *The State of the World's Children 2013.* www.unicef.org/sowc2013/files/Table_1_Stat_Tables_SWCR2013_ENGLISH.pdf.

Vaka'uta, Koro. "Tongan Women Activists Celebrated." Radio New Zealand, June 22, 2015.

CHANGING POLICY: USA

Aratani, Lori. "Placing a Value on School: Girls Help Open Doors for Peers in Mali." *Washington Post,* April 14, 2005.

Congressional Record. Senate passed S1177, Every Child Achieves Act as amended. July 16, 2015.

Fine, Julia. "Why Malala's Bravery Inspires Us." CNN.com, December 17, 2013.

"Girls Gone Activist!" New Moon Girls. www.newmoon.com.

"Girls Hit the Lobby Trail for Their Overseas Peers." *Washington Post,* February 26, 2008.

Morello, Carol, and Karen DeYoung. "Historic Deal Reached with

Iran to Limit Nuclear Program." *Washington Post*, July 14, 2015.

Penn, Ben. "School Girls Unite." *Youth Today*, June 2, 2010.

School Girls Unite. *The Activist Gameplan! Put Your Passion into Action*.

"School Girls Unite Aims to Remove Obstacles to Girls' Education Worldwide." *Kensington Maryland Gazette*, June 22, 2005.

"This Week in Photos: Cardin Greets Biden." *Politico*, July 13–17, 2015.

Tinney, Jason. "Girls Helping Girls: Howard County Girls Advocate Child Marriage and Education." *Her Mind Magazine*, 2012.

"United They Stand: Girls in Maryland Help Girls in Mali Go to School." *Time for Kids*, February 18, 2005.

"Why Day of the Girl?" Plan International. plancanada.ca/why-the-day-of-the-girl.

"Young Feminists Have Their Day." *Ms.*, Fall 2012.

LEADING CHANGE: MYANMAR

Chan, Sewell. "First Freely Elected Parliament in Decades Opens in Myanmar." *New York Times*, February 2, 2016.

"The First One Hundred Days." *Mizzima Weekly*, January 14–20, 2016, 30–31.

"Girl Determined Making Goal a Success in Myanmar." Goal, October 23, 2015. goalprogramme.wordpress.com.

Graham, John. "Myanmar's Suu Kyi Says Peace Talks Will Be Priority." *Mizzima Weekly*, January 14–20, 2016, 20–21.

Litner, Bertil. "Burma and Myanmar Mean Exactly the Same Thing." *Mizzima*, January 11, 2012. archive-2.mizzima. com/edop/letters/6395-burma-and-myanmar-mean-exactly-the-same-thing.html.

Mahtani, Shibani, and Myo Myo. "Picking a President, Suu Kyi Opts for Loyalty." *Wall Street Journal*, March 11, 2016.

Moe, Wai, and Richard C. Paddock. "Loyalist of Aung San Suu Kyi in Line for Myanmar Presidency." *New York Times*, March 11, 2016.

"Suu Kyi's Victorious Party to Join Parliament on February 1." *Mizzima Weekly*, January 14–20, 2016, 11.

Wansai, Sai. "Is the NLD Treating the Ethnic Nationalities as Insignificant?" *Mizzima Weekly*, January 14–20, 2016, 25–27.

Win, Thin Lei. "Where Are Women in Myanmar's Peace Process?" *Mizzima Weekly*, January 14–20, 2016, 23–24.

GENERATING JUSTICE: NEW ZEALAND

Amnesty International NZ. *Active*, youth magazine. Term 1, 2015.

Amnesty International NZ. *Active*, youth magazine. Term 2, 2015.

ENDING EXPLOITATION: TANZANIA

Anti-Slavery International. *Child Domestic Workers: A Handbook on Good Practice in Programme Interventions*. Horsham, UK: The Printed Word, November 2005.

US Department of Labor, Bureau of International Labor Affairs. *Findings on the Worst Forms of Child Labor*. 2013.

CHAMPIONING EQUALITY: KYRGYZSTAN

Aisaeva, Aishoola. "The First Stories about Girls' Lives in Kyrgyzstan." Global Voices, October 30, 2014. rising. globalvoices.org/blog.

———. "Latest Project Updates from Girl Activists of Kyrgyzstan." Global Voices, January 7, 2015. www. rising.globalvoicesonline.org.

Bek, Ian. "Kyrgyzstan and the Second World War." *Postcard from Bishkek*, May 9, 2010. ianbeck.kg.

Girl Activists of Kyrgyzstan. Girls Day video. www.youtube.com/watch?v=P_-cfpkGj4A.

———. Girls Day video. www.youtube.com/watch?v=tb_7gZTvVSI.

———. Girls Day video. www.youtube.com/watch?v=u9lhbaTJ1gA.

Girls Not Brides. "Child Marriage, Kyrgyzstan." www. girlsnotbrides.org/child-marriage/kyrgyzstan/.

Human Rights Watch. "'Call Me When He Tries to Kill You': State Response to Domestic Violence in Kyrgyzstan." October 28, 2015.

Kasmamytova, Dariya. "Girl Activists: Telling Our Own Digital Stories in Kyrgyzstan." Global Voices, August 26, 2014. rising.globalvoices.org/blog.

———. "Never a Shortage of Topics for Girl Activists in Kyrgyzstan." Global Voices, August 2, 2014. rising.globalvoices. org/blog/2014/09/02/never-a-shortage-of-topics-for-girl-activists-in-kyrgyzstan/.

———. "Raising the Issue of Gender-Based Violence and Inequality in Kyrgyzstan." Global Voices, October 30, 2014. rising.globalvoicesonline.org.

Rittman, Mihra. "Kyrgyzstan Does the Right Thing." Human Rights Watch, May 12, 2016.

Thorpe, Meredith. *Glimpses of Village Life in Kyrgyzstan*. Bishkek: Sonun zher, 2004.

United Nations Office of the High Commissioner of Human Rights. Committee on the Rights of the Child Examines Report of Kyrgyzstan. May 28, 2014.

IGNITING LITERACY: USA

"Changing the World, One Word at a Time." *The Queen Latifah Show*. www.youtube.com/watch?v=YshUDa1oJYY.

Lane, Diane Luby, and the Get Lit Players. *Get Lit Rising.* New York: Simon Pulse/Beyond Words, 2016.

McGavin, Rhiannon. *Leaf.* Self-published, 2015.

RAISING VOICES: USA, GGM

Marshall, Ebony. "Beyoncé's Feminism Is Elitist." *Women's eNews,* April 29, 2015.

———. "I Am Pro-choice Because I Am Pro-woman." *Women's eNews,* June 20, 2015.

Rosen, Wendy. "Journalism Boot Camp Teaches Young Women to Voice Social Concerns." *Streetwise,* August 7–13, 2013.

"A Weekend in Chicago: Where Gunfire Is a Terrifying Norm." *New York Times,* June 5, 2016, 1.

Williams, Amie. "The Inspiration behind GlobalGirl Media." Huffington Post, September 10, 2014. www.huffingtonpost.com/pioneers-for-change/the-inspiration-behind-gl_b_5794336.html.

STOPPING CHILD MARRIAGE: MALAWI

AVERT. www.avert.org/hiv-aids-malawi.htm.

BBC. www.bbc.com/news/world-africa-32325177.

Cole, Diane. "If These Two Teenagers Ran the World, We'd All Jump for Joy." Goats and Soda. NPR, March 17, 2015.

Dunning, Denise, and Joyce Mkandawire. "How Girl Activist Helped to Ban Child Marriage in Malawi." *Guardian,* February 26, 2015.

Girls Not Brides. www.girlsnotbrides.org/child-marriage/malawi/.

Human Rights Watch. "Malawi: New Marriage Law Can Change Lives." April 17, 2015.

IFAD (International Fund for Agricultural Development). www.ruralpovertyportal.org/country/home/tags/malawi Rural Poverty Portal.

International Women's Health Coalition. iwhc.org/2015/02/malawi-bans-child-marriage-work-just-beginning/.

"Marriage, Divorce, and Family Relations Bill, 2015." *Malawi Gazette Supplement,* January 30, 2015. www.humandignitytrust.org/uploaded/Library/Other_Material/Malawi_-_Marriages_Divorce_and_Family_Relations_Act_2015.compressed.pdf.

Mlozi, Howard. *Information on GENET Malawi's Work in the Fight against Child Marriage.* GENET Malawi, December 2013.

Park, Madison. "A Rite of Passage That Pushes Girls into Sex." CNN, February 4, 2014.

Population Reference Bureau. www.prb.org/pdf12/malawi-datasheet-2012.pdf.

UNICEF. www.unicef.org/malawi/reallives_16694.html.

ABOUT GIRLS IN GENERAL

Girl Power Alliance. "Power to the Girls!" December 2015. womenwin.org/files/GP%20PowerToGirls.pdf.

Poole, John. "Where the Girls Are (and Aren't)." Goats and Sodas. NPR, October 29, 2015.

PLAN INTERNATIONAL, *Counting the Invisible, Using data to transform the lives of girls and women by 2030,* October 2016.

UNICEF. *The State of the World's Children 2016.* www.unicef.org/sowc2016/.

UN Women. "Youth Leaders Call for 'Big Leap' for Gender Equality at first CSW Youth Forum." March 14, 2016. www.unwomen.org/en/news/stories/2016/3/youth-forum-at-csw60.

US Department of State. *United States Global Strategy to Empower Adolescent Girls.* March 2016. U.S. Department of State, USAID, Peace Corps and Millennium Challenge Corporation. www.state.gov/documents/organization/254904.pdf.

Williams, Alex. "Move Over, Millennials: Here Comes Generation Z." *New York Times,* September 18, 2015.